W9-AOU-101

PAUL NASH

The Master of the Image

1889–1946

PAUL NASH

The Master of the Image

1889–1946

MARGOT EATES

ST. MARTIN'S PRESS NEW YORK

Copyright © 1973 by Margot Eates
All rights reserved.
For information, write:
St. Martin's Press, Inc., 175 Fifth Ave.,
New York, N.Y. 10010
Printed in Great Britain
Library of Congress
Catalog Card Number: 74-76711
First published in the
United States of America in 1974

Illustrations reproduced and printed by
Newgate Press Ltd, London
Text printed and bound by
W & J Mackay Limited, Chatham
0 7195 2671 X

Contents

Illustrations in Text

*To
Ruth Clark
in gratitude
for her friendship to
Paul and Margaret Nash
and to the Author
this Book
is affectionately dedicated*

Foreword

PAUL NASH was one of the most gifted artists working in Great Britain between the two world wars and he reacted to both wars in a particularly authentic way. Although alive to contemporary influences, he was not overwhelmed by the current tides of fashion from Paris. He died comparatively young, aged 57, in 1946. A Trust in his name was set up by his widow, Margaret, on her death in 1960, whose task was to look after the residue of his work and place it in important galleries and museums, then to prepare an informed, reliable and well illustrated book to reach as wide a public as possible. The Trustees asked Margot Eates, who had edited the Memorial Volume, published at the time of his retrospective exhibition at the Tate Gallery in 1948, to write this book. The Paul Mellon Foundation very generously agreed to contribute towards two years research and to help with photographs, thus materially aiding the Trust's funds in providing for the adequate preparation and illustration of this book.

We asked the late Cecil Day Lewis, then Poet Laureate, to write a Foreword in his own terms as a poet, believing that one artist can have significant views on another, sharing to some extent the same world-stage, but working in a different medium. We were very grateful to Cecil Day Lewis and think his 'Personal View' will be to many a lively and helpful introduction to Paul Nash, the painter.

We should like to thank Margot Eates for the time and energy she has put into the research for, and preparation of, this book. The documentation which she has prepared will be given to the Tate Gallery, where it will be available for the use of future students. The books, letters and other documents used will be found referred to under Acknowledgements, but a special word must be said about Margaret Nash's work in collecting together photographs of Paul's paintings and drawings with titles and dates ascribed. No one knew more about his work, nor had a deeper understanding of it, than Margaret, his wife and lifelong companion. Although occasionally her memory of a date or title may be in dispute, this collection, which she gave to the Library of the Victoria and Albert Museum, must remain the solid basis for knowledge of the work of Paul Nash.

Paul Nash: A Private View

BY C. DAY LEWIS

CASTING ABOUT for a way to approach Paul Nash, a painter I never met, and for something a poet might have in common with this painter, my eye chanced upon a reproduction in the Memorial volume of 1948. It is an oil, entitled *Pond in the Fields*. Trees encircle the small pond: I get the impression that they are thrashing restlessly in a high wind; but the surface of the water is almost tranquil. I do not like to give literary interpretations to works of graphic art; but the picture seems to hold out a meaning which can be grasped in terms of my own art. What I see is the still centre of a tornado, the still centre which is the core of a poem: here is an image of the movement and the calm which are both necessary to the achievement of any work of art. At a less impersonal level, I see the pool as an image of the artist or poet, surrounded by perturbations and distractions, not indeed detached from them, but in spite of them and through them preserving the integrity of his own nature.

Another subject which Paul Nash made his own was Wittenham Clumps. Before I ever set eyes on these curious protuberances, I had been fascinated by a picture of his which conveyed to me, through the air of mysterious solitariness, dominance, magnetism he imparted to one of these low Clumps, a feeling that this was, in some special sense, holy ground. In his autobiography, *Outline*, Paul Nash wrote, 'I belonged to the country': and it was not only his farming ancestors who created the sense of belonging. He had this sense by virtue of what prepossessed him as an artist. Throughout his several changes of style, he remained an inveterately English painter (it is a shock to see the Italianate face in the photograph of 1912), imbueing the natural scenes and objects which were his familiars with a touch of the mysterious, as did Samuel Palmer, but never—after a few very early works—treating them with any facile or literary pseudo-mysticism. His Englishness as a painter is given in his own words: 'it was always the life of the subject rather than its characteristic lineaments which appealed to me'. He wrote about a certain part of Kensington

Gardens as 'my first authentic *place*'; and I am prepared to believe that this was not hindsight. I too as a child had my equivalent for his enclave in Kensington Gardens; but mine (a Rectory garden in County Wexford) only assumed its full significance many years after I had ceased to know it. It may be that the painter quickly recognises each *genius loci*, by reason of his special kind of innocence, whereas for the poet they grow their *mana* more slowly, recollected in tranquility rather than apprehended immediately.

In *Outline* the painter commented on the 'curiously symmetrical sculptured form' of Wittenham Clumps: to the child 'they were the Pyramids of my small world'. The sculptural quality in many of his finest pictures is evident, and this feeling for tangible form started very young, when the boy delighted in the texture and solidity of a hen's egg. He might have become a sculptor. As a youth he hoped to emulate D. G. Rossetti, painting pictures and writing poems; and, like many good painters, he wrote accomplished prose. I doubt if his vocation became absolutely clear to him till the day when Sir William Nicholson looked at the young man's drawings and said, 'My boy, you should go in for Nature.' From then on he concentrated chiefly on natural subjects (though he was extremely versatile, going in also for book illustration, theatrical design, textiles, etc.). He soon began to learn the lesson that 'figures cannot easily be introduced into landscape' unless they are treated from the start as 'an integral part of the structure of the composition'. This, in terms of his own craft, the young poet also must learn—that verbal felicities or dazzling afterthoughts can not be superimposed on a poem, like cherries on a cake; ideally, every word must be essential to the poem's structure if it is to be a whole poem.

Painting before the First War in Dedham Vale, Paul Nash could say, firmly but not dismissively, 'I did not want to paint landscapes like Constable.' Of the pictures he did paint, 'none looked very much like the places, but in some degree they expressed perhaps the mood of the landscape'. Distortion and selection are

used in a poet's work as much as in a painter's. But, in speaking thus of a landscape's mood, Paul Nash committed himself to modernity: most poets today seek to explore and communicate their states of mind: abstract painting is presumably the most extreme point the painter has reached in the same direction. 'The mood of a landscape' must, unless we believe the pathetic fallacy is no fallacy, be a way of saying 'a man's mood induced by contemplation of a landscape'.

But Paul Nash would not in his young days have accepted such an interpretation. Instead of introducing human figures into a landscape, he saw features of the landscape in human terms. In a letter of 1912 to Gordon Bottomley he wrote, 'I have tried . . . to paint trees as tho they were human beings . . . because I sincerely love and worship trees and know they *are* people and wonderfully beautiful people.' Years later he was to talk about inanimate objects—the great standing stones at Avebury—as 'personalities'. On the other hand, if we look at a pen-and-wash drawing of the same year, *Under the Hill*, we see the trees in the middle distance are less like trees than like boulders in a rocky massif. This over-riding habit of metaphor—trees felt as human beings, trees seen as objects sculpted by nature —runs all through his work, showing how poetic a painter he was, and therefore how firmly in the English tradition.

But there was a steeliness in him too which prevented his work from becoming vague or fuzzy. His poet-mentor, Bottomley, had impressed on him that 'the greatest mystery is obtained by the greatest definiteness'. The steeliness of the artist, the strength of his calling, comes through most astonishingly in the letters he wrote to his wife from France during the First War. 'I believe I am happier in the trenches than anywhere out here.' And again, 'Oh, these wonderful trenches at night, at dawn, at sundown!' He describes with rapture what he has seen, what the blasted landscape offers the painter's eye. This was in 1917, remember, when the euphoria felt by the Brooke-Grenfell generation was long past. Yet, with the absolute commitment of the artist to his subject, Paul Nash revels—there is no other word for it—in the colours and forms which he finds around him. It is not that he was stunned into insensitivity by the western front: several subsequent letters declare his indignation at the sufferings and the cant which the combatants were exposed to. But he was saved from futile introspection by the singlemindedness, the inspired egotism, of the artist who is sure of his vocation.

George Wingfield Digby says of Paul Nash that 'always he collected his strange store of "objects": shells, pebbles, curiously distorted sticks and stumps, seed-pods and other plant forms. . . . On these things his imagination seemed to feed and they were the ingredients, or starting points, of many of his pictures.' This brooding over *objets trouvés* has, I believe, a parallel in the poet's method of composition. In our work, we find ourselves compulsively attracted by individual words, their sounds and meanings, or by brief phrases which at first convey to us nothing rational but which, by brooding on them attentively, we come to accept as the seeds of a poem. Was it not Paul Nash himself who spoke of 'the common thing which is really marvellous'? To me, this phrase not only gives the reason for Nash's attraction to the *objet trouvé*: it also speaks for an ideal of poetry which I myself have tried to realise—the value residing in common things, the beauty of the unconsidered.

After he reached maturity, Paul Nash came to rely more and more on the tension of opposites, the juxtaposition of paradoxical or apparently unrelated objects. The pictures he painted of crashed aircraft in the Second War derive their singularity from 'being out of their element and being found not among the clouds but in cornfields or on the moors or stretched across the sands under the cliffs'. This tension of opposites, the fruitful mating of apparent incompatibles, works in the same way as the 'conceit' in metaphysical poetry. Paul Nash did not approve of that word: when someone praised his youthful drawings as 'a very pretty conceit', he replied 'Conceit! It is a vision.'

'Visionary', like 'poetic', can be a depreciative word when applied to a painter. My untutored layman's eye can see three main stages in Paul Nash's development. The first, though his preoccupations changed from time to time during it, runs up to about 1927: the second period, when he was affected by surrealism or abstract painting, occupied the Thirties: his last period covers the years between 1940 and his death and it is to the work of these years that 'visionary' most properly applies. In some of the Thirties' pictures I get the impression of rather cerebral experimentation, of a man trying to construct visions by reconstructing his way of seeing things. The war ended this phase. Paul Nash became natural again, and again in command of his master-habit of metaphor. We see it in *Wood against the Tide* (1941), where the land rolls up to the trees like a billowing sea: in *Landscape of the Summer Solstice* and *Landscape of the Vernal Equinox* (1943), both of which

feature Wittenham Clumps, but formalised now so that they resemble giant mushrooms: in *Solstice of the Sunflower* (1945), where the vast flower looks like a prophetic vision of a jet engine, and in *Flight of the Magnolia*, painted in the same year, which levitates a cluster of these blooms as though they were balloons filled with hydrogen. Such paintings look to me like true visions, whereas *Event on the Downs* (1933) with its intrusive tennis ball seems a *voulu* and shallow attempt to create the metaphysical surprise: it is hallucinatory, not visionary.

In these late 'visionary' or dream pictures, where objects shade off into different though related objects (hills into mushrooms, for example) the artist was revelling, I like to think, in his own daring, his accomplished touch and sense of power. He may well not know—what artist does?—when his feeling of experiment and freedom has produced a work whose meaning will prove to be factitious, or when some audacious liberty he has taken with his medium fails to

justify itself. From such imperfections or defeats he will rise, kept aloft by the joy of the artist in the practice of creation. Only one thing will the painter or the poet find spiritually crippling—a period of *accidie*. Such periods caused Paul Nash, a mentally robust and a hard-working man, less damage than most artists; equally, he was not badly scarred by the bitchery of Roger Fry and Wyndham Lewis after the First War.

What appeals to me most as a poet about the work of Paul Nash is, then, the joy, the exhilaration, of the creator which I feel in it. Chiefly, perhaps, it is the habit of metaphor—of changing some visual form sufficiently to admit the idea of some other form while still retaining enough of the identity of the original one—which communicates to the layman the painter's or the poet's belief that the visible world is not a chaos but one great network of relationships. In this sense his work offers us an enlargement of possibilities. It is thus that the artist justifies the ways of God to man.

Preface

DEFINITIVE STUDIES of an artist's work, providing both a record of his production and a critical assessment of his style, are often proposed and seldom achieved. When the Paul Nash Trustees invited me to undertake a critical study of the artist's paintings and drawings, they doubtless hoped that the resultant book might have some claim to finality. In the event, however, their hopes and my own were only partially fulfilled. Limitations of time and space precluded the possibility of a *catalogue raisonné*, even had the necessary information been available, and at an early stage it was agreed to abandon the initial project. The account of Nash's work which I have given is, moreover, in some sense only a 'private view' (like the foreword contributed by the late Poet Laureate, Cecil Day Lewis), because all such critical assessments must of necessity be largely subjective in character. There is no absolute standard for a Judgment of Taste, and any interpretation of an artist's work must always to some extent depend upon the personality of the critic who writes about him.

It had been my original intention to confine myself to a study of Paul Nash's art, since his life had already been the subject of the detailed and accurate biography by Anthony Bertram, published in 1955. But just as the biographer found that he could not write of Nash's life without dealing in some detail with his paintings, so I, in my turn, discovered that it was impossible to consider the paintings divorced from the biographical context. I should like to take this opportunity of acknowledging my indebtedness to Mr. Bertram, on whose book I have constantly relied for factual information, though I have sometimes differed from him in my interpretation of events and attitudes and have occasionally preferred an account given by Margaret Nash in her typescript Memoir of her husband. The mutual devotion and understanding which characterised the relationship of Paul and Margaret Nash and the amused tolerance with which each regarded the other's occasional foibles, rendered them the surest guide to their own and each other's reactions. To say this, however, is not to imply that there is no need to approach either Nash's unfinished autobiography and other writings, or his wife's Memoir with a critic's normal degree of objective scepticism. Views and events recollected in tranquillity sometimes assume a surprisingly roseate hue which may, alas, have to be discounted by the faithful historian.

Throughout the preparation of this work I have been greatly aided by the critical comments of Ruth Clark, Paul and Margaret Nash's oldest and closest friend. She has read the book in typescript and has been kind enough, not only to correct certain errors of fact, but also to supply me with additional information. Her one fault has been an excessive modesty about her ability to assist, and I am glad to be able to thank her publicly for her kindness and forbearance.

The time-consuming labour of proof-reading was most generously undertaken by E. H. Ramsden and Richard Smart, who, as a partner in the firm of Messrs. Arthur Tooth and Sons, was latterly Nash's agent and intimate friend. Freda Lingstrom rashly volunteered to compile the General Index, a task which she has carried out with characteristic care and discrimination.

To these three friends I should like to say, 'for this relief, much thanks', as I felt myself too close to the text to be capable of finalising either the corrections or the index. I must, however, hasten to add, that any faults the careful reader may detect should be attributed to me and not blamed upon my generous collaborators.

In attempting to trace Nash's artistic development it was imperative to acquire some idea of the full range of his production, even though in the critical text it has only been possible to refer to a relatively small number of his paintings and drawings. The compilation of the card indexes, recording in varying detail well over a thousand oils, watercolours, and drawings, has proved a formidable labour, which could not have been carried out without the patience and determination of Sally Martin, who has also been largely responsible for preparing the lists for publication. I am most sensible of my debt to her.

Though invaluable work was done both by Margaret Nash and by Anthony Bertram on the dating of many pictures, a number of problems have remained unsolved. In reaching my own conclusions about some of these, I have benefited greatly from the kindness of Andrew Causey, who has recently been making a detailed study of Paul Nash and who, with real generosity, placed the result of his researches at my disposal.

The collection of the information and photographs essential to a work such as this necessarily depends upon the co-operation of a great number of private collectors and the help of the Directors and staff of many public galleries, museums and institutions. Most of the photographs I have used for reproduction or for reference were already in the possession of the Nash Trustees, but some of the monochromes and all of the colour transparencies from which the plates have been prepared, involved special arrangements with the owners of the works illustrated, and to them I should like to record my gratitude. Formal permission to reproduce was seldom necessary, because Paul Nash usually retained the copyright in his works, and it is now vested in the Trustees. In a few instances, however, the copyright was assigned, and in those cases I am grateful for permission to reproduce. Amongst private owners the majority have understandably, though regrettably, preferred to remain anonymous. This anonymity in no wise lessens my feeling of obligation. In the number of those who are not reluctant to acknowledge their ownership particular mention should be made of Her Majesty the Queen (for gracious permission to reproduce *Hydra Dandelron*), and of Her Majesty Queen Elizabeth The Queen Mother (for gracious permission to reproduce her version of *The Landscape of the Vernal Equinox*), Mr. John Carter, Lord Croft, Sir Michael Culme-Seymour, the late Sir Herbert Read and the late Lance Sieveking. I hope that it will not appear invidious if, from a long list of public and private galleries and bodies, I also express my particular thanks to the Directors and staffs of those who have been at particular pains to answer my questions or to provide me with photographs—The Aberdeen Art Gallery, the British Council, the Brighton City Art Gallery, the National Gallery of Canada, the Carlisle Art Gallery,

the Dunedin Art Gallery, the Department of the Environment, the National Gallery of Modern Art, Edinburgh, the Manchester City Art Gallery, the Tate Gallery, the Whitworth Art Gallery, Manchester, The York City Art Gallery, Messrs. Christie, the Hamet Gallery, Messrs. Roland Browse & Delbanco, and Messrs. Sotheby.

Messrs. Faber & Faber have kindly permitted me to quote passages from the collected poems of Herbert Read, and to the Harvill Press I am indebted for similar permission to quote a passage from *Creative Intuition in Art and Poetry* by Jacques Maritain.

The final preparation of the text for publication has been carried out under the kindly guidance of Mr. John G. Murray, whose various suggestions and criticisms have always proved helpful. I am also much indebted to Mr. Ken Wilson of the Newgate Press for his personal supervision of the monochrome and colour plates.

In affording me the opportunity to continue (since I cannot say 'to complete') the work which I began in the *Memorial Volume* in 1949, the Paul Nash Trustees honoured me with a fascinating task. The attempt to interpret to a later generation the work of an artist, who made so notable a contribution in his own time to the main stream of English art, is in itself a rewarding labour. In the case of Nash it is the more rewarding, because in some sort it also commemorates all that was done by Margaret Nash to record her husband's art. Between the time of his death in 1946 and her own in 1960, she toiled unceasingly upon the compilation of her photographic record, the collection of material for the Memorial Exhibition and other shows, and upon the sponsorship of the biography, the unfinished autobiography, the book of photographs, entitled *Fertile Image*, and, of course, the *Memorial Volume*. Her single-minded devotion and her vivid personality, which had been so greatly prized by Paul Nash, impressed themselves on all who encountered her, and in concluding, it is my pleasure to be able to pay tribute to her memory, no less than to that of Paul Nash himself.

Margot Eates
Chelsea
January 1973

I

Prelude 1889–1906

THE MASTER OF THE OBJECT was the *sobriquet* conferred on Paul Nash by René Magritte, the Belgian Surrealist painter. As a description it delighted Nash, who later referred to it, in a letter to a friend, as 'rather a nice title like the Master of the Amsterdam Cabinet and other half mythical personages'.

The title was indeed an apt one, since it was in his understanding and mastery of the object and in his use of it as an image to express his inner meaning that Paul Nash's great achievement lay. The crispness and wit of the words were perfectly calculated to appeal to him, for they mirrored the qualities of his own mind and might well have been used by him when seeking to explain his work, though he would probably have hesitated to lay claim to the complete mastery of his medium which they imply.

The mastery was hard won. At every stage of his life Nash had to struggle afresh to find the perfect expression of his ideas when he began work on a new phase. He was not endowed with that natural facility which has been the undoing of so many promising artists. To 'lisp in numbers for the numbers came' is not always an auspicious beginning even for the ambitious poet, and an equivalent endowment in a painter can be equally perilous, for both may lead to an early self-satisfaction which impedes further progress and ends in a well-merited obscurity. Had Nash devoted himself to the trade of words and chosen to attempt the literary career which originally appealed to him, he might in fact have doomed himself to just such an obscurity, for in his early years words came more readily to him than line or colour and he was frequently betrayed into stereotyped verse of a wholly derivative kind. The essentially poetic character of his response completely failed to emerge from these unfortunate lines, and it was left to the successive stages of his development as a painter to reveal the true aspect of his mind.

A basically poetic approach, particularly towards the rendering of landscape, has always been regarded as peculiarly characteristic of the finest achievements of the English school of painting. The statement of the subject, however straightforward and literal it may at first sight appear is often modified by an element of highly personal interpretation which endows the painting with an added meaning over and above that implicit in the theme itself. This added meaning is usually extremely subjective and frequently 'romantic', so that it becomes apparent that the artist is concerned not so much with the formal rendering of what is in front of him, as with the emotional response it evokes in himself. The process of transmutation at its best is closely equivalent to the similar process in English nature poetry, which strives to convey an intense awareness of the basic metaphysical values underlying surface appearances.

Awareness of such hidden values is not, of course, an exclusive prerogative of the English either in literature or in art. But for the English there can be no doubt that in painting it has often taken precedence over the more formal considerations of line, colour and mass, and has at times lead to a certain disregard for technique. The sheer pleasure in the sensuous qualities of painted surfaces, so evident in much French nineteenth and early twentieth century work, has rarely been a notable characteristic of the English approach, and it must be admitted that its absence may leave the beholder unsatisfied, unless its loss is counterbalanced by an intensity of vision and depth of awareness capable of surmounting all merely technical considerations and tactile values.

This is, I admit, a broad and somewhat dangerous generalisation. It cannot, in the main, be applied to the finest work by Constable and Turner, for instance, nor is it so often applicable to watercolour painting as it is to oils. The use of oil pigments is a slower and more laborious process, in which it is easier to lose the original vision than is the case with watercolour, and it is with the latter that many English painters have shown themselves to be more at ease and to have expressed themselves more readily.

1

To say this is not to denigrate the contribution made by English painters to the main stream of art. Every work of art which can claim serious consideration must be assessed in its own terms and not by reference to other standards. It is ridiculous to assume, as some critics have done, that there is necessarily something more essentially admirable in good oil painting than in fine watercolour, or that large works are more 'important' than small ones. Yet it is by these standards that certain writers on nineteenth and early twentieth century art have judged the English painting of the period and found it wanting, although, illogically enough, they have excluded from their strictures the tiny watercolours of Paul Klee, whose importance as a leading member of the Bauhaus few would have the temerity to deny. Perhaps he has been exempted from blame because he was not English.

In tracing the development of Paul Nash and assessing the importance of his contribution, it is therefore essential to divest oneself of the prejudices engendered by an excessive devotion to the École de Paris and by a belief that English painting is more or less 'good' according to the degree to which it approximates to, or differs from, continental models.

Both as a man and as an artist Nash was, at one and the same time, highly individual and extremely English, and it is in these terms that he must be judged. In the course of his career he was naturally influenced, more or less deeply, by various contemporary movements, but he belonged to no 'school' and made no attempt to found one of his own. In this sense he was an isolated phenomenon, a fact which occasionally led to a misunderstanding of his aims and a failure to appreciate his true worth, despite the appreciation which was accorded to his work by discerning collectors and his generally acknowledged position as a leading figure in English art.

His outstanding achievement is all the more remarkable when one considers that he showed no early promise and that nothing in his background and upbringing could have led anyone to predict his future development. Deep sensitivity and a curious awareness of the places and people by which he was surrounded he undoubtedly possessed even as a small child, but he failed to give them expression, so that his dreams, his pleasures and his fears might easily have remained no more than vague memories of a childhood shot through with simple gaiety and haunting melancholy.

The gaiety remained with him throughout his life and is, indeed, a constant factor in his art. One of the greatest mistakes that can be made in studying his work is to assume that this most poetic of painters was a solemn and withdrawn figure 'hidden in the light of thought', taking himself very seriously and having little truck with his fellow men. Such a supposition would be wholly false and would completely distort any interpretation put upon his painting. The warmth and humanity of his personality, the brilliance of his wit, the kindliness of his humour and the fundamental humility of his approach to nature are everywhere manifest in his pictures. He never lost a childlike delight in simple things and though he played an important role in many of the theoretic controversies of the contemporary art world, he remained faithful to his own vision in a manner which recalls the lines:

> *'He prayeth best who loveth best*
> *All things both great and small.'*

Here Coleridge expresses that sense of wonder in the face of nature which is inherent in the greatest art as it is in the deepest religion. But it is no barrier to gaiety and does not imply the dreary solemnity that may be nothing more than a mask to conceal a lack of personality and a failure to come to terms with life.

The popular and mistaken notion that the artist is an absent-minded, grubby, bohemian amorist, with more paint on his clothes than on his canvases, is wholly divorced from anything that Paul Nash ever was. For him there was no division between art and life. Each was an aspect of the other, to be savoured to the full. He was an extremely social and sociable being, with an immense warmth of personality and a great sympathy, kindliness and generosity, which made him an ideal friend to whom young and old alike were equally attracted. Debonair is perhaps the most apt word to describe him. Even the sufferings caused by the prolonged illness from which he died so untimely, left his courage and his sense of humour unimpaired. As I have recorded elsewhere[1], his friend Archibald Russell, then Lancaster Herald, called him 'the last civilised man'. In his perfectly tailored suits, topped by an impeccably styled and well brushed broad brimmed hat, he looked like a distinguished ambassador with artistic leanings. He loved good food and good wine. He expanded in good company. He expressed himself with wit and precision as much in the spoken as in the written word.

[1] *Paul Nash: Paintings, Drawings and Illustrations*, ed. Margot Eates, with Essays by Herbert Read, John Rothenstein, E. H. Ramsden, Philip James, Lund Humphries, 1948. Hereinafter referred to as *The Memorial Volume*.

His life held many struggles, though they were not of the dramatic kind which involves starvation in a Paris garret, but he always emerged from them as an urbane and integrated man, largely because he took himself less seriously than he did his art, which he pursued with the concentration of 'the single eye'.

Yet, as I have said, the pursuit of art did not appear as an inevitable choice of career, and even when he decided to adopt it, his development was slow and his progress uneven. What, then, was his background, and how did he come to follow an unexpected road?

Paul Nash was born on May 11th, 1889, the eldest child of a fairly typical upper class professional family. His father, William Harry Nash, was a barrister, born in 1841 and called to the bar in 1873. He was appointed Revising Barrister for Gloucestershire when Paul was a small boy, and later became Recorder of Abingdon. Relatively late in life he married Caroline Maud Jackson, the daughter of Captain John Milbourne Jackson of the Royal Navy, and there were two further children by the marriage. John Northcote Nash, also destined to become a painter (and, unlike his brother, a Royal Academician) was born in 1893, and their sister, Barbara Milbourne Nash, in 1895.

The children were born and brought up at Ghuznee Lodge in Sunningdale Gardens, a part of the Earls Court area of South Kensington. The house has been brilliantly and imaginatively portrayed in the unfinished fragment of Nash's projected autobiography, which was posthumously published under the title *Outline*.[1]

'When I look back at Ghuznee Lodge', he wrote, 'I see a grey, high house facing across the line of vision taken by the other houses in the street, bending its gaze past the church and over Earls Court Road, away to the more attractive expanses to the west, where lay amiable squares and genteel crescents, and where, no doubt, it would have looked more comfortable. Somehow, it was a pariah of a house, with its outlandish name and pretentious conservatory where nothing, ever, would grow. Certainly it did not belong where it was and I don't think the Vicar liked living opposite even to its blind side.'

The house had all the haunting oppressiveness of its type and period. The dim dining-room 'lived in a sort of warm glow, like a jungle, and looked onto a meaningless garden, actually only an "ornamental" promenade about twenty yards across between two blocks of houses. . . . Opposite the dining-room was the drawing-room, an entirely unreal place to me, which led, quite logically, to the mocking glass void with its withered plants'.

It was in this 'rather unfriendly drawing-room' that Paul used to spend the statutory evening hour with his mother, when, banished from the far more cheerful and congenial atmosphere of the second-floor nurseries, he was sent downstairs to await his father's return from the Inner Temple. The alien feeling of the room may well have served to heighten the child's perception of his mother's nervous and apprehensive nature. 'I can remember', he wrote, 'the evenings in the drawing-room where I had spread my expensive soldiers or the ironically "de luxe" animals all about the floor, while my mother waited for my father's return from the mysterious place, the Temple. I would look up from my battle at her beautiful dark head with its agate eyes and abundant hair. Her mouth would be parted rather sadly. The shades thickened in the corners of the room; the conservatory, now emptied of light, became a ghost house; only the fire kept the darkness away until my mother shook off her reverie and rang for the lamp. At the same time a foot would sound on the steps outside and my father's key tinkled in the lock.'

The children's real life was lived out in the 'happier rooms above', presided over by the lovable personality of their nurse, a country girl named Harriet Luckett, in whose charge they made their daily expeditions to Kensington Gardens. These expeditions to the Gardens were to have an important and lasting influence on Paul, since it was there that he made his first discovery of 'A Place' and assimilated the beauty of trees and grass and open spaces, until they became a part of his being. Fortunately his encounters with nature were not confined to walks in the park, for the Nash family belonged to the countryside of Buckinghamshire, and the children's grandfather, John, lived in a large, comfortable country house called Langley Rectory, a place complete with gardens, stables, cottages, carriages and horses. The old gentleman was a widower and was already seventy-five when Paul was born, but despite the difference in their ages and despite John Nash's autocratic ways, the two became great friends and the child had all the benefit of becoming part of the still unspoilt English countryside.

[1] *Outline: An Autobiography and Other Writings,* Paul Nash, with a Preface by Herbert Read. Faber & Faber, 1949. The autobiography covers the artist's early life up to the outbreak of the First World War and is supplemented by a selection of letters to his wife from the Ypres Salient, his notes for the completion of the book, and seven essays, six of which are reprints. The quotations from it are so numerous that the reader need not be troubled with page references.

The nature of that countryside and of the life lived in it by families of the social standing of the Nashes have been so well described by Paul himself in *Outline* and by his biographer, Anthony Bertram[1], that there is no need to dwell upon them here. Suffice it to say that, even within a few miles of London, the pattern of country life remained much as it had been throughout the eighteenth and nineteenth centuries and only began to change radically at the end of the First World War, with the increasing use of the internal combustion engine and the social revolution of the inter-war years. It was, in the main, even for the poorer agricultural labourers, a relatively good and satisfying life, and there was between the landowner and his tenants and employees an organic relationship, based on mutual dependence and mutual interest. In the case of a good landlord and gentleman farmer like John Nash this was particularly true, and though his attitude might be patriarchal, it was always benevolent. Seed time and harvest, the welfare of man and beast, the changes of the seasons, still remained the governing factors of daily life and though the routine was varied for each, and the well-to-do had amusements not available to their poorer neighbours, everyone, as Nash put it in another context, got his living 'out of the land'.

From *Outline* it is clear that in his early childhood the country round Langley exerted a much stronger and more formative influence on Nash than did his life in Kensington. He felt himself at home in the fields and woods, as he never did in Ghuznee Lodge. This may perhaps in part explain the immense unhappiness of his London school-days, from which, as he says, he 'emerged impaired in body and spirit, more or less ignorant and equipped for nothing' at the age of seventeen.

'The long and complicated purgatory' of his school life began in January 1898, when he was sent as a day boy to Colet Court, the preparatory department for St. Paul's. The size of this establishment, which had more than three hundred boys, drawn from very varied social backgrounds, made it singularly unsuitable for an exceptionally sensitive child, who quickly realised that 'an organised system of bullying went on from which there was no escape . . . it was carried on without the knowledge of the masters and in defiance of the prefects and was run by a small group dominated

[1] *Paul Nash: The Portrait of an Artist.* Anthony Bertram, Faber & Faber, 1955. Since I have drawn extensively on this study of Nash's life and work, it is pointless to trouble the reader with notes of every page reference.

by a tall heavy boy with a fattish white face and quiet voice'. Such bullying has, of course, always been common, but to Paul it came as a hideous shock, and though he 'got through' his dose of it fairly well, as he put it, he discovered in himself a certain lack of nerve, which produced an agony of suspense, even though, when the anticipated moment of horror came, he often found that he could rise to the occasion and master it.

Nash writes of the masters at Colet Court as patient and kindly men, but there were probably too few of them either to cope with the bullying or to be able to devote time and individual attention to a pupil with a blind spot for mathematics. And it was in this field that Paul showed no aptitude whatsoever. Though he was 'capable of quite complicated methods of computation', the answers 'were fantastically wrong', and no one could find a way of making him understand the reason for his invariable mistakes. In his biography, Anthony Bertram has quoted Nash's own statement, 'I have seen mathematical teachers reduced to a sort of awe by my imbecility', and has gone on to suggest that in later years, when Nash's work began to acquire an abstract character, his art reflected 'a second and more successful effort to tackle this inaptitude', and that 'the discipline of mathematical order, which he could not acquire by calculation in numbers, he did to some extent realise in the creation of geometrical images, but it remained foreign to his naturally organic sensibility'.

The assertion that a grasp of mathematical processes was foreign to Paul Nash seems at first glance to provide an easy and attractive explanation of the difficulties which beset him as a child, though it is by no means clear what Bertram means by the phrase 'naturally organic sensibility', since nothing can in fact be more fundamentally organic than mathematical form. But on closer examination it appears that the true significance of Paul's 'blind spot' has escaped his biographer, who has, in consequence, failed to understand its importance in relation to the artist's later development.

The inability in this case, I suggest, lay not in any fundamental difficulty in understanding mathematics as such, but in understanding the approach of the masters who attempted to teach them. In other words, there was a breakdown of communication between the teacher and the taught. The extreme example of such a breakdown is to be found in autistic children, who are often not stupid, but merely unable to follow the normal means of communication. They may be

able, for instance, to read and comprehend single letters, but when it comes to combining those letters into words, which they already know and use, they encounter a sort of psychological block, which all ordinary methods of teaching are unable to surmount. What is required in such cases is, therefore, to discover the exact nature of the obstacle and this can only be done by finding the manner in which the pupil receives and assimilates ideas and impressions.

There are undoubtedly a great number of highly intelligent and intellectual people whose method of learning differs widely from the norm. They 'see' from a different angle, and because their whole approach is differently oriented, they find it virtually impossible to learn facts and methods which are taught in the conventional manner appreciable to their fellows. They can learn, but they cannot be taught, for they have to evolve their own means of assimilation.

Paul Nash was not dyslectic or autistic in the clinical sense. As a child he was bright and receptive. As a man he was communicative and brilliant. But throughout his career there seem to have been subjects which he could not be taught, but had to learn for himself. In other words, he was essentially individualistic and his intense individualism of approach, though it sometimes had its disadvantages, was for the most part his strength, both as a man and as an artist, for he saw life no less than art through his own eyes and not at second hand.

Be that as it may, the inability had immediate and disastrous consequences. Like most boys of his period, Paul was already destined to follow one of the family careers, and that which had been marked out for him apparently without reference either to his wishes or to his abilities, was service in the Royal Navy, a profession traditional in his mother's family. That he was not destined to follow his father's legal footsteps and become a barrister seems somewhat strange, particularly as it was a profession in which he might well have commanded success. But it may be that the length of time that was then needed to establish oneself at the Bar, combined with the comparative lack of financial security from which the family suffered, made the regular promotion and eventual pension of a naval officer appear more attractive.

Unfortunately for the family hopes, in which Paul himself appears at least to have acquiesced, since there is nothing to suggest the contrary in *Outline*, a grasp of mathematics is a prerequisite for a naval career. And in mathematics Paul continued to make no progress whatsoever. He remained at Colet Court till the end of the summer of 1903. For the last three years of his time there he had been a boarder, because towards the end of 1901 his family left Ghuznee Lodge and went to live in a small country house which his father had built in Wood Lane at Iver Heath, a short distance from the Nash family home at Langley. The reason for this move was the rapidly deteriorating health of Mrs. Nash. That nervous melancholy which had oppressed Paul's earliest childhood had grown upon her and it was felt that she might benefit from the better air and greater peace of the countryside.

By this time the prospect of becoming a boarder and having to live away from home was much less terrifying than it would have been two years earlier. Paul had won his cap in the first football eleven, had vanquished the leading bully, and had already made himself quite a notable figure in the little world of the prep school by his prowess in amateur theatricals and in the craze for turning the smallest incidents of everyday life into themes for elaborate detective investigation in the manner of Sherlock Holmes. These pursuits developed his inherent ability for impersonation, and he showed a considerable ability in the designing and painting of simple theatrical sets and programmes. Although Anthony Bertram is inclined to attribute some importance to these activities, their significance can be overestimated, for it must be admitted that an illustrated manuscript of an abbreviated acting version of *As You Like It*, written and decorated for home theatricals at a somewhat later date, indicates little more than a slight boyish aptitude for imitation, and displays no originality at all.

In the autumn term of 1903 Paul moved on from Colet Court to the senior school of St. Paul's, but at the end of the year his father, quite undeterred by the mathematical disasters, transferred him to 'The Planes' a cramming establishment at Greenwich. Nash's own account of his horrifying experiences in that place make amusing enough reading, but they wholly failed of their object, since even the full force of the Commander's ivory ruler, applied with malignant fury to fingers covered with chilblains, was quite powerless to drive into Paul's head the mysteries of mathematics. In 1904 he predictably failed the Dartmouth entrance and returned ignominiously to St. Paul's.

During the two ensuing years little serious attempt was made by the senior school to teach him anything. 'As an awkward case', he wrote, 'I was relegated to the

notorious 'Upper Transitus', where no one pretended to work and which had a reputation to keep up as the form which could not be disciplined. . . . People were always walking about or falling over in false faints. Minor panics were frequent and conversation, interrupted by subversive noises, never ceased. Much of the din was made by the poor ineffectual little master shouting and beating his desk to instil order. . . . Most of the books were piled on the floor or built into screens on top of the desks. Inside the desks might be found anything from toy pistols and motor horns to a clutch of white mice. In this atmosphere I became rather demoralised. Most of the non-mathematical subjects were taken by a small sour man with a club foot, who appeared to find it more amusing to exercise his very real talent for sarcasm than to teach. After a time I gave up work and took to ragging and other diversions.'

Although his transfer to another house slightly improved matters, he summed up the whole business in *Outline* by saying, 'I cannot look back at this period of my life without distaste and disappointment. At home the spectre of my mother's illness had come nearer. All our resources were being pitted against it without avail. And now I looked like being another embarrassment to my unfortunate father when he most needed support'.

The spectre of Caroline Nash's mental breakdown haunted the family, though every effort was made by Paul and his father to spare the two younger children the full impact of it. For prolonged periods Mrs. Nash was too ill to remain at Wood Lane and had to be sent into a nursing home. In order to meet the heavy expenses involved, her husband and elder son would let the pleasant new house and take refuge in some cottage or rooms in the neighbourhood. But always they tried to return home for the school holidays, so that the younger children could return to a normal atmosphere, and sometimes their mother was sufficiently recovered to be able to join them. These family sufferings endured in all for some nine years, till Caroline died in the spring of 1910. The most lasting effect of the experience lay in the bond it forged between Paul and his father and the unquestioning trust which the older man came to place in the younger.

The short term effects, however, were well nigh disastrous as far as Paul was concerned. There can be little doubt, though he does not say so in *Outline*, that the sad concentration on the emotional and practical problems created by his mother's illness distracted his father's attention and caused him to ignore the inevitable consequences of Paul's scholastic failure. How otherwise is it possible to explain the curious family assumption that the boy might possibly be able to make his way as an architect, a profession which, no less than that of a naval officer, depends upon a firm grasp of mathematics? Again, understandably, nothing came of the idea. Nevertheless, still undeterred by the previous failures, William Harry Nash's friends and relatives (and in particular his brother Tom, so evocatively described in *Outline* as 'the Oracle of Elm Park Gardens') 'warmly advised him to cut his losses' and place the boy in a bank.

II

The Apprenticeship 1906–1910

AT THE SUGGESTION of working in a bank Paul Nash at last rebelled. Up to this point he appears to have been strangely acquiescent in all that had happened to him and to have accepted his undoubted miseries as an inevitable part of the painful process of being 'educated'. His failure to protest, or at least to make his protests felt, resulted in part from the then generally acknowledged doctrine that children were in no position to judge what was best for them, but also in part from an immense loyalty to his father and a desire to spare him further anxiety and pain. The combination of his mother's illness and his failure at school had, moreover, left him curiously young and immature for his age. Nevertheless, the thought of a stool in a bank was one which even he could not endure, and he suddenly electrified the family circle by his announcement that he intended to earn his living 'as a black and white artist or illustrator of some kind'.

What can have prompted such a notion is almost impossible to imagine. The Nash circle was not an 'artistic' one, even in the then accepted sense of the word, and they knew nothing of professional painters at first hand. Caroline Nash's brother, Lieutenant-Colonel Hugh Jackson of the Royal Engineers, was an excellent amateur watercolourist, whose 'tender limpid paintings' of the rivers and plains of India were the chief adornment of Ghuznee Lodge, and the Jackson family had included another distinguished amateur, Paul's great-uncle, James Grey Jackson, who 'was not only a sailor, but had spent his life in travelling and in writing books which he illustrated with designs of undoubted character'.[1] The latter's achievements in this field were, however, unknown to Paul in his boyhood and it was not, indeed, until towards the end of his life that he learnt anything of them.

The only other artistic connection possessed by the family was through Paul's redoubtable 'Aunt Gussie', the wife of the Elm Park Gardens Oracle. She had attracted the undying devotion of Edward Lear, who had always regarded himself as too ugly to propose to

[1] *Outline.*

her; but 'When he was sad and failing in his solitude at St. Remo, he begged her to come out and choose his burial place'. Nash goes on to record that his aunt's 'drawing-room at Elm Park Gardens was full of his dry, luminous watercolours'. These, he asserts were almost the first watercolours he had seen, although, in saying this, he forgot that he must, even earlier, have 'encountered' the Jackson ones in Ghuznee Lodge.

The early association with good watercolours, amateur and professional, though they saved Nash from the ugliness and sentimentality of many of the fashionable steel engravings adorning the walls of the period, may well seem inadequate to explain his notion that he might himself become an artist, and a professional one at that. It is true that both at the Greenwich cramming establishment and at St. Paul's he had gained a certain superiority because of his prowess as a caricaturist and inventor of lampoons, but when one day he had happened to watch Eric Kennington, his contemporary at St. Paul's, 'knocking off likenesses of the plaster casts' in an upstairs corridor, he does not appear to have identified himself, consciously as least, with the young artist nor to have thought of painting and drawing as a possible career. 'No drawing I had ever done', he wrote, 'could be said to justify such a hope'.

Of the accuracy of this statement there is no means of judging, since none of the childish caricatures and stage designs has survived. The figure drawing and calligraphy of the illustrated play I have already mentioned, which may perhaps be dated to about the period of his leaving school, suggests nothing more than a fairly firm physical control over the pen and a certain facility for adapting to his own ends figures copied from the illustrations in other books. The rage for constructing model theatres and sets, to which he had fallen victim at school, may have inculcated in him some sense of volume and relationship, and it may have been this which led his relatives to suggest an architectural career. But if this was the case, it can only be said that the feeling for volume, if not for over-all design, must

have been short-lived, for of it there is little trace in the earliest work that remains to us.

Why then did Nash in his eighteenth year suddenly imagine that he possessed any qualifications to become an artist and what prompted his desire to be one?

The question is difficult, if not actually impossible, to answer. It must be admitted that few young men have set out upon a difficult career with less obvious talents to command success. He knew nothing, except by the merest hearsay, of the world he wished to enter. Despite his perceptiveness and intelligence, he found it difficult to learn by conventional methods. He had had no lessons in drawing and painting and, though he had some untutored practice in the production of caricatures, he had no real grasp of anatomy and knew nothing of the art of recreating landscape in line and colour, beyond what he may have picked up from the Lear and Jackson watercolours. Since his family connections were wholly professional and lay mostly in the law and the armed services, no useful contacts were available to him in so different a field. Seldom can an artist of real stature have entered upon his life's work with fewer qualifications and less reasonable prospect of success.

On the credit side of the balance must be set his extraordinary visual sensitivity. His possession of this particular quality from his earliest years is amply demonstrated by his ability to recall and recreate the scenes and settings of his childhood. *Outline* provides endless proofs of this power. Throughout its pages it is clear that Nash is not describing what in later years he believed he had seen as a child, but what he actually saw. His descriptions, not only of the places and people he encountered, but also of his response to these encounters, have the ring of truth. They are not mere adult attempts at literary reconstruction. They are records of fact and not emotions recollected in tranquillity.

The sharpness of the visual impressions of his childhood may in part be attributable to a certain isolation. There was no one with whom Paul could readily share his childish experiences. His mother was remote from him, withdrawn into the shadowed world of her own anxieties and fears. His father was preoccupied with his professional duties and distracted by anxiety on his wife's account. His brother and sister were too young to be his companions. His homely country nurse, Harriet, was full of kindly common sense of the sort which is reassuring to a sensitive child but does not encourage his imaginative flights of fancy. At school,

apart from shared enthusiasms for model theatres and play acting, Paul's chief point of contact with the other boys lay in a certain prowess on the football field. It is therefore perhaps fair to suggest that he had in himself reserves of vivid and unshared visual experience, which fed his imagination and gave substance to his dreams.

Even if this hypothesis be correct, it is hardly sufficient in itself to explain his sudden resolve to be an artist. Most artists who have received no early encouragement and have sprung from families lacking any particular artistic background have shown a very early disposition to express themselves graphically. But apart from the theatre models and the caricatures, there is no clear evidence to suggest that this was the case with Paul Nash.

It is therefore surprising that in *Outline* Nash makes no attempt to explain his choice of career, although it is by no means self-explanatory. He seems to assume that the reader must necessarily understand his motives for the decision.

The clue to the mystery probably lies in the actual words he uses. He intended to earn his living 'as a black and white artist or illustrator of some kind'. This, if we consider the statement carefully, suggests that in his eighteenth year 'art' was for him not an independent activity, but one subordinate to literature and a means for expressing literary ideas. Such a view is less surprising than it may appear at first sight. The Lear and Jackson watercolours, with which Paul had been brought up, were essentially topographical in character, and may have been regarded by him more as factual records of places than as independent works of art. Apart from these, his principal, if not his only, encounters with 'art' were in the illustrations which adorned the romances and poems of the period. The turn of the century was still a heyday for the illustrator, whose work had not yet been wholly superseded by the ubiquitous photogravure and half-tone. To earn a livelihood as an illustrator seemed a reasonable proposal if one enjoyed reading books and could produce a tolerable imitation of the kind of pictures with which they were normally embellished.

If this is the true explanation, it is sufficiently disconcerting in view of Nash's later career, since it implies that his wish to draw was wholly unconnected with his childhood capacity for the visual enjoyment of landscape, and that the paintings he had known so well in the drawing-rooms of his mother and his aunt were to him not much more than illustrations of places. In support of this view, however, it must be remem-

bered that the caricatures and stage designs in which he had indulged were essentially 'illustrative' and were not manifestations of some innate 'Will to Form'.

The only member of the Nash circle who was not horrified by the boy's announcement was his father. William Harry Nash was sympathetic and placed no obstacles in his way. At this stage it apparently occurred to neither the father nor the son that any kind of professional training might be needed and by way of practice Paul started out by trying to illustrate the historical novels of Stanley Weyman, a former colleague of his father's at the Bar. The drawings were 'criticised' by a certain Mr. Paxton, a newspaper draughtsman who had sometimes drawn Mr. Nash in court, but his opinion for what it was worth proved useless, since, when the drawings were submitted for consideration to another family friend, Reginald Smith of the old established publishing firm of Smith, Elder, they were eventually returned with an expression of the writer's regret at being unable to commission, as he would have liked to do something to encourage 'your father's son'.

This disappointment and others like it did not discourage young Nash, who persevered with determination born of inexperience. He did, however, realise that something more than mere determination might perhaps be needed for success and on December 17th 1906, five months after leaving school, he registered as a student at Chelsea Polytechnic, where he worked for the following year and a half, and achieved the very modest success of a half guinea landscape prize in a holiday competition. Of his time at the Polytechnic he wrote, 'I soon found that the Chelsea Polytechnic was of no use to me. At that period its instruction was not practical enough for my needs and I began to feel I was wasting my time'.

The realisation did not in fact dawn as quickly as the passage would imply, for it was not until the autumn term of 1908 that he began work as an evening student at the London County Council school in Bolt Court, just off Fleet Street. The emphasis on the need for practical rather than theoretic instruction is interesting in view of Paul's school time experiences with mathematics. Once again he had found conventional methods of teaching impossible to assimilate and had in consequence made no progress of any kind.

The establishment at Bolt Court was much more to his liking. Although it had life classes, like those of any other art school, its main purpose was to give practical instruction in design, lithography and etching. The students were mostly young men already employed by commercial firms who wished to improve their technique. It is unfortunately impossible to judge exactly how much Nash really 'learnt' during the two years he spent there, though it is possible that the respect for and understanding of craftsmanship, which marked his later work, may have begun at this time. If so, it had little immediate effect on his current production, which, in the few examples that have survived, is seen to have been both tentative and dull.

An elaborate Christmas card design, inscribed for his cousin, Nell Bethell, which is probably attributable to this period, has all the faults engendered by a slavish imitation of the debased formulas of the contemporary commercial school and stems from a wretched mixture of sub-Rossetti Pre-Raphaelitism and bad Art Nouveau. A few book-plates commissioned by his friends and neighbours still exist. These enabled him to earn a few guineas with which to pay his fares to Bolt Court, for he was anxious to be as little burden as possible upon his father. Apart from this practical aspect of the engravings, the less said about these the better. Far more interesting, despite their widely varying quality, were the imaginative drawings to which he turned his attention at the same time.

'Instead of profiting by the commercial art training of Bolt Court, and becoming a slick and steady machine for producing posters, show cards and other more or less lucrative designs, I fell under the disintegrating charm of Pre-Raphaelitism, or, rather, of Dante Gabriel Rossetti. For some time previous to this, romance as a guiding force had gradually taken hold of me. The historical romances of my early author, Stanley Weyman, soon gave place to something more deep and potent—The *Morte d'Arthur* and, thence, to poetical romance and its less remote practitioners, Tennyson, William Morris and so, head over heels, into poetical adventures of all sorts, but with no very clear direction. Each discovery of a new writer was a fresh, disturbing shock. Whitman, Blake and Coleridge shook me in turn.'

The chronology of these literary passions is by no means clear, nor is it certain whether he indulged in the pleasures of romantic novels and poetry before he left St. Paul's. The passage quoted suggests that the greater and lesser lights of the romantic firmament did not swim into his ken until he was established at Bolt Court. But if this was so, it is impossible to understand what had originally prompted his notion of a career as an illustrator. Bertram has given some account of his reading between 1909 and 1911, culled from letters

written to Mercia Oakley and Nell Bethell. Apart from some allusions to the letters of Keats, the standard is not very high, and he seems to have been mainly attracted to romances tinged with the atmosphere of a Druidic twilight. Quite rightly Bertram discerns in the references some elements of the kind of imagery which appealed to Nash and which he was to embody in his own work, 'the symbolism of birds, an empty wood filled with a presence, and a curtain stirred uneasily by a presence just the other side—the presence of the absent'.

But in all this there is no mention of Rossetti, Tennyson and the rest, and one is therefore forced to assume that the romantic influence of the later nineteenth century poets must have reached Paul not later than his last year at St. Paul's, and that it was the impact of this encounter prior to July 1906 that determined his career.

Like the chronology of his reading, the sequence of Nash's early drawings is difficult to establish. Bertram comments upon the fact that in the production of the book plates he made no progress at all between 1907 and 1909. Examples of both dates have survived and are executed in what Bertram justly terms a Rossetti–Morris–Crane manner. The same lack of development marks the imaginative and 'vision' drawings, and it is impossible to tell whether any surviving examples ought to be dated earlier than 1909. Their chief claim to consideration lies in the fact that, unlike the book plates, they are a personal expression of the imaginative faculty. To say this is not, however, to claim for them any true originality. Both in form and content they are derivative and afford ample proof of Nash's intellectual and emotional immaturity at this period.

The question of the sequence of the vision drawings is an early example of the general difficulty in establishing a satisfactory chronology for Nash's work as a whole. Nash himself related the beginning of the series to two different experiences—the assimilation of Blake's poem to his friend Butts, which contains the lines,

'Over sea, over land,
My eyes did expand
Into regions of air.'

and to the romantic passion he conceived for a young neighbour, Sybil Fountain, whose 'face encircled with blue-black hair, with eyes wide-set and luminous, and a mouth, like an immature flower about to open' seemed to inhabit the twilight skies and haunted his dreams. He had been in love, briefly, before this, and

in the January of 1909 had made a shy, boyish proposal to Mercia Oakley. The longer lasting preoccupation with Sybil Fountain is, as Bertram has pointed out, 'curiously without dates'. All that we know is that he still imagined himself to be in love with her as late as 1912. She was the subject of *Vision at Evening, Our Lady of Inspirations (Plate 1)* and other drawings, which may mostly be dated to the time when Nash was still working at Bolt Court. Returning home at night from his evening classes there, he used to pause beside the still unspoilt banks of the Alderbourne and listen to its 'limpid tones in the still night'.

'These journeys through the night,' he wrote, 'this halt by the stream, and this voice, made up the influences which compelled me to write poetry. For now I needed an outlet for a new thing which began to stir in me and growing gradually, to absorb my whole mind and body, the strange torture of being in love … With all the ardour of a passionate disciple of Dante Gabriel I began, inevitably, to set this face in my drawings, the new Beata Beatrix.'

Our Lady of Inspiration may be regarded as the key drawing for the vision period. Like most of the early work, it is executed in pen and wash, and is an overtight and ill-conceived design, since the profile of Sybil Fountain, covering the disc of the moon and projecting beyond the circle only at the tip of the chin, is centrally placed in the upper part of the composition, the lower half of which is filled with a fussily stylised group of trees. They are the self-same trees which he drew about the same time in *Angel and Devil (Plate 1)*, to illustrate one of his own poems. This drawing, which later in life Nash regarded as the 'best of its kind', suffered once again from the excessive division of the field into an upper and lower register, accentuated by over-contrasted tonal values. The figures of the winged combatants, the angel with the sword standing upon the hill, and the assailing devil poised menacingly in the air above him, exhibit a certain sense of arrested movement and avoid the uncomfortable centrality of the inhabited moon. An attempt has been made to unite the upper and lower sections of the composition, both by decreasing the area of the lighter toned landscape and by carrying the line of three pale bare trees up into the darkness forming the background of the combatants, a night sky otherwise relieved only by some roughly suggested stars. The leafless trees are, however, quite unconvincing, since they are wholly out of scale with the formalised wood that fills the hollow between the hills, and they are rendered in a

style which conflicts with that of the landscape as a whole.

It was two other drawings of 1910 which first brought Paul Nash to the notice of people who were to have a profound influence on his early career. The story of both meetings has been fully recounted elsewhere and need not be repeated.

The first of these drawings was an imaginative composition entitled *Flumen Mortis*, in which the surface of a stream, flowing between orchards and fields of poppies, was 'covered with human heads upturned in sleep and carried gently along by the tide. The fields were being scythed by winged reapers and above the distant hills a huge dolorous face appeared, with hair streaming across the sky and threaded with the feathers of its flat outstretched wings.'[1] It belonged to the same category as the rest of the vision drawings, though in this case its subject may have been inspired by the recent death of Nash's mother, which occurred on February 14th 1910, so that both the drawing and the poem which it illustrated might have been attempts at achieving a personal catharsis. What is not in doubt is that the deeply felt character of the imagery attracted the notice of William Rothenstein, when he came to judge a competition at Bolt Court and caused him to afford it 'full marks'. He invited young Nash to his house and so began a real and lasting friendship between the already famous painter and his young contemporary, who as the years passed, was to receive many tokens of interest and considerable practical support from the older man.

The second drawing is of a very different sort, though it too belonged to the spring of 1910. *The Crier by Night (Plate 2)* was a sketch on the fly-leaf of the book of that title, which had been lent to Nash by a neighbour. When he returned it to her, with apologies for having unthinkingly defaced the volume, she sent it on to its author, Gordon Bottomley. He was a poet-playwright, who had himself been deeply influenced in his youth by Rossetti, Morris and Swinburne. An early ambition to become a doctor had been frustrated and at sixteen he had been placed as a clerk in a Yorkshire bank. Repeated lung haemorrhages rendered this uncongenial occupation impossible, and while still very young he had been forced to withdraw from active life. He had established a quiet mode of living among the lovely hills of Cartmel and Silverdale, not far from Morecambe Bay. There, in the contemplation of nature and the pleasures of writing and

[1] *Outline.*

reading, he had come to terms with life and had married and made a place for himself in the literary world, albeit his health prevented frequent visits to London. He had produced various books of verse, which were published in very limited editions and commanded only a small public. Of these *The Crier by Night* was one. Claude Colleer Abbott, in his introduction to the published correspondence between Bottomley and Nash[2] admits that much in these early books 'was derivative but they earned him some reputation in a small circle as a cloistered poet with a sense of drama'. In 1903, a year after the appearance of *The Crier*, he had come to London for the first time, and during that visit and a second made the following year, had met and made friends with Yeats, Edward Thomas, Lawrence Binyon, Masefield, Ricketts and Shannon.

It may be that these contacts with a wider world gave him an undue sense of his own importance when he withdrew for prolonged periods to his northern seclusion. It is obvious from his letters that he was vastly conscious of being a literary figure, and he was certainly only too ready to regard himself as an arbiter of taste both in literature and art.

Such was the author whose dramatic poem had fired Paul's imagination so greatly that he had illustrated the borrowed copy without its owner's permission. The incident appears a trifling one, and it would undoubtedly have been wholly forgotten had it not been for the fact that the friend from whom Nash borrowed the book sent it to Bottomley for his comments. Bottomley immediately wrote to Nash, the first letter of a correspondence which was to continue with various interruptions until the painter's death thirty-six years later.

That first letter has unfortunately been lost, but it is clear from Nash's curiously naïve reply, dated 9th April 1910, that the poet had been enthusiastic about the drawing, and this enthusiasm gave vast encouragement to the youth at a moment when he felt that he was at 'a difficult place in the road'.

What Bottomley saw in the drawing it is difficult to imagine. By critical standards it is a poor performance. Blanid, the heroine of the poem, stands in an open doorway, and with closed eyes turns her head away from the menace of a misty figure which approaches the threshold from the wet darkness outside. The anatomical distortions cannot convincingly be attributed

[2] *Poet and Painter, being the correspondence between Gordon Bottomley and Paul Nash*, ed. Claude Colleer Abbott and Anthony Bertram, Oxford University Press, 1955, from which this and other letters are quoted.

to a desire to enhance the sense of crisis by their means, but are evidently due to genuine inability to draw a figure in an awkward position. Such sense of tension and dread as the sketch unquestionably possesses comes from the use of rough hatching, the disposition of the shadows behind Blanid's right shoulder and the genuine 'feeling' of the scene, which emerges, however tenuously, through all the technical faults. The Pre-Raphaelite derivation of the design (even to the heroine's seemingly broken neck, which recalls the similar distortion of the Virgin Mary's in Holman Hunt's *Christ in the House of his Parents*) probably meant more to a man of Bottomley's tradition than it would to anyone today. Yet even so, his excessive enthusiasm is no great tribute to his critical powers.

In any case, Bottomley's interest was aroused, and he soon determined that young Nash should be moulded into the kind of illustrator he desired. Had he succeeded in this object, Nash's career might well have ended before it had properly begun.

The real service which Bottomley did perform for the young artist was to give him encouragement at the moment when it was most needed. Nash was far too intelligent, despite his strange immaturity, not to realise that he had made no progress in the basic disciplines of his craft, and the knowledge that an older man, who had made a place for himself in the literary world, and was the friend of great people like Ricketts and Shannon, had been able to discern his intentions through all the imperfections of line and form, meant a

great deal to him. It was a debt he never forgot, even though in later years he freed himself altogether from his friend's potentially dangerous influence.

An interesting aspect of the early letters between the two men, is the frequency with which they both allude to Nash's poems. He sent them to Bottomley for criticism, and here too received considerable encouragement from him. To be a poet-painter was still Nash's ambition, and his friend's enthusiasm undoubtedly served to increase his reliance on the genuineness of his basic poetic intuitions, however derivative may have been the form in which they were then couched.

Bertram has attached considerable importance to the early years, and has sought to prove that the youthful 'vision drawings', with their emphasis on the 'inhabited sky', were the precursors of the final phase when, in the years immediately before his death, Nash 'returned to his parish', and once more peopled the heavens with a life of his imagination. The theory has a certain attractiveness, but I believe the connection to be, in fact, more remote than Bertram (or, indeed, Nash himself for that matter) imagined. The true link seems to me to lie in the unquestioning trust which Nash placed in the truth of his poetic intuition at the beginning and at the end of his career. In the intervening years he occasionally swerved from his allegiance to it and allowed himself to be diverted by his intellect, but his disloyalty was never more than temporary and every return to his true bent was marked by work of true poetic insight and real originality.

III

The Iver Heath Period 1911–1916

'OR SOME TIME I roamed over the hills, watching the changing scene. Yet at no time could I say, honestly, "this is the view". At last, feeling tired and hungry, I stretched myself on the turf to eat my lunch. Instantly, I saw that not far from where I lay was the point at which to make my drawing. . . . I did not begin at once to draw. My landscape studies since I left the Slade had taught me already one thing. It was better to think or absorb first, before beginning to interpret. There was also the Sinodun lunch to absorb. . . .

'My thoughts wandered to the shooters over the hill and to Jack and Ted by the river. At this moment there was probably little to choose between us. Each had paused in his particular pursuit to consume the good Sinodun lunch. . . . There was our bond—the food cut and packed up, to be eaten outdoors by the shooters in the barn, by the fishers on the river bank, and by me on the hill. I was as good as they. I hunted my quarry, I watched and waited, I had to know where and when to strike. And what was there to choose between a bird, a fish and a sketch, except that my drawing would last longest?

'As I began to draw, I warmed to my task. For the first time, perhaps, I was tasting fully the savour of my own pursuit. The life of a landscape painter. What better life could there be—to work in the open air, to go hunting far afield over the wild country, to get my living out of the land as much as my ancestors had ever done.'[1]

In the space of two and a half years from the beginning of his friendship with Gordon Bottomley, Paul Nash had emerged from a long protracted mental and spiritual adolescence to a new self-confidence and self-realisation. The way had been full of interest, but it had not been altogether easy. The old inability to learn from the formal teaching of others had dogged him. Just as he had left the Chelsea Polytechnic because he knew that he was not profiting from the instruction there, so too he had left Bolt Court in the summer of

[1] *Outline.*

1910, and in the autumn of that year he had entered himself at the Slade, at the age of twenty-one. After a year there he felt able to assure Bottomley that he had acquired 'a greater feeling for form and shapes and a way of seeing things more simple, more whole'. He had even on one occasion managed to gain the approval of that very formidable figure, the inimitable Henry Tonks, who bestrode the school like a colossus. 'As a new student I sought an interview', wrote Nash, 'and confidently displayed my drawings, secure in the good opinion of at least two authorities. . . . But Tonks cared nothing for other authorities and he disliked self-satisfied young men, perhaps even more than self-satisfied young women, if any such could be found in his vicinity. His surgical eye raked my immature designs. With hooded stare and sardonic mouth, he hung in the air above me, like a tall question mark backwards and bent over from the back, a question mark, moreover, of a derisive, rather than an inquisitive order. In cold discouraging tones he welcomed me to the Slade. It was evident he considered that neither the Slade, nor I, was likely to derive much benefit.'

The benefit which Nash did in fact derive from the year and a half he spent there stemmed more from the social atmosphere of the place and the contacts which he made than from the teaching. Despite his assertion to Bottomley, during most of the time he remained at the Slade he was too preoccupied with his own ideas about 'vision drawings' to be able to absorb very much from the life classes and the other instruction available to him. Stanley Spencer, Mark Gertler, William Roberts, Edward Wadsworth, Charles Nevinson and Ben Nicholson were all contemporaries of Paul's at the School, and with the last named in particular he became great friends and was taken to meet his father, the famous Sir William.

Apart from the 'vision drawings', Nash was still toying with the idea of becoming an illustrator, and one result of this was that he expended an immense amount of time and effort upon a drawing of *Lavengro Teaching Isopel Armenian in the Dingle (Plate 2)*, as he

had recently fallen under the gipsy spell of Borrow. He began on a kind of Pre-Raphaelite formula and toiled away, until he came to the conclusion that it would not do, and 'submitted it to a scrubbing with a nail-brush and warm water, by which it got rid of its pre-Raphaelitism and emerged with a broken surface pleasant to work over with a pencil and on which to emphasise those virtues of drawing which had been obscured by the pen-and-ink'.[1] Nash himself appears to have been pleased with the result, even in long retrospect, but it is difficult to understand the reason for this satisfaction, for it is, in my opinion, a very indifferent performance, and I cannot agree with Bertram that the 'drawing is a firm geometrical design, a composition of pyramids which successfully conveys the massive quiet of the evening and of the meditative figures'.

Notwithstanding such reservations, the drawing has a real importance in the story of Nash's development, not only because of his own estimate of it, but also because for the first time there is a genuine attempt to break away from imitation of other men's formulas in the rendering of his own ideas. He used live models for his figures—Mercia Oakley and Rupert Lee, the latter a close friend and contemporary at the Slade—and he had gone to Regent's Park to find his dingle. 'First I looked cannily around for my models', he wrote to Bottomley in March 1912, 'and lo! found first Isobel and a man who was a Lavengro. Of these I made two good drawings—at least they were good compared with any I have done afore, and then after thinking and walking and exploring and experimenting evolved a good dingle. Then came a 'orrid tussle between Paul and the picture. The picture said at the end of each day —'ah you're beaten now. It's like nothing on earth I'm a beastly mess, you can't right me, tear me up. But I said I'm damned well going to right you so good night and blew out the light. And at last I got its back broken and now its comparatively docile tho a little odd.'

More successful, was another pen-and-ink study, heightened with body colour, which he produced about the same time—*In a Garden Under the Moon*. Once again it has been clearly over-worked in a struggle to convey the atmosphere of the scene, but the sense of movement in the small dancing figure contrasts interestingly with the stillness of the seated Shah and his

garden setting. Madge Pemberton, Rupert Lee's fiancée, was the model for the dancer, and the picture was still in her possession at the time of her death in 1970.

This more direct approach to nature disturbed Bottomley, who feared less it might divert his protégé from what he regarded as his true bent. Paul was in fact still working on a number of imaginative illustrations for books such as Bottomley's *The Riding to Lithend*, and this appeared to the author far more important than any dangerous excursions into landscape. Nevertheless, into the landscape Paul Nash began to disappear, in spite of his friend's well-intentioned efforts. Now at last the full influence of the countryside which he had experienced so deeply in his childhood, and from which the unhappy impact of his school days had sundered him, began to reassert itself. It is certain that the brief experience of living on his own in London, where he had taken a room at 19 Paulton's Square, Chelsea, in order to be nearer to the Slade, had some part in his increased appreciation of the country. It is true that he fell under the spell of the metropolis— 'O the poetry of London!' he wrote to Bottomley, 'I have come to love London my eyes have been opened to its inner beauty I only pray I may be able to write about it or paint about it'. But it was the contrast that appealed to him and stimulated in him a greater awareness of his surroundings. 'I feel I am expanding (Mentally!) my orchards and my fields, my deep woods they seemed everything—enough, here I am more alive things pulsate, it is life warm, tingling and inspiring all about me and something in me begins to wake up and stretch and gaze eagerly on every side.'

It was in this mood of expansion that he had recently made the acquaintance of Sir William Richmond, R.A., who perfectly fitted the then popular notion of what an eminent Academician should be. His work has long since fallen into oblivion, and if he is ever remembered by posterity at all, it will be because of the advice he gave to Paul Nash. He was a god-son of William Blake, and as such an object of interest, and indeed reverence, to Paul, who had approached him with an introduction obtained through the good offices of his future step-mother, the Hon. Mrs. Audrey Handcock. Richmond was a somewhat awe-inspiring figure, of whom Nash wrote that 'Blake might have had, as it were, a spiritual hand in his making. He was not unlike the ancient, vigorous olde men of the designs'. Though he was a bad artist, he turned out to be a good mentor 'wise and kind. He had

[1] *Poet and Painter.* In this and subsequent quotations from Nash's letters the original spelling and punctuation (or lack of it) have been retained.

a booming, Blake-like voice, but inadequate control of the letter R. Nearly all our interviews ended the same way, "Wemember, my boy, drwawing, drwawing, *always* drwawing."' It was in one of their weekly interviews, to which Nash used to take a pile of work for criticism, that Sir William suddenly pounced on a drawing, in which the landscape element was unusually pronounced, and unexpectedly enunciated the memorable words—'My boy, you should go in for Nature!'

'I had only a vague comprehension of his meaning, but out of curiosity, I began to consider what Nature offered, as it were, in raw material. How would a picture of, say, three trees in a field look, with no supernatural inhabitants of the earth or sky, with no human figures, with no story? I wandered over the stubble. The air was filled with the delicate agonies of the peewits who were wheeling and curvetting about the sky in eccentric flights. A few were walking or running in the furrows, where the shadows of the elms were lengthening in the afternoon sun. In the blue vault above vast cumulus clouds mounted up in slowly changing shape. A full level radiance illumined the scene, articulating all its forms with magical precision. A phrase of Gordon Bottomley's came into mind, "The greatest mystery comes of the greatest definiteness". I had been looking at the "mystery" lately, it had for me an increasing significance. There were certain places where it seemed to be concentrated.'

So began Paul's rediscovery of the 'Place', carrying him right back in time to his first discovery of a 'Place', when, as a little boy, he had been walking by the side of his nurse Harriet Luckett. 'It was beyond the Round Pond going towards the Tea Gardens that I came upon my first authentic *place*. Hereabouts the Gardens have almost a wild quality and coming in from the open spaces round the Pond, you have a sense of entering a wood. . . . For me it held a compelling charm. . . . You might say it was haunted, but indeed that influence was spread all round its neighbourhood. This tree merely guarded the threshold of a domain which, for me, was like hallowed ground. There are places, just as there are people and objects and works of art, whose relationship of parts creates a mystery, an enchantment, which cannot be analysed.'[1]

These two passages from *Outline* summarise far better than could any other words Nash's aims and achievements over the ten or fifteen years following his departure from the Slade in the summer of 1912. He had deliberately chosen his course as a landscape

[1] *Outline.*

painter, albeit a landscape painter with a difference, and all the blandishments of Gordon Bottomley fell on deaf ears, even though from time to time he still produced illustrative compositions in which the drama lay in the figures and was not confined to the interaction of the various landscape elements of a 'Place'.

Sir William Richmond had opened his eyes afresh to the meaning of landscape, but as usual he had to find his own way to the pictorial interpretation of it. He could learn, but he could not be taught, and this perhaps explains his otherwise almost inexplicable immunity to the influence of Post-Impressionism, which had first burst upon London in the famous exhibition organised by Roger Fry at the Grafton Galleries in November 1910. Nash was altogether too preoccupied with discovering an artist's vocabulary for himself to be able to turn his attention to an alien tongue and had therefore had no need of Tonks' admonitions to the students not to be lured from their serious work by such reprehensible French beguilements.

Once Nash finally realised what it was that he had to do, he did it very quickly. Within the space of a few months all the technical experiments had been resolved into a highly personal style, which, though it was still often tentative, did succeed in giving accurate expression to his feeling. This does not mean that the style was always consistent. It was not. But that was all to the good, because it allowed of a flexibility which would have been impossible had he turned his technique into a rigid formula.

The themes which he chose for his pictures were largely drawn from the landscape round his home at Iver Heath, to which he had returned after the brief sojourn in Chelsea. Other landscapes which he often drew were those he could visit from Sinodun House, where his uncle lived just below Wittenham Clumps, near the eastern end of the Vale of the White Horse, and it was to one of these Wittenham views that the passage quoted at the beginning of this chapter refers. The Clumps, standing on the northern range of the hills bordering that part of the Vale, are a landmark seen from miles around, and they are a constantly recurring landmark in Paul's own work (and particularly in the early and late phases of it), from the time he first drew the Clumps, until the closing months of his life, when he was working in his studio on a large, mixed oil and watercolour study of them, which remained unfinished at his death. Their importance as a symbol to him would be hard to exaggerate. It is

almost as though he had so completely identified himself and his aspirations with this wood upon the hill, that he used its image repeatedly in order to express his personal reaction to the drama of the universe around him. If I am right in this interpretation, its implications are of peculiar importance for an understanding of Nash's art. Bertram, probably rightly, has suggested a connection between the Clumps and the ancient religious significance of the High Place—'I will lift up mine eyes unto the hills from whence cometh my help'—and it should be observed that the trees are planted upon and within the ramparts of an Iron Age hill fort, a fact which was of course known to Nash, although in his delightfully eighteenth-century manner he would certainly have referred to its builders as 'Ancient Britons'. This ancient association endowed the hill with a sense of permanence, not merely natural and geological, but human as well. In taking the Clumps as a personal symbol, Nash thus identified himself with a work both of nature and of man which had existed long before him and would long outlast him, and had thereby placed himself within a span of years far outreaching that of the life of man. It is possible that the curious sensation which most of us have experienced on a first encounter with a place, the sensation that 'we have been here before,' may have some connection with this kind of natural self-identification, and may be a form of that experience expressed by Wordsworth in the lines,

> 'Not in entire forgetfulness,
> And not in utter nakedness,
> But trailing clouds of glory do we come
> From God who is our home.'

Wittenham Clumps and the valley below were the subject of several of the studies included in Paul Nash's first one-man exhibition at the Carfax Gallery in November 1912. He had obtained from Sir William Richmond an introduction to its owner, the famous A. B. Clifton, who had greatly disconcerted him by expressing no marked enthusiasm for the 'recommendation' given by Richmond. Nevertheless, when Clifton began to inspect the drawings laid out for his approbation, he changed his tone and, 'as in his sleep, murmured, "Yes, they are something new"'.

Looking back at my former dating of the drawings shown in that exhibition, and considering them now in the light of what Nash himself said of his development, I am convinced that I was wrong in ascribing all

of them, irrespective of subject, to 1911.[1] It now appears to me that the 'pure' landscapes must in fact all belong to the year in which they were exhibited, and that it is only the imaginative compositions, such as *Falling Stars, (Plate 3) Pyramids in the Sea*, and *The Wanderer* that can possibly be placed in the previous year. In that case we must presume that the *Bird Garden* series, of which there were three, was probably begun in the summer of 1912, and was followed by the much simpler and more straightforward line drawings of the Clumps and its surroundings executed in the autumn months preceding the show. The suggested sequence does not, however, solve the problem raised by the various studies he made of the group of elm trees near his father's house, the first of which was shown at the Carfax under the title of *The Three*. There is another version of the drawing in the collection of Lord Croft, which probably ought to be assigned to the same year, and a third, *The Three in the Night*, which may be somewhat later and was first exhibited in 1914. The style, here as elsewhere, affords no certain guide, and all that can be safely said is that the one first exhibited must be regarded as part of the new awareness of the possibilities of 'Nature' as a subject, which had been prompted by Richmond in the summer of 1912. In asserting this, however, I am contradicting Nash's own conjecture for the year, since he himself pencilled in the date '1911' on one of the photographs of *The Three*, but this would not be the first instance in which his memory demonstrably played him false.

In the months preceding and following the Carfax show it is clear that Nash was consciously suppressing the 'imaginary' element in his work, except when he was concerned with actual illustrations for the works of Bottomley and other favourite authors. The progressive elimination of the 'imaginary' did not, however, result in any loss of poetic quality. Indeed, the reverse is true, for he was now free to give full rein to his imaginative intuition in the treatment of his subject. He was no longer working within the prescribed limits of a dead or dying tradition and was in consequence able to realise the potentialities of his highly personal approach to nature. He had emerged from his protracted apprenticeship and, at the age of twenty-three, had at last become an artist with a real contribution to make.

[1] The dates given in *The Memorial Volume* were based on information hastily gathered by Margaret Nash and myself, and have frequently had to be revised in the light of later research.

The contribution lay in the imaginative quality that differentiated young Nash's landscape studies from those of his contemporaries. The 'Personality of the Place' was implicit in all of them, and from then on until the end of his life it was only on rare occasions that he lost his awareness of it. The poetic quality of the early drawings undoubtedly resides in that 'relationship of parts' which 'creates a mystery', and Nash's instinctive appreciation of such relationships is apparent in his handling of the scene before him even when he fails to solve all the technical problems of its presentation. Bottomley, in criticising a group of drawings submitted for his approval, mentioned the deficiencies of the foreground in *The Peacock Path* (*Plate 4*), which obviously must have struck him as devoid of interest, because it was devoid of detail. Now it is certainly true that the handling of the path's edge, where a somewhat rough upright hatching represents the deep grass bordering it, is to some degree both mechanical and monotonous, but the manner in which the unseen trees on the left cast their long shadows from the raised verge across both the path and the long grass beyond it, completely succeeds in counteracting this monotony, and at once places the beholder in a much wider area of parkland than is within the actual drawing. The character of the whole landscape is perfectly recreated in the study of one part of it. The high-summer foliage of the heavy trees is not too weighty to be borne on their sturdy trunks, which have all the feel of really growing from roots that spread wide beneath the lush turf. The day is drowsy with the heat of a summer afternoon, in which only the peacock chooses to walk along the transverse path, strutting from one patch of shade to the next, towards some unseen goal on the low ridge beyond the boundary of the park. The evocation of the place and the hour is complete.

The theme of a path, itself enclosed or half-enclosed by trees or fences, and leading to a wider horizon and an unseen objective in the indicated distance, became a constantly recurrent theme in Nash's work. He had already tried it out in one of his night studies, *The Archer*, in which the design is far less ably realised, for the heavy group of what are presumably cypresses are oddly arranged on hillocks, their lines being insufficiently prolonged into the distance to convey the needful mystery. The drawing, with this title, was another of those shown to Bottomley, but at that time the figure of the archer was the feature which dominated the scene. Later the figure was (some-

what imperfectly) eliminated, and the composition received the uninspired new title of *Night Landscape* (*Plate 3*).

The various studies of the Wittenham Clumps made at this period depend for their power upon the sense of air and distance surrounding the wood upon the hill. Surprisingly, the fact that the tree group is centrally placed both in the pen-and-ink drawing of *The Wood on the Hill* of 1912 and in the watercolour of *Wittenham Clumps* (*Plate 5*) (from the Bottomley collection and tentatively ascribed by Bertram to 1914) does not in any way detract from the aesthetic effect of the composition and does not destroy the mystery of the wide distance beyond it. In both, groups of birds wheel over the fields, and it may be that it is their freedom of movement across the landscape which prevents the eye from stopping short at the central feature. A very large, but single flock of birds, approaching from the right and just reaching the middle of the picture, serves a similar purpose in *The Green Hill* (*Plate 5*), although here the rigid centrality of the design is more skilfully masked by continuing the conifer plantation on the low hill down its right flank, and balancing the effect by two tall single elm trees on the left.

The birds which inhabit so many of Nash's skies at this time are often disproportionately large. Their size may betoken their psychological importance for him, since there is no question of his having been influenced by a similar disproportion in the birds of the Florentine quattrocento frescoes, of which he had no knowledge. That birds had some symbolical significance in his work cannot be doubted, for, apart from their physical presence in a number of early drawings, we have the added testimony of such titles as *Spring at the Hawk's Wood*, *Bird Garden*, *Night in Bird Garden*, and *Bird Chase*. It is as though the area of land depicted 'belonged' to them in some special sense. They claim it for their own, for it is they, and not the human landlords, who are its possessors.

Another, but equally specific, sense of ownership, is expressed in the title of *Their Hill*, one of the twenty-one exhibits in the Carfax show. In that case, however, the 'They' of the title were not birds, but the prehistoric denizens of the place, who had carved their title deed upon the face of the hillside in the form of the long lynchets which terrace its flanks.

The deletion of the archer figure from what became *Night Landscape* is, therefore, symbolic of much in Nash's attitude at this time. The significance of a place resided in itself, its drama was implicit, and there

17

was no need of a human intervention, which was extraneous to it. How much this was the case is perhaps best exemplified by a drawing probably executed shortly after the first exhibition and called *Barbara in the Garden* (*Plate 6*). In the middle distance stands a highly stylised line of trees, bordering a steep valley, beyond which is glimpsed a distant line of hills. Into the foreground of this setting Nash has introduced two stiffly stylised girls, while, farther off, he has outlined a third retreating towards the trees. There is an air of unreality about the sketch, as if the artist were desperately seeking to include an extraneous human interest in his composition and becoming excessively bored with the attempt. Since the drawing is in the Bottomley collection, such an explanation may not be wide of the mark, for it is clear that from time to time Paul Nash felt impelled to prove his loyalty by a passing pictorial allusion to his former style.

With his engagement to Margaret Theodosia Odeh, the daughter of a retired clergyman, who had been Chaplain to the Bishop in Jerusalem and had worked both there and in Egypt, Nash's interest in the human element in pictures revived. He met Margaret in the studio of Rupert Lee in Chelsea in the spring of 1913, and from then on she and some of her friends frequently posed for him, although the figure studies which he executed at this time were usually undertaken rather for their own sake than as features in larger landscape compositions. From this period onwards for the next ten years or so there were, too, a number of portrait studies, ranging from rough pencil sketches to carefully finished pen-and-ink drawings, sometimes heightened with colour. In this connection it is interesting to note that there exists only one portrait in oils—that of *Alice*, the wife of Eric Daglish, the engraver, whom he painted in 1921. Like most of his portraits, with the exception of the roughest and most spontaneous sketches, the oil is a lifeless presentation of its subject, and is far more an accurate map of familiar features than a felt rendering of someone he cared for. Even the strongly characterised and firmly drawn head of his father, made in June 1913, and the two portraits of Gordon Bottomley (the earlier of 1912, in pen-and-wash, and the later of 1922 in pencil and coloured chalks) lack the living qualities which Nash reserved for trees and stones, for sea and sky. Indeed, were one to judge by his treatment of portraits, one might imagine Nash to have been coldly aloof from people and totally uninterested in them. Yet the reverse was true, and throughout his life he remained warmly involved with

his fellow men and women, deeply concerned in all that concerned his friends, and instantly responsive to their needs. This side of his character, though it does not emerge from his formal art, is, however, instantly apparent in the rough and vivid caricatures with which he was wont to adorn his letters, and, still more, in his verbal descriptions of people, both in correspondence and in the unfinished autobiography.

Margaret Odeh brought Nash into a world that was wholly new to him. She was a woman of strong and remarkable personality, rather older than her fiancé, and with a much wider range of experience. After a rather unusual childhood in the Near East,[1] she had gone to Cheltenham Ladies College at the age of fifteen, and thence to Oxford, where she had taken an honours degree in English. At the time of their meeting she was working for the Tax Resistance League, a non-militant suffrage organisation and was also organising secretary to the Committee of Social Investigation and Reform, which was concerned with the problem of prostitution. Thus for the first time Nash came into contact with a politically and socially conscious circle, which he found both interesting and stimulating, though he did not permit himself to be drawn into it to the extent of allowing these new interests to distract him from his work.

This period was, nevertheless, one of tremendous expansion in his life. At the Slade he seems to have been fairly selective in his friendships, but his association with Will Rothenstein, who was always ready to be active on behalf of his younger contemporaries, had already brought him into contact with a circle of artists and potential patrons. His show at the Carfax Gallery had aroused interest. He had met Gordon Craig, whose outstanding contribution to theatrical design had already made him famous. He had become a friend of 'Eddie' Marsh, soon to be acknowledged as a prince of patrons, collectors and friends, not because of his wealth (for he was only 'comfortably off') but because of his discernment and loyalty. In November 1913, jointly with his brother John, who had also embraced an artistic career, Paul held a small two-man show at the Dorien Leigh Gallery in South Kensington, which attracted considerable notice, that of Roger Fry among others. Nash knew, of course, about Fry's patronage of various English artists, which appeared to depend on their willingness to accept his dictates as to what did and did not constitute art for art's sake and

[1] She had been educated in the boy's school run by her father, until she was sent to England to continue her studies.

to follow in the footsteps of the Post-Impressionists, whom their oracle was seeking to render fashionable. Fry had been complimentary. He had been genuinely attracted by work which Nash had contributed to one of the shows of The New English Art Club, and he invited him to design for the Omega Workshops. This invitation Nash accepted, but little came of it; for he disliked and distrusted Fry's assumption of superior oracular status, and preferred his independence to any submission to dictatorship. A patron more to his mind, who was acquired during the exhibition in South Kensington, was Charles Rutherston, the Manchester collector, who over the succeeding years was to acquire for his loan Collection, housed in the Manchester City Art Gallery, sixteen of Nash's watercolours and two of his oils, most of them of outstanding quality.

Like so many of the younger artists of his time, Nash was attracted by the theory underlying the formation of Fry's Omega Workshops. The idea of a group of painters, designers and potters, working in a loose association, possibly centred on some country house, and selling their products through group exhibitions, had already been discussed by him with Will Rothenstein, who had gone so far as to offer the loan of his town house for shows. But nothing came of that either, and Nash was too busy with his own life and work during the period before and after the outbreak of the First World War to pursue the project further.

He was by now a regular exhibitor with the New English Art Club and contributed to other mixed shows, and his reputation was growing steadily. 'Nash trees' had gained a certain vogue, and he began to realise the danger of allowing them to lapse into a too often repeated formula. On a visit he and Margaret paid to the Bottomleys at Silverdale he started to experiment with the mountains he had never encountered before. 'You can't think,' he wrote to Eddie Marsh in August 1914, 'with what apprehension I regarded those distant mountains—I who had never yet met a mountain. Soon we approached them and got to grips and they turned out kindly green and brown fellows, not really formidable. But some lakes were terrific with their guardian hills—my aunt you should see them at night and evening! There is no doubt about them then. My pictures are promising for later developments but individually rather nice and gentlemanly still, I feel I have given a jump right away from "Nash trees".'

One of the chief dangers in the formula lay in the temptation to gain an easy effect by repeating his hatched technique *ad nauseam*. He could and did vary the finished results by the introduction of softly or sharply contrasted colour washes or crayons, but basically the pictures remained essentially coloured drawings, employing the same main structural lines in pen or pencil. As drawing had not come easily to him, and his technical mastery was hard won, this is perhaps, hardly surprising. Now, with his usual courage, he faced the problem, and turned his attention to solving it. A not altogether happy example of these attempts is to be seen in the two studies of *The Monkey Puzzle*, which he drew at Grange-over-Sands during the visit to the Bottomleys. Here he was obviously struggling to build up the structure of the landscape in graduated tones, even though he relied overmuch upon the drawn outline. Rather more successful, though fussy in effect, is *Mackerel Sky*, which probably belongs to the same period.

Into the happy dream of his engagement and his peaceful work broke the rude interruption of the Great War. For a young man who was in many ways so typical a product of the English landed gentry and one side of whose family, moreover, had such a long service tradition, he was surprisingly lukewarm about the conflict. He was, as he said of himself, a gentle sort of creature, it was not his war and he did not, at first, see any need to do anything about it. The cheap hysteria of jingoism which was sweeping the country left him unmoved, and he felt wholly repelled by the notion of being expected to kill anyone at any time. However, after a month or two of self-questioning, he came to the conclusion that this was an attitude he could no longer maintain, so he enlisted in the Artists Rifles, though 'For home service only', and proceeded to marry Margaret. He was subjected to a little mild drilling in Regent's Park and on Hampstead Heath, and after not very onerous guard duties at the Tower of London, found himself moved into 'barracks' in a large and comfortable mansion at Roehampton. He had a taste of less pleasing conditions in other barracks at Romford and elsewhere, but the Romford interlude was relieved by his encounter with the young poet, Edward Thomas, whose death in action came as a grief to him. His wife continued to live in the little Bloomsbury flat she had shared with Ruth Clark before the marriage, and there he used to return on leave at short intervals. As far as he was concerned, it was, in fact, a somewhat amateur sort of war until the beginning of 1917, when he was gazetted as a second lieutenant in the Hampshire Regiment.

It was during this probationary period, so far removed from the horrors of front line warfare, that (according to his wife) Paul 'developed that astonishing industry which afterwards enabled him to work under almost any circumstances, however ugly, noisy or inhibiting. Thus, he managed to produce paintings which were exhibited in the New English Art Club, the London Group and the Friday Club'.[1] The watercolours of the two years between the end of 1914 and the beginning of 1917 were so direct a development of the landscapes he had produced for his two first shows, that I have chosen to regard them as belonging to the 'Iver Heath Period', from which they stemmed. Indeed, it would be difficult to do otherwise, since there is no means of establishing a firm sequence and the stylistic evidence may well be misleading. Two drawings which may be tentatively dated 1915 and 1916 respectively are particularly worthy of comment —*Outside a Wood* (*Plate 9*) probably identifiable with a work shown in the New English Art Club exhibition in 1915, and *A Lake in a Wood* (*Plate 8*), which was exhibited in the foyer of the Birmingham Repertory Theatre in May 1917, but must have been drawn in the previous year.

As a design, *Outside a Wood* shows a considerable advance on the earlier compositions. The old elements of strongly differentiated trees, redolent of personality, the long grass streaked with shadows, the defining line of the boundary fence, are all there, but they are now organised into a far subtler pattern and the handling is both broader and more assured. It is interesting to contrast the treatment of the grass that edges the steep bank which slopes abruptly to the open field outside

1 This and other passages written by Margaret Nash are drawn from the typescript of her unpublished memoirs of her husband's life.

the wood, with the much more timid and mechanical rendering of the grass verge in *The Peacock Path* of three years earlier, just as it is revealing to contrast the curving line of the woodland beyond, emphasised by its enclosing fence, with the over-rigid horizontality of the wood's edge in *Trees and Shrubs* (*Plate 7*) of 1914. The composition now no longer falls into virtually unrelated zones, but is deliberately united by expanding the width of the field to the right of the picture in such a way that the foreground and middle distance are continuous.

The tones of *Outside a Wood* are muted, with a pleasing predominance of earthy browns and yellowish greens. Very different, however, are the brilliant colours of *A Lake in a Wood*. Here the strong blues and greens, and the firmness of the defining pen-and-ink outlines provide a somewhat unexpected and sudden break away from naturalism into a geometric and indeed almost abstract treatment of landscape, for which it is difficult to offer any convincing explanation at this particular point in Nash's career. Although both he and his brother John had been included by Spencer Gore in an exhibition of 'English Post-Impressionists and Cubists', which he arranged at Brighton in 1913, it is clear from a letter to Albert Rutherston, quoted by Bertram, that Nash was amused rather than convinced by the classification, and it is certain that it had little relevance to most of the work he was producing. The real importance of the break represented by the lake drawing lies in its prophetic quality, for without the particular formal discipline of this geometric composition, the painter might have found himself less well equipped than he did to meet the tremendous emotional impact of the experiences which lay immediately ahead.

IV

The First War 1917–1919

'I HAVE JUST RETURNED, last night, from a visit to Brigade Headquarters, up the line, and I shall not forget it as long as I live. I have seen the most frightful nightmare of a country more conceived by Dante or Poe than by nature, unspeakable, utterly indescribable. In the fifteen drawings I have made I may give you some vague idea of its horror, but only being in it and of it can ever make you sensible of its dreadful nature and of what our men in France have to face. We all have a vague notion of the terrors of a battle and can conjure up with the aid of some of the more inspired war correspondents and the pictures in the *Daily Mirror* some vision of a battlefield; but no pen or drawing can convey this country—the normal setting of the battles taking place day and night, month after month. Evil and the incarnate fiend alone can be master of this war, and no glimmer of God's hand is seen anywhere. Sunset and sunrise are blasphemous, they are mockeries to man, only the black rain out of the bruised and swollen clouds all through the bitter black of night is fit atmosphere in such a land. The rain drives on, the stinking mud becomes more evilly yellow, the shell holes fill up with greenish water, the roads and tracks are covered in inches of slime, the black dying trees ooze and sweat and the shells never cease. They alone plunge overhead, tearing away the rotting tree stumps, breaking the plank roads, striking down horses and mules, annihilating, maiming, maddening, they plunge into the grave which is this land; one huge grave, and cast up on it the poor dead. It is unspeakable, godless, hopeless. I am no longer an artist interested and curious, I am a messenger who will bring back word from the men who are fighting to those who want the war to go on for ever. Feeble, inarticulate, will be my message, but it will have a bitter truth, and may it burn their lousy souls.'[1]

The message which Nash brought back from the battlefields was neither feeble nor inarticulate, and it did rouse people to a much fuller and more vivid realisation of what was happening in the Flanders

[1] From a letter to Margaret Nash, published in *Outline*.

trenches than even the words of 'the more inspired war correspondents and the pictures in the *Daily Mirror*'. Yet, strangely enough, it was not his first personal experience of trench warfare that brought complete realisation of its horrors to Nash himself.

He had been sent out to the front with his regiment in the spring of 1917. He had only been in France once before when he had visited Normandy and Brittany with his uncle and aunt a few months after the death of his mother in 1910. At that time he had been so absorbed in his vision drawings and was still so immature, that he did not savour the atmosphere. Now he came to the experience with the sharpened perceptions of an established landscape painter and the clearer judgment of a man of twenty-eight. He was prepared to enjoy the French and to bring to his enjoyment a slight touch of cynical amusement. He was, moreover, already habituated to the corporate life of the army, and had learnt how to make himself comfortable and get on with his fellows at close quarters, without allowing their presence to impinge unduly on the pursuit of his art. His poetic insight, now purged of all traces of that imitative sentimentalism which had marred his Pre-Raphaelite phase, was keener than ever before, and was united to a far greater depth of human understanding.

By the middle of April he had already had experience both of trench warfare and of life behind the lines. Although he loathed war and violence and was bitter about the humbug printed in the popular press at home, responding eagerly to his wife's letters which spoke of 'a revolution which will come at home', yet in his replies he confessed himself happier in the fighting line than out of it. 'There is an easy confident strength, an easy carriage and rough beauty about these men which would make your heart jump and give you a lumpy throat with pride. The other day as I watched them I felt near tears somehow. Poor little lonely creatures in this great waste', and again, 'I begin to think in much, much larger forms. I confess too this thing that brings men to fight and suffer together, no

matter from what original or subsequent motives, is a very great and healthy force. The cause of war was probably quite futile and mean, but the effect of it is huge. No terrors will ever frighten me into regret'.

On his way to the front in March he had encountered with immense pleasure the beauties of the countryside and the strange fantasies of a French cemetery, with wire wreaths and little cherub dolls floating in air suspended from slender threads. This and much else he had described in innumerable letters to Margaret Nash, which have been printed in *Outline*. The beauty of 'the back garden of the trenches', with the strange colours of torn earth and the vivid green of spring thrusting up through it, softened the first impact of the horrifying landscape and he began to draw it feverishly, totally regardless of personal danger, as he perched, high on the banks above the trenches, intent on his work even in the midst of a heavy bombardment. 'Flowers bloom everywhere', he wrote, 'and we have just come up to the trenches for a time and where I sit now in the reserve line this place is just joyous, the dandelions are bright gold over the parapet and nearby a lilac bush is breaking into bloom; in a wood passed through on our way up, a place with an evil name, pitted and pocked with shell holes, the trees torn in shreds, often reeking with poison gas—a most desolate and ruinous place, two months ago, today a vivid green, the most broken trees even had sprouted somewhere and, in the midst, from the depth of the wood's bruised heart poured out the throbbing song of a nightingale. Ridiculous incongruity! One can't think which is the more absurd, the war or nature; the former has become a habit so confirmed, inevitable, it has its grip on the world just as surely as spring or summer. Thus we poor beings are doubly enthralled'.

This spirit of mingled gaiety and gloom he expressed in clear, brightly coloured sketches like *Chaos Decoratif* (*Plate 12*) and *The Gateway, Voormezele*. Others there were in more sombre tones, but, on the whole, of the twenty drawings which he got passed by the censor and sent home to his wife in May, with minute directions for their mounting and framing, the major part were light-toned. In them he concentrated very largely on the torture of the trees, whose maimed, decapitated forms are minutely studied. A few, like *Study—Leaving the Trenches* (*Plate 13*), contain some human element, but the figures depicted are not golden, clean-limbed boy heroes, but anonymous, steel-hatted, heavily accoutred men, blankets neatly swung over their left shoulders, who plod doggedly forward after a weary

turn of duty. The trench along which they file over the duckboards winds across the centre of the picture towards trees, only one of which has been mutilated by shell fire, and which therefore seems to offer some sense of normality in a war-torn landscape. Although the figures are seen only from the back and convey a sense of corporate rather than of individual reaction to their temporary respite, they are depicted with a far greater feeling of movement and purpose than had ever characterised Nash's earlier studies of human beings.

Towards the end of May, after a short rest behind the lines, Paul was again in the trenches, and one very dark night, after supper, stepping up on to the edge of the cutting to look at the results of a short bombardment of the enemy positions, he took three steps forward, missed his footing and fell heavily, breaking a rib. It was only three days before the start of a big offensive, in which most of his fellow officers were wiped out in the disastrous battle for Hill 60. Possibly because of the need to clear the hospitals before this offensive, Nash was sent home, and at the beginning of June found himself in the Swedish Hospital in London. His injuries were not serious, and he was shortly allowed home, in time to supervise the final preparations for a show in the Goupil Gallery of the twenty war drawings he had packed off from France eight weeks earlier.

The exhibition created something of a stir. The scenes were so obviously not idealised. There was about them an actuality, an immediacy, that brought to life everything about the front which people had read and heard, but had found themselves quite unable to visualise. It is, in this connection, interesting to compare some of the most directly topographical drawings with photographs of similar areas hanging on the walls of the Imperial War Museum. These photographs confirm the accuracy of Nash's record, but they are completely lifeless and unreal by comparison. They fail to convey any of the bizarre quality of the strange contrasts and they have in them nothing of the feeling of the battlefield. They are like typed copies of a narrative, the original of which conveys the atmosphere of a story not only in its words, but in the very strength of its calligraphy.

Discerning critics realised that they were faced with the work of a major artist. John Drinkwater, at that time a very influential figure, became a passionate advocate as well as a close friend, and organised support for a move to send Nash back to the front, not as

a combatant but as an official war artist. Will Rothenstein, as always, was ready to lend his aid, and recruited other influential supporters. Articles were written; drawings were reproduced; letters were sent to the right quarters. Finally John Buchan, then in charge at the Ministry of Information, was persuaded, despite his own inability to respond personally to the force and truth of Nash's interpretation. In November 1917 Paul therefore returned to Flanders, complete with staff car, chauffeur and batman, and began an intensive tour of the battlefields, the horrors of which were even more grim than when he had left them nearly six months before. Many of the accredited war artists did most of their work at base headquarters, and it took all Paul's determination and charm to convince the authorities that they must allow him to go where he would and draw what he pleased. His driver, a wild, gay Irishman, was equally fearless, and together they drove over roads exposed to heavy bombardment, pausing only to allow the dust and smoke of the shell-bursts to clear. Under these nightmare conditions Nash often produced 'twelve or twenty sketches in a single day', drawn in pencil and crayons on rough brown paper.

The work possessed an actuality that was lacking in the more leisurely drawings executed by artists working well behind the front lines. The conventions and mannerisms that had grown in the Iver Heath days and in the early years of the war, and had been still to some extent evident in many of the drawings exhibited at the Goupil Gallery in July were, perforce, abandoned, and now the broader, more geometric techniques which had first appeared in *The Lake in a Wood* stood Nash in good stead. He found that he could express the force of his visual experience without having recourse to carefully drawn outlines, which were, indeed, quite alien to the shell-torn landscape of mud and blood and bursting shells. 'Sunset and sunrise are blasphemous, they are mockeries to man, only the black rain out of the bruised and swollen clouds all through the bitter black of night, fit atmosphere in such a land'. This, and the rest of the passage I have quoted, perfectly convey the sense of horror and desolation which Nash set himself to recreate. For the first time he found no difficulty in evolving a personal technique adapted to express his reactions. He worked in a white fury of passion and the technique created itself. There was no room for any preoccupations with composition, form and texture. He had become one with his subject and he knew neither weariness nor fear.

Before the end of the year he returned to England from the Ypres Salient and set about the task of translating some of his sketches into more formal terms and, for the first time, he began to paint in oils. With the aid of the War Office, but without their financial backing, it was arranged that he should hold a big one-man exhibition of his drawings and paintings at the Leicester Galleries in May 1918. Arnold Bennett, who contributed a foreword to the catalogue, wrote, 'The Interpretive value is, to my mind, immense. Lieutenant Nash has seen the Front simply and largely. He has found the essentials of it—that is to say, disfigurement, danger, desolation, ruin, chaos—the little figures of men creeping devotedly and tragically over the waste. The convention he uses is ruthlessly selective. The wave-like formations of shell-holes, the curves of shell-bursts, the straight lines and sharply defined angles of wooden causeways, decapitated trees, the fangs of obdurate masonry, the weight of heavy skies, the human pawns of battle.'

The exhibition included fifty-six works, of which five were oils and five were lithographs, the rest being either the original drawings in chalks on brown paper, or watercolours based on them. Some of the most telling were undoubtedly the simple original sketches, in which the strange forms and colours of the tortured earth were presented exactly as the artist felt them, without any attempt at 'picture making'. They are essentially plastic in conception and, almost in the Surrealist sense of the term 'the image has been laid' without the intervention of a complicated cerebral process on the part of the artist. In many of the more studied designs, probably incorporating elements from several quick sketches welded into a single composition, as for instance, in *Broken Trees, Wytschaete* (*Plate 15*) and in *Sunrise, Inverness Copse*, the same immediacy is evident. Other more complicated designs, on the other hand, have lost something in the process of translation into a more considered medium. The most instantly acclaimed of all the works in the show was the famous oil painting, *We are Making a New World* (*Plate 16*), which is an enlargement of the *Sunrise* sketch and has retained the full impact of the original, the force of which has actually been enhanced by substituting for the original darkness of the storm clouds a dull and sinister red. That it shows no diminution of vision is perhaps surprising when one considers that Nash had no previous experience with oils and was having to master a new technique in the brief space of four months between his return from the Ypres Salient and

the opening of his show. In the same short period he also produced the five lithographs, using a medium in which he had presumably had some training at Bolt Court, but which he had certainly never employed in the intervening eight years. They are an astonishing achievement, for in them he is making a far more considered and objective statement than in the rest of the work. Their rigid simplification is not due to the speed of a sudden impression, but to a deliberate elimination of every non-essential. Their technical mastery is superb. By the simplest variation of strong cross hatching the whole play of light and shade, the brooding sense of inevitable doom, is perfectly conveyed. Here, as is his peace-time studies of trees, the artist is concerned with the drama inherent in relationships, and though in the lithograph of *Marching at Night*, for instance, human beings are involved in that drama, their involvement is not that of individuals but of a group, subjected to the same inexorable fate as the long avenue down which they march.

The identity of man with the landscape was never, either before or after, realised by Paul Nash with the same sense of overwhelming necessity as during this brief and poignant war period. The reason is, perhaps, not hard to find. Once he had emerged from the imitative phase of his Pre-Raphaelite days and had escaped from the excessive influence of Gordon Bottomley, he had increasingly become aware of the enduring stability of nature when compared with the evanescent pretensions of man. The everlasting hills and immemorial elms had offered him a deeper and more spiritual satisfaction than the forms of the men and women who moved among them. In consequence his figures grew increasingly more summary and lifeless as the aspects of the landscape assumed more dominant personalities. But now, under the savage impact of war, the degree to which men and their landscape were alike overtaken by one and the same inevitable catastrophe, and were torn and twisted from their normal selves in a single cataclysm, was borne in upon him, and as a result he produced a number of studies in which human beings played an important part.

Nash's war was not the war of burning patriotism, in which the thought of 'hearts at peace, under an English heaven' softened and exalted the bitter actuality of present suffering. The men he drew were not destined to leave 'a white, Unbroken glory, a gathered radiance, A width, a shining peace, under the night'. Passionately English though he was, he could not console himself, as Rupert Brooke had done, by extolling the glory of a war fought in defence of a beloved fatherland. His war was that of Herbert Read, and it is Read's poetry that constantly springs to mind as one contemplates Nash's paintings—

> *The villages are strewn*
> *In red and yellow heaps of rubble;*
> *Here and there*
> *Interior walls*
> *Lie upturned and interrogate the skies amazedly.*

and again,

> *When first this fury caught us, then,*
> *I vowed devotion to the rights of men,*
> *Would fight for peace when it came again*
> *From this unwilled war pass gallantly*
> *to wars of will and justice.*
> *That was before I had faced death*
> *day in day out, before hope had sunk*
> *to a little pool of bitterness.*

The men caught up in the black drama were united by a sense of corporate suffering and corporate endurance. Their individual reactions of dogged courage, good humoured tolerance, bitter resentment and wild gaiety or wild terror and despair were, in a curious way, corporately felt and corporately expressed. They developed a common sense of companionship, which, with typical English reticence, they rarely expressed in words, but which was perfectly expressed for them in Read's poem, 'My Company'—

> *You became*
> *In many acts and quiet observances*
> *A body and a soul, entire.*
>
> *I cannot tell*
> *What time your life became mine;*
> *Perhaps when on a summer night*
> *We halted on the roadside*
> *In the starlight only,*
> *And you sang your sad home-songs,*
> *Dirges which I standing outside you*
> *Coldly condemned . . .*
>
> *My men go wearily*
> *With their monstrous burdens.*
>
> *They bear wooden planks*
> *And iron sheeting*
> *Through the area of death.*
>
> *When a flare curves through the sky*
> *They rest immobile.*

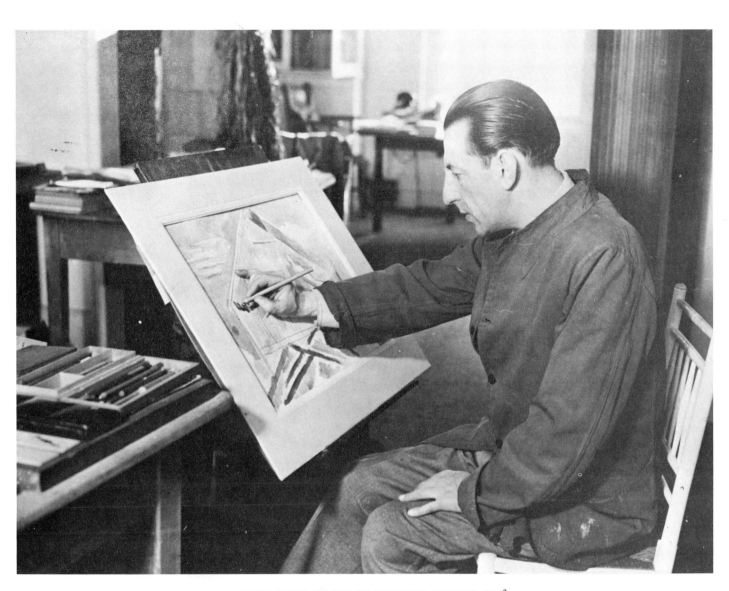

PAUL NASH IN HIS HAMPSTEAD STUDIO, *1938.*

Photograph: The Manchester Guardian

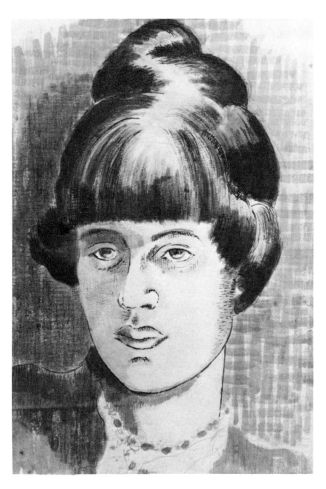

MARGARET NASH AT CHALFONT, *1918. Crayon.*

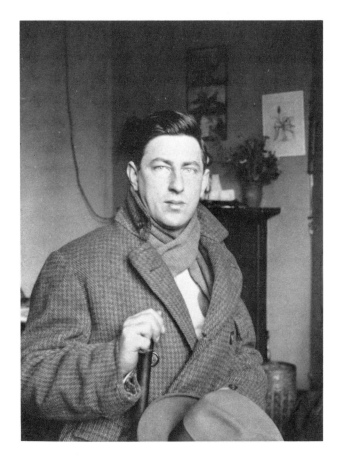

PAUL NASH, *c. 1920*

Then on again,
Swearing and blaspheming—
'Oh, bloody Christ!'

My men, my modern Christs,
Your bloody agony confronts the world.

These are the men that Nash drew, toiling across the battlefields, struggling on the duckboards of the mule track, resting in the dim lamp-light and candle smoke of the dug-outs. He had caught the corporate feeling of each company, 'the body and the soul, entire'.

It is small wonder that many years later Read wrote of that memorable show at the Leicester Galleries, 'I had myself just returned from the Front, and it is perhaps worth recording that my interest in Paul Nash's work dates from this time. I was in no mood for any falsification of this theme; I wanted to see and hear the truth told about our hellish existence in the trenches . . . I was immediately convinced by the pictures I then saw, because here was someone who could convey, as no other artist, the phantasmagoric atmosphere of No Man's Land. . . .'[1]

The problems which confronted Nash at the close of 'The Void of War' Exhibition in June 1918 were twofold. He had to execute paintings of the war on a much larger scale than anything he had yet attempted, in order to fulfil the official commissions that resulted from the show, and he had to cope with the considerable financial difficulties which these commissions involved. From his own pocket he had to pay for the mounting and framing of the fifty-six works that had been exhibited, and the War Office had rapaciously demanded a forty per cent discount on everything they bought (though this demand was subsequently slightly modified). Paul had sold well, but the Gallery's normal twenty-five per cent commission had to be deducted from every sale, and at the end of May he found himself with a net profit of about ten pounds and the pay of a second lieutenant with which to carry on. He had no studio, and the tiny Bloomsbury flat was too small for the execution of works on a large scale.

Fortunately by this time his brother John, who had been taken out of the front line and commissioned as a war artist, largely owing to Paul's efforts, was faced with a similar problem, and they were able after much searching to find a large, barn-like herb-drying shed at Chalfont St. Peter, in the Chilterns, which they could

use as a joint studio. The living conditions were far from ideal, as Margaret Nash has recorded—'We managed to secure a double bed for our empty room, an oil stove, a frying pan and a kettle and a few crocks. It was a sparse existence, as there was absolutely no other furniture. I boiled a kettle for our morning tea on the oil stove, which stood at the side of the bed, so that we got a warm drink inside us before we faced a cold room and no hot bath. Our meals were cooked in the shed and most of our belongings were kept there, since it was really quite spacious. . . . We were at Chalfont St. Peter when peace was declared in 1918, and curiously enough I cannot remember any kind of emotion of pleasure or excitement when the news came through, as we were all so tired and exhausted by the struggle for existence. We just dumbly relaxed and then began to worry about the future.'[2]

It was under these working conditions that a large part of the painting of *The Menin Road* (*Plate 19*) was carried out, though by the beginning of 1919 Nash transferred it to a room he had managed to rent in Gower Street. The canvas was too big for the room and, according to Margaret Nash, 'he was only able to see it at a distance by climbing out of the window on to a flat lead roof projecting over a bay window below, and peering at the picture through the window of the room'.

The Menin Road is an immensely impressive painting, and it is an extraordinary achievement for an artist who had only taught himself to use oils six months before it was begun. The line of the 'road' traverses the canvas from left to right, but is marked only by the mutilated trees of the once arching avenue beneath which it had run. The road surface has been lost and is indistinguishable from the surrounding ground, pocked with shell-craters. Shell-bursts spurt upward in the distance to meet the baleful rays breaking from the edge of torn and ragged clouds. Stagnant water lies in pools in the deep ruts of tank tracks, and through the scene of desolation a few men move forward towards an unseen objective. The mood is set by the sombre tones of sepia and fawn and brown, relieved here and there by the whites and yellows of the stagnant water, and by the rusty red of corrugated iron sheeting, a red which is, ironically, echoed in the one surviving strong plant, a tall spray of sorrel by the edge of the crater pool in the foreground.

[1] Herbert Read's Introduction to *Paul Nash* in the 'Penguin Modern Painters' series, 1944.

[2] By the late summer the Nashes had found more comfortable quarters in Chalfont, where a bath was available and breakfast was supplied, but they continued to eat the rest of their meals in the shed.

Both the composition and the choice of colours are elaborate, and yet the integrity of vision, which had stood out so vividly in the earlier and smaller works on the same theme, survives intact. This is the more surprising in that Nash was afterwards by no means uniformly successful in maintaining the original force of his conceptions when seeking to translate them from small watercolours into larger oils.

The great painting was completed in April 1919, and almost at once he set to work on a canvas only slightly smaller for *A Night Bombardment*, which had been commissioned by the Canadian War Records. Once more it is a work conceived on an ambitious scale, but something of the authenticity of genuinely felt experience seems to have been lost in a preoccupation with the intricacies of design, and it does not bear comparison with either the larger *Menin Road*, or with *Void* (also in the Canadian collection) painted a year earlier for the exhibition.

His mind was, in fact, already turning away from the orgy of horror, and indeed it would have been impossible for him to have sustained much longer the white heat of inspiration generated by the Western Front. In two years he had lived through a whole lifetime of bitterly vivid artistic experience and it was inevitable that a sense of revulsion must come to anyone whose powers of responding to emotional and visual stimulus were so finely adjusted. At Chalfont St. Peter, moreover, he had rediscovered the landscape of his native county. He yearned for the peace and rest of its woods and hills, and the nightmare of the Flanders fields began to fade.

> 'Sing on! The night is cool.
> Morning and the world will be lit
> with whitebeam candles shining and O the frail
> and tender daring splendour of wild cherrytrees.'[1]

So, even while he toiled on *The Menin Road*, he broke off from time to time to celebrate the return to sanity in sketches like *The Field Path* (Plate 21) and *Sudden Storm* in which the only apparent menace lies in the rain-charged clouds. They are evocative drawings, filled with a renewed awareness of how good it was to be alive again, but they are in no sense experimental, Nash was too weary to begin the hard search for a new style and a new technique, and it is almost as though he had stepped back in time to the themes and the methods which had preoccupied him before he had drawn *A Lake in a Wood* in 1916.

[1] *Cherry Trees,* by Herbert Read.

No consideration of Paul Nash's contribution to the records of the First World War would be complete without some reference to the work of other artists commissioned for the same task. Many, like Orpen, were painters of an older school who went about their job in the grand manner. Others, like Nash's old schoolfellow, Eric Kennington, were content to produce idealised portraits of the young heroes engaged in the conflict. Of these records one might have said, '*C'est magnifique*', but in all honesty one would have been bound to add, '*mais ce n'est pas la guerre*'. More theoretically interesting and more in accord with the modern spirit which was beginning to manifest itself, were the paintings and drawings of the Vorticists, under the acidulated leadership of Wyndham Lewis, C. R. Nevinson, William Roberts, and Edward Wadsworth. Their version of Cubism had sprung from the experiments of the Italian Futurists, but in 1913 they had, in theory at least, broken with their masters, disclaimed the Futurist aim of rendering movement, and proclaimed the primacy of the machine in their own counter-manifesto, published in *Blast*, their new review which ran for only two numbers.

Several of the painters in the group had been Paul's contemporaries at the Slade and they too had been briefly associated with Fry's Omega Workshops in 1913 and, like him, had left the enterprise. Since they formed the most closely knit and most articulate 'school' of the period, it is interesting to speculate to what degree, if at all, Nash was influenced by them. *A Lake in a Wood* suggests a passing tribute to the geometrical theories of Cézanne, but it is the only work up to 1917 that could be regarded as owing allegiance to what were then regarded as 'advanced' artistic theories, and there are no watercolours or drawings in which there is any trace of the Futurists' preoccupation with simultaneous movement or of the Vorticists' devotion to the machine. When the machine does make its first appearance in the art of Paul Nash, it does so as an alien and hostile instrument of destruction on the battlefields and even then it is more often represented as broken and abandoned débris in the deserted landscape than as an active force in the work of universal destruction. Whether subconsciously or deliberately, Nash succeeded in 'putting the machine in its place', as a thing of passing malevolence, but of no lasting importance in the scale of permanent values, and in this way subtly readjusted the balance in favour of nature and of man.

It is nevertheless possible in some of the latest of the series of war paintings and more particularly in *The*

Menin Road to discern a slight stylistic affinity with Vorticism, especially as it was interpreted by Nevinson. The strongly marked diagonals of the composition may reasonably be thought to owe something to a knowledge of Nevinson's successful use of the same device, and the lithographs again appear to have a limited technical resemblance to Vorticist work.

In all Nash's paintings of the war, however, human suffering (and therefore by implication human hope) merges with the vast suffering of nature and triumphs over the machine, and it may be that it was in this manifestation of a universal spirit that the secret of his success as a war artist lay. He emerged as by far the most important and original painter of the war, and his triumph received not only expert but even popular acclaim. A monograph with excellent colour reproductions of fifteen drawings with introductions by Jan Gordon and C. E. Montague had been published by *Country Life* in 1918; reproductions and notes on his work had appeared elsewhere. His name was known, his status appeared to be assured. At the age of thirty he had arrived at a point in his career when he could claim that his sudden and apparently inexplicable resolve to become an artist thirteen years before had been fully justified.

V

The Dymchurch Period 1919–1924

IN 1919 PAUL NASH was faced with the prospect of the 'struggles of a war artist without a war', as he records in the preliminary notes for the unfinished chapters of *Outline*. Up to this point he had received an immense amount of support and encouragement from people who were in a position to be of use to him. His early contacts with Sir William Richmond, with Gordon Bottomley, and with Will Rothenstein had served to justify his faith in himself. He had found friends, patrons and advocates among men of the standing of Edward Marsh, John Drinkwater, Charles Holmes, Michael Sadler and Eric Maclagan, all of whom had sponsored him in his efforts to gain secondment as an official war artist. The five exhibitions he had so far held had all been successful, and he had become a regular contributor to the shows of the New English Art Club, the Friday Club, and the London Group. Even Roger Fry had sufficiently overcome his chagrin at Paul's defection from the Omega project to back the application to the Ministry of Information in the summer of 1917, and Nash had also managed to maintain his friendly relations with the Vorticists, whose work he regarded as having been 'vindicated' in an exhibition held shortly before he had left for active service at the front.

Now, however, despite the triumph of *The Menin Road*, when it was shown in the exhibition of war panels at Burlington House in the latter part of 1919, he began to encounter many difficulties, both practical and professional. He had little or no money, his army pay had ended, and the tiny flat in Judd Street was too small to serve as a studio. He was, moreover, very tired. But far more disturbing to a man of his sensitive though sanguine temperament was the professional antagonism of which he gradually became aware. It may have been fermented by Roger Fry, who had felt confident that Nash would repay the support given to his application for appointment as a war artist by accepting the artistic dogmas of which he was the high priest. It came as a shock to Fry to discover that his theories were not acceptable to a young man to whom he was prepared to extend his patronage, and that Nash was determined to preserve his independence and not to form part of the 'school' that was growing up round the Bloomsbury Group. The war paintings had been only too clear evidence of this deplorable unorthodoxy. They appeared to Fry to be propagandist in tendency, and as such could not be regarded as art for art's sake. Their creator must be put in his place. Margaret Nash, in her manuscript notes on her husband's life has categorically stated that 'Fry's persecution followed Paul into civilian life and he did everything he could to prevent him earning his living as an artist. Since he controlled the minds and purses of most of the prominent picture buyers in London, it was not so very difficult for him to starve Paul out by incessantly disparaging his work at public exhibitions and whenever he encountered it in the private houses of various buyers. This forced Paul to accept a commission for a war painting for the Canadian Government after the war was over, and also forced him to try and keep himself alive by embarking on commercial designing.' She goes on to speak of the triumph of *The Menin Road*, which 'was acclaimed by Walter Sickert amongst other people as not only a war picture but a fine work of art. This redoubled the attacks on him of Fry and his satellites and also earned the jealousy of Wyndham Lewis who tried to alienate the friendship of Osbert and Sacheverell Sitwell and other important friends.' This account of jealousies which have always been a typical feature of the art world at all periods, bears the stamp of complete authenticity. Unfortunately it was suppressed by Anthony Bertram in the biography—either because he did not believe it, or because he regarded it as unimportant—and its suppression has had the effect of distorting Bertram's account of a minor but painful episode which directly resulted from the campaign of vilification to which Paul was being subjected.

In the search for a further source of income to supplement his earnings from painting and design, Nash had taken to art journalism, generally under the

pseudonym of Robert Derriman. During the course of 1919 he edited the *Sun Calendar*, choosing excerpts from English poems and illustrating them. He also contributed an introduction to a collection of comic verse by his friend Lancelot Sieveking, with illustrations by John Nash. Both these he did in his own name, but in addition he published fourteen articles (all but three under the Derriman signature) in *New Witness*. In discussing these essays Bertram took up an attitude of rather solemn disapproval, presumably because he failed to realise that they must not necessarily be regarded as invariably representing their author's true views. The cloak of an assumed identity tickled Nash's sense of humour and gave him an opportunity of poking fun at the professional critics. Unluckily, however, he allowed the joke to go too far, and by mentioning his own work with approval and his brother's with enthusiasm, he incurred the wrath of Frank Rutter, who had penetrated the disguise and presently proceeded to expose it. The incident was closed by a letter of public apology from Nash, which appeared in the January issue of the *Arts Gazette*, and in April he wrote a rueful account of the affair to Gordon Bottomley, explaining that Margaret, Rupert Lee, the editor and the publisher had all been in the secret and had all thought it to be a huge joke. Apparently not one of them had realised that it might be in questionable taste, let alone dishonest. As one of his friends has said, 'Never for one moment had it occurred to Paul that he was sinning against a critic's major ethic' and 'he thought it would seem odd, and point to the authorship of the articles, if he omitted any mention of Paul and John Nash. . . . He was curiously childlike in many ways.' In his letter to Bottomley he went on to say, 'It was a ridiculous piece of wrong-headedness on my part and of course I had to stand the racket; it ended by my diligent denouncers casting their last stone in the shape of a published paragraph setting forth my dirty deed in plain terms—this after much mud had been slung behind my back and a good many quite untrue versions spread around—I promptly replied by a frank apology for the facts and a stiff denial of the rumours and upon that the nine days wonder expired. During its period I made some interesting discoveries, chief of which was who were my real friends.'

Among these true friends was Walter Sickert, and among the enemies Wyndham Lewis, who induced Edward Wadsworth to attend the private view of an exhibition which Paul was holding in a borrowed studio in Fitzroy Street, and to insult him publicly, an action for which Wadsworth later most humbly apologised, when he learnt the true facts and realised how much he had been misled by Wyndham Lewis.[1]

The Fry-dominated atmosphere of post-war 'intellectual' London, combined with the exhaustion of the war years told on Nash's health and he withdrew to the solace of the Chiltern countryside at Whiteleafe, where his brother and sister-in-law had a cottage and where he once again devoted himself to landscape painting. He was, however, too tired to respond to the challenge of the scene by evolving a new style in which to extol it. As a result, many of the paintings and drawings attributable to this immediately post-war phase must be accounted relative failures, though a number of them are pleasing in a mild and unexciting way. It is evident that he stood in real danger of lapsing into being nothing more than a sound academic painter, for he was mainly relying upon the stylistic repertoire which he had established before his encounter with the void of war, and, particularly in the oil paintings, one is hardly aware that he was exploring the possibilities of new visual experience. Neither the watercolour nor the oil version of *Whiteleafe Cross* (*Plate 25*) are much more than well observed and tastefully composed landscape studies, and though *March Woods* of 1920 possesses all the feel of trees before the buds break, its design is dull and the sense of woodland stretching out beyond the field of vision, which had been so strong in early works like *The Peacock Path* has not been perfectly realised. More satisfactory in this respect is *Snow Landscape*, though the couple contentedly picnicking on the chilly slope are oddly at variance with the coldness of their surroundings. To the Whiteleafe series also belong several distinctly formalised pen-and-ink drawings, heightened with chalk and watercolour. They are generally attributed to 1921–22, and this may be correct, for on the whole they bear the evidence of a more original approach and a deeper awareness of structure, providing a welcome contrast to the fussy outlines and highly mannered use of colour in two of the 1919 watercolours, *The Corner* and *Red Night* (*Plate 25*). In these an excessive preoccupation with the patterns of the foliage produces an effect of restlessness in scenes which essentially require a more reposeful treatment. A much more satisfactory work among the earlier Chiltern studies is *Beeches in the Wind* (*Plate 26*), a fascinatingly lively drawing in which the

[1] The account of the quarrels of this period is given by Margaret Nash in her memoir.

force of the gale whistling through the branches of roadside trees that fill the greater part of the available space seems to sweep the eye along from the scurrying cloud shadow on the hill to the left into the more sheltered stretch lying below the slope on the right. This same sense of wind-speed is again seen in the later *Tench Pond in a Gale (Plate 27)*, one of the finest water-colours of this intermediate period. It is puzzlingly dated '1921–2' in Paul's fine calligraphy, and one can only assume that he had been unsatisfied by the sketch in its first form and had laid it aside until he had re-solved, to his own satisfaction, whatever formal prob-lem it was that he encountered in the presentation of his theme. Both the treatment and the title prove that, by the time of its completion, he had recaptured the intensity of his vision and was once again in full command of the poet's eye.

The translation into formal terms of an intuitive response to an intellectual or visual stimulus is not, of course, an automatic process, and there is an inherent danger in its becoming so. To use a personal formula too often inevitably produces a sameness of effect that fails to convey to the beholder the essence of the artist's visual experience. For this reason a constant renewal of aesthetic approach is essential, and it was of this renewal that Paul Nash stood in need during the two years following the end of the war. The necessity to supplement his income by accepting commissions for book illustrations and industrial design was not calcu-lated to counteract the weariness of his strained nerves, and though he enjoyed his new role as a teacher at the Cornmarket School of Drawing and Painting at Oxford (a post which he shared with Albert Rutherston from October 1920 until July 1923), such tasks were bound to distract him from his more important work.

Renewal, nevertheless, was at hand. By a happy chance the opportunity for future discoveries had already been granted during 1919. In that year the Nashes had met Raymonde Collignon, the French *diseuse*, and had visited her at Dymchurch, on the Romney Marsh, in order to discuss a design for the cover of a book of her songs, and in the following year they spent some time at a cottage there, to be near to Alice Daglish and her husband, Eric, one of Nash's pupils and friends, and another friend, Colonel Bertram Buchanan, who was farming at Iden, near Rye, not very far away. The discovery of Dymchurch marked a turning point in Nash's art. The vast flat triangle of the Marsh, bordered on the north by the tree lined barrier of the Royal Military Canal, and on

the south-east by the long twelve-mile arc of the sea wall, came as a revelation to him. His imagination had already been stirred by the flatness and the distant horizons of Flanders, but these he had learnt to know as the desolate setting for a nightmare experience. On the Marsh he was faced with even longer prospects, in which the only menace was the menace of the sea, rolling in deceptive calm against the long sands, and yet capable of assaulting and even of overtopping the defensive wall, when lashed by the full force of the equinoctial gales. Behind its defences the Marsh itself lay verdant with rich pasture and occasional patches of cultivation, and here and there along the wall as well as behind it were dotted little Kentish hamlets, while, at the southernmost tip of the triangle, rose the tall vertical of the Dungeness lighthouse, guarding Denge Beach and Denge Marsh.

This lonely unspoilt beauty had already attracted a small group of artists, actors and writers, who had had no use for more conventional seaside resorts. Beside Raymonde Collignon and the Daglishes, Paul and Margaret found other friends, including Sybil Thorn-dyke and Athene Seyler, who had taken cottages at Dymchurch and were enjoying its commanding posi-tion in the middle of the sea-wall arc between Hythe and Dungeness. When the Nashes rented a cottage there for a short time in the summer of 1920 they were extremely welcome to their friends. Their charm and gaiety made them a social asset wherever they went, except in the circles dominated by Fry and Wyndham Lewis. There were, however, two people then at Dymchurch who viewed their arrival with little en-thusiasm, even though these two had never fallen under the influence of the fashionable Bloomsbury Group. Claud and Grace Lovat Fraser had come to Dymchurch with the express purpose of escaping from intellectual snobberies, and they profoundly distrusted everything they had heard about Paul Nash and his brother John. Paul was far too well known for their taste, he had received too much publicity and even notoriety, and would not fit into the simple atmosphere of Dym-church. Grace Lovat Fraser has given me an amusing account of the way in which she and her husband discovered their mistake. They had just been express-ing to the friends, with whom they were walking along the sea wall, their reluctance to make the acquaintance of Nash and his wife, when they unex-pectedly came upon Athene Seyler, standing with the dangerous visitors. There was no possibility of retreat and introductions were made. Within five minutes the

30

Lovat Frasers had not only realised the extent of their error, but had in fact fallen completely beneath the spell of Paul and Margaret's warmth and charm. A friendship had been cemented which was to stand Grace Lovat Fraser in good stead when tragedy overtook her the following year.

Nash himself was completely enchanted by Dymchurch. In May 1921 they rented a cottage with a fair sized room which served as a studio and living room, and there they remained until the end of 1924. In June 1921 they were joined by the Lovat Frasers, but almost immediately after their arrival, Claud Lovat Fraser became desperately ill. Until he was removed to hospital, where he died, Paul was constantly by his side and then he accompanied the bereaved wife to break the news to her parents-in-law. The affectionate support she then received has always remained with her as one of the most consoling memories of her life, and I record it here because it affords an excellent example of that just sense of proportion which was so characteristic of Nash. Throughout his life he was ever ready to sacrifice his personal preoccupations to a greater human need. Quite apart from any consideration of personal friendship, in this case he mourned the loss of a man whose distinguished contribution to English stage design he had much admired.

The illness and death of Lovat Fraser had been a great shock, because they were contemporaries, and Paul was only recovering from the deep impression it had made upon him, when, on a visit to his father, he found the old gentleman stretched, apparently lifeless, on the floor of his room. In fact Mr. Nash was not dead, but in a deep faint, from which he shortly came round. Despite this recovery the new shock proved altogether too much for Paul's over-strained nerves, and within a week he himself collapsed and fell into a coma, and remained unconscious for several days. Owing to the unfailing energy and determination of Margaret, who had a life-long distrust of local doctors, he was removed to the London Hospital for Nervous Diseases, where his condition was diagnosed as the effects of prolonged strain and it was decreed that he must not work for at least a year. At once Will Rothenstein, Albert Rutherston, Eddie Marsh and other influential friends came to the rescue. They wrote letters to everyone, and gathered enough money to enable the Nashes to carry on in the face of this crisis. Fortunately, the results of the collapse proved far less serious than had been feared, and within three months Paul was beginning to work again.

It is impossible to establish the exact number of studies which Nash made of the shore, the sea wall and the hinterland of the Marsh, from the time of his first prolonged stay at Dymchurch in 1920 up to the moment when he and his wife left the Marsh and moved to Iden just across the nearby Sussex border at the end of 1924. One of the earliest and most formalised of the series is *Coast Scene (Plate 32)*, an oil painted in 1920–21 and bought by T. E. Lawrence in the latter year. It is a curious composition and suggests that Nash was as yet by no means at home with his subject. He had set out to express the assault of an angry and determined sea upon the strong rampart of the coastal defences. In order, presumably, to emphasise the encroachment of the water, the bend of the wall has been exaggerated until it forms a shape resembling a prehistoric arrowhead, the apex of whose curving triangle is set three-quarters of the way up the right side of the canvas. From the apex there projects, like the tang of the arrow, a long ramp, which slopes down into the advancing tide. The waves are stylised into heavy folds, sharply outlined and broken by patches of formalised surf. The tower of Dungeness, with its large flanking buildings, is outlined against the sky, and at the point of intersection between the ramp and the sea wall stand the two tiny 'matchstick' figures of the artist and his wife, supported, as it were, by the artist's signature, which is set behind them, while above their heads wheels a flight of gulls. It is an awkward and uncomfortable picture, because the lowering clouds are drawn in an unconvincing curve that follows the curve of the sea defences and thereby fails to provide the necessary counterbalance to the main design of the landscape. Some of the geometric conventions that Nash had employed with consummate mastery in *The Menin Road* have been re-used, but they fail of their purpose because the basic structure of the painting is unsatisfactory.

The ramp reappears in *Night-tide (Plate 35)*, a sombre work in blacklead and watercolour, in which the curve of the wall has been much flattened and the ramp is nearer to the foreground. In this evocative drawing the same type of wave forms have been employed, but the water seems to have an even greater force and weight because it lies beneath the darkness of the sky and its advance is the more relentless because less broken by foam. Sea wall and sea merge into the dark infinity of the horizon, and along the path beside the wall paces the darkling ghost of a cloaked figure, through the rough-hatching of whose form can be

seen the *pentimenti* of the landscape. The figure was clearly an afterthought, but a successful one, and had it possessed more substance it would have appeared less appropriate to the scene. The same compositional scheme is used in *The Shore* (Plate *38*), an oil of 1923, in which the shimmering opalescent mistiness of summer sun on water, sand and sky is contrasted with the firmly drawn white line of the sea wall and the ramp, both heavily shaded in a brown which reappears in the wooden breakwaters, that here and there traverse the stretch of sand, and visually serve to link the water's edge with the dry sand above the tide line, here anti-naturally but convincingly rendered in pink.

The peculiar soft luminosity of the English coast is differently, but equally, evoked in watercolours such as *Dymchurch Strand* and *Dymchurch Wall* (Plate *39*), which, as E. H. Ramsden has remarked, 'for all their quality of enchantment . . . owe their appeal in a higher degree than might initially be supposed to the geometrical basis of their construction—as well as to the tonal oppositions of light and shade as to the formal contrasts of vertical and horizontals, of the straight line and the curve'.[1] Here, in fact, Nash was instinctively applying all that he had learnt about the basic structural form of landscape as it had been revealed to him in the nakedness of the battlefields. The magic of relationships, which had originally conveyed to him his sense of 'personality' in places, now stood revealed in the same and yet in a different way. The early landscape studies had been devoted to the rendering of the personality of places in terms of intricate pattern. Now Nash was preoccupied by the bare bones of the landscape and strove to interpret the relationship of the parts in more fundamental terms. In his earliest landscape phases he had sometimes been tempted to draw only what he saw on the surface, albeit with a feeling for what Bertram has called 'the presence of the absent', but the war had largely purged him of that tendency and by 1921, as Ramsden says, 'Nash never sought to *reproduce* nature, but rather to *represent* her in *equivalent* terms, for which reason his art derives its sanction, not from the closeness of its approximation to the objective reality, but from the preciseness of the degree to which this equivalence is attained. Hence it is because of the preciseness of the equation in the finest examples of the work of this period—because, so to speak, the drawing never ceases to be a drawing, though embodying the very essence of the scene evoked by it, that this particular phase of his art may be said,

1 'Paul Nash as Landscape Painter' in *The Memorial Volume*.

by analogy, to possess a certain ethical validity'.

Winter Sea (Plate *40*), the oil painting begun in 1925, but not completed until twelve years later, marks the supreme point of Nash's achievement in this mode. The equivalence is perfectly stated in geometric forms, though the natural source of the inspiration is in no way obscured. The painting is at one and the same time both valid as an 'abstract' composition and convincing as a marine study. By reason of the dual approach, the painter has been enabled to make a statement that is temporal as well as eternal. The sea may be the sea at Dymchurch seen in the dusk of a particular winter day, but it is also an archetypal sea, in the Platonic sense, the very pattern of all such seas from everlasting unto everlasting. The fusion between spiritual insight, visual apprehension and intellectual expression has been completely effected, so that it remains for ever indissoluble, with the result that the painting is undoubtedly one of the great achievements of the English school.

Although the studies of the sea and the sea wall may be regarded as the most important and original part of Nash's *oeuvre* during the five years he lived at Dymchurch, he executed a number of other paintings and drawings of the Marsh itself and of the higher land lying to the north of it. In all of these his awakened interest in basic structure is apparent and colour is, in consequence, employed in a more abstract manner than had been the case in the earlier landscapes, though the method owes much to his war-time experiments in this direction. Thus, in the well-known oil of *The Pond*, an apparently arbitrary substitution of blue and pink for the green and brown of turf and path beneath the spring trees emphasises the structural relationship of the pond to its surroundings, and in the painting of *Sandling Park* (Plate *46*), both composition and handling are reminiscent of Cézanne. A real affinity with Cézanne is, indeed, now to be found for the first time in Nash's work, but though it is sometimes strong, it is never excessive, for it is clear that, once he had consciously found himself faced with the structural problems which had confronted the Post-Impressionist, he set out to resolve them in his own way and by his own personal researches arrived at much the same solutions. The point is one of considerable importance, because it is easy to assume that a 'similarity' of style or method necessarily argues a consciously accepted influence. Yet such an assumption may be wholly misleading. At all periods in the history of art, painters and sculptors, given a sensitivity to the ethos, have tended to show in their work an affinity with the style

of their contemporaries, not because they have been knowingly influenced or have taken the easy path of direct imitation, but because they have responded to similar visual stimuli in a manner conditioned by the intellectual and psychological 'climate' of their period. To say this is not, of course, to assert that there are not and have not always been a great many imitators, of whom the school have been made up; but Nash was never one of them; quite apart from the singleness of his eye and the independence of his character, such imitation would have been actually difficult for him, owing to his curious inability to learn from others. This factor must, therefore, always be taken into account when considering how far it is ever possible to identify his work with that of any of the fashionable contemporary movements and schools.

It is therefore particularly interesting to note how closely the watercolours of the Royal Military Canal, for instance, do in fact resemble comparable tree and water studies by Cézanne. They are works of extraordinary beauty and sensitivity, in which delicate patches of colour are used to delineate the foliage, and large areas of the paper are left white. The technique was new to Nash and he employed it to immense effect in such works as *The End of the Canal* and *The Bridge over the Dyke* (*Plate 30*). The same freedom bestowed by the large areas of blank paper is seen again in *The Willow Pond* (*Plate 28*), *The Viaduct* and in the exquisite *Walnut Tree* (*Plate 29*) of 1924, though here the emphasis is rather upon the drawing itself than on the slight colour with which it is enhanced.

A different aspect of the concern for structure appears in the large canvas now called *Chestnut Waters* (*Plate 24*), the studies for which were begun in the house of the elder Lovat Frasers, after their son's death. The design is conceived on a rather ambitious scale, and is elaborately worked out to emphasise the contrast between the relatively slender sloping trunks of the trees planted on each side of the water, and the massive blocks of colour representing the overhanging foliage. The design is altogether too laboured and cerebral, and the problem of equivalence has not been adequately resolved, largely because the almost naturalistic handling of the sloping trunks conflicts with the far greater degree of abstraction in the heavily leaf-laden branches sweeping down between them. In comparison with the drawing of *The Backwater* of three years earlier on which the preliminary study may have been based, *Chestnut Waters* in its final form must be adjudged a failure. In its earlier form,

under the title of *The Lake* (*Plate 24*), it left still more to be desired, for the over-large recumbent female nude in the foreground, is completely misconceived, even though, despite his own dissatisfaction, Nash showed it in its original form at the Leicester Galleries in 1924, before he had painted out the figure.

In 1922 Heinemann had published in a limited edition a book called *Places*, in which seven original wood engravings by Nash were 'illustrated' by his own prose poems. The work summarises his feeling for the symbolism of the 'Place', and in the engravings he introduced, on the whole successfully, the human element. The success was, I believe, largely due to the fact that he was working in black and white and that, because of this, he was able to render his figures in precisely the same terms that he employed for the more important landscape surrounding them. They therefore played somewhat the same subsidiary role as the philosophers and peasants in so many Sung paintings. They are no more than observers of the natural mysteries surrounding them. They have no more and no less importance in the scene than the smallest leaf or stone. They possess nothing and they leave no imprint on the place, for though they are one with it they cannot dominate it, and their presence or their absence neither increases nor diminishes its self sufficient existence.

It would probably be true to say that the human intruders were actually less significant to Nash than they were to Chinese painters and that for this reason one feels them to be far less alive than their settings, a fact which is rather amusingly demonstrated by two pencil sketches of this period, the one a study of a group of nudes, and the other a sketch of magnolia buds (the earliest extant flower study by Nash). The treatment is precisely the same in both, though on the whole there is a greater feeling of volume and reality in the flowers than in the women. It is therefore scarcely surprising that, after the failure of *The Lake*, human beings disappear completely from Nash's work, except in his designs for the theatre and in a few of the book illustrations which he undertook in the next few years.

Henceforth his ruling purpose was to seek for the inner significance of the perceived object and to express that significance in equivalent terms. In this aim there can be little doubt that he was enormously encouraged by the commission he received from the Nonesuch Press, probably towards the end of 1923. What he was asked to produce were twelve wood engravings to illustrate a limited edition of the Creation

story as set forth in the first chapter of *Genesis*, to be printed with all the taste, craftsmanship and attention to detail characteristic of that famous Press. Whatever it may have been that the publishers expected to receive from Nash, what they actually got must have far surpassed their expectations. Instead of producing something on the lines of *Places*, or presenting the Creator in the dislikeable guise of one of Blake's old men (either of which might have appeared to be a possibility) Paul gave them twelve abstract visions of the cosmic myth, so powerful and so beautiful that they will always hold their place among the most significant and important illustrative designs ever conceived. Beginning with the black rectangle of 'The Void, with its upper corners cut away to suggest the imminence of the coming miracle, he passed on to 'The Face of the Waters', 'The Division of the Light from the Darkness', 'The Creation of the Firmament', 'The Dry Land Appearing', 'The Sun and the Moon', 'The Stars Also', 'The Fish and the Fowl', 'Vegetation', 'Cattle and Creeping Things', 'Man and Woman', and ended with 'Contemplation' (*Plates 36 and 37*).

A detailed discussion of these engravings would be out of place in a book devoted to Nash's drawings and paintings, but some consideration of his approach to them is vital to true understanding of his future development as a whole. He conceived the series, as I have said, in abstract terms, the technique he employed being not dissimilar to that which he had used for the strongly contrasted, heavily cross-hatched blacks and whites of the war-time lithographs. The sharpness of the contrasts and the perfectly maintained balance of each composition have the effect of making the area covered appear much larger than it is (the engravings measure only four and a half inches by three and a half inches) and each design in turn has an intensity and power that makes it a work of art in its own right, independent of the others in the series. The least successful of the engravings are the three in which there is least abstraction and a closer reference to organic form —'Vegetation', 'Beasts and Creeping Things', and 'Man and Woman'. Here Nash obviously felt under some compulsion to present a recognisable image, and because this is totally at variance with his treatment of the other nine engravings, the result is poor by comparison.

In setting about his task, Paul Nash deliberately chose a highly theoretic approach, and this is specifically stated beneath all but two of the ten extant pencil studies for the series (the drawings for 'Void'

and 'The Stars Also' are missing). The drawings, on thin pages torn from a notebook, are of a different proportion from the finished wood-engravings, being approximately the same width, but roughly half an inch higher. These dimensions were altered, as not being suited to the proportion of the page, a fact which is to be regretted, since the greater height enhances the sublimity of the designs. Beneath the drawings are written, in order of their correct sequence, 'crystal tent', 'prism straight intersection', 'eclipse', 'Pyramid angular', 'sphere', 'arc & spiral rhythm', 'Dome & cone & tube', 'rectangle (*sic*) box form'. The spaces below 'Man and Woman' and 'Contemplation' are left blank, so that we have no indication of the artist's choice of geometric form, which has to be deduced from the design.

These pencilled notes are, naturally, of great importance, since they appear to imply an intellectual interest in Cézanne's theory of basic form, and they serve to throw some light on Nash's own more deliberate approach towards the problem of structure during his important Dymchurch phase.

What is, however, totally unexpected is the completeness of abstraction he reached through this reliance on basic geometry. Cézanne himself never reached it, and though by this stage Paul must have been familiar with the work of the Facet Cubists and was well acquainted with the experiments of the Futurists and the Vorticists, there is nothing in the rest of his production at the time or earlier to suggest that he had been particularly interested in these developments. Equally unexpected is the choice of extreme abstraction with which to 'illustrate' the Bible story. He had been brought up in the orthodox atmosphere of upper class Anglicanism, which was still rooted in the eighteenth-century tradition of being 'charitable without ostentation and pious without enthusiasm'. His own faith in God was deep and simple, with something of the simplicity of a child, and he did not bother his head with abstruse intellectual theories nor concern himself with the obscurities of theological speculation. His background was educated, but not intellectual, and he had been brought up to an appreciation of the exquisite prose poetry of the *Authorised Version*, without feeling any particular need to affirm or deny its 'literal' truth. It was an attitude typical of his class and generation, and though the shattering experiences of the First War may have led him to question many accepted beliefs, there is nothing to indicate that they radically altered his basic attitude.

What then accounts for the total revolution in his style? I think the explanation is relatively simple. Paul was, first and foremost, a poet and he saw with a poet's eye. When confronted with the task of discovering an equivalence for the immeasurable sublimity of the Jewish vision of creation, he suddenly realised, by intuition and not by ratiocination, that no figurative treatment would be capable of embodying so tremendous a theme within the tiny compass of the space at his disposal. He could not set out to compress the early episodes of the Sistine Vault into a few square inches. To attempt to do so would only result in producing caricatures of Blake at his worst. He must rely on pure form. In the beginning the world 'was without form and void' and the divine purpose, as expressed in the creation myth, had been to produce form. So to form he turned, and it was only when he allowed his reason to guide him into adapting a ready-made cubist formula for the delineation of organic creation that he fell below the standard set by pure intuition.

Never, perhaps, has abstract art been seen in a more purely lyrical form than in the finest of these drawings and their related engravings. Even Naum Gabo, though he has reached it, has not surpassed it. Every line is rightly placed and is fraught with symbolic meaning, for here there is a perfect juncture of inspiration and technical mastery. Only once, in the more abstract designs, did Nash make an error of judgment when engraving the plate from the original drawing. In the printed version of the elliptical arches in 'The Creation of the Firmament', he strangely chose to invert the design, so that the horizontal double ellipse which originally formed the height of the firmament now appears as the base from which it rises. Were one not familiar with the pencil drawing, one would accept without question the design in the book, since the sense of uplifting has been perfectly caught. With the knowledge of both versions, however, one inevitably regrets that the artist did not adhere to his earlier vision, for something of the inspiration has been lost.

With the immense achievement of these engravings and with the still unfinished canvas of *Winter Sea*, the flame of inspiration for the moment dimmed, and Paul Nash's creative imagination rested upon its 'seventh day'.

VI

The Iden Period 1925–1929

THE PAINTER who is essentially poetic in his approach may from time to time be led into betraying his initial inspiration. He may come to distrust his intuition and to feel that the very fact that his work differs in certain fundamental respects from that of his contemporaries might possibly be regarded as an indication of his own failure to respond to vital stimuli. Art is by its very nature contemplative, both for the executant and for the beholder, but while the beholder is only called upon to contemplate the visible result of the artist's experience and thereby to make it his own in a personal sense, the artist is faced with the far more difficult and lonelier task of translating his psychological and spiritual reactions to given stimuli into visually appreciable terms. Both in the selection of his theme and in his mode of treating it he has only his unaided judgment to guide him, unless he is prepared to accept the subjects and styles adopted by others and to rest content with making a limited personal contribution to their development. It is in this choice between two approaches that the distinction between original and academic art may be said to reside. The distinction has nothing whatsoever to do with public acceptance or rejection, with 'traditional' and 'avant-garde' subjects or styles, or with the age and status of the artist. It is equally possible to find examples of original and of academic painting in 'Op Art' and in 'Action Painting' as in apparently straightforward landscapes and portraits, and the two trends can be observed in the art of all periods. The two trends can, moreover, frequently be traced in the work of a single painter or sculptor, since few artists, however great, have been able to sustain consistently their ability to see with the 'single eye' and to resist the temptation to look at their world through the eyes of others. Even artists as highly individual as Michelangelo and Leonardo were capable of producing merely academic work, and this is true to an even greater extent of painters such as Rubens and Van Dyck, Monet and Van Gogh, Cézanne and Picasso, and of the sculptors of all periods from anonymous Egyptian carvers of the second

millenium down to Barbara Hepworth, Henry Moore and the contemporary workers in metal and plastics.

To call a painting or a sculpture 'academic' is not necessarily to condemn it, even though the word does inevitably imply a certain failure of creative impulse. Now, as I have already attempted to show, Paul Nash more than once stood in danger of lapsing into academicism. In the years between his second exhibition, held at the Dorien Leigh Gallery in 1914, and his first experience of trench warfare in 1917, he had begun to crystallise his work into something perilously akin to an imitation of his own style—a weakness to which all artists are prone when they have found a market for their wares. The tremendous emotional impact of the battlefields had cut right across this tendency, and he had expressed his reactions to war in terms that were wholly new and wholly individual. With the completion of his war-time task, however, the temptation to yield to academicism temporarily reasserted itself, though it was fortunately soon arrested by his discovery of Dymchurch and his consequent resolve to explore the problems of basic structural form in his own way. Throughout the four years of that exploration, culminating in the first stage of *Winter Sea*, in the evocative use of white spaces and in the completely successful abstraction of the *Genesis* drawings, he had maintained a delicate balance between the structural elements of his compositions and their poetic content. He had 'seen' behind the surface appearance of his subjects and presented their inner meaning in an almost transcendental manner, which raises the finest examples of his work at this period to a high level of artistic validity. How far this sense of inner meaning and this transcendental quality can be justifiably termed symbolic in the period under discussion is open to question. Both Anthony Bertram and George Wingfield Digby, though from slightly different standpoints, have argued that it can.[1] It is true that as early as 1919, as Bertram

[1] *Meaning and Symbol in Three Modern Artists,* George Wingfield Digby. Faber & Faber, 1955. All discussion of this author's views refer to the same work.

has pointed out, Nash himself had stated that 'Art is not primarily concerned with representation. Art is concerned with creation, convention, abstraction and interpretation', and that, in making a somewhat similar point in a letter to *The Times* fourteen years later, he had spoken of imagination building on observed phenomena and had defended the eye 'turned inward in contemplation'. Both statements are unequivocal in their claim for the primacy of intuition and interpretative imagination in a work of art based on nature. But that is not tantamount to saying that art is of necessity concerned with the production of 'symbols', unless we extend the meaning to imply that any work of art that conveys the artist's feeling for the subject he is drawing or carving is *ipso facto* symbolic because it symbolises his feelings. But to use the word in this extended sense seems to me to lead us into great difficulties, for by a very slight further extension we should be driven into the extreme position of having to admit that all language is completely symbolic and that, because the word 'table' is not the table itself, but only a description of a particular object with a plane surface and legs, it is therefore a 'symbol' for that object.

Even if we limit the meaning of the word symbol, and do not apply it to every description, verbal or pictorial, of the objects perceived by the senses, but confine its use to the formal interpretation of ideas connected with the perceived objects, we may still overstate the case, as I think it has been overstated by Wingfield Digby and Bertram in relation to the Dymchurch drawings and paintings. The *Genesis* drawings are admittedly symbolic in the strictest sense, because in them Nash had to confront the problem of representing highly abstruse and metaphorical language in visual terms. He wisely made no attempt to place upon the Biblical text the traditional and literal interpretation, but chose to convey its meaning in abstract symbols. But that is an entirely different process from the one involved in presenting the immanent spirit of a landscape without departing widely from its objective appearance. The latter process may call for a certain selectivity or some subtle alteration of actual proportions or relationships, in order to heighten its inherent drama and to emphasise the painter's response to it; but though the outcome may not be a photographic 'likeness' of the scene, it remains recognisable and does not in any way depend for its meaning and effect upon the introduction of any extraneous elements. For this reason I contend that, once Nash had shaken himself

free from the mock heroics of his 'visionary' phase and had emerged as a serious professional landscape painter in 1912, until he became seriously interested in a completely different approach to formal relationships about 1927, it is misleading to speak of symbolism in connection with his work. It is true that Wingfield Digby has made out a plausible case for the element of symbolism in Nash's early work, considered as 'on the one hand, the primitive expression of the unconscious, while on the other hand, it is an idea corresponding to the highest intuition produced by consciousness', as defined by Jung in his *Commentary on The Secret of the Golden Flower*, but though I agree with much that he has said about the *meaning* implicit in, for instance, the engravings of *Places*, or in the drawings and paintings of the sea wall, defending the shore against the inrush of the invading sea, I prefer to regard this as evidence of a true intuitive awareness of what Julian Huxley terms the 'Numinous', rather than as symbolism in any acceptable sense of the word.

A feeling for the numinous, however strongly developed, is, nevertheless, a psychic quality which can all too easily be submerged by other interests, or even be wholly lost in the pressure of more mundane and transient concerns. At the end of 1924 Paul Nash stood at a point of his career when it might have been expected that he would proceed to the development of the concepts adumbrated in *Genesis* and *Winter Sea*. But beneath the weight of other preoccupations, his vision temporarily failed him, and he allowed himself once more to drift towards a more orthodox academicism. This was less surprising than might at first sight appear. He had his living to earn (for even artists and their wives must eat) and patrons are notoriously suspicious of anything that smacks of what they feel to be fantasy, until it has received the *imprimatur* of commercial as well as critical success, and can therefore be regarded as a safe investment. Nash had, moreover, been working extremely hard over a prolonged period preparing for his one-man show at the Leicester Galleries in 1924, and had, in addition done a number of wood engravings, book illustrations and industrial designs. His hope of being able to execute two large murals for Leeds Town Hall, for which he had prepared the water colour designs in 1920 at the request of Michael Sadler, had unhappily proved abortive, but he was interested in architectural decoration and would have readily accepted commissions had they come his way. Over and above all this, he had been teaching until the summer term of 1923 at the school

in Oxford, and in the autumn of that year had accepted the post of Instructor in Design at the Royal College of Art. None of this was exactly conducive to the mood of contemplation without which an abiding sense of the numinous cannot be sustained.

At the close of the year he realised the need to seek for fresh inspiration and, unfortunately as it turned out, France suggested itself as the right place in which to look for it. He had visited Paris briefly in 1922, and now he and Margaret passed through the capital on their way to the Riviera, where they hoped to escape from the rigours of the Dymchurch winter. To their dismay, they were met by weather conditions no better than those they had left, but when the sun broke through at last, Paul was delighted to discover that the colours of Cros de Cagnes, where they were staying, were soft and shimmering like those of the Kentish Coast and very different from the garish brilliance he had been led to expect from the paintings of his contemporaries. He set to work, and by the end of a two months stay he had produced a great number of small sketches and more highly finished watercolours, which he translated into oil paintings over the next two years. The sketches are delicate, charming little studies, carried out in a careful development of the Dymchurch style. They gain their authority from the sheer excellence of the precise draftsmanship and are in the main tinted drawings rather than watercolours in the technical sense. Nash was fascinated by the unfamiliar shapes of the Mediterranean buildings and rendered them in notebook sketches with a loving insight that makes the drawings appear far larger than their actual size. In such studies as those of a gateway and a terrace it is obvious that he had identified himself with a new 'Place', and some of his notes depicting the oyster boats hauled up on the shore show an equal understanding of a new environment.

Most regrettably, the spirit of the place failed to survive its translation into oils. The paintings were not done on the spot, but were worked up at home over the next two years. They are marked by a certain remoteness, so that one is often left with the feeling that he had been, after all, no more than a detached and interested observer of a new scene, from which the true status of a 'Place' was missing.

Though this unusual detachment was in part due to a certain uncongeniality in the subjects he selected for his canvas, it arose in the main from a growing preoccupation with style for its own sake. Now perhaps for the first time Nash was consciously acknowledging

to himself the influence of Post-Impressionism, which may have come to exercise a stronger hold because he had seen and worked in the land that had inspired Cézanne and Van Gogh. As a result oils such as *The French Farm, Balcony, Cros de Cagnes, Riviera Window* (*Plate 43*) and *Mimosa Wood* (*Plate 44*), all painted between 1925 and 1927, are only competent essays 'in the French manner' and have little of Nash's authentic handwriting about them. Structure and texture are overstressed, and it must be admitted that, for all their competence, they are monstrously dull, because they were prompted by the intellect and did not spring from the individual inspiration of 'the single eye'.

The Riviera visit ended with a hurried trip to Italy, which left Nash quite unmoved. In her unpublished notes, Margaret Nash has attributed Paul's lack of reaction to the Florentine scene to the unhappy atmosphere of Fascism which pervaded the place, and has asserted that Siena, which was freer from this pervasive political influence, greatly attracted him. The explanation may be feasible, since Nash needed to feel thoroughly at ease in his surroundings before they could play upon his creative imagination. But be that as it may, no sketches survive from the three-week visit, and it left no mark upon his subsequent work. All that commemorates it is a particularly arid, harsh and unsuccessful oil in the Edward James collection, entitled *Souvenir of Florence*. It depicts a large and unconvincing vase standing on a window-sill, beyond which there is a glimpse of the Ponte Vecchio. It was painted a year later, and might just as well never have been painted at all.

The escape to the South had been in vain. Nash was still dogged by overwork, and wrote bitterly to Gordon Bottomley, 'in the old days I had leisure and I mean to have leisure again, now I'm driven & it dont suit me a bit. When I was a painter I had the evenings for amusing myself now Im a bit of a painter and a pedagogue & a lecturer & a designer for the theatre and for textiles and a plugging engraver to boot. But it wont do. So Ive quite firmly resigned my usher's job at the Royal College of Art & I'm not going to lecture again if I can possibly afford not to & when my present jobs for books are cleared off Im going to settle down to paint again'. He was not to disentangle himself as quickly as he hoped from the pressure of outside claims. Mrs. Odeh fell ill, and the shock of her mother's serious illness caused Margaret Nash to have a miscarriage from which she recovered only slowly. For the next

four years the lives of both Paul and Margaret were overshadowed by the knowledge of the approaching deaths of his father and her mother.

Towards the end of 1925 they moved from Dymchurch to Oxenbridge Cottage at Iden, near to their old friend Bertie Buchanan, and there Paul devoted such time as he had for painting to working up the Riviera oils and to studies of the Sussex landscape lying to the west of the Romney Marsh. Some of the Sussex landscapes, such as the watercolour of *Oxenbridge Barn* of 1925, show a revived feeling for the 'Place', but the same cannot be said of many of the oils, which remained dull and obsessively 'French' until about the middle of 1927. There are, of course, exceptions to this stricture. Unfortunately these exceptions do not include most of the larger flower pieces to which Nash now began to turn his attention. Here again the preliminary watercolours or drawings succeed in capturing something of the ephemeral delicacy of their subjects, but this does not survive their translation into oil paint, and the living quality of translucent petals disappears in a welter of heavy impasto. Neither *Dahlias* nor *Canterbury Bells* add anything whatsoever to our experience of flowers, and they fail to convince us of the artist's pleasure in them. *Bog Cotton* (*Plate 49*) and one or two other still-life oils are more convincing, but even in these a failure to differentiate sufficiently between the surface textures produces a dull effect that could have been paralleled on the walls of any Royal Academy show of the period. Nash came to flower painting at the wrong moment in his development, when his intuition had been overborne by his intellect, and at this stage he never produced anything beyond a superficial simulacrum of flowers, devoid of life and providing no clue to his personal reaction. It is rather as though he had muttered, 'Sit still, damn you, while I take your portrait', and then had proceeded to load the poor thing down on the canvas with a weight of pigment from which it cannot escape. Slightly later he was to make a much more interesting and abstracted use of flower forms, and much later still they were to afford him inspiration for work of considerable spiritual insight. But the time was not yet. He was himself imprisoned in preoccupations from which he could not escape, and here I would be inclined to agree with Bertram and Wingfield Digby that the drawings of caged song birds, of which the earliest date from this period, might be reasonably interpreted as having some symbolic reference to Nash's loss of freedom, although they were perfectly 'straightforward' studies

of his step-mother's canary, hanging in the window of the family house at Iver Heath.

What it was that began to effect the gradual release of Nash's creative imagination in the early part of 1927 we shall never know. It does not appear to have been connected with any specific experience or event, unless it be that he had suddenly come to terms with the house to which he and his wife had moved more than a year before. On New Year's day in 1927 he wrote to Bottomley about the cottage, saying, 'It is a garden house and ship to live in, full of sun and wind. It stands on the high ground of Iden Cliff, looking over sloping fields to hills below Fairlight. I have become a gardener to my surprise and spend my time between painting and digging.' Gardening was to remain a passion to the end of his life. He had now managed to rid himself of a few of his unwanted commitments, such as the teaching job at the Royal College, and was nearing the end of his work as an illustrator for the time being. In consequence his work, as he wrote to Bottomley, was growing in variety, even though this variety included textile designs, a rigid discipline of repeat patterns to which it may be possible, at least in part, to attribute his increasing interest in abstraction.

He himself was conscious of a change. In reply to his New Year letter, Bottomley had written about the aversion of the Scots to 'the Modernist movement with its denial of nature', and this phrase prompted an interesting response from Nash. 'Frankly', he wrote, 'I am uncertain how much of my recent work you care for—I know a gulf has gaped between us so far as aesthetic sympathies are concerned and your occasional references to modern work make me uneasy when it comes to considering my own in reference to your tastes. So I always plump for the Theatre! There I feel we can always meet and "deny Nature" together! . . . But you don't surely mean that Cézanne, aye and Van Gogh did not base their art on the actual facts of everyday life though I grant you they had more vision than either Manet or Degas whose vision certainly became extremely limited. But what I need explained more than anything is the Modernists movement's *denial of Nature*, really I am not being just captious. I very much want to know what you mean to convey by that phrase—so one day when you feel like it let fly!' Bottomley replied in somewhat rueful vein, and after an interchange of two more letters, there was a gap of more than two and a half years before the correspondence was resumed. The gulf between the two old

friends was very wide indeed, and neither wished to hurt the other by emphasising its width.

The change in Nash's work took the form of a simultaneous development in two different directions, foreshadowing the two main aspects of his art during the next ten or twelve years. Despite Gordon Bottomley's misgivings, neither development was a 'denial of Nature' but rather presented one particular aspect of the artist's approach to her, and both stemmed from his previous work. Emotionally and physically he was now more deeply and continuously involved in the countryside and countryside pursuits than he had ever been, and he had at last more leisure to enjoy and feel it. He gardened and walked and painted, but he was not in the least cut off from society, for there were many friends living in the neighbourhood, including two fellow painters, Edward Wadsworth and Edward Burra. It was a full, gay life with a new sense of freedom, which enabled Paul to revive his old interest in country lore and natural history. From the time of his childhood he had always been sensitive to the changing face of the seasons, in a way that is hard for the townsman to grasp, and at Iden, in the heart of the country, the impact of weather upon seed time and harvest was now intimately bound up with the seasonal changes in his own garden. He therefore lived through the seasons with a re-awakened consciousness of their full meaning, for he had become a participant in their drama. The tiller of the soil is always an actor and not a spectator in the changing scene, and this active role is a factor that must be borne in mind when considering Nash's later use of the seasonal theme, because it is not difficult to be misled into applying an over sophisticated symbolic interpretation to the countryman's natural reaction to seasonal phenomena. This empathic understanding of the face of nature is often found in the simplest and least learned countrymen, and Paul Nash, with his extraordinary warmth of human understanding and his intuitive ability to enter into the lives of others, was now conscious once again of being in harmony with his neighbours, and of living, like them, from the land.

> 'Man, moulded with earth,
> like clay uprisen,
> his whistling mingles
> with the throstle's this even.'

The unity expressed by Herbert Read in these lines from *The Sorrows of Unicume*, struck Nash afresh in the Iden landscape.

To say this, however, is not to deny that at the same time an awakened feeling for symbolism began to play an active and indeed conscious part in his work. One of its earliest manifestations is to be seen in the painting called *February (Plate 54)*, executed in 1927. This is an extremely 'painterly' study of a tree stump, cut off some eighteen or twenty inches above the roots. The stump is set on a hillside that slopes down towards a valley beyond which rises a wooded down. The painting would be a perfectly straightforward, naturalistic study of a relatively uninteresting subject, were it not that a cleaver is stuck transversely into the cut surface of the wood. Now it is not impossible that Nash, walking over the hills on a fine winter's day, may have observed and drawn that particular cleaver, stuck into that particular tree stump, at the midday break, when the woodsman had gone home for his dinner. There is nothing essentially improbable about the subject. There is no question of a surrealist or contrived juxtaposition of incompatibles. And yet, for all that, we are faced with what I think we must regard as Nash's first really surrealist painting. The cleaver may have been there. But if it was, it clearly conveyed to the painter an extraordinary feeling of significance, over and above its straightforward interpretation as the instrument used in felling the tree. We are presented with 'an event', full of both menace and promise, even though neither the one nor the other can be certainly interpreted. Another important point about the composition is that it introduces for the first time the image of the severed or uprooted tree encountered in a peaceful context. Eight years later the motif was to become an important one in the 'Monster' series, but up to the time when he painted *February*, all Nash's trees, save only those mutilated by shellfire on the battlefields, had been tall and living, crowned with the glory of their boughs. There is here, in other words, some reference to death, even though we may not divine its exact import.

An amusing story is told by Ruth Clark concerning the picture. When I showed her a photograph of it, she chuckled and exclaimed, 'Ah, yes, the Model'. It appears that after Nash abandoned the practice of including human forms in his paintings, his wife, who was more familiar with the ways of the Inland Revenue than he, insisted that the trifling item for 'Hire of Model' should be retained in his Tax Return, lest the authorities should begin to question his status as a professional artist. Paul agreed, but insisted in his turn that each year one picture should be solemnly elected to

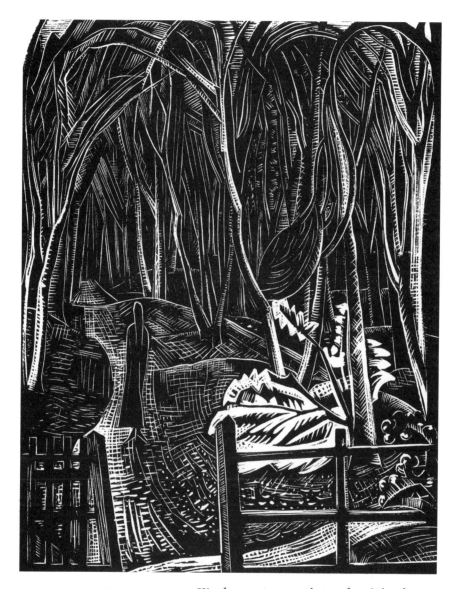

WINTER WOOD. *Wood engraving, actual size: from 'Places', 1922*

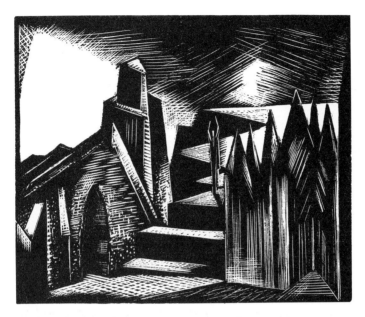

DIE WALKÜRE: ACT 3, THE VALKYRIE'S HOME

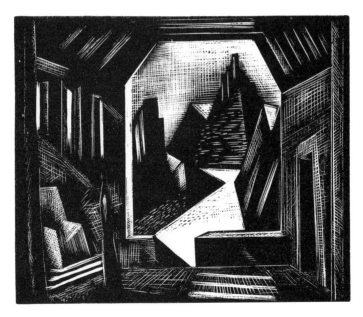

GÖTTERDÄMMERUNG: THE HALL OF THE GIBICHUNGS.

Wood engraved illustrations to 'Wagner's Music Drama of the Ring'

represent the work for which the hypothetical model had been hired. For the financial year 1927/8 the choice had fallen upon *February*. The story is interesting, because, though Nash was immensely professional and serious in this approach to work, he never fell into the error of being solemn and could always laugh at himself, and joke about his art and other people's attitude towards it.

The symbolic element is far more pronounced in *Swan Song* (*Plate 55*), a small oil of the same or the following year. Here again Nash was concerned with the drama of the changing seasons, but he has represented it less naturalistically. He has brought together into a single, carefully worked out composition, the autumn fungi and dry, falling or fallen leaves. Together they form a 'still-life' (even though there is implied motion in the dropping foliage, suspended above the ground in a light breeze) and the centre of the group is dominated by the brilliant colour of the poisonous Red Cap toadstool, scarlet-flecked. The sad and somewhat menacing significance of these autumnal symbols is stressed by the large scale on which they are drawn, since by size they bear no relation to the dual landscape against which they are set. Behind them, on the left, stretches a wide, sea-like plain, its horizon touching the blue sky which is menaced by the approaching storm clouds. On the right, with a different plane of vision, and without any horizon line, stretches a forest glade leading to an unseen distance along the path beneath the copper coloured leaves. In the painting we are therefore presented with three devices which were to be constantly employed by Nash in his later paintings—the magnification of the 'Natural Object', the dual or triple scale and the dual horizon. The surprising thing about *Swan Song* is the complete mastery with which an entirely new mode of expression is handled. As Herbert Read rightly observed, 'With *Swan Song* . . . the way seems open to an imaginative freedom of treatment far removed from the artist's earlier style,'[1] but, though this is true, the relationship of the painting to *February* must not be forgotten.

Though these two works foreshadowed the line of Nash's later development, the experiment he had begun in them was not immediately pursued, for he was at the same time feeling his way towards a new manner in the rendering of 'straightforward' landscape. He had begun to free himself from the preoccupations of his

[1] In *Paul Nash* 'Penguin Modern Painters'.

'French' style and was again allowing the immanent spirit of a place to dictate his mode of rendering it. In *Savernake Forest* (*Plate 47*), an oil of 1927, for example, we have a work richly imbued with Nash's feeling for the personality of the woods. A long ride through tall over-arching beech trees has been perfectly observed. The cambered path, dipping into a slight hollow and then rising steeply beyond it, leads the imagination onward into the furthermost, unseen depths of the forest. The moss and beech-mast covering its verges are flecked with pale yellow, hinting at the sunshine that filters through the boughs crowning the immensely lofty beeches of the deserted avenue. Their tall slender trunks are delineated in a manner which is at the same time both bold and precise. Here indeed is a statement about beech woods which is archetypal and has rarely, if ever, been surpassed.

Far less naturalistic, but perhaps equally successful in its rather mannered style, is *Wood on the Downs* (*Plate 52*), painted two years later. The work has, unfortunately, been rendered over-familiar by excessive reproduction, and it is therefore difficult to be critically detached in discussing it. Strangely enough for the great English public of the early thirties it seems to have represented the quintessence of what they chose to regard as modern art—not too difficult for them to understand, but sufficiently formalised, not to say abstracted, to provide them with the satisfaction of being able to enjoy a 'modernistic' painting. The sketch from which it was developed was a study of the beech trees on Ivinghoe Beacon in the Chilterns, which had been drawn in the spring of 1928. The style of this was more naturalistic, but by the time Nash came to transfer the idea to canvas, he had resolved the scene into a pattern of strictly defined rhythmic curves. The massed pinky red of the thickening buds was treated as a single, unbroken shape, and not divided into the plume-like tracery of the beeches he had depicted some seven years earlier in *The Pond*. The work has a quality of nobility and, like all good landscape painting, it serves to deepen our own awareness of such a scene, but for some tastes it may be thought a trifle over cerebral to be completely satisfying. The poetry is there, but it has been pondered too long and therefore may fail to carry us headlong with the artist on the flood tide of his original inspiration.

Fidelity to the original insight is more perfectly sustained in the equally stylised *Landscape at Iden*, which, together with the very similar *Month of March* (*Plate 53*), was based upon the view across the orchard at the

back of Oxenbridge Cottage. Nash's passion for gardening had led him to protect his plants with wattle fences, erected as windbreaks against the upland gales, and their shape and colour appealed to him as formal elements in a composition, as did the large stack of sawn logs, piled for winter fuel. Somewhat surprisingly he carried out an unformalised view of the garden, not in watercolours but in oils, at the same time that he was producing the more abstracted versions of the subject, but it is insignificant by comparison and lacks conviction. At that moment clarity of definition was his aim and could best be achieved by the use of strongly contrasted verticals and horizontals. Even the clouds appear as horizontals, blocked in white against the clear pale blue of the sky.

Month of March introduces two motifs which became favourites with him, the ladder and the opened window. The use of both motifs in this particular painting is clearly formal in intent. The inner edge of the opened window-frame serves to divide the composition asymmetrically, while the regular trapezoid of the ladder echoes the irregular cone formed by the receding plantation of pink-budded saplings and the tall, wattle-covered hurdle. Bertram has put forward a case for regarding such elements in these compositions as symbolic, reminding us, for instance, that 'The ladder was a common symbol in mediaeval teaching for the contemplative life: and Nash was a contemplative artist'. As applied to the use of the ladder device in a picture like *Month of March*, this strikes me as altogether too far-fetched a notion. If the painting is symbolic (and I am inclined to regard it as being so) then the symbolism is in all probability more closely related to the order imposed by man on the chaotic abundance of nature, and the ladders, fences, hurdles and baskets are no more than the instruments by which that order is imposed. Man himself is absent from the scene, but he has left the impress of his handiwork upon it. Nor must we forget, in our search for abstruse meanings, that the actual objects which Nash sets as foils to nature in these landscapes, were actually there, though not necessarily in the exact position in which he chose to place them. They are not yet '*objets trouvés*', in the full surrealist sense, and they only serve to emphasise the significance of the landscape in virtue of their inherent right to be part of it. They have not been brought in from somewhere else, to act as a commentary, nor, being part of the scene, are they magnified into an anti-natural proportion.

The truncated pyramid of the woodstack forms the

pivotal point of the composition in *Landscape at Iden*, and figures again in a watercolour of the same period (*Plate 53*). There can be little doubt that Nash was fascinated by roughly sawn wood. He obviously felt a sensuous enjoyment of its shapes and colours, and took an intellectual pleasure in the uses to which it was put. The rough hewn timbers of the Dymchurch breakwaters, the duckboards in the trenches, the gates and rail fences, and, later, the planks in the harbour shipyards at Rye, all bear witness to this feeling for the material. His liking for wood led him to make a picture of the *Wood Shed*, at the back of the cottage, but here his imagination totally failed him and the composition was so lamentably dreary and drab that it stood about in his studio for years, until he hit on the idea of turning it into a pseudo-surrealist affair by the addition of a couple of snakes. The afterthought was no improvement, and under its present title of *The Two Serpents* it remains one of Nash's worst paintings.[1]

The rigidly geometrical scheme of the later Iden landscapes was applied to studies made within the house. *Autumn Crocus, Dead Spring* (*Plate 51*) and *Coronilla* (*Plate 51*) all explore the possibilities of receding planes and straight lines, and though they all employ as their basis the familiar objects of the house and studio—window-frames, mirrors, easels, paint-boxes, tables, they are essentially abstract, or at least abstracted in the cubist sense. *Lares*, which is a formalised study of a Victorian cast iron and tiled grate, is an amusing play upon the idea of the Roman gods of the hearth, but, like many over-elaborate jokes, it fails. *Mantelpiece* and *Studio*, on the other hand, being less contrived, are relatively more satisfactory, despite an arid objectivity that suggests a lack of real interest. Bertram has suggested that at this point Nash was deliberately subjecting himself to the mathematical discipline of the ruler and the T-square in order, as it were, to compensate for his youthful failures in this field. The theory is plausible, but though it may provide part, I do not think that it provides the whole of the solution to a rather puzzling manifestation of an 'alien' excursion. It must not be forgotten that three or four years earlier Paul Nash had chosen the geometric approach when illustrating the first chapter of *Genesis* and that, as I have suggested in relation to the Iden landscapes, he had sought to bring form to chaos by these means. It was, moreover, a mode of

[1] According to Ruth Clark, Nash himself thought highly of this painting, which only goes to show what poor critics of their own work painters can be.

thought completely consistent with its period, for its possibilities had been and were still being thoroughly explored by the Cubists and the artists of the de Stijl and Constructivist groups. An artist in harmony with the ethos could, indeed, hardly have escaped the challenge presented by the new scientific and philosophic concepts of form, even though the methods involved were actually foreign to his nature. That they were foreign to Nash is proved by the aridity one can detect in some of the results.

The Diving Stage, Mantelpiece and *Landscape at Iden* were the most 'experimental' works shown in the one-man exhibition at the Leicester Galleries in 1928, but in the same year Nash exhibited various purely abstract compositions in his show of wood-engravings at the Redfern Gallery. The new incipient surrealist phase was absent from both shows. Though the way had already been opened to the new 'Imaginative Freedom' on which Read has remarked, the time for its full manifestation had not yet come.

The freedom to work and the peace of mind to concentrate, for which Paul Nash had yearned when he went to Iden, were sorely shaken before he left it. In February 1929 his father died, and Paul thereby lost the person who, next to Margaret, was closer to him and more beloved than anyone else. The father and son had loved each other with a warmth of loyalty and understanding which surmounted all the barriers of age and of the wholly different worlds in which they moved, and the older man's death left on the younger an acute and lasting sense of loss. Margaret's mother had died the previous year, but, though she had been very dear to both her daughter and her son-in-law, she had been less close to them than 'The Dad', as William Harry Nash had always been called. Her loss, however, presented them with a practical problem, for something had to be done about old Mr. Odeh, who survived his wife.

1929, Nash's fortieth year, was therefore filled with the kind of preoccupations which might well have rendered continuous work difficult and have distracted him from the contemplative frame of mind generally regarded as absolutely essential for the kind of painting he was now concerned with. Frequent journeys to London, brief sojourns in the Judd Street flat, hours closeted with the family solicitor, arrangements for the sale of the family house at Iver Heath, arrangements for his step-mother's move, and finally the decision to leave Iden in the following year, were not activities conducive to his work. Strangely enough, however, it was under these conditions that he produced, not only the final versions of some of the most original Iden landscapes, but a work that proclaimed the opening of a new phase, in which the imaginative release of the early surrealist pictures was combined with the discipline of the abstract compositions.

The windows of the little flat in Judd Street looked out over a cleared building site towards the neo-gothic fantasies of St. Pancras Station. Nash was fascinated by this view, and two years earlier he had devised *St. Pancras Lilies (Plate 48)*, an oil in which the stiff gothic foliage of the Victorian architecture was wittily compared with the stiff leaves and petals of a lily, standing in a vase on his window-sill. The many visits to the solicitor's office during 1929 entailed longer stays than usual in the flat, and in consequence, the strangeness of the station exerted a still greater hold over him, particularly when the view towards it was rendered even more alluring by the addition of scaffolding for a fair ground, set up on the building site. This view was the inspiration for *Northern Adventure (Plate 57)*, in which all that he had taught himself about geometric structure was made to serve purely imaginative ends, for beyond the fairground skeleton the stairway to the station, viewed in a strange perspective, leads to a goal we cannot see, past geometric forms glimpsed through the arches of the station entrance. It is the beginning of a new adventure, which for Nash himself, however, was to carry him not northward, but to the south.

VII

The Rye Period 1929–1933

THE SOUTHERN ADVENTURE, which marked the opening of a new phase in his work at the end of 1928, had about it an air of fantasy appropriate to the imaginative release Paul Nash was now experiencing. Margaret Nash, in her memoir, records that her husband had become aware, after the great success of the Leicester Galleries exhibition in 1928, that 'the popularity of that show was dangerous to him, as it might have induced him to settle down into a delightful way of painting which would have secured him a very large income in a short time'. She goes on to say that he was 'always aware of the spiritual danger of ease and money, and he quite deliberately turned his back, from the moment this exhibition closed, on that kind of artistic expression' and that 'though he still painted lovely landscapes of various kinds . . . he never quite returned to the most representational period of his work which was shown in that exhibition'.

This is a perceptive statement, even though in it Margaret ignored the extent to which the combination of imaginative release and constructive discipline forming the new style had been anticipated in some paintings that Paul had produced side by side with the more 'popular' landscapes during the five years at Iden. Whether the deliberate avoidance of the easy road was wholly due to his shocked realisation of the risks inherent in excessively popular esteem may be questioned. There is undoubtedly a large element of truth in the statement, but it seems to me not impossible that he might have acquiesced in obvious success, however reluctantly, had he not, within a few months, had to face the traumatic experience of his father's death and the inevitable disruption of old family associations that followed it. Despite the contemplative nature of his art, there is much in Nash's career to suggest that revolutions in his style were often associated with suffering rather than with tranquility. The shared misery of the trenches had forced him to a wholly new vision, quite unconnected with his previous style. And now the sorrow of his father's death and the loss of the settled family background he had so long enjoyed may

have acted as a catharsis which quickened the development of a deeper insight. Later in his life illness and the impact of the Second War evoked new responses and stimulated fresh adventure that might never have come about without the purgation of personal suffering. Many people are embittered or frustrated by sorrow and pain, whether psychological or physical, but Paul Nash was not one of them, for he possessed the inestimable ability to learn by experience and to grow in stature through suffering, so that in the course of the years he became not only a great artist, but a great man, not in terms of material importance but of spiritual and moral integrity.

Although he was infinitely practical and resourceful where his work was involved, and would always take immense pains to master new techniques and to understand, for instance, the industrial processes used in producing the textiles, glass, posters and book illustrations he had been asked to design, he was not versed in the management of business affairs or in dealing with small daily problems of life, which were generally left in the more capable hands of his wife. His inexperience in such matters must therefore have rendered the settlement of his father's estate doubly irksome to him, though, as the eldest of the family, he was not one to shirk his responsibilities, however much they troubled him. How impractical he could appear is delightfully illustrated by a story told of the occasion when his wife and Ruth Clark departed to Normandy for a holiday, leaving him to join them there later. Although Margaret had provided him with his tickets and given him minute instructions about the journey, a friend decided that it would be wise to escort him to London and put him on the train. Arrived at the station, the friend observed how lost and forlorn Paul was looking, and so accompanied him to Newhaven where he was struck by grave misgivings as to Paul's ability to board the boat, and did not leave him till he was safe on deck to be met by his wife on the other side.

After all the practical anxieties of the previous year, it was not, therefore, surprising that Nash felt the need

for a change of scene. He and Margaret accordingly set forth for the south of France, accompanied by Ruth Clark, who was just recovering from a serious operation, and by Edward Burra, the painter, 'who', as Margaret records, 'proved at times an alarming fellow traveller'. The tale of the six weeks holiday was amusingly told by Nash in a letter (quoted in full by Bertram) to his friend and patron, Percy Withers, always referred to in the Bottomley correspondence as 'The Mutual'. '*Jamais plus, jamais plus*, my dear Percy, will I go abroad in a circus', he wrote, 'Of course *everyone* wanted something different, we ricochetted round the Côte d'Azur like a demented game of billiards. Incidentally quite often we enjoyed many things but it was not really the holiday of our dreams!'

They went to Paris; they went to Toulon; they crossed the bay to Tamaris; they went to Nice and Marseilles and they took Paris again on their homeward way. When, in the course of these wanderings, they visited their old haunts at Cros de Cagnes 'Ruth said, This was where she would have come if she'd only known—having always sworn that nothing would induce her to go to Cros because she knew she'd hate it'.

The whole letter is a perfect example of Nash's sardonic but kindly humour and of his extraordinary powers of evoking a scene or recreating a personality in a few words. But it is far more than merely a diverting epistolary exercise, for it demonstrates to the full the character of his insight with regard to people and places. I have spoken before of the virtues of 'the single eye', that cultivation of the individual way of seeing by means of which an artist maintains the integrity of his approach. But to possess the single eye in that sense does not preclude the ability to regard life with a dual vision, to look on the surface and beneath it, to view a scene both subjectively and objectively, to be actor and audience, to enter and to stand aside. The letter to Withers shows the personal aspect of this dual vision. Nash could laugh at himself and at other people with an air of complete detachment, when, only the moment before, he had been in the thick of the mêlée and totally absorbed in whatever was happening around him.

It was a writer's gift, but it was also an artist's and from a practical point of view it was invaluable, since all the marchings and countermarchings and sudden retreats of the Riviera adventure did not prevent him from working. In the trenches he had developed a fortunate immunity to interruptions of every sort and this immunity had always stood him in good stead, since up to the time he left the Iden cottage to establish himself at Rye, he had never had adequate studio space and had always worked in a small living-room or wherever else happened to be convenient, with all the buzz of domestic life and callers rising round him.[1] During the Riviera trip he drew in cafés, in hotel bedrooms, in the country and on the sea shore and the sketches he made formed the basis of the oil paintings and watercolours he worked on after his return to England, first at Iden and then at New House, Rye, not far away, a property which he bought at the end of 1930, in order to house Margaret's widowed father and to provide himself with a studio to work in.

According to his letter to Percy Withers, he had started a series of café drawings in Paris, 'which continued throughout the trip, terminating with an austere design suggested by the Refreshment Room in Dover Platform'. One or two of these can be traced, though whether in their original or in their 'worked up' form it is difficult to determine. A café watercolour in the Rutherston Loan Collection in Manchester suggests that their basic intention was to produce a rather fluid abstraction, which did not depend for its effect upon the intersecting rectilinear planes of the Iden interiors.

The real 'discovery' made in these café studies was the introduction of the mirrored image. Every self-respecting French café possessed (and still possesses) at least one large mirror on the back wall. Their function was two-fold, for they enabled Madame to keep an eye on the clients and the waiters, and they lent an air of lightness and gaiety to a dark interior. But to Nash they presented another aspect, for they enabled him to explore the possibilities of the double image, since they served both as a background to the objects in a room, and a means of looking at the street outside with one's back to it. The potentialities of the theme caught his fancy and what began as a *jeu d'esprit* became a recurrent motif to be used to more serious effect in his later works. A good early example of the device, belonging to the Riviera group, is the watercolour known as *Night Piece, Toulon* (*Plate 62*). The actual view out of the window, which is mirrored in *Night Piece*, is recorded in another watercolour (*Plate 63*) that bears no title, and may have been re-worked at the end of the decade, as it contains the addition of a little head, suggestive of drawings made in Hampstead.

[1] Even at Rye he worked in the sitting-room, but it was a 'through' room, and as the house also had a dining room, and small morning room, he was not disturbed by casual callers.

One of the most important of the Toulon experiments was finalised in *Harbour and Room* (*Plate 60*), which records a dual vision of a somewhat different sort, though its dream image may have sprung, as Bertram believes, from the same source. The side walls of a typical French hotel bedroom, with their striped wall paper, marble fireplace and gilt mirror, are surmounted by a moulded cornice, but beneath the cornice facing the spectator the third wall has disappeared, giving place to a view of a man-of-war, riding at anchor in Toulon harbour, the waters of which invade the building, though at a slightly lower level than the bedroom floor, which is cut away to reveal the waves lapping against the steps of a model-sized customs building, neatly erected like a large dolls' house, against the right-hand wall. The fusion of interior and exterior clearly expresses the artist's yearning to break through the flimsy man-made barriers of sense perception to the wider horizons beyond. The theme is surrealist in its dream content, and bears a close resemblance to similar expressions of subconscious release painted by Magritte and de Chirico, and like the work of these two painters, the statement is made in precisely defined terms. That is to say, the dream content is not conveyed in misty outlines and melting tones, but in clear-cut forms and solid blocks of colour suggestive of physical substance rather than of visionary images. But whereas by the use of the same means Magritte and de Chirico both almost invariably succeeded in their rendering of the visionary quality of their images, the same cannot be said of this early essay in the mode by Nash. Although he used somewhat the same colour harmonies of blacks, browns and russets, which he had employed to such imaginative effect in *Northern Adventure*, the imagination is not carried forward into hidden distances and unlimited possibilities outside the field of actual and imagined vision, but is pulled up short by the curve of the harbour jetty, and so turned back into the 'actual' room. In other words, the reconciliation between the conscious and subconcious planes is not perfectly effected, and reason breaks in to question the validity of the dream experience. The watercolour version of the painting is somewhat more successful (as was often the case with Nash at this time), because the relative swiftness of the medium made it possible to 'lay the image', in the surrealist sense of the phrase, before it eluded the painter, whereas the deliberation required for oils tended to obscure the impact of the 'seized moment'.

Another work in which the extended perspectives of the mirror and dream images were presented is the famous *Voyages of the Moon* (*Plate 59*). According to Margaret Nash 'It was based on the long, high-walled restaurant of the Toulon hotel with its entire covering of mirrors that reflected, in a strange astronomical manner, the repeated reflection of large white electric globes which were placed along the ceiling and looked like moons receding into the distance'. In the index to her photographic record of Nash's work, she gives the date of the final painting as 1934, with a note to the effect that it had earlier borne the title '*Formal Dream*' (*Plate 59*). This earlier incarnation, recorded in a photograph, is distinguished from the final work by the decorative cast-iron capital supporting the glass ceiling, but these are absent from the watercolour version (*Plate 58*), owned by Edward James, and alternatively known as '*Globes floating in a many-pillared room*' or '*Glass Forest*'. The chronology of the versions is puzzling, since Nash himself seems to have inclined to 1936 or 1937 as the date for the completion of the oil. As several earlier works were given final corrections in those years, it is possible that there may be some justification for accepting a double date for the oil, and regarding the watercolour version as a preliminary study for the completion of the work. Even so, the origin of the composition is to be found in the Toulon visit, since it is related to the mirror images of that period.

If we accept this view, then we must regard the same place as the origin of two very fine watercolours, *The Three Rooms* and *Forest and Room* (*Plate 68*) and the small oil painting of *Metamorphosis* (*Plate 69*), based on the second of these drawings. All five works are closely related and form a coherent group in which the illusion of a seemingly endless dream perspective of transparent walls is endowed with the actuality of a perceived 'place'. On the other hand, the 'moon' of the *Voyages* is riding high in the dark sky above the room in which its mirror images are imprisoned, whereas the westering sun of *Forest and Room* and *Metamorphosis* is about to sink below the horizon line of the sea on whose surface is traced the path of its radiant reflection. This sun path links the paintings to *Winter Sea*, although there the source of light is hidden by the snow-laden cloud-veil covering the sky.

Whatever may be the correct resolution of the problem posed by the chronological relationship of the group, it is reasonable to see in it the evidence of Nash's enduring preoccupation with themes that touched him nearly. The drama inherent in the relationship of the

heavenly bodies to the earth on which we stand had first appeared in some of the war paintings (the early 'vision' drawings were too artificially contrived to be accepted as valid expressions of true feeling) and the theme had been fully developed in the *Genesis* designs. It then temporarily disappears from the work of the Iden phase, only to reappear in an entirely new form in this strange and evocative sequence of variations on a theme.

The drama of relationships had always been one of the most important factors in Nash's art, but hitherto, as we have seen, he had largely confined himself to the presentation of this dramatic element in landscape, and where he had been least conscious of the felt relationship of its parts, he had been least successful in conveying the personality of the place he was painting. It is, indeed, this failure to understand the significance of relationships that renders many of the Cros de Cagnes and some of the early Sussex landscapes monotonous, just as it is the mastery of the related parts in the earliest landscape drawings and in the best of the work done at Dymchurch and Iden that gives to them a timeless quality far transcending the actual scene recorded.

Now, in the Riviera adventure the drama of relationships of a different kind manifested itself, and with its discovery Nash approached one of the particularly fascinating aspects of Surrealism, that of the *objet trouvé*. It is certain that he was already intellectually involved in the Surrealist movement, since on passing through Paris on their way south, he had spent an hour or two at an important Surrealist exhibition, which may have been a factor in his ability to find a fresh release in the following months. A year later, in 1931, when he began to undertake regular art criticism for the *Weekend Review* and the *Listener*, he contributed articles about de Chirico and Picasso. Herbert Read and Edward Burra had themselves already subscribed to many tenets of the movement. But though a short acquaintance with Surrealist theories may have contributed to the release of his imagination in a new direction, nevertheless, Nash's encounter with the 'Found Object' took a highly personal form. One of its earliest manifestations is seen in a painting entitled *The Nest of the Siren*. Anthony Bertram has written at some length about the piece, and has detected in it all sorts of symbolic meanings, which are patently unconvincing. In reality, the little human-headed bird, perching on the turned baluster, was the gay and irrelevant decoration of a small coster's cart, which had caught Nash's

fancy one evening in Caen, as it stood in front of a window box. Its apt incongruity against the background of pot plants turned it at once into the perfect *objet trouvé*, the first of many he was to paint. But in this particular instance, the only imaginary addition to an otherwise observed 'event' was the nest, cunningly set in the greenery behind the little figure. Because of this it seems to me that elaborate interpretations are misplaced and that such 'significance' as the painting may be thought to possess lies entirely in the apprehension of an observed incongruity between the object and its setting, which the artist had reconciled by a deliberate commentary in the form of the added nest.

Though the fused or mirror image and the found object now took their place in his art, Paul Nash remained, as always, catholic in his outlook, and the work of the next two years was extremely diversified. In 1931 he completed a canvas called *Opening* (*Plate 56*), but though the painting and its related watercolour belong to the time he was working at the New House, his original sketch of the design, showing the abstracted doorway, was given to Lance Sieveking in 1927. The sketch, however, does not indicate the prospect of the 'perilous seas' glimpsed through the opening in the final oil.

An interest in complete abstraction had not been entirely stifled by Nash's new preoccupations at Rye, and he painted the most important of his purely abstract compositions—*Kinetic Feature*, a subtle harmony of related curves, pivoted on a fluted upright, resembling a broken column. It is a successful essay in its *genre*, but though he was a passionate advocate of the best in the abstract movement, it was not really his mode, and he turned from it to pursue a course more natural to him in the field of imaginative adventure. The rightness of his choice cannot be questioned, for though the greatest purely abstract art is essentially imaginative and depends for its validity on the degree of sensitivity and feeling for natural principles which the artist brings to its production, the kind of insight it implies was foreign to Nash, and in his hands it therefore tended to be coldly intellectual. Naum Gabo, Barbara Hepworth, Moholy Nagy, Ben Nicholson and others could express in the straight line and the curve an intensity of emotional awareness which Paul Nash could thoroughly appreciate, but could not match when employing what, for him, remained a foreign language.

He himself, in a letter written to Cecil Collins in 1944 and quoted by Bertram, interestingly summed up

his own view of the development of his artistic attitude during the years at Rye, when he said 'This section shows the break from "interpretive" landscape and still life painting to the experiment of non-figurative design or "near" abstract, which coincided practically with so-called "Surrealist" content', and he traced the fusion of the dual methods to *Northern Adventure*. Despite the significance of this painting, Bertram is, however, probably correct in regarding the illustrations to Sir Thomas Browne's *Urne Buriall* and *The Garden of Cyrus* as having been more crucial. Before discussing the effect which this commission had upon Nash's mode of expression, some consideration must be given to the drawings and paintings that record his visit to America in 1931.

He had been invited to be a member of the jury for the international competitions organised annually for American and European painters by the Carnegie Institute of Pittsburgh. He left England for the United States with his wife in September 1931, and they sailed in great style on S.S. Mauretania, accompanied by the French and Italian jurors, Monsieur le Sidanier and Signor Oppo, an ardent Fascist, whose tactless remarks about England, France and America, delivered in a French so execrable that only Mrs. Nash could understand them, had to be translated by her and diplomatically toned down in the process. She records that it was impressed upon Nash at the outset that they 'must keep up an expensive air in order to do justice to the great honour of representing Great Britain on the International Jury'. This was an injunction that Margaret can have found little difficulty in obeying, and Paul's aristocratic manners and appearance admirably suited him for the appointed role, though they both found it hard to be suitably expensive in their tastes, when faced with the innumerable bottles of strong spirits carted around by Homer St. Gauden's chauffeur in a Gladstone bag for the proper entertainment of his European guests, who must not be allowed to suffer the privations of the then teetotal States. Paul and Margaret maintained the required grandeur on the outward journey and during the weeks spent in America, but on the return journey they had to abandon all thoughts of prestige and to come back third class. The Carnegie Institute, for all its munificent hospitality, did not usually extend it to the wives of its guest jurors, and could not be expected to realise that Paul was not accustomed to travelling unescorted, so a compromise had to be struck, when there was no longer any danger of the great American public being shocked by its results.

The 'ship architecture' of the Mauretania made a profound impression on Nash, and inspired a series of finely composed, but relatively straightforward studies in watercolours and oils, which were executed after his return to Rye at the end of October. The Atlantic, presenting as it did an aspect of the sea that was new to him, left a lasting mark upon his work, for, as the great ship cut through the waters, Nash for the first time was able to appreciate to the full the immense variation of wave forms viewed from above. Hitherto his seas, stormy or calm, had been seen in relation to the wide expanses of the Marsh coast or rocky beaches of the Côte d'Azur. Deeply though he had felt them, and perfectly though he had rendered them, either naturalistically or in some abstract equivalence, they had remained essentially landsman's seas, contemplated by an observer and not experienced by a participant. Now in mid-Atlantic, the viewpoint changed. The artist assumed the guise of the mariner (aided, perhaps, by some naval instinct inherited from his mother's side of the family) and he saw the seas as navigable waters to be both loved and feared, but, above all, to be understood for what they were. His powers of empathy were fully awakened to express the indwelling spirit of the waters, even as he had long expressed the spirit of the land. His emotional responses had been enlarged and the sea had gained for him a new dimension, which from then on was to inform all his studies of English and foreign coasts.

The American landscape, on the other hand, appears never to have entered into his consciousness at all, though he saw a good deal of the country during his journeys between New York, Pittsburg, Virginia and Washington and may have witnessed the beginning of that astonishing phenomenon, the American 'fall'. In the painting of his American contemporaries he found little to attract him, and he shocked them by his insistence on the importance of James Thurber's comic drawings. He appears, however, to have got on well with the collectors and to have enjoyed the tour, while remaining throughout a detached and somewhat cynical observer of the scene. Upon one collector, at least, his personality made a lasting impression. Professor Elizabeth Demarest had already bought several examples of his work before they met at an official gathering in Pittsburgh, and a friendship between her and Paul and Margaret was intermittently continued in later years by an exchange of occasional letters. After her death, Nash received a communication from her trustees, informing him that, after the death of

another, elderly, beneficiary, he would inherit an income of about £400 a year. The news reached him in 1946, a few months before he died, but though he did not live to benefit by the legacy, the knowledge of it cheered him, at a moment when he was facing the alarming prospect that, even if he recovered, he might never be able to work again.

At the end of October 1931, Nash returned to the studio at Rye, to cope with the financial problem of maintaining a large house, even though his father-in-law, who had a flat in it, made some contribution to the costs. Two exhibitions, a retrospective one at Oxford and a show of his book illustrations at Batsford's, were a financial failure, and it was imperative to replenish his purse. He therefore turned to art criticism for the *Listener* and the *Weekend Review*, and gave up much of his working time to the production of designs for glass, china and textiles, as well as a series of end-papers for the Curwen Press and doing posters for Shell and other large companies. His aristocratic view of the respectful deference due from the business man to the artist who consented to design for him, and of the folly of allowing oneself to be swayed by the supposed requirements of public taste is admirably summarised in Anthony Bertram's biography and does not concern us here.

One far less commercial commission was that given him by Desmond Flower of the publishing house of Cassells, who asked him to illustrate a book of his own choice. His choice fell on Sir Thomas Browne's *Urne Buriall* and *The Garden of Cyrus* to be published in a single de luxe volume, with a foreword by John Carter. 'This book', wrote Philip James, in the essay on 'Paul Nash as Book Illustrator and Designer', which he contributed to the *Memorial Volume*, 'judged by all standards, is one of the great illustrated books of this or any age. It approximates more closely to the French edition de luxe than to the ordinary English style of illustration, for it is essentially the work of Nash the painter. And yet it avoids the self-conscious extravagance which makes so many French books almost lose their identity as books. It is a splendid achievement in all the branches of book-building, and a fine piece of team work between publisher, artist, printer and binder', and Herbert Read called it 'one of the loveliest achievements of contemporary English art'.

It was an inspiration on the part of the publisher to allow Paul Nash a free hand in the choice of a text for illustration, and on Nash's part to make the choice he did, for the work was exactly suited to his mood of the

moment; he was beginning to evolve his imagery with a greater consistency than ever before, and he was increasingly aware of mortal transience, because of his recent experience of the death of his own father and of his wife's mother, and of his knowledge that Margaret's father would soon follow them. By this I do not mean that he had grown morbid or gloomy, or that the fires of his wit and gaiety were quenched, but rather that the barriers between life and death were down, and that he had brought his personal fusion of the 'here' and the 'beyond' (as first expressed in *Harbour and Room*) to bear upon the phenomenon of death.

Browne's splendid seventeenth-century prose, with its mixture of sonority and quaintness, his fusion of classical learning, gothic fantasy, scientific observation and mystic speculation, were exactly adapted to the tenor of Nash's thought, and evoked in him a richness of imagery that marked the final liberation of his imaginative powers and laid the foundation of his mature symbolism, as it was to be manifested in his later work. Anthony Bertram has discussed in detail the exquisite hand-coloured collotype plates and has considered their meaning. They are closely related to the parts of the text which they adorn, sometimes as exact illustrations of a particular passage, and sometimes as more detached comments upon it. In them the whole range of Nash's artistic vocabulary at that date is displayed. But now his drawings of flowers and trees, of landscape and of seascape backgrounds, of architectural settings and animal forms, of human bodies and abstract shapes, are all reconciled in a single expressive purpose. Thus, the symmetrical pattern formed by the funeral pyre echoes the Iden woodstack, the long perspectives of the aerially suspended framework representing 'The Mansions of the Dead' recall the ladders, fences and hurdles in the garden views from Oxenbridge Cottage, and sense of distance achieved in that plate has in it something of the mystery achieved by the diminishing perspectives of *Savernake* and *Path Through the Woods*. The abstract and abstracted designs have in them a reminder of *Genesis*, while the scaly-surfaced sea of the 'Quincunx Artificially Considered' brings to mind *Winter Sea* and its related studies. The human or angelic form, introduced in several places, is more satisfyingly treated than in other examples, and the architectural elements have all the imaginative precision which had marked the best of the small Cros de Cagnes sketches but was not carried over into the oils of the 'French' period.

The element which is new in many of these designs

is the extraordinary sense of suspension achieved in them. It was an effect which Nash had not seriously attempted since the clumsy efforts of his 'visionary' days, except for his early rendering of bird flight and for the falling leaves of *Swan Song*. Even in the latter, however, the feeling of suspension is imperfectly conveyed. But in 'Sorrow' the angelic form really does appear to cleave the air, the sunflower and teasel head of ' The Quincunx Naturally Considered' (*Plate 67*) do hover in the air above the pine cone precariously balanced on the twig, and in the abstract geometric shapes of 'The Quincunx Mystically Considered', as well as in the tailpiece to *Urne Buriall*, we are left in no doubt of the aerial suspension. But most strongly of all is this feeling conveyed in 'The Mansions of the Dead'. The open tiers of rectilinear platforms seem to sway on their supporting and interpenetrating clouds, while above them a towering framework extends the perspective backward and upward into the heights of heaven. 'The Soul, which had wings in Homer, which fell not, but flew out of the body into the mansions of the dead', flies in a grasshopper form, surrounded by a nimbus, and is thrice repeated in suspension, while a fourth soul, which has 'landed' on one of the platforms, entirely convinces us that it has but this moment folded its wings on reaching its aerial perch.

This illustration also exists in the form of an oil painting, a watercolour and the coloured tracing on which the oil was based. Of the four versions the painting is the least successful, since its outlines are too harsh and its colours over defined to capture the dreamy quality needed to interpret the text. A more successful oil, derived from one of the designs for *The Garden of Cyrus* is *Summer*, finished in 1933, the year after the publication of the book. Several other drawings and paintings derived from the illustrations were produced about the same time.

Apart from their intrinsic quality, the illustrations to the volume are of immense importance in relation to the symbolism of Nash's later work. It is evident that from the very beginning of his career, he had been conscious of a super-added meaning, over and above the relatively direct transcripts which he made of the landscapes before him. To a certain extent this awareness may have been due to his childish 'visions', and even more to the encouragement to persevere in them which he had received from Gordon Bottomley. But I do not believe that this was a decisive factor in his attitude to the *genius loci*, the personality of 'the Place', and the feeling of 'the presence of the Absent',

as Bertram has called it, with which all his best and most perceptive landscapes are imbued. It seems to me that his 'Discovery of the Place' in Kensington Gardens has far more to do with it, and that his ability to express the *genius loci* so perfectly is derived from a particular childhood gift of being able to identify himself with the scenes on which he looked, and thereby to draw from them a profounder meaning than would be apparent to the ordinary observer.

The question then inevitably arises as to whether Paul Nash was a mystic painter. This is a fascinating problem and one which it is not easy to resolve. When considering the significance of forms with dual associations, which occur so frequently in Nash's work, Read maintained, though somewhat ambiguously, that 'to describe such associations as "mystical" is, in my opinion, a misuse of the word—there is nothing mystical in forms which can be explained in scientific terms (and have been so explained by Sir D'Arcy Thompson, for example). But Paul Nash would not have insisted on the word—he would, I believe, have willingly substituted the word "poetical". What deserves more emphasis, however, is what he called "the drama of the event". He was not satisfied with what might be called the *passive* landscapes of a Constable. He certainly preferred the fury of a Turner. But Turner's diction (to continue the dramatic metaphor) was too rhetorical; Nash was essentially a metaphysical painter, which explains why he found no difficulty in associating himself for a time with the Surrealist movement. But he was not in any true sense of the word a mystical painter—he was not a visionary like Blake or Palmer, seeing in the landscape "the symbol of prospects brightening in futurity". '[1] The meaning of this passage is by no means clear and, as Bertram has pointed out, in it Read appears to treat 'mystical' and 'visionary' as synonymous terms. The conclusion is misleading, since all authorities have drawn a sharp distinction and are agreed that visions and voices cannot be regarded as mystical phenomena. Read's suggestion that there is, moreover, some kind of prophetic quality in the visionary art of Blake and Palmer raises a further difficulty, but it is one that need not be examined here, since it would be impossible to maintain that Paul Nash's work holds in it any prophetic element or that his aim was to outline the shape of things to come.

The real difficulty here lies in the definition which one chooses for the word 'mystic'. Has it the loose and

[1] 'Paul Nash as Artist' in the *Memorial Volume*.

general connotation most usually attached to it, or should it be employed only to denote recognisable types of experience, marked by certain specific characteristics?

Bertram, having rightly questioned the validity of Read's tacit assumption that mystical and visionary are synonymous, goes on to tackle the semantic problem from his own Catholic standpoint. He quotes the views of Dean Inge and William James[1] on the content of mystic experience, and then prays in aid a passage from Jacques Maritain, which he regards as conclusive:

'Poetic and Mystical experience are distinct in nature; poetic experience is concerned with the created world and the enigmatic and innumerable relations of beings with each other; mystical experience with the principle of things in its own incomprehensible and supermundane unity . . . Poetic experience is from the very start oriented towards expression, and terminates in a word uttered or a work produced; while mystical experience tends towards silence, and terminates in an immanent fruition of the absolute.

'But different in nature as they may be, poetic experience and mystical experience are born near one another, and near the centre of the soul, in the living springs of the preconceptual supraconceptual vitality of the spirit. It is not surprising that they intercross and communicate with one another in an infinity of ways.'[2]

Bertram then goes on to give a limited assent to the view that Nash's symbols might perhaps be related to 'the lower level of the doubtful "objective or symbolic mysticism",' and, having attempted, somewhat lamely, to assess Nash's attitude to the personal God of Christianity and the possible relation of his symbols to such a belief, he concludes by allowing him to have been 'mystical' only 'on the lower level and by affinity'.

This somewhat limited and narrow view confines 'true' mystic experience, by implication, to Christianity, or at least to the small group of monotheistic religions which have drawn a sharp distinction between the Creator and his creation, in order to avoid the 'heresy' of pantheism, and have in consequence denied the possibility of a completed identification between the 'One Without a Second' and the world of its 'creating'.

Those Catholic writers who have maintained this orthodox view have, inevitably, often found themselves forced into denying the validity of so-called 'nature mysticism', because the core of its experience invariably suggests a pantheistic solution to the problem of the universe. This is, in fact, the position taken up by Professor R. C. Zaehner in his *Mysticism Sacred and Profane*, in which he attempts to prove that, because the *interpretation* placed by Christian and Moslem mystics on their experience differs from that given by Hindus and Buddhists, when discussing their own mystic experience, there is an actual difference in the essential core of the experience itself, and that the former group, being 'true' from a theological point of view, is of necessity on a higher plane than the latter. This theory, in its turn, leads Zaehner to the conclusion that, since the interpretations placed by 'nature mystics' on their experience accords more nearly with the Hindu than the Christian interpretation, nature mysticism pertains to a lower plane and is in reality nothing more than a manifestation of the collective unconscious.

Professor W. T. Stace, a much more reliable and less partisan scholar, whose examination of the mystic problem is far more profound, has taken an entirely different view, and has demonstrated the existence of a 'universal core' in mystic experience, identifiable in the accounts given by mystics of all religions and of no religion at all.[3] He has, however, convincingly distinguished between 'extrovertive' and 'introvertive' mysticism, and has shown that, though the universal core of both types of experience is marked by seven characteristics, five of which are common to both, it is by the two characteristics that are different that the groups can be distinguished. The five common characteristics he identifies are: a sense of objectivity or reality; a feeling of blessedness, joy, happiness and satisfaction; a feeling that what is 'apprehended' is holy, sacred and divine; a realisation of the paradoxical nature of the experience; and, finally, a feeling that it defies exact verbal description. But whereas he defines the first two characteristics of the extrovertive experience as 'the Unifying Vision—all things are one' and 'the more concrete apprehension of the One as an inner subjectivity of life in all things'; those of the introvertive type he defines as 'the Unitary Consciousness, the One, the Void, pure consciousness' (that is, the stream of consciousness devoid of all conceptual images) and 'nonspatial, nontemporal'. From his detailed philosophic and logical examination of the significance of both types, he concludes that in varying degrees they afford incontrovertible evidence of a

[1] *Christian Mysticism*, W. R. Inge, and *The Varieties of Religious Experience*, William James.
[2] *Creative Intuition in Art and Poetry*, Jacques Maritain. Harvill Press, 1954.
[3] *Mysticism and Philosophy*, W. T. Stace, Macmillan 1961.

paradoxical, trans-subjective, Universal Self, in the void of which all diversity is unified.

In the passage in which he deals with 'nature mysticism' Stace writes, 'it is a mistake to suppose that this phrase signifies another type of mysticism distinct from the two we have already recognised. It is either the same as extrovertive mysticism, or it is a dim feeling or sense of a "presence" in nature which does not amount to a developed mystical experience but is a kind of sensitivity to the mystical which many people have who are not in the full sense mystics', and he goes on to quote Wordsworth's famous lines,

> *a sense sublime*
> *Of something far more deeply interfused,*
> *Whose dwelling is the light of setting suns,*

as evidence that the poet probably never had a definite extrovertive mystic experience, but that he was sensitive to mystical ideas.

If we are to accept Stace's general theory, the problem as to whether Nash, on the evidence of his later work, can in any sense be regarded as a mystical painter can be more easily discussed in the terms provided. In these terms it is clear that Nash was certainly not an introvertive mystic, for never at any time was he devoted to the exploration of the Unitary Consciousness. But if we consider the extrovertive aspect, with particular reference to nature mysticism, there is, I think, evidence to suggest that he did experience from time to time the level of consciousness described by Stace, and that he was not merely sensitive to the mystical in the sense of the Wordsworth lines quoted above. In *Outline*, in a passage which Bertram himself quotes, but of which he apparently fails to understand the full implication, Nash wrote, 'Whatever happened to me throughout my life, I was conscious of the influence of the place at work upon my nerves—but never in any sinister degree, rather with a force gentle but insistent, charged with sweetness beyond physical experience, the promise of a joy utterly unreal'. 'Sweetness beyond physical experience' is, of course, the significant phrase in this passage, though it might be taken as no more than an indication of the Wordsworthian type of sensitivity, were it not for evidence afforded by his work. The *genius loci*, the perception of an indwelling spirit or personality in places, the hint of the 'presence of the absent' had been manifested in his work, though with varying intensity, from the moment he emerged from his early imitative Pre-Raphaelite phase. But, as he grew older, so his paintings increasingly depicted his

search for 'equivalence', a search of which he himself was fully conscious. Now it does not seem to me that equivalence is something which can be deliberately sought, unless one is already aware of its existence. In other words, the equivalence is nothing other than an expression of the 'unifying vision', which Stace regards as the first of the seven characteristics of extrovertive mysticism.

The paradoxical nature of the experience frequently emerges, particularly in relation to the 'Found Object' and other symbols of Nash's most overtly Surrealist period, and the sense of the 'Numinous' (a term which in this context I prefer to 'sacred or holy') is given in the statement about the 'promise of a joy utterly unreal'. Five of the seven pre-requisite characteristics of extrovertive mysticism are, therefore either explicitly mentioned by Nash or are implicit in his work. The 'sense of objectivity or reality' may presumably be deduced from the definition which he almost invariably gave to his pictorial images when seeking to render a spiritual experience transcending words, which could not be adequately 'described' except in symbols. In making this suggestion I am conscious that I am claiming for Nash a considerable degree of spiritual and metaphysical insight, but it must be remembered that William James, Stace and other authorities have shown that extrovertive mystical experience (whether they have recognised it as such or not) is far less uncommon than is generally supposed and may be compared to the sudden opening of a window upon some unlooked-for prospect, glimpsed for a moment and then lost, sometimes to be rediscovered, and sometimes never to be seen again.

If I am right in this conjecture, then we must presumably regard Paul Nash's symbols as an attempt to render the ineffable, even though in his actual choice of them (whether deliberative or instinctive) he may have drawn, as both Wingfield Digby and Bertram have contended, upon the inherited wealth of the collective unconscious.

There can at least be no doubt that in his choice of *Urne Buriall* for illustration Nash was moved to interpret his own new-found awareness of death and immortality, and that in *The Garden of Cyrus* he had discovered a verbal equivalent of the underlying unification, which he had so long sought, and which was there symbolised by Browne in the geometric pattern of the quincunx. That he did not look to more recent literary works for the resolution of the problems which preoccupied him may seem surprising to a

generation reared on the myth of modern science and indoctrinated with the views of empirical and analytic philosophy. But he was essentially a poet and his attitude was never academic. He described himself in *Outline* as 'a lazy, incurious reader', and he never bothered his head with the possible scientific inaccuracy of what he read, nor troubled to question the authority of statements which happened to appeal to his imagination. Books were for him only a point of departure for his personal adventures and he was in consequence more concerned with the poetic quality of the ideas they advanced than with their factual validity. Words always fascinated him, and when he wrote, either informally in letters to friends, or more painstakingly for publication, he used them to immense effect. Who but he, for instance, would have thought of describing the statements contained in a Victorian book on natural history as 'the lore of this discreet compendium', or have quoted with such obvious relish a passage he had come upon in an old guide book to the region of the Avon Gorge, which spoke of 'a natural tendency of the wealthier citizens to locate their homes in the bracing air of the higher lands'?[1] One can feel his mind revelling in the complacent pomposity of the sentence. He took words and phrases, threw them up into the air like coloured balls, and juggled with them to produce new patterns upon which his poetic imagination could work.

It was, therefore, the quality of the poetic prose and the 'curiousness' of the ideas and facts which it enshrined, which attracted Nash to the work of Sir Thomas Browne, and the force of the impression which it made on him is shown by the number of his paintings and drawings based on the symbolism he devised from the two books. Some of the symbols are, of course, Browne's own. Others expressed Nash's interpretation of Browne's phrases, and, even if they do not always accurately represent the author's words, they are invariably valid poetic equivalents for them. An interesting example of this purely interpretative manner is found, for instance, in the strange convolvulus figure, half man, half tree representing 'The Mandrake', which he employed in the illustration for 'The Quincunx Naturally Considered', and re-used as the theme both of a watercolour and an oil.

I think that it may be safely asserted that the task

of illustrating Browne's two books gave him a new and deeper insight into the possibility of expressing his experience in symbols, and that for this reason the year 1932 may be regarded as one of the most formatively important in his whole career. He had found the poetic vocabulary for which he had sought and he could with confidence use it to translate the discoveries of his liberated imagination. It is perhaps because of this that the significance of the Found Object assumed a place of outstanding importance in his art. Before he had only 'felt' it. Now he began to 'understand' it. A curious example of this dual apprehension is provided by a superficially uncompromising watercolour study of rough-hewn timber balks standing, vertically stacked, against a wall of the disused Rye shipyard. He called the piece *Totems* and the title has a wealth of meaning. The wooden posts are in themselves insignificant, and yet from such stuff man, through the long ages of his history, has fashioned to himself his idols and his beliefs.

The Rye interlude, though crucially important to Nash's artistic development, was of brief duration. He and his wife had moved into New House in December 1931. In the summer of 1932 Margaret's father died there, and at the beginning of 1933 Nash contracted influenza, which was followed by a serious attack of bronchial asthma. A grave view was taken of his condition and he was sent to a clinic at Tunbridge Wells and advised that the climate of Rye did not suit him, though for a month or two after his return there he seemed better. Fortunately Margaret had inherited a little capital from her father, and she and her husband found themselves 'for the first time in many years with a small private income'. 'It looked', she wrote, 'as if we were to have some rest, after the long strain of two years and a half at the New House, during which my father's health had rapidly deteriorated and our finances had been strained to the utmost by the extra burden of a large house. . . . We were able, after the many troublesome legal affairs had been completed, to look forward to a period of rest and travel'. But gradually, after numerous medical consultations, it was borne in upon them both that their lives were not after all to be as carefree as they had hoped, and that the malady to which Paul had fallen victim might deprive them of the freedom and security for which they had longed. After some hesitation they decided to sell New House and in July 1933 they left Rye for good.

[1] In his essay 'Giant Stride', published in the *Architectural Review*, and republished in *Outline*.

VIII

The Swanage Period 1933–1936

THE CREATIVE LIFE OF THE PAINTER, the poet, the writer and the musician is beset with difficulties and however much each in his own fashion may wish to remain

> *hidden*
> *In the light of thought,*
> *Singing songs unbidden*
> *Till the world is wrought*
> *To sympathy with hopes and fears it heeded not,*

the day to day problems of ordinary men fall to their lot. The grocery bill cannot be discharged with a couple of stanzas; and the collector of taxes will not even be amused by the offer of a large and splendid landscape or an impressive sheaf of glowing reviews. Public indifference to creative work has, moreover, consequences of another and still more serious sort. The artist has an instinctive need to communicate his ideas, and to be met by blank incomprehension and even ridicule not only affects him financially but also frustrates him and tends to dry up the wells of his inspiration.

These bitter truths had never escaped Paul Nash. His temperament was social and he expanded in an atmosphere of sympathetic understanding, which was congenial to his work. Nor was he indifferent to the material side of life. He had been brought up in the solid, unostentatious comfort enjoyed by the English professional classes at the turn of the century and his chosen way of life was not in the least bohemian. He liked good food and good wine in moderation, his clothes were invariably well tailored and his surroundings elegant. At times, as in the trenches and in the discomforts of the shed at Chalfont, where he had painted *The Menin Road*, he had to rough it and had done so without much complaint. But while he had no desire for the affluence he might have acquired as a 'fashionable' painter and was never at any time prepared to compromise his own rigid aesthetic ideals in deference to the whim of wealthy patrons, he regarded the good artist as worthy both of his hire and of an understanding appreciation. He had, therefore, always been concerned with the practical problem, which faces all artists, the problem of communicating with their potential public and patrons, for work must be understood before it is bought. Group exhibitions, in which a united front could be displayed, seemed to him to offer one of the most sensible solutions, largely because (in theory at least) they could command a wider public than the one-man show and generally tended to be less commercial in tone and, on that account, less likely to discourage a new public. He himself had been fortunate in attracting the loyalty of a small number of private patrons, who became his friends and made a practice of buying at his shows or directly from the studio. Nevertheless, useful as his friends were to him, he, like every other artist, felt the need of a wider circle capable of providing informed support, both moral and financial.

When, in 1928, he had by deliberate choice abandoned a career of conventional painting in order to pursue a more experimental course, he had realised that the mixed exhibitions to which he had hitherto contributed were less appropriate to his needs than they had been. The Royal Academy of the day, was, of course, out of the question, though, according to Margaret Nash, he was sounded on the possibility of standing for election and had declined.[1] His reputation was, however, already great enough to make the need for a regular outlet less pressing for him than it was for many of his contemporaries in the experimental field. He had, in fact, no difficulty in arranging for one-man shows at intervals of about two years in those galleries interested in 'advanced' work, the number of which was far smaller than it is today. But he was never indifferent to other opportunities, nor did he ever lose his strong fellow-feeling for friends who had been less fortunate than he in securing public recognition for ideals expressed in art forms which appeared at that time, in England at least, to be revolutionary.

The idea of forming a new group suggested itself as

[1] The date of this approach is uncertain.

the best means of solving a common problem. It must be formed from a nucleus of experimental artists, but it must not impose upon them any rigid set of principles, such as had been propounded in the *Vorticist Manifesto* and had sealed the doom of that group from the outset. Accordingly, having secured the agreement of those amongst his friends whom he regarded as most likely to be in harmony in such an enterprise, he announced the formation of Unit One in the columns of *The Times* on June 12th 1933, a few weeks before his departure from Rye and while he was still suffering severely from the after-effects of the first disastrous onset of asthma.

Beside Paul Nash himself, the artists who formed this group were the painters, John Armstrong, John Bigge, Edward Burra, Tristram Hillier, Ben Nicholson and Edward Wadsworth; the sculptors, Barbara Hepworth and Henry Moore; and the architects, Wells Coates and Colin Lucas. Herbert Read was their spokesman and the editor of *Unit One*, a volume published by Cassells and intended as an annual, which contained essays by the members of the group. They held their first (and, as things turned out, their only) exhibition in the Mayor Gallery. For that show Douglas Cooper (quite inexplicably, considering his later views on English art) acted as secretary. Read's introduction to the book set forth their aims and made it clear that they were not attempting to work to some agreed programme, but were loosely united in a common purpose.

'Unit One', he wrote, 'is the name given to a newly formed group of English painters, sculptors and architects, all of whom are well known as leaders of the modern movement in art and architecture in England. These artists have not agreed that there is only one method of painting, sculpting or building, nor even that their art should express a common sentiment or even a conscious direction. In fact, in the words of Mr Paul Nash, the instigator of the group, the common bond is that each one "stands for the expression of a truly contemporary spirit, for that thing which is recognised as peculiarly of today". The bond then is spiritual, not technical. What therefore, is the object of the group and whence its name?

> 'The artists composing the "Unit" have found "by conception or the idiom of their expression or often because of both qualities they have become separated from the main trend of contemporary English art" and this, as a study of their past work will show, is the result of a logical spiritual development.

'But however diverse in their ways and means, the majority of these artists are somehow allied in purpose. This was the first argument in forming a group; others naturally followed. It was felt that by uniting individual artists, all of whom were working under certain difficulties, many rather discouraged and some actually persecuted in petty ways, that they would be putting new life and impetus into a force they all believed in— the true contemporary expression—as it existed in England. The title then combines the idea of unity— Unit—with that of individuality—One.'[1]

Looking back, after a lapse of over thirty years, Herbert Read wrote in 1965, 'there was an unusual degree of mutual sympathy and understanding between us, an unusual intensity of effort and feeling, and the formation of a "front" *vis-a-vis* the indifferent public. The English have never been very good at organising groups or promoting movements . . . the aims of the group were quite frankly strategical; its members were united against the common enemy, an indifferent public, and had little stylistic unity in their work; nevertheless there was one principle which was put forward as an aim. It was felt, by Paul Nash in particular, that the weakness of English art in the past had been its lack of structural purpose. . . . The new Unit would see to this—would insist on design as a structural pursuit. Each member of the group was to be free to interpret this aim in his own way, but what emerged was a synthesis of art and nature—what we were to call organic form'.[2]

Although in retrospect it seemed to Read that an 'unusual degree of sympathy and understanding' united these highly individual artists, the harmony between them did not survive the test of closer association. The English inability to join in what a Dutch sculptor once called 'collective manifestations' became apparent and disputes arose. A secret ballot was called for, from which only Paul Nash and Henry Moore emerged scatheless, for they were so generous, kind and popular that it never occurred to anyone to blackball them. By the end of 1934, little more than a year after its formation, *Unit One* was in ruins, and, despite his attempts, Nash could not rebuild it. Had he not been in poor health, a prey to recurrent attacks of asthma, he might conceivably have been able to hold the group together by the sheer force of his personality and his

[1] Paul Nash in *Unit One*, ed. & introduced by Herbert Read, containing contributions by members of the group. Cassell, 1934.
[2] Introduction to the catalogue of the exhibition 'Art in Britain 1930–1940 centred around Axis, Circle, Unit One', held at the Marlborough Gallery.

good-tempered raillery. But he was too preoccupied by his battle against illness and by the need to carry on his own work to have either the time or the energy to spare for careful diplomacy, which was, in any case, rendered more difficult by his move from Rye and the wanderings of the next few months, when the lack of a settled home and the temporary cessation of visits to London removed him from constant personal contacts with the other members of the unit.

Unluckily the July of 1933 was exceptionally hot and Paul wilted under its assault. He proved quite unable, for the first time in his life, to address his orderly mind to the task of sorting out his studio prior to the move. He was obviously so ill that Margaret decided that she must be left to organise the packing alone, while he was sent to rest in a more peaceful setting. When faced with a crisis of this kind she was invariably resourceful and determined, and though not physically strong and often ill herself, her indomitable will rarely failed her when there was need for action. Her early training as an organiser in the fields of women's suffrage and social welfare had, moreover, given her an eminently practical approach to difficulties. For it must not be forgotten that in the early years of her engagement and marriage she had continued her work among prostitutes and had organised a hand-weaving industry, as well as arranging suitable war-work for many of the women she helped, and had occasionally acted as a probation officer while her husband was in the army. The stories of her adventures in those days, when, disguised as a lady of easy virtue, she had actually entered notorious brothels in search of girls unwillingly recruited to them, or had been approached by 'proprietors' with offers of large sums to escort groups of young women to white slavery in South America, lost nothing in the telling. Her mixed inheritance of Irish and Arab blood gave her a particular zest for life, but equally condemned her to moments of depression and lassitude, from which she could only be roused by Paul's need of her, or, after his death, by her passionate desire to perpetuate his memory. Towards him her protective instincts were always at their strongest, and now, in the midst of the household chaos, they strengthened her resolve that he must be spared fatigue. Not only must he go away, but he must go under escort, for she had no illusions about his ability to look after himself. Luckily Ruth Clark was free to accompany him on what was to prove one of his most exciting imaginative adventures, the 'Adventure of the Megaliths'.

The small, and in those days the peacefully sleepy, market town of Marlborough, on the range of downs to the north of the Salisbury Plain, was the place chosen for their stay. The air of its uplands was bracing but not harsh, and, more important still, the whole land for miles around was steeped in the strange atmosphere of prehistory and lay on the confines of Savernake Forest, which he wished to revisit.

In his early years as a landscape painter Paul Nash had felt the spell of such an atmosphere, and the feeling of its mystery had marked the drawings of Wittenham Clumps and was seen in his study of the lynchet terraces cut by prehistoric ploughs on the flanks of *Their Hill*. The charm of this mystery lay in its vagueness and remoteness. 'They' had buried their dead in the mounds on Sinodun, and 'they' had tilled the hill slopes. He had not attempted to discover who 'they' were. It was enough for him 'they' had left their mark upon the personality of 'the Place'. So, in the early landscapes, 'they' had become an indissoluble part of the unseen presence, anonymous and timeless, but *there*. But for a long time he had lost sight of these ancient dwellers in the land, since the signs of their former habitation were less visible in those parts of Kent and Sussex where he had been working, and the great Roman fortress and port of Lympne, whose mighty ruined walls cascade down the steep hill to meet the edge of the Marsh had, seemingly, held no magic for him.

Now, in the high summer of 1933, the site of the vast triple circle of immense megaliths, covering an area of more than twenty-eight acres within the encircling rampart and fosse of Avebury, struck him with full force. It is indeed a magic place, and no one who has ever come upon it, bathed in the sunshine of a summer day, can ever forget the impact of that sight. The medieval village, built partly within and partly outside the bounding rampart, strangely contributes to the mystery of the scene, while the great standing stones of the Kennet avenue, linking the vast megalithic complex with the small Sanctuary at Overton, seem to lead the eye onwards to adventures of past ages. The vast scale of the stone circles, within the lofty rampart, bears eloquent witness to the reverence accorded to the sacred site by its Neolithic and Bronze Age builders, and much of the sense of awe with which they regarded the place still lingers there.

Myth and legend cling to such megalithic monuments, and Alexander Keiller, who lived in the manor house within the circle and had already begun his long

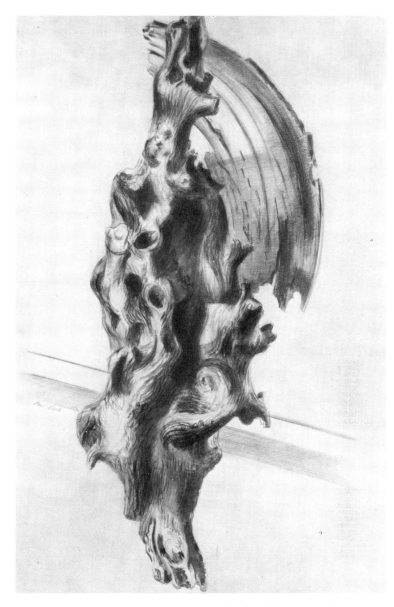

WOOD FETISH. *Pencil and wash, 27 × 14½ ins., 1934.*
A Found Object interpreted.
Coll. Sir Michael Culme-Seymour Bt.

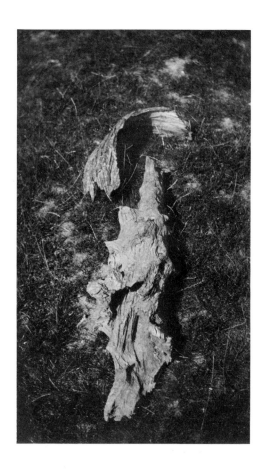

MARSH PERSONAGE.
Photograph by Paul Nash, of the Object in situ at Dymchurch

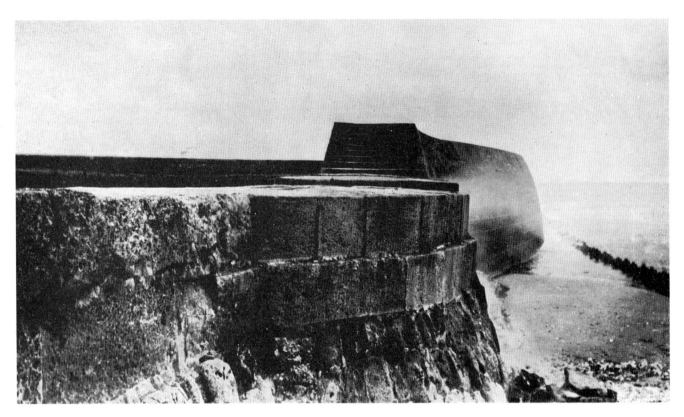

BREAKWATER. *Photograph by Paul Nash at Swanage*

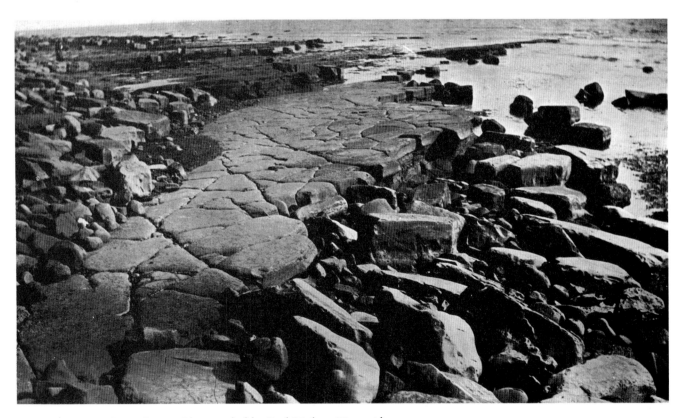

THE FLATS, *Sea Coast, Dorset. Photographed by Paul Nash at Kimmeridge*

task of scientific excavation and reconstruction, repeated to Nash much of the local lore as it had survived in the countryside and as it had been recorded by William Stukely and other seventeenth and eighteenth century antiquarians. For Nash the scientific side of Keiller's work held no interest. He had no sympathy with it, and it merely served in his eyes to ruin the indwelling spirit of the ancient places. Indeed, when he revisited Avebury at a later date, at a time when Keiller's work was more advanced and many of the fallen stones had been re-erected, he was horrified. But the wealth of legend was quite another matter, and his imagination revelled in it. It was a logical continuation of the 'quaint and curious' learning of Sir Thomas Browne, and was deeply rooted in the symbolic tradition which had become Nash's personal idiom.

In connection with Nash's own use of the standing stone in his work much has been written by Wingfield Digby and Bertram. The former, in particular, has given a brief but illuminating account of the mythology of stones, and has considered their symbolic and psychological meaning in relation to different cultures. The cult of stones is, as Wingfield Digby points out 'widespread over the world, and whilst it goes back to remote antiquity, it is still practised today in the Near East.' It is to be found in the Bible, in the worship of Astarte, in the Minoan and Greek traditions, and everywhere it is connected with legends, with religious observances or with magic cults, and sometimes with all three. Some authorities, including Keiller himself, have traced in the actual shapes of standing stones forms which they have identified as 'male' or 'female', and the significance of the monolith is as strongly asserted by some scholars as it is hotly denied by others. Despite all the study that has been devoted to the ubiquitous phenomenon of monoliths, stone avenues and stone circles, and despite all the theories that have been evolved to explain them, we are still in the dark as to their significance for the people who erected them at the expenditure of immense labour. That they are religious or magic in intent cannot be seriously doubted. Not only did they certainly have such a meaning for their builders, but they have in a curious way retained much of the atmosphere of their cult for anyone sensitive enough to perceive it. The ground whereon they stand remains strangely hallowed ground, and the fear and hatred with which they were regarded by the peasantry in this country from the Middle Ages up to at least as late as the end of the eighteenth century, bears eloquent testimony to the

power of that hallowing. Whatever the symbolic significance of the stones, there can be no question but that it corresponds to some deep seated sense of awe in the primitive consciousness, and that this sense of awe has persisted through the ages, though often transmuted into ignorant superstition. Perhaps we should be right in seeing the meaning as that of an unchanging strength, enduring when the softer forms of animate nature perish, and if this be so, then the symbolism is closely linked with that of 'the eternal hills', since earlier generations, untrained in the science of geology, had no means of knowing that even the shape of hills and the form of stones are alike transmuted by the forces of nature in the long course of the millenia.

What, then, was the meaning of the megaliths for Paul Nash? It is interesting in this context to quote from a description given by Ruth Clark to Anthony Bertram, which provides a vivid account of the first encounter with Avebury. 'Suddenly we saw on the left the great Stones standing up in the field. Paul was excited and fascinated. We spent long hours on the great grass banks entranced by the sight of the stones below in the large green enclosure—great "personalities" erect, or lying prone or built into the structure of houses by indifferent generations of dwellers in Avebury. His response was to the drama of the Stones themselves in this quiet setting; his sensitiveness to magic and the sinister beauty of monsters was stirred, and he long contemplated the great mass of their forms, their aloofness, their majesty, the shadows they cast on the grass, the loveliness of their harsh surfaces and the tenderness of their colouring. He seemed to have found renewed vitality in this countryside and in these ancient symbols. At this point of time—at this point of change in his life—they gave to an English painter virtue and inspiration'.

In studying the meaning of this revealing passage it must be borne in mind that Ruth Clark knew Paul Nash well—better, perhaps, than anyone else save his wife—and that she had known him and had followed the development of his mind for over twenty years before they encountered the Megaliths together. Being herself endowed with great sensitivity and unusual powers of empathy, she is peculiarly fitted to assess and interpret the quality of Nash's reaction to any given experience. It therefore seems to me that the stress which she lays upon two aspects of the first megalithic experience must be taken into account in attempting to understand the nature of his reaction to the standing stones. In the first place, she emphasises the *drama* of

their personalities when contrasted with the green stillness of their setting. They were 'monsters', of the kind he was to find and interpret in his later work, and the quality of their personality lay in their aloofness; in other words, in a certain paradox created by their presence in an otherwise quiet and typically rural English scene.

In the second place, however, she speaks of the 'loveliness of their harsh surfaces and the tenderness of their colouring' and mentions the shadows which they cast. This is a formal, or pictorial judgment, in contrast with the psychological and interpretative reaction described in the earlier part of the passage. It corresponds moreover, to Nash's own account of his reaction to the stones, in which, after speaking of the animistic feeling which he detected in *objets trouvés*, he said 'the beauty and mystery of the Megaliths was something peculiar in a different sense. I think mainly a formal sense'. These quotations, taken together, suggest that the immense fascination of the standing stones lay for him at least as much in their formal relationship as in their symbolic significance, and that, though he was instinctively aware of that significance, their drama resided to an even greater extent in their physical relationship to the landscape. In suggesting this I am not denying that his instinctive reaction to them may not have been partly derived, as Wingfield Digby would maintain, from the storehouse of the collective unconscious, and that it may be possible to 'interpret' their symbolism in his paintings in the light of Jung's theories regarding the archetypal image or symbol.

Nevertheless, I believe that it is easy to carry such an interpretation too far. It is, of course, possible to assume that the images and symbols of an art such as that of Nash ought to be assessed by two different standards, and that the meaning of a painting or a sculpture may be different for the artist who produces and for the psychologist who analyses it. But who is to say which of them is right? Is it not possible to be so steeped in learned theories that one ignores a simpler truth? Nash himself certainly thought so. When showing Ruth Clark *Nocturnal Landscape* (*Plate 77*), a strange and rather harsh imaginary landscape based on the theme of stones (not those of the Avebury circle, though bearing a close relation to the megalithic series), he stepped back from the canvas with his head on one side, as was his wont, and exclaimed, 'Come here, Ruth! Jam for the psycho boys, don't you think?' The fact that the 'psycho boys' he had in mind were the then fashionable Freudians, with their excessive

emphasis on phallic symbols, does not make the quotation less apt in the present context.

The task which Nash in fact set himself when he began to give pictorial expression to the experience of the megaliths was, yet once again, to find an equation between the varying elements of the scene as he felt or as he saw it. The portrayal of the underlying unity was now his aim, and he sought to give this visible shape in a formal synthesis. 'Last summer,' he wrote in his contribution to the *Unit One* volume, 'I walked in a field near Avebury where two rough monoliths stand up, sixteen feet high, miraculously patterned with black and orange lichen, remnants of the avenue of stones which led to the Great Circle. A mile away, a green pyramid casts a gigantic shadow. In the hedge at hand, the white trumpet of a convolvulus turns from its spiral stem, following the sun. In my art I would solve such an equation'.

The embodiment of this 'equation' is to be found in the watercolour, the *Landscape of the Megaliths* (*Plate 74*), of which his words are an almost literal description, although the finished drawing, like the school print lithograph based on it, is usually, though perhaps wrongly, dated to 1937, three years after the publication of the essay. The difference between the writing and painting lies in the introduction of more stones in the avenue, and a second, more blunted conical hill to the left, which echoes the form of his 'pyramid', that is to say, the strange truncated cone of Silbury Hill, a mile away from Avebury in the Kennet valley. One 'mythical' element has been added to the scene, as if to solve the equation. A snake, entwined round the convolvulus stem, raises its head above the plant and seems to be haloed by the low disc of the moon. In this snake we undoubtedly have the quite deliberate introduction of mythology. Snakes are not in fact uncommon on the Marlborough downs, and Nash and his companion, walking through the fields, may well have come upon them. But the snake is not mentioned in the original terms of the equation and I believe it to be an 'intellectual comment' on the apprehended drama, rather than an integral part of it. Snakes had figured in his *Urne Buriall* symbolism, but they were not a normal element in his imagery before that time. He himself records his childish horror of the adders and grass snakes met during country walks on holiday in Hampshire, when they robbed his expeditions of their pleasure, and left him, apparently, with a sense of lurking evil in the harmless countryside. It may therefore be questionable whether for Nash the serpent form

held any of its ancient meaning of the 'earth-demon', who according to H. G. Baynes, expressed the 'sleeping potential or primordial energy of life'. The Christian view of the snake as a sinister embodiment of Satan is far more likely to have presented itself to his conscious mind, and since I am suggesting that in *Landscape of the Megaliths* he introduced the serpent symbol as a conscious comment, and was not drawing upon the resources of the collective unconscious, I believe that we must accept the image at its probable face value, and take it as representing the forces of evil present in a peaceful scene. There is, however, one other possible explanation of its presence in this work. It is not improbable that Nash had either been told by Keiller, or had read in some 'discreet compendium' of seventeenth century learning the theory recorded by the great Wiltshire antiquarian, William Stukely, that the Sanctuary at Overton, the circles of Avebury and the mound of Silbury Hill formed a single 'snake complex', representing a serpent, its head at Overton, its tail at Silbury, and its body, in the form of the stone avenue, passing through the pivotal point of Avebury itself. If Nash knew of this legend, then it may be that the snake in the drawing ought to be seen as a reference to it. 'Curious lore' of this sort had a great appeal for Nash, whose mind was in many ways strangely attuned to the seventeenth and eighteenth centuries, when it was not yet thought necessary to provide a 'scientific' explanation for every natural or man-made wonder, and when folk lore and magic had not yet been subjected to the cold examination of the social anthropologist.[1]

For Paul Nash, on the conscious plane at least, the stones possessed a dual force, for, though they roused in him a sense of wonder and of awe, by reason of their mystery and their antiquity, it was, in the final analysis, their plastic value as dramatic elements in the landscape which most appealed to him. That this was so is perhaps best demonstrated by the use he made of them in his variations on the monolithic theme.

Apart from the actual studies made at Avebury he did not get down to work on the subject for some months. He and his wife did not immediately seek a settled home, but visited friends and spent some time in the Judd Street flat, before leaving England in November 1933. Their intention was to pass the winter in Spain, but caught by the hardest winter France had

experienced for many years, they broke their journey from Paris at Avignon, where they were forced to remain much longer than they meant to, in order that Paul might recover from a renewed and very severe attack of bronchial asthma. After a few weeks they went on to Nice, so that he might be in the care of an English doctor, and there he at last began work on his megalith canvases, although he was still in poor shape, and wrote bitterly to Ruth Clark, 'I suppose the English winter would have knocked me out but I often sit and wonder why the hell I'm here—a tiresome invalid, profitable to no one but the bloody French— of all the laughable fiascos. . . . Nobody comes to this mounteback paradise now only *very* rich invalids can afford to be so expensively bored'.

One visitor (apart from Matthew Smith, the painter, who lived nearby and drove them somewhat perilously to revisit their old Riviera haunts) did call on the Nashes and the story of her visit is amusingly recounted by Margaret. 'A certain American lady, hearing that a famous British artist was living in Nice, came over to see him from Monte Carlo, and was shown to her utter astonishment not the nostalgic Riviera landscapes she had hoped to buy, but very austere studies of the megalith period. I could see that she was completely baffled by Paul's art, and eventually she came out with a naïve question—"Well, Mr Nash, I am deeply obliged to you for your courtesy in shewing me your paintings, but why do you paint?" Paul, for the only time in his life that I can remember, was so taken aback by this direct question that he lamely answered, "I am afraid I cannot explain why I paint". There the question and answer ceased, and the poor lady went away somewhat like one of Edward Lear's delightful birds, with this great problem unsolved.'

Austere and indeed harsh some of the megalith paintings undoubtedly are, and in particular is this true of the oil, *Landscape of the Megaliths (Plate 72)*, which, according to the chronology given in Margaret Nash's lists, was the first of the series, which ended with the *Circle of the Monoliths* in 1938. They were very different in character from the watercolour *Landscape of the Megaliths*, which I have discussed above, and to which Margaret herself variously assigned the dates of 1934 and 1937—the latter being the year in which the lithograph produced for School Prints was executed. The oil suggests that once again Nash was attempting to come to terms with a new theme and was having, in the process, to devise a new technique for its

[1] Since writing this passage, I have learned that Nash owned a copy of William Stukely's *Antiquities of Wiltshire*, but whether it was in his possession in 1934 or was acquired later is uncertain.

expression. Both paintings are so largely abstracted as to bear little naturalistic reference to the place which inspired them, and both suggest a certain failure on the part of the artist to effect a convincing synthesis between his intellectual approach to his subject and his emotional response to it. They lack spontaneity, and therefore leave the impression that Nash felt that there existed something very important that he ought to be saying about the scene, but that he couldn't for the life of him discover the right vocabulary in which to say it. As in some of the abstracted studies of the Iden period, he was struggling with an unfamiliar language, and in two other paintings of the same group, *Equivalent for the Megaliths* (*Plate 73*) and *Objects in Relation*, he admits defeat, for here totally abstract geometric forms take the place of the semi-abstracted stones, and are set against a more naturalistic, though formalised, landscape, as if to say, 'Solve the riddle for yourselves —it's beyond me.'

The riddle, according to Wingfield Digby, can be read by reference to an extremely complex system of interpretation, based on the mythical symbolism of stones, and he suggests that in *Circle of the Monoliths*, for example, 'the four monoliths must in this case be taken to stand for the four psychological functions (sensation, intuition, feeling, thinking) which represent the developed structure of the conscious, differentiated and civilised mind. This is entirely in accord with the basic meaning of the megalith or pillar, regarded from a subjective point of view. . . . The colours of the stones, particularly their contrasted blues and reds, emphasise the opposed principles of judgment and perception on which those functions are based'. In making this assertion, he is not, of course, maintaining that Nash himself was necessarily, or even probably aware of such a significance, but rather that he was expressing his instinctive response to particular stimuli in forms instinctively based upon the primeval resources of the collective unconscious. Interesting though such an interpretation may be, it fails to convince me, when applied to the megalith group, because I believe that the paintings under discussion were intellectually rather than instinctively conceived, and that, precisely because of this, they failed to convey the painter's intended meaning.

A far more convincing painting, because it impresses the spectator with a feeling of much greater spontaneity and immediacy, is the strange and rather terrifying *Nocturnal Landscape*, a wholly imaginary moonlight scene, in which vastly enlarged flint pebbles

have taken the place of the Wiltshire megaliths, and are supported, as it were, by the presence in the background to the left of the canvas, of the 'egg-crate' form, taken directly from *The Mansions of the Dead*, and to the right by a distant view of the Cornish group of stones, known as the 'Men-an-Tol', which, as Bertram points out, Nash had never seen and must have come upon in some book or postcard. The whole scene, with its harshly contrasted shadows and sharply defined blues, yellows and whites, possesses a nightmare power, and though it was about this work that Nash made his remark that it would be 'jam for the psycho boys', thereby dissociating the stones from their apparently phallic connotation, one cannot deny that the symbolic quality is latent in the picture, whether or not we can 'read it' and whether or not the painter himself understood its meaning.

Although the bedroom on the first floor of the *Hotel des Princes* at Nice served as the 'studio' in which the first paintings of this megalithic group were begun, Paul Nash was always sufficiently interested in his surroundings to be able to respond to them creatively. In two oils, *View R* and *View S*, he amusingly recorded the view from his window, using as the *objets trouvés* to give added meaning to the scene, two of the letters of the hotel's illuminated sign, seen in reverse. When he had sufficiently recovered from his bronchial attacks and from an operation on his nose, he at last was able to continue the, interrupted journey and did in fact succeed in reaching Spain with his wife and together they visited Gibraltar and Ronda and crossed over for a few days to North Africa. The trip gave rise to some of his loveliest watercolour studies of the sea and of rocky coasts. Superficially they appear perfectly straightforward sketches, but in fact they are records of places seen with a heightened perception that renders them memorable and universal statements, extending far beyond the narrow compass of the small sheets of drawing paper on which they are painted.

By March the expenses of the holiday and of the medical treatment Nash had undergone had taken a heavy toll of their resources, and he and his wife returned to the Judd Street flat. 'It looked as if our trip abroad had done him very little good', wrote Margaret Nash. 'A sense of despair began to overcome him, as he felt that at any moment the attacks to which he was becoming subject might prevent him from working'. At this juncture, however, Nash was given the name of a special German inhalant, with which he could ward off to some extent 'the crippling and prolonged

attacks' which had become a regular feature of his life, and by means of this alleviating vapour he was able to carry on his work until the end.

On their return, apart from the tiny London flat, the Nashes were temporarily homeless. They visited various friends and went to stay for a few weeks in a cottage on the edge of Romney Marsh. Its climate proved inimical to Paul's asthmatic condition, but the visit nevertheless provided him with a new and important source of inspiration, in the form of the most famous of his 'Found Objects', to which he gave the name *Marsh Personage*—a strange decayed fragment of tree trunk, near to which, on the edge of the marsh, lay an equally strange curved section of bark. These he united, and they were mounted to form the *Personage*, which was exhibited in the Surrealist Exhibition two years later and which, for the rest of his life, was the dominating feature and presiding genius of his studio. This discovery turned his mind once more in the direction of surrealism, and was to provide him with the key to the doorway of the new adventure which began when the Nashes went to stay at Swanage, in a house lent to them by their old friend, Hilda Felce.

In Swanage they remained for the next two years, first in Mrs Felce's house on the slope of Ballard Down, overlooking the bay, and then, when she returned from the Riviera in February, in rooms they took at No. 2 the Parade, on the front. In spite of the now severe chronic asthma from which he suffered, the sojourn there was one of his most productive periods, and the amount of work he accomplished is well-nigh incredible considering the physical disability under which he laboured.

The eastern stretch of the Dorset coast on which the town is situated is remarkable for the variety of its geological formations—chalk, shale, alumina, Kimmeridge clay, limestones and oolites. This wide range of formations has produced a landscape equally varied, and the whole area is rich in fossil remains of a great many geological periods. Inland the downs are rich in the remains of history and prehistory, stretching northwards towards the line of barrows and hill forts of central Dorset and Cranbourne Chase. Here indeed was a country where Nash could feast his eyes on the beauty of landscape and seascape and nourish imagination on ancient lore. It was a region that exactly suited his love of the countryside and his interest in the 'curious', and everywhere he turned he could find 'Places' and encounter 'Object-Personages' in the form of tree stump, stone, seaweed and fossil. He had come,

as it were, into a kingdom he had sought, and for a time he devoted all his energies to its exploration.

His exploration was now strongly marked with Surrealism, though more literal transcripts of the scenes before him were not wanting. *No. 2 The Parade*, for instance, is a simple study of the view from his balcony, but the way in which he has handled the Victorian decorative ironwork of the structure gives to the prospect a feeling of some unexpected encounter. The effect is that of a shock of recognition—'Yes, I have seen that before, and yet I have never really *seen* it at all'. This immensely heightened perception is to be found in almost everything that Nash painted or drew in these two crowded years, and in most of the work he finished soon afterwards, which was based on the Dorset studies. *Stone Forest* (*Plate 78*), a watercolour of the fossil trees on the foreshore near Lulworth, is not just a drawing of a fossil formation; it is a window into the remotest past, before men trod the earth. *Wood Sea*, the drawing of piled drift wood, and *Stone Sea* (*Plate 79*), in which the field walls surge over the downland like engulfing waves, are both fully realised images of the equivalence he always sought. These, like *Sunset at Worth Matravers* (*Plate 83*) and a number of other works based on the Dorset landscape, may not have been actually completed until after he had left Swanage and was preparing for a big show at the Redfern Gallery in 1937, as a sequel to the immensely successful exhibition he had held there in 1933. But for all that, they are essentially works of the Swanage period and bear all the marks of the particular 'release' he found there.

The names of the places within easy reach of Swanage—Ballard Down and Ballard Point, Worth Matravers, Peveril Point, Arishmel Gap, Kimmeridge, Corfe—read like a roll call of the watercolours based on their topography. But it was not only with the immediate environs of Swanage and the Isle of Purbeck that Nash was concerned. His expeditions carried him much farther afield, for he had been commissioned by Jack Beddington, that brilliantly discerning director of Shell's publicity, to undertake the compilation of the *Shell Guide to Dorset*. In this task he received the enthusiastic co-operation of Janey Russell, the wife of a new but close friend, Archibald Russell, then Lancaster Herald and later Clarenceux, King of Arms. It was typical of the warmth and charm of their personalities that Paul and Margaret should, in the space of a few months, have received an offer from Jane Russell to drive them wherever they wished in the county. She

had, as Margaret Nash records, 'already been well trained by Archie in long distance driving, since he was an enthusiastic collector of the rare English moths which are found almost exclusively in certain parts of Dorset, and she was not only a delightful companion but an extremely long-suffering and expert driver. This enabled Paul', she goes on, 'to make wonderful and extensive studies of Dorset, and he collected a large number of photographs with his beloved Kodak No. 2, and also produced an astonishing number of drawings and watercolours'. Twelve of the photographs and four of the watercolours were reproduced in the *Guide*, which appeared in 1936, but the collection of personal *aides-memoires* from which the ultimate choice was made was far larger, and it served Nash as a basis for the more developed studies of the Dorset scene, mostly with surrealist overtones, in the following years.

The problem of uniting two disparate views in a single composition had already fascinated him for some time. His tentative solution for it was first seen in the dual horizon of *Swan Song* and in the double image of *Harbour and Room*, and it is also, quite literally, 'reflected' in the mirror images of other works begun at Toulon. His newly acquired and intimate knowledge of the Dorset seaside and hinterland now encouraged him to pursue his imaginative researches in this direction, often in combination with the studies of enlarged stones or *objets trouvés*, the vastly increased scale of which gave an entirely new meaning to their natural or contrived setting. Thus, for example, *Objects in Relation* are nothing other than two Roman shale cores, discarded in the industrial process of manufacturing spindle-whorls. He painted them against a stylised downland, overlooking the sea, but the immense magnification of the standing and the fallen conical cores relates them to the truncated cone of Silbury Hill, and, going further back in time, to the late 'vision' drawing of *Pyramids in the Sea* and to a curious pencil sketch on the same theme made at Dymchurch about 1923. *Cloud and Two Stones* (Plate 75), completed in 1935, is marked by the dual horizon device, so that the two vastly enlarged standing pebbles, transformed by their scale into megaliths, are set against the varied perspective of two different landscapes. A dual landscape of a different sort, introducing the multiple rampart of Badbury Rings hill-fort in the background, was worked out in the setting for *Landscape of the Megaliths*, and again, at a later date, there is a dual landscape theme in *Circle of the Monoliths*, the last of the major works based on the Avebury experience.

It is dangerous to pontificate about the dating of any of the Dorset paintings. Though Nash himself ascribed *Cloud and Two Stones* to 1935, the same pair of pebbles appear in *The Nest of the Wild Stones* (Plate 75), a watercolour which he showed in 1937, and regarded as 'belonging' to that year. Nests had always caught his fancy from his childhood, when he hunted them, and in this imaginative watercolour the two stones have taken on the guise of larks, the one brooding beside two circular pebbles that represent her eggs, while the taller stone has obviously only just alighted on the brim of the hollow in the downs.

For Paul Nash the quality of Swanage itself was by its very nature surrealist, as he affirmed in an article contributed to the *Architectural Review* in April 1936, under the title 'Swanage, or Seaside Surrealism'. 'But it was not until the middle of the Victorian era', he wrote, 'that Swanage began to develop the slightly fantastic element which today gives it such a strange individuality'. He then briefly traces its development from 'a vigorous fishing village with its own fleet of "Stone" boats continually being loaded and unloaded by sweating quarrymen' into the "family place" of 1890'. He then goes on to say that 'modern Swanage is of such extreme ugliness architecturally, that the inhabitants instinctively look out to sea or across the bay to the noble contour of Ballard Head. To see Swanage in its true horror of Purbeck-Wesleyan-Gothic you must approach it from the sea', and then he continues by imagining a shipwrecked stranger, hurled inshore and battered against the wooden break-waters, who discerns 'through the murk a sequence of faint lamps gleaming on the wet asphalt. At last, a particularly shrewd buffet from a driving wave flings the half-dead visitor clear onto the water-front. The refuge saves him, and, as he sinks forward, his eye falls on the embossed letters round the vase. The fitful light momentarily throws up the silver-painted words, "St. George's, Hanover Square".' His half-drowned visitor then proceeds to make other equally startling and anomalous discoveries, without of course lighting upon the curious explanation that the irrational element in the townscape owes its origin to the benefactions of two local lads who made good, John Mowlem, the founder of the well-known firm of contractors, and George Burt, later a High Sheriff of London—'As they increased in individual importance they began a sort of rivalry to *improve* their native town . . . It was Burt, however, who made Swanage what it is, and, as far as

I can ascertain, was alone responsible for transferring to Swanage the useful and ornamental oddments acquired in the course of his transactions in London. The Wren façade from Mercers' Hall, the clock case from London Bridge—he sold the clock separately—several dozen lamp-posts from different boroughs, and so on . . . '

But, 'quite apart from its superb natural setting, its quarry landscapes and the lovely bay', he found that Swanage possessed 'a strange fascination like all things which combine beauty, ugliness and the power to disquiet'.

'The power to disquiet' is, of course, one of the essential elements in surrealist experience, and it was expressed over and over again by Nash in his work at this period. The disquiet is not always sinister in intent, as it seems to be in *Landscape of Bleached Objects*. It may be benign, but even the benignity disturbs, shaking the beholder from his settled ways into a new mode of apprehension. Take, for instance, the wonderful surge of waters against the jetty in the watercolour of *Sea Wall (Plate 85)*, where the wall is no longer seen as a defence against the sea, as it was in the Dymchurch period, but has itself become an integral part of the rhythmic tidal sweep. And, again, taking the upland path across the sun-drenched grass, with the great bluff of Ballard Head in the background, we come upon *Event on the Downs (Plate 76)*. The picture was one of those chosen by Paul Nash for his retrospective exhibition at the Cheltenham Art Gallery in 1945. In the catalogue he wrote:

'It happens that this exhibition contains a high proportion of what I call "imaginative" pictures, but which might be labelled "surrealist". Because most popular labels are misleading and I prefer to be understood, I am including here a piece of writing on "Surrealism in Landscape", by the critic E. H. Ramsden, which appeared in *Country Life* in 1942.'

He then proceeds to quote the passage in which Ramsden discusses the significance of *Event on the Downs*:

'In the contemplation of a landscape or anything that evokes an emotional response there is always a residue; some quality of feeling that remains unidentified and cannot be directly attributed to the images involved.

'It is upon this over-plus, whereby a certain glory is shed upon the face of the common world, that the value of any profound experience of this kind depends. It is for this reason, also, that the beautiful has been described as belonging to "the order of transcendentals"; for whether it is realised in nature, in poetry, in painting or in any other of the arts, the cumulative effect is the same, though it evades definition and cannot by any process of analysis be resolved. The advance in every case is therefore from the known to the unknown, from the perceived to the imagined, or as Browning puts it in respect of the musician:

> *And I know not if, save in this, such gift be allowed to man*
> *That out of three sounds, he frame, not a fourth sound but a star.'*

'In other words, neither in the contemplation of nature nor in the enjoyment of the arts is the content exhausted by what is "given", since what is "said" is almost invariably less important than what is implied . . . The aim of art is no longer to reproduce or to represent nature, but to render in equivalent terms the "emotional content" of experience. Thus, without the introduction of *motifs* that at first sight may appear to be unrelated to their context, such for instance as the tree stump and the tennis ball in *Event on the Downs*, the scene would not only be incomplete, it would be meaningless; because, in fact, it would cease to express the imaginative "event" which is the sole preoccupation of the painter and that alone by which he is justified. In this case, moreover, the particular "focus" of the tree stump gives to the scene a certain immediacy which provides a sharp contrast to the nostalgic distance of the cliffs, while the juxtaposition of the tennis ball, which, like a miniature world, repeats on its surface the contour of the road, gives to the composition as a whole a balance that is as vital as it is exact. But though the painting is based on natural and clearly defined objects, everything contributes to prove that it is not the painting of a landscape as such that concerns the artist, but the *transcription of a mood*, which is something far subtler and more difficult to accomplish, since it requires at one and the same time a high degree of imagination and an intuitive faculty that is rigorously controlled.'

IX

The Hampstead Period 1936–1939

'EVER SINCE THE DISCOVERY that pictorially, for me at least, the forms of natural objects and the features of the landscape were sufficient without the intrusion of human beings, or even animals, I have pursued a diverse research in land and by sea, interpreting the phenomenon of Nature without ever missing men or women from the scene.

'Gradually, however, the landscape, as a scene, ceased to be absorbing. Some drama of beings, after all, seemed to be necessary. A few attempts to escape into the refuge of abstract design proved me unsuited. But at this point I began to discover the significance of the so-called inanimate object. Henceforth Nature became endowed for me with new life. To contemplate the personal beauty of tree and leaf, bark and shell, and to exalt them to the principals of imaginary happenings, became a new interest. To imagine instead of to interpret. . .'

With these words Paul Nash announced his future and summarised his past in the preface to the catalogue of his exhibition at the Redfern Gallery in 1937. The show held there two years before had only hinted at the new developments, for most of the work included in it had belonged to the phases up to and including the years at Rye. There were, it is true, a few relatively straightforward studies of Nice, but, though he included the recently completed *Sea Wall*, it was only in the pencil drawing of *Wood Fetish* (*facing p. 56*) and in watercolours of *Avebury* and *Monolith* that the new trend can have been fully apparent.

Whether Nash had himself realised the significance of his new trend at the time of the 1935 exhibition may be doubted. It is more probable that he had accepted it as a logical development of what had gone before, without troubling to seek for precise definitions and intellectual explanations. Those came later, and what had been latent in the earlier studies of the megaliths and in the exploration of the Swanage curiosities, overtly declared itself by 1937, when he frankly acknowledged the animistic element in his approach to nature. This, Anthony Bertram writing from a Catholic point of view, is naturally at pains to deny, and in a certain sense he is right when he asserts that Nash '*knew* of course that these things are not persons, but he found the marks of personality in their "character" as experienced by persons or in their shape as modified by persons. He was himself mirrored in the tree he contemplated'. But while it is perfectly true that, ratiocinatively, Nash did know this, and did not expect his new-found 'Object Personages' to walk, talk and think, and while he often amused himself with constructing them from strange assortments of chance-found material, this does not necessarily imply that the feeling of 'animation' and 'personality' which he ascribed to them was due to their association with man. According to Bertram, the power of the Avebury stones lay in the fact that he 'found the long-dead Briton resurrected in the monolith'. This strikes me as nonsense, because it argues an anthropomorphically-centred attitude, which is directly contradicted by the whole tendency of Nash's art. The power of things he painted, whether they were trees or stones, waves or clouds, the work of nature or the artifacts of man, were alike linked by the apprehension of an underlying unity mirrored in all things. Such unity is both immanent and transcendant and is, perhaps, best expressed in the Zen question, 'Has that dog (or that stone, or that man) the Buddha Nature?'—to which the answer is equally both 'yes' and 'no'. On this level apprehension always eludes rational definition, and can therefore only be expressed in terms of the poetic symbol, and to attempt to 'explain' the symbol more often than not involves the loss of its meaning, for Blake was right when he held that,

> 'He who bends to himself a Joy
> Doth the Wingèd Life destroy;
> But he who kisses the Joy as it flies
> Lives in Eternity's sunrise.'

The discovery of 'the significance of the so-called inanimate object' had always been implicit in Nash's work, but the pace of discovery had been accelerated

from the time of his visit to Toulon, when his journey, as we have seen, had turned in a surrealist direction. But before considering his relationship to the official Surrealist movement, mention must be made of his physical journeyings, which involved a move from Swanage to London.

For a time the Nashes had toyed with the thought of building a house on the Dorset coast, but an unusually severe onset of asthma, following a visit to London towards the end of 1935, resulted in Paul being advised to move away from the climate of the Isle of Purbeck and he was counselled to settle in Hampstead, which at that time was regarded as having air peculiarly beneficial to asthmatic conditions. Margaret, with her usual determination to do whatever might be best for her husband's health, at once resolved on a move, and by January 1936 they had established themselves in a Hampstead hotel to begin the task of house-hunting. By good fortune they quickly found the place that suited them, and in the summer they were already settled in No. 3 Eldon Grove, where, for the second time in their lives, they enjoyed the comfort of an elegant house, large enough to provide Paul with studio space, and where, for the third time, he could indulge in the pleasures of garden-making.[1]

It was in this house that he set to work upon the completion of many unfinished canvases and watercolours, which had been laid aside in his frequent moves and which could now be brought out and considered at leisure. To this reconsideration he came with a renewed energy, born, perhaps, of his personal contact with the Surrealists. He had for some time been interested in the theory and practice of the movement, and had written appreciatively of the work of Max Ernst and de Chirico, though it might be thought that in many ways his own art was nearer in spirit to that of René Magritte. Apart from Nash, who was always responsive to new ideas and sympathetic to fresh developments, few English painters had yet grasped the possible significance of Surrealism, and even the revolutionary contribution made by leading figures like Picasso was relatively unknown, save to the frequenters of the most esoteric and 'advanced' West End galleries. A notable lack of enthusiasm for all forms of experiment in art was characteristic of the English in the years before the Second World War, and it pro-

duced a curiously stultifying atmosphere, against which the younger artists found it hard to struggle. And yet, almost by reason of the inherent sense of frustration, those painters and sculptors who had real faith in their own vision and had the technical skill to express that vision in plastic form, succeeded by virtue of their own determination in producing the vital climate of art in this country during the long years of war that followed. It had been against the bitterness of public indifference that Nash had been waging war when he made the abortive attempt to induce the experimental artists to present a united front in *Unit One*, and now, two and a half years later, it was hardly surprising that he was invited to be one of the members of the English Committee, responsible for the organisation of the International Surrealist Exhibition in London in 1936. Herbert Read, whose own enthusiasm for the movement was at that moment unbounded, was a leading spirit in the venture, the other members of the Committee being Hugh Sykes Davies, David Gascoyne, Humphrey Jennings, McKnight Kauffer, Rupert Lee (Paul's old friend, who acted as Chairman), Henry Moore and Roland Penrose, with Diana Brinton Lee as Secretary.

The Surrealist Manifesto had been published in 1924, when André Breton, the principal literary exponent of the movement, had defined its aim as 'pure psychic automatism by which it is intended to express . . . the real process of thought'. In proposing such a goal, the artists and writers who formed the original group had been largely influenced by Sigmund Freud, since, as E. H. Ramsden has said, 'once attention is centred in the subconscious the relevance of the dream image to the whole field of investigation immediately becomes evident; while once the importance of the dream world, that world in which all the accepted distinctions between the actual and the possible, the real and the imagined are effaced, is comprehended, the value of projecting those images which "a too conscious control has censored" likewise becomes apparent. At the same time, any discrimination between oneiric and paranoic values must, in respect of such images, be recognised as comparatively indifferent'.[2] The automatism which, theoretically at least, was regarded as a prerequisite for work which could rightly claim to be surrealist, required that the images presented by the subconscious should be automatically 'laid'—in other words that the painter, sculptor and writer should, as it

[1] Although the house was large enough to provide a separate studio with north light on the top floor, the central heating did not extend to that storey and Nash therefore generally preferred to work in the large double sitting-room, both for warmth and for company, since he was unaccustomed to solitude when painting.

[2] *Introduction to Modern Art*, E. H. Ramsden, O.U.P. Second Edition 1950.

were, uncritically represent whatever irrational juxtaposition of objects or ideas had been seized by him at the moment of apprehension, without permitting himself to exercise a conscious selection of his symbols. 'An apple incuneated in a tumbler, an umbrella inclined in a close-stool' were regarded as typical products of the Surrealist method.

There is always, however, a wide divergence between theory and practice in most fields of human achievement, and in practice, as Ramsden has pointed out, 'it is doubtful whether more than a small proportion of the work produced is actually so achieved', a contention certainly borne out by an examination of the work of the leading surrealist painters, in whose pictures irrational images of the subconscious have manifestly been subjected to a perfectly rational process of selection and arrangement, in order to produce paintings of striking power and real aesthetic value. The true achievement of the group lay in 'this other reality', 'this synthesis or unification of the interior and exterior reality', even though it was by no means uniformly successful in its avowed object of seeking 'the liberation of man from every fetter, social, political, intellectual, moral, artistic and spiritual, by which he has hitherto been bound'.[1]

Herbert Read had, apparently unreservedly, accepted the general dogma of the Surrealists, but his personal interpretation of it was far less violent and much more apolitical than that of its original proponents. Indeed, his main claim was that 'surrealism in general is the romantic principle in art' and though he acknowledged the difficulty of assuming that works of art could be produced as pure automatic expressions, he appears to have upheld the contention of 'the absolute impossibility of producing a work of art by the conscious exercise of talents'.

The liberation of the imagination and the presentation of the dream image were the goals towards which Paul Nash had, quite independently, striven since his deliberate rejection of more academic modes in 1928. Nevertheless, his formal association with the Surrealists only extended to his participation in the London exhibition. His complete honesty and sturdy independence made it impossible for him to align himself completely with any movement, however much he might for a time be drawn to it. He could only express himself in his own language, and could never ape the postures of other men. In the formation of *Unit One* he had asserted his profound belief in the

[1] *Surrealism*, Herbert Read, Faber & Faber.

importance of purely formal values, not to the exclusion of the imaginative function, but as an essential means of expressing it. For him his art, if it were to be worthy of that name, must succeed in effecting a synthesis of the two elements, neither of which he would allow to be exclusive or paramount.

On the other hand, the release of the imagination, which he strove to express in these formal terms, had come increasingly to depend upon the juxtaposition of seemingly paradoxical and irrational images, in order to convey his sense of the underlying unity, and it was in this aspect of his work that he found a considerable kinship with the Surrealists. His contribution to the show consisted of twelve exhibits—four oil paintings, *Harbour and Room*, *Encounter in the Afternoon*, *Mansions of the Dead* and *Landscape of the Megaliths*, five collages (a technique which he employed with elegance and wit, but with conscious deliberation), two 'designed objects' and one 'Found Object Interpreted', which was none other than his beloved *Marsh Personage*. *Moon Aviary* is typical of the 'designed objects', being the framework of egg-crates he had employed as the aerial platforms for *Mansions of the Dead*, with the addition of perching 'birds' in the form of Victorian ivory tatting bobbins, the whole structure being enclosed within a glass dome and meant to be viewed through a blue glass mask.

Bertram is inclined to dismiss the importance of the 'Object as image', except in cases where Nash consciously made use of it as part of a pictorial composition and holds that otherwise 'the objects he constructed or assembled were largely play'. Well, what if they were? The imagination grows on what it feeds on, and it may feed on toys as well as on temples. It is certainly true that Nash was intensely serious about his work; but serious and solemn are not synonyms, and neither gaiety nor merriment were ever far from him. He could take immense pleasure in simple and even silly things, and did not spend his whole life in solemn meditation, 'inly revolving the doom of Thebes'. He was a thoroughly balanced and integrated human being, and for that reason was able without difficulty to combine work and play, laughter and tears, childish fun and adult sophistication, in a manner which is constantly manifested in his work. The capacity to joke in and about one's work, and to sit lightly to the affairs of life is an invaluable endowment, which is however frequently misunderstood, and never more so than when a critic or an art historian is discussing an artist. One of the most general misconceptions about painters

and sculptors is that they spend their time taking themselves very seriously; but, as Max Beerbohm once said, 'only the insane take themselves seriously', and Paul Nash, like Michelangelo before him, was 'only human after all'. He was serious about his work, but he was solemn neither about it nor about himself. His 'toys' must, therefore, be taken for what they were to him—objects that could be played with, because they were fun (usually by reason of a fortuitous resemblance to something else, on which they acted as a commentary)—and yet objects that might assume the power to stimulate and free his imagination for fresh adventures.

The objects of his 'semi-surrealist' period have, moreover, another aspect. Many, or indeed most, of them, were 'curiosities' in the eighteenth-century sense of the word—the sort of things that appealed to the fancy of the educated upper classes and were assembled in cabinets in their libraries and studies; strange pieces of seaweed, and driftwood, interesting shells, unidentified bits and pieces from antiquity, odd engravings and drawings and such like. One must not forget that the collection in Don Soltero's Coffee House in Cheyne Walk claimed to possess 'Pontius Pilates's wife's sister's maid's hat', and that even so 'serious' an architect and collector as Sir John Soane did not hesitate to include amongst his important Egyptian and classical antiquities the skeleton of a cat imprisoned in a drain-pipe. Such curiosities were neither symbolic nor important to their owners. But they had the power to arouse wonder and interest, and I suggest that for Nash his 'objects' both natural and contrived served precisely the same purpose.

If I am right in this conjecture, then it follows that caution must be exercised in attributing symbolic meaning to the *objets trouvés* which figure in so many of Nash's paintings at this period. Thus, in *Environment of Two Objects (Plate 81)*, in which a Victorian china doll's head and a half-burnt wooden knob, both greatly magnified, stand incongruously on the cracked clay of the Kimmeridge beach, I greatly doubt whether Bertram is warranted in saying, 'The pretty, trivial toy that a child lost yesterday, now staring aimlessly at the sea, the relic of a burnt ship meet in tragic irony on the platform of clay, that is bituminous and burns and poisons the air with vapours of sulphurated hydrogen'. This is altogether too far-fetched. The doll's head was a bit of Victoriana, which Paul had acquired in some junk shop because of its chance resemblance to Margaret. The turned knob or finial he had probably picked up on the Kimmeridge beach, washed ashore

on a high tide. Though slightly smaller it was of the same general shape as the china head, and this, combined with the turned ridges, which had the air of a stiff coiffure, also reminded him of his wife. The accidental setting in which he had found the knob suggested a 'suitable' environment for both objects, and by his skilfully formalised rendering of the characteristic geological formation, he completed his comment on the equivalence in a perfectly conscious and witty manner. Incidentally, Bertram has rightly drawn attention to the fact that the painting, which is dateable to 1937, is based on a photograph of the Kimmeridge flats taken by Nash during his stay at Swanage. Such a use of photographic studies became increasingly common with him, since, as a result of his physical condition, he could only rarely make extensive pencil or watercolour studies in the open air, particularly not in bad weather; he was therefore forced to rely upon his photographs and rapid pencil notes taken on the spot, and combined with his powerful visual memory. With most artists such a practice would have resulted in a deadness and artificiality in the finished painting, but in Nash's case this was not so, because his photographs were of such perceptive quality that they were at once independent works of art and living extensions of the painter's eye.

The subjects most frequently to be found in Nash's work in 1936 and 1937 were 'objects', 'encounters' and 'environment', mostly derived from themes of the Swanage period. He did, however, devote some time to the completion or re-working of earlier oils and watercolours, generally with a certain degree of revision which brought them into line with his current preoccupations. For the careful historian, anxious to construct a reasonable chronological sequence, these revisions are disconcerting, since there is rarely any means whereby it is possible to tell how much of any particular painting had been finished earlier, and what parts of it were added to or amended. But Nash, understandably even if inconsiderately, was not working with an eye to his biographers; he was returning to old work with a fresh eye and a vision renewed by recent encounters. He was, moreover, under the financial necessity of getting together a body of work large enough for big exhibitions at the Redfern Gallery in 1937 and the Leicester Galleries in 1938. *Winter Sea*, *Chestnut Waters*, *The Two Serpents*, *The Archer*, and *The Archer Overthrown (Plate 70)* were all completed in this way for the Leicester Galleries' show. Only in the cases of *Chestnut Waters* and *The Archer Overthrown*

have we photographs of the canvases in their earlier states; the former before the recumbent nude in the foreground had been painted out, and the latter before the addition which gave the picture the character of a 'private myth', in which the archer, a constructed object made from an oval piece of board, is menaced by the vague shadow of a figure with flying hair. *The Two Serpents* had been painted at Iden, and was then entitled *The Woodshed*, and it may be reasonably conjectured that the only addition made to it in 1937 consisted of the serpents themselves; but they are so obviously contrived and so little felt that they do nothing to redeem an inferior and rather meaningless composition.

According to Margaret Nash, one painting of this period in particular was hailed by André Breton as a masterpiece, and indeed *Landscape from a Dream (Plate 89)* is generally so regarded, though this is not a judgment in which I personally concur. That it was actually founded upon a dream experience is probably true, and there can be little doubt that Nash strove to 'lay the image' in orthodox surrealist fashion. And yet the final result has a curious air of being contrived rather than perceived, and fails to carry full conviction, so that one is left with the impression that this is a theory about a dream and not the dream itself. The conscious mind has played too active a part, and yet, curiously enough, one of the definitely conscious elements that have been introduced is one of the best. On a stretch of downland, with cliffs falling to the sea on the right, stands the open framework of a five-fold screen, through which the coastline can be seen. From the centre of the painting, extending towards the left, is a large mirror, which reflects a completely different sunset scene, in contrast to the blue sky and white-grey cloud of the main landscape, and into this mirror, gazing at his own reflection, stands a vast hawk, while another small hawk wheels down from the mirrored sunset sky above. The consciously introduced elements in the composition are the three large balls, lightly resting on, or slightly suspended above, the surface of the grass. As a formal device they serve to echo the disc of the westering sun, and they both prolong the sense of depth in the mirrored landscape and introduce into an otherwise still scene a feeling of whirling motion. But they are intellectual and not dream concepts, for they are 'portraits' of something which Nash had not dreamed. He had seen them in a film set in the South American Savannahs, and had been fascinated by watching the way in which the wind, sweeping over the surface of

the land, gathers up the loose dry grass, whirling it into great balls, which then roll before the force of the gusts across the wide plain. The idea of the insubstantial lightness of these balls, liable to disintegrate as quickly as they have been formed, caught his imagination, and made them suitable 'props' in a dream landscape, of which in fact they are not integral parts. As we shall see later, he again introduced them in a very different and more naturalistic landscape in the Forest of Dean, which he visited some two years afterwards.

Finer than any of the oils he produced at this period were some of the watercolours painted at the same time. The finest of these must be adjudged by any standards to be among the glories of the English school.

Of these perhaps the most beautiful of all is *Empty Room (Plate 88)*, a watercolour in which the whole atmosphere of dream experience has been perfectly caught. Here the fused image is employed in a supreme expression of the liberated imagination. The right-hand wall of the room is indicated with architectural precision, the details of the cornice, the door-panelling and the architrave being firmly though lightly pencilled in. The wall is plain, but in or through a patch of peeling plaster the forms of two flying seagulls can be discerned. The floor boards are delineated with equal care, but to the left they vanish, to give place to the surge of waves that beat against the lofty chalk cliffs, which form the left-hand wall, and extend the perspective of the imagined room far beyond the limits of the other wall, to where the stone 'chimneys' of the Great Harry Rocks stand out from the Dorset coastline, palely gleaming in the moonlight. The 'room' has no ceiling, though the plaster cornice is carried over half the space between the wall and the cliffs, to a point where it merges imperceptibly into the strato-cumulus clouds of the moonlit sky.

The work is a final statement of Paul Nash's artistic creed at this period, for it proclaims the release of the spirit from the bonds of its physical environment, while at the same time glorifying the beauty of the natural and man-made elements of the landscape. The artist is seen to be perfectly at one with every element in his composition, and he therefore achieves not only a complete and satisfying fusion of his images, but realises to the full the inner meaning and outward semblance of them. Landscape painter, seascape painter, architectural draftsman and Surrealist are united in a single expressive purpose.

To make a comparison between *Empty Room* and *Harbour and Room* is revealing, for the latter, even in

its watercolour form is relatively enclosed and the free range of vision to the prospect beyond is inhibited both by the dark line of the man-of-war lying across the back of the actual room, and by the low harbour buildings which close the vista. It is as though the painter had managed to escape from his bedroom, only to be inextricably caught in the buildings outside it. In *Empty Room*, on the other hand, the 'too too solid flesh' has melted, and with it the walls of the prison-house, so that the spirit is altogether freed for an unending adventure on perilous seas in fairy lands which are not forlorn, because they are apprehended under the guise of a friendly and familiar coast.

Almost equally satisfying, though in a somewhat different way, are some of the watercolours in the Edward James collection, which, like *Empty Room*, are also developments of earlier ideas. Amongst these may be mentioned the watercolour study for the oil of *Metamorphosis*. Here, under the title of *Forest and Room*, a hat-stand gives the suggestion of the forest tree, beyond which extends the long 'room' perspective derived from the repeating mirror images seen in *Voyages of the Moon*. *The Three Rooms* is another interesting development of the same motif, in which the 'rooms', drawn in three registers, each express a different type of release and equivalence. *Voyages of the Fungus (Plate 87)* is a coastscape in a different and gayer vein. Above the great bluff of Ballard Head float the bright pink clouds of an evening sky, and on the surface of a brilliantly blue and rather choppy sea rides the fantastic flower-like form of the voyaging fungus.

Not all the works produced for the 1938 exhibition are so surrealist in feeling. The house and garden at Eldon Grove had provided Paul with a renewed interest in his personal environment, an interest which had been lacking since the days at Iden and Rye. He had once more thrown himself with enthusiasm into the creation of a garden, of which the most personal feature was a small grotto, adorned in true eighteenth-century style with shells, to which he added from a stock he had gathered at Swanage. The garden and its grotto afforded him subjects for a number of relatively naturalistic watercolours and a couple of oils, though in all of these his object was expressiveness of semi-abstracted form rather than exact portraiture. Thus, in the oil of *Grotto in Snow (Plate 96)*, not completed until 1939, the interest lies in the balance of the colour harmonies. The convention whereby the steely blue of the sky, against which the stylised shape of the church is blocked-in in yellow, is carried down across the line

of the dividing wall to surround the snow-engulfed grotto, is a challenge which we must accept. It is not meant to startle the beholder, nor is it some sort of personal cliché. Its purpose is simply to focus our attention on the grotto, by demonstrating the repetition of tone from the overcast sky in the colours of the snow shadows in the garden.

The two and a half years that Nash spent at Hampstead were crowded with work and saw the beginning of other experiments and other adventures. He had returned to the Royal College of Art as an instructor in the school of design, where he worked for two periods a week until the College was moved out of London in the early months of the war. His reputation as an artist now stood so high that he was invited to contribute a 'one-man' retrospective exhibition of sixteen oils and eleven watercolours to the Venice Biennale in the summer of 1938. He contributed articles to various papers and reviews; he designed a subtle abstract mural in different woods for the exhibition of the Timber Development Association in 1936; and continued his work as an industrial designer in various media, an aspect of his activities which was excellently represented in a small retrospective exhibition of the industrial designs and graphics at the Curwen Press, in 1937.

But the new adventures were connected with two places; one a house called 'Madams', belonging to Mr. and Mrs. Charles Neilsen and set on the edge of the Forest of Dean, near Newent in Gloucestershire, and the other the Avon Gorge at Bristol.

He had been invited to stay at Madams in the summer of 1938, and there began a love affair with a landscape, which was continued by occasional visits until shortly before his death. The landscape itself was varied, and he recorded it in an endless series of photographs, upon which he could base his watercolours and related oils when he returned home. It was at Madams that he first encountered his 'Monsters', the larger successors of the Object Personages that had provided the inspiration of his Swanage period. These particular 'Monsters' were two fallen trees, lying in a field at some distance from the house, and in them he at once detected that 'animation' which contradicted their apparent lifelessness. He found in them material for both watercolours and oils, and they exercised a strange hold over his imagination. He wrote an essay on them for the *Architectural Review*, which was later reprinted as a pamphlet by Counterpoint Publications, and was again reprinted in *Outline*.

Growing trees he had always felt to be endowed

with personality, as his account of his childhood experience in Kensington Gardens clearly shows. The sawn tree stumps in *February* and in *Event on the Downs* had held for him an inner meaning. But he had never before concerned himself with whole-length fallen trees. 'Of course, there are many such stricken trees lying in the fields throughout the country . . .', he wrote. 'Yet, look at them how you will, they are no more than fallen trees, interesting to draw for their personal characteristics, as I found, but, though they lie on the very shores of Swanage, quite innocent of further implication.

'The trees of Monster Field were another story altogether. If they had been no more than trees in their perpendicular life it was as much as you could believe. Horizontally, they had assumed, or acquired, the personality of monsters.

'To begin with, like many objects who suffer change, they were now, as it were, in reverse. In the old life as trees, they were accustomed to stand more or less solidly attached to earth, growing outward and upward, waving their crowns against the sky. In the new life their roots and trunks formed throat and head. The uplifted arms had become great legs and hoofs outstretched in wild, mad career. What were they like, what did they most resemble in life?

'In life? Let me be clear upon that point. We are not studying two fallen trees that look like animals, but two monster objects outside the plane of natural phenomena. What reference they have to life should not be considered in relation to their past—therein they are dead—they now excite our interest on another plane, they have "passed on" as people say. These now inanimate natural objects are alive in quite another world; but, instead of being invisible like so many of that huge community, or only made visible by the complicated machinery of spiritualism, they are so much with us that I was able to photograph them in full sunlight.' And he goes on to liken one of them to the horse in William Blake's interpretation of the 'sightless couriers of the air' and asks, 'Did it then crash to earth, fusing its image with the rigid tree?'[1]

How far his thoughts were tinged with the remembrance of the theories of the transmigration of souls and with the recollection of *Urne Buriall* at the moment of his encounter with the 'Monsters' who can tell? They were certainly in his mind when he wrote the passage quoted above.

Despite his indomitable courage and his determina-

tion to compass the work he felt he must accomplish, he was an ailing man. He was well aware that the condition of his heart and lungs had been so impaired by the repeated attacks of bronchial asthma that it was most unlikely that he would live out man's allotted span. Both he and his wife had accepted the view of some of the doctors who had attended him that his symptoms were similar to those suffered by the victims of poison gas and that, in his case, they were almost certainly due to the same cause, because he had gone on to the field of Paschaendale to paint before the gas had cleared.[2] They knew that an untimely death awaited those who had suffered in this way. But his fortitude and his gaiety did not fail him. He loved life, and savoured it to the full, so that he had need of some way of thought which might reconcile him to his inevitable doom. Had he first found that way in the transmigratory implications of *Monster Field (Plate 90)*? The feeling that the beasts were endowed with the power of rapid motions suggests that this was so, and it links them in a highly significant manner with the denizens of the air, natural and imagined, to the pursuit of which he dedicated the last six years of his life.

Whether this be so or not, he was also drawn to another, more earth-bound monster, a dead and gnarled tree stump overhanging a pond, of which he did two evocative watercolour studies, *Minotaur* and *Monster Pond (Plate 93)*. Another monster image is seen in *Landscape of the Death Watch*, in which a tree stump takes on new life from the fungus growths which, as Anthony Bertram observes, seem to explode upward from it.

Nash's other monster, or creature or personage— what you will—was still larger in size than his sightless courier and, unlike it, was a man-made and not a nature-made object. He called it the *Giant's Stride*, because, though firmly founded on rock at either end, the vast Clifton Suspension Bridge, designed and begun by the famous Victorian engineer, Isambard Kingdom Brunel, spans in a single leap or stride the mighty chasm of the Avon Gorge. He discovered it on a visit to Bristol in the spring of 1939, and recorded it in several watercolours and in an article he contributed to the *Architectural Review* in September of that year.[3]

Before the publication of that article, the Nashes had

[1] Reprinted in *Outline*.

[2] This view concerning the origin of his malady originated from a French doctor, who had cared for many war victims. It was not generally accepted by his medical attendants in England, and has been rejected by Bertram.

[3] Reprinted in *Outline*.

already determined on a removal from London. Despite Neville Chamberlain's repeated concessions to Hitler and his ill-founded prognostication of 'Peace with Honour', the atmosphere of the late spring and summer of 1939 was tense with the foreboding of approaching war. At the same time Paul's health was deteriorating and it was obvious to both Margaret and himself that, if and when war came, he would only be a liability in London. They began to clear the Hampstead house and to store their belongings. In August they went to Oxford to 'prospect', and after a stay at the Randolph Hotel, a brief sojourn in pleasant rooms in Beaumont Street, into which they moved just before the declaration of war, followed by a short stay at 62 Holywell, they found a large flat in the Banbury Road, of which they took possession in July 1940.

X

The Second War 1940–1944

THE STRUGGLES of a war artist without a war (the predicament with which Paul Nash had been faced in 1919, as he says in the notes for the unfinished autobiography) promised to be nothing compared with the struggles of a potential war artist during the cold war in the autumn and winter of 1939. Everyone had expected the immediate devastation of London and other great cities from the air. The museums and galleries were closed; the schools and colleges were moved into the country; the art collectors seemed to have gone to ground like hibernating hedgehogs. Life (and death) would at any moment become both real and earnest, and nobody was concerned with the plight of the painter and the sculptor, whose products seemed at that moment nothing if not redundant. Nash was keenly aware of the economic aspects of the problem for others as well as for himself. Younger and more able-bodied men and women might presently find some place for themselves in the war effort, but there were many who could not hope for useful work, and something must be done about them. He himself was in the fortunate position of having some cash in hand, owing to the success of recent exhibitions, but the expenses of his illness were always heavy, and he knew that others had different, but equal, drains upon their resources.

But as far as he was concerned, an even more important issue was involved. He was from the outset deeply and passionately involved in the moral aspects of the conflict. His love of freedom fired his loathing for everything for which the Nazis and the Fascists stood, and he felt that the artist, who symbolised the liberty of the spirit, must be employed in expressing the true significance of the struggle. The artist in wartime must speak for the nation, even as Picasso had spoken for the ideals of freedom in the Spanish Civil War.

When positive action was needed, Nash was not the man to stand aside and wait for the bureaucratic 'them' to take a muddled initiative, and he now felt that clear and decisive guidance was required. As soon as he was established in the Oxford lodgings, he set about the organisation of the Arts Bureau in Oxford for War Service, gathering round himself as Chairman an impressive executive committee, which included Lord Berners, Lord David Cecil, John Betjeman, John Piper and Albert Rutherston. Their object was to enlist the support and services of everyone who might be of help, from the Vice-Chancellor of Oxford to various army chiefs. The core of a useful and influential advisory service was built up, and by the spring of 1940 official bodies were ready to take the initiative, the most important of these being the War Artists Advisory Committee, which, under the Chairmanship of Sir Kenneth Clark, worked in association with the Ministry of Information.

The function of the artist in a modern war is hardly as wide-ranging as it was in the military operations of the past, if we may believe Michelangelo's jesting account of the artist's role in Renaissance warfare, as it is reported in the *Portuguese Dialogues*. 'What is more profitable in the business and undertaking of war', he asked, 'and what is of more use in the operations of sieges and assaults than painting?', on which basis he proceeded to enumerate every armament and strategy imaginable for which the skill of the painter is indispensable, to say nothing of the designs for shields and helmets, crests and medals, halberds, banners, standards and trappings of all sorts. And, as if to prove his point, he concluded by asking, 'What country is more bellicose and better armed than our Italy . . . where are there more continuous routs and sieges and in what country . . . is painting more esteemed and celebrated?'

This expansive view of the painter in wartime went somewhat beyond the point to which Paul Nash himself was prepared to go in his championship of the cause. But his own experiences in the First World War had made him anxious that the role of the artist should not be forgotten, and the early establishment of the War Artists Advisory Committee, must have been a cause of considerable satisfaction to him. He for his

MARGARET NASH. *Photographed by Paul Nash at Oxford*

THE ARTIST'S HANDS

part was invited to become an official artist to the Royal Air Force, a commission which he took up in March 1940 and held until the end of the year, when, as Anthony Bertram records, he 'began to work for the Ministry of Information on a much freer basis. They had first refusal of all his war work at reduced prices, for which advantage they gave him travelling and maintenance allowances, facilities to visit Air Force and other service establishments and the cost of his materials. What they did not want, he could sell at his own prices'. This arrangement was greatly to Nash's advantage, since the salary he had been accorded by the Air Ministry was at the rate of only £650 a year, which was inadequate for the maintenance of himself and his wife, when to their living expenses was added the heavy cost of the special inhalants he required to keep him going.

Though financial anxiety and constant ill-health, combined with a sickened loathing for the mean unpatriotic profiteering which he saw on every side, rendered the first year of the war wretched to him, so that a mood of bitterness and discouragement began to be reflected in his letters to his most intimate friends, he soon became immersed in his work as a war artist. He was fascinated by the planes which surrounded him at all the airfields he visited, and he enjoyed his contacts with the men who flew them. But the actual physical experience of flight was, despite his pleadings, denied to him on medical grounds, and he felt the lack of it acutely, since in the earlier war he had known the battlefields as a combatant before returning to them as an official artist. Yet what he lacked in actual experience, his amazing gift of empathy and imagination supplied, and, as Bertram rightly contends, in his work 'he was to convey the feeling of flight better than any other artist'. This is not merely a theoretic judgment, but a truth attested by many pilots who were actively engaged in the Battle of Britain. In other words, Nash succeeded in expressing what the men of the Royal Air Force felt about their planes and about the job they did in them.

In a revealing article which Nash contributed to *World Review* on 'Art and War' in May 1943 he pointed out that human beings had played the principal role in battle paintings until the first gas attack, when 'the human element of war pictures began to decline', and finally 'machines pictorially speaking, took the place of men'. Men had, it will be remembered, played some part in his own pictures of the First World War, but even they did so only under their corporate aspect, as equal victims with their environment of an inexorable and mechanical violence, loosed from a sky that had lost its heavenly character and become no more than an upward reflexion of a terrestrial hell. In those drawings from the battlefields of 1917 human individuality had vanished, and even the personality of places and of trees had been so distorted and denied that it was no longer even true, as Siegfried Sassoon had written, that

> *A linnet who had lost her way*
> *Sang on a blackened bough in hell,*

for the only voice rising above the roar of the guns had been the voice of the artist, crying in the wilderness to proclaim the outrage done to the earth.

But now for Nash in 1940 war assumed a different guise. Its total dehumanisation made it in a certain way more tolerable to him, because it was less personal. It was no longer a combat between men, but between monsters, and the monsters with which he was professionally concerned were aerial ones. These monsters were, of course, crewed by men in order to serve man's destructive purposes. But nevertheless in aerial combat, except at the closest quarters, the human element was invisible, and being encased within the fuselage, might reasonably be thought of as nothing more than a part of the machine—the monster's brain and nerves, directing its movements and actions from within.

Margaret Nash, in a passage describing this period of her husband's work, says that Paul Nash's attitude was 'misunderstood by the particular officers of the Air Ministry who had to deal with him as their artist, since they were really interested in the individual pilots and their achievements and quite missed the imaginative approach he made to the warfare in the air'. They were, naturally, senior officers, brought up in an earlier service tradition, and were rightly proud of their men. It is hardly surprising that they should have failed to perceive the larger implications of the machine age, and did not realise, as perhaps only the poet and seer could have realised, that the machine had in fact supplanted man, and that only a long and dire struggle could reverse so baleful a development.

Even if we are prepared, however reluctantly, to admit that war is the natural condition of man, it is certain that man's reaction to that condition must of necessity vary from generation to generation, as war develops new forms of horror. For this reason the art in which succeeding wars are recorded, celebrated or

vilified, will likewise vary in its modes of expression. The validity of art, either in war or peace, always depends upon the sensitivity of its response to the ethos. Uccello's *Rout of San Romano*, so greatly admired by two such different modern painters as Paul Nash and Ben Nicholson, validly expressed, in terms of pleasing irony, the last, dying phase of chivalrous single combat. The great sea-battle pieces of the seventeenth-century Dutch masters were an authentic mode for the celebration of sea-power. The vast canvases in which Rubens and his contemporaries glorified victorious monarchs were logically followed by the immense martial history paintings of the eighteenth and nineteenth centuries. Warfare could still be seen in terms of glamour and of glory, whatever might be the sufferings of the ordinary men and women caught up in its toils. With the general mechanisation of the First World War, the scene changed completely, and the attempts made by artists like Eric Kennington to exalt the individual hero became largely meaningless. Human courage and human endurance remained, but they could no longer be authentically expressed in such personal terms. Only the art of Paul Nash and the best work of the Vorticist painters succeeded in evolving a vocabulary suited to a new and far more horrifying situation.

With the Second World War the scene again changed, and this time the role of aerial combat was largely decisive. It was therefore wholly fitting that Paul Nash should have been called upon to paint for the Royal Air Force, since he, perhaps above all his contemporaries, was peculiarly qualified to understand the implications of the change and to symbolise it for his own and succeeding generations. How far, then, did he succeed in this task of interpretation?

Anthony Bertram, while writing with great appreciation of some of the Second War oils and watercolours, and with certain reservations about others, has curiously made no attempt to answer this question in specific terms. John Rothenstein, on the other hand, has been more critical, and has compared the work of the Second War unfavourably with that of the First, because he believes that 'the overwhelming emotional impact of the First World War had made him an artist, but the second cataclysm meant little more than an interruption of long-established habits, the renunciation of deeply pondered projects', and he goes on to say that Nash's hatred of collective violence and destruction was 'a theme which he had treated with too much finality to stimulate him a second time to comparable

achievement'.[1] This is a plausible contention, but a study of Nash's correspondence with Sir Kenneth Clark and others (some of which is quoted by Bertram, but was not available when Rothenstein made his assessment) disproves it. From the outset Nash had been intensely involved, in an emotional sense, for the Nazi régime in Germany stood for everything that he most distrusted and loathed. In 1914, as can be seen in his letters to Gordon Bottomley, Nash had not regarded the war as 'his' affair, and it was not until he became physically involved in the combat in the trenches in 1917 that he dropped his attitude of annoyed detachment and ceased to regard the whole business as 'an interruption of long-established habits'. At that time he had been emotionally immature and somewhat self-centred, and though he loved his country with a painter's eye and a poet's mind, he was still too self-conscious (perhaps because he had only recently begun to discover himself) to be capable of identifying himself with larger issues. The first five months in Flanders shattered that encapsulated attitude, and he emerged, like Herbert Read's company, 'a body and a soul entire', as, perhaps, the most expressive painter of his period.

In 1939 the situation was different. He knew, or thought he knew, what to expect and he was already filled with the horrifying vision of the 'Rose of Death', as the Republican Spaniards of the Civil War had called the Falangist parachutes that spelled their doom. In the years between the wars he had come to love England with a passion born of familiarity and understanding, and he could not be and was not indifferent to her fate, when everything for which he most cared was under threat of annihilation. While it is true that war inevitably disrupted his settled way of life, and broke in upon the train of imaginative experiments upon which he was engaged, his chief desire was to be of service, and since he could no longer take an active part, he wished to serve his country through the propaganda which he believed his art could convey.

In this particular ambition he was frustrated, for his hatred of Hitler and his gang expressed itself in forms altogether too delicately witty, too esoteric and too ironic to appeal to the mass mind, so that of his propaganda collages (which he intended as posters) none was ever used. In the series *Follow the Führer!*, for instance, in which cut-out prints of a shark masquerading as a balloon, an eel turned into a submarine, and a skull, all converted by subtle pen strokes into likenesses of Hitler, lead the German forces *Into the*

[1] 'Paul Nash as War Artist' in *The Memorial Volume*.

Skies, Under the Sea (*Plate 101*) and *Over the Snows*, the imagery is too subtle, the joke too personal and the treatment too delicate, to carry the message to the millions. Again, *Lebensraum* (*Plate 100*), where the 'living space' that Hitler was for ever demanding, is seen as a desert, with bleached animal skulls surrounded by dead trees, represented by the dried leaves of an aspen applied to the watercolour, is so intellectually sophisticated that it fails to carry conviction, even though its dream image was probably precisely laid. Such propaganda offerings were not, however, part of Nash's commissioned work, and though he was disappointed at their rejection, he was perhaps not greatly surprised. They are mainly interesting as examples of his love of word play, visually rendered.

His official work was connected entirely with the drawing and painting of aeroplanes and their exploits, and it is by these pictures that his success as an artist in the Second World War must be assessed.

John Rothenstein contends that, because, in making records of the Royal Air Force 'he was conspicuously qualified to portray neither of the two principal components of this marvellous organisation, the men or the machines', and because 'no artist ever showed a slighter awareness of his fellow men', Paul Nash failed in his object and that his paintings are 'in any specific sense hardly records of the war at all', and that 'his aircraft of the Second World War might, for the most part, be flying on any occasions'.[1] But is this true? I think not, for I believe that, in making the assertion, Rothenstein has missed the true explanation for what he regards as Nash's detachment from the subjects he was recording. In the first conflict he had actually shared in the experience of the combatants, marching with his men and living in the trenches under shell fire. In the second he was destined to share the passive role of the civilians for whom the planes above their heads, whether bombarding or defending them, appeared wholly impersonal and abstract instruments of destruction. He was therefore looking at his subject in the two periods from two entirely different points of view, but both were equally valid. In the war of 1914 to 1918, the horrors of the trenches were confined to the immense armies that manned them. In the war of 1939 to 1945, the civilians likewise bore the brunt of constant bombardment, and were as truly in the front line as the smaller number of men actually engaged in combat. It is this, therefore, and not the degree of Nash's emotional involvement, which

[1] John Rothenstein, 'Paul Nash as War Artist', in *The Memorial Volume*.

explains the difference of his approach as a war artist in the two conflicts.

Again, had his physical condition not prevented him from living in London, and had he shared the prolonged experience of the Londoners in the night and day raids that constantly menaced them, he might have sought to give expression to the outrage of the bombed city, somewhat in the vein in which John Piper recorded the deserted vistas of the ruined streets, even as Nash himself had portrayed the mangled earth of Flanders over twenty years earlier. But he was only occasionally in London, and when there he was generally engaged on business connected with his official duties, or, later in the war, with his exhibitions at Tooth's or the Redfern Gallery.

His encounter with the war was therefore largely limited (except for the privations shared by everyone) to his visits to the various Royal Air Force bases round Oxford, to his inspection of wrecked enemy aircraft, and to the extensive study of official photographs of planes in action and at rest, combined with the personal accounts given by many pilots who visited the Nashes in their Oxford flat. Both in the 'picture histories' which he began to prepare at this time, and in his article on *The Personality of Planes* he outlined his approach to his new task. As usual it was the element of personality which attracted Nash—'everywhere one looked, alarming and beautiful monsters appeared, the tank, the air-plane, the submarine, the torpedo and the mine, all had individual beauty in terms of colour, form and line, but beyond, or was it *behind*, the actual appearance, these things possessed each a personality difficult to define and yet undeniable. It was not wholly a matter of mechanistic character. There seemed to be involved some *other* animation—"a life of their own" is the nearest plain expression I can think of—which often gave them the suggestion of human or animal features'.

In this article, published in *Vogue*, he then gave an illuminating account of the method he employed in order to familiarise himself with his new assignment. 'By nature,' he wrote, 'I am unable to appreciate even simple mechanical contrivances. Until I was able to study machines at close range, photographs and pictures were my only guide. . . . To become familiar and friendly with these aerial creatures, I made a large array of their images in my room, changing the prints from time to time and gaining gradually, I thought, through their constant presence, a sense of their essential nature and behaviour. I did not trouble to learn their names, and to follow their actual anatomy was

often beyond me. . . . At last my appointment was confirmed, my permits and passes issued.

'My method was to decide upon the aspects of the plane I wished to record and take photographs at once. I would then make a free, rough drawing in line, generally upon dark paper, which would "take" both a hard wax chalk and watercolour in thin washes.'

He then proceeds to describe his personal reactions to the different types of aerial creatures. Though at first sight he found the Wellington rather 'jolly', he came to feel very differently after an attempt to stare one out of countenance. 'I was shaken. The baleful creature filled me with awe. . . . To watch the dark silhouette of a Wellington riding the evening clouds is to see almost the exact image of the great killer whale hunting in unknown seas'. The Whitleys he regarded as intellectual things. 'Yet, with all this, it is a queer bird-like creature, reminding me of a dove! Look at its head and lovely bird-like wings. As it sailed through the low clouds at sunset, it might be the dove returning to the Ark on Mount Ararat. But it is more than this. If it is a dove, it is a dove of death!'

He then considered the character of short-nosed and long-nosed Blenheims, and of Hampdens, finding the first bafflingly enigmatic and the second shark-like, while for the third, the Hampdens, he could only suggest some reptilian equivalent from the mists of prehistory.

The animate quality of his new monsters emerges with great clarity from his studies of them, as it does from the titles he gave to his drawings of them. Thus, for instance, the watercolours in his series of *Bombers' Lairs* (*cf. Plates 102, 103*) vividly suggest the watchfulness of predatory animals awaiting the hour of dusk before their sortie in quest of their quarry. 'Ideally, of course,' he wrote 'airplanes should nest in the clouds. Even now some kind of aerial base jutting up above the tree-tops may be taking place in a designer's mind. But, as things are to-day, the nearest form to a nest the airplane can be said to inhabit is its hangar, and since this bears so little resemblance to any construction of a "cosy" nature, I prefer to substitute the idea of a lair, a place associated with large, wild savage beasts . . .'. The analogy is not far-fetched, since it does in fact exactly render the functional significance of the hangar, and the interpretation is an excellent example of Nash's constant search for symbolic equivalence, both verbal and visual. Again, the 'portraits' of the bombers not only convey his own sense of their personality, but also render much of the particularly personal relationship which pilots established with their 'crates'.

But it was in the many studies of planes in the air, taking off or coming in to land, that the poetic feeling of equivalence which Nash commanded fully came into its own. In drawing after drawing the essential difference between one strange bird-like creature and another is conveyed with a complete understanding of the nature of flight itself; for though Nash had never flown, his intuitive imagination enabled him to participate in the freedom of the skies experienced by the men who manned the planes. Though that experience was often expressed by airmen in crudely childish slang, there is no doubt that their actual apprehension of it was often poetic in character, and they themselves regarded much of Nash's work with pleasure and enthusiasm, very different from the rather cool reception accorded to it by their superior officers, who had hoped for a more academic rendering of their young heroes' exploits, and were merely flummoxed by getting instead watercolours with such titles as *Whitleys at Play*.

The heroic exploits were, however, not neglected by Nash, who reconstructed them from photographs and accounts in a number of large watercolours of outstanding quality, such as *Target Area: Whitleys over Berlin* (*Plate 108*), *Objectives—Blenheims bombing the barges at Le Havre, Night Fighter* and *Day Fighter* (*Plate 105*). In the two former he unhesitatingly and by sheer power of imagination, provided the bomber's eye view of a ground target, with an extraordinary grasp of the emotional 'feel' as well as of the surface appearance of the ground from the air. The two latter, on the other hand, required less imaginative effort, except in the rendering of speed at close quarters, and because of their more factual nature are on the whole less successful.

Fine as were the drawings dedicated to the planes of the Royal Air Force, those in which Nash studied the fate of enemy aircraft were finer still. His intense hatred of the Nazi régime, combined with his sense of the depersonalisation of modern warfare, caused him to overlook the personal tragedy of the German pilots, hurled to destruction with their machines by the English fighter crews in the Battle of Britain. In this his attitude towards the enemy seemed ruthless and uncompromising, and it was therefore with a kind of lyrical joy that he celebrated the doom of the raiders. Once more his imagination was called into play, for he did not go to view the wreckage of every enemy aircraft which he drew. Many 'dead' planes he did see, and he made a particular study of their wrecked forms

in the great Cowley dump, where the tangled airframes were piled to await removal to the melting furnaces. In this way he equipped himself to interpret news of the raiders being shot down all over England, for he was able to combine his long study of the landscape with his more recent knowledge of aircraft, and thereby to produce watercolours of great beauty and marked individuality. His *Messerschmitt in Windsor Great Park*, which has nose-dived into the soft earth and displays its baleful character, now stripped of terror, at an awkward angle to the ground, is quite different from *Raider on the Moors*, or *Raider in the Corn*, though in all three the incompatibility of the monster with its setting is sharply defined. These are essentially studies of an evil thing destroyed. But in *Down in the Channel* (Plate 107) and in *Raider on the Shore* (Plate 106) the emphasis is somewhat different. So utterly helpless is the enemy monster in defeat that he has almost lost his baleful character and merges into, rather than contrasts with, the familiar landscape in which he lies. Supremely was this the case in the most lovely of all the drawings in this series—*Deadmarch, Dymchurch*. This exquisite watercolour (itself a victim of enemy action when it was sunk in the Atlantic *en route* for exhibition in America) hauntingly portrayed 'a sea change into something rich and strange', for the fallen enemy aircraft washing helplessly to and fro in the shallows off the coast Nash loved so well, had itself become a large wave form, lapping the shore.

As was the case with his pictures of the first war, Nash's watercolours and drawings of the second are, on the whole, far more distinguished than his oils. At all times he tended to 'lay the image' of his vision with greater conviction in the more rapid medium. The seized moment was of supreme importance to him, and in consequence he could often be a trifle laborious when he had to be deliberate. His famous painting of *The Battle of Britain* cannot, in my view, be wholly exempted from this stricture, though it has met with general acclaim. It is without doubt a fascinating and heroic attempt to render the conflict symbolically, and the composition is admirably worked out to express, by such devices as the narrowing of the width of the Channel dividing England from the enemy-held coast, the immediacy and closeness of the danger which threatened this country. The meanders of the broad river seen from above as it winds to the sea are evocatively balanced by the curving smoke trails of the aircraft in the sky as the battle is engaged in the air above the straits. The rather bright colour harmonies have been chosen to convey the sinister paradox of mortal combat in late summer weather so glorious that none of us who lived through those days can ever forget it. For many people the painting is a completely satisfying statement of its theme, and I have been told by one of the combatants that 'this was exactly what it felt like'. This may well be so, and yet I think that for later generations, with no personal knowledge of the events it symbolises, the picture must necessarily fail of its purpose, because, unless one remembers the summer and recalls the threat implicit in those elegant white vapour trails, the impression left on the beholder will probably be one of gaiety rather than of potential doom, narrowly averted. Exhausted relief and not exuberance was our mood, and of this the painting gives no hint.

No such false impression can possibly be conveyed by the other large war canvas, *Totes Meer* (Plate 98), in which the sad grey-green waves of the 'Dead Sea' are made up from the wrecked and tangled carcasses of enemy aircraft, piled in the vast dump at Cowley. They lie, barren and forgotten, stripped of their animation and helpless, beneath the cold light of an alien moon, and even if the stuff of which the frozen sea is fashioned cannot be immediately identified by the beholder, he must at once be struck by the atmosphere of hopeless desolation which hangs over the scene. Here in a deliberate statement, Nash has caught both the tragedy and the triumph of the bitterly glorious years.

XI

The Final Phase 1940–1946

IN CONSIDERING THE LAST TRIUMPHANT PERIOD of Paul Nash's work it must not be forgotten that, when the Second War began in the autumn of 1939, he was still a comparatively young man, having only passed his fiftieth birthday four months earlier. But his constitutionally strong and wiry frame had been shattered by repeated attacks of the bronchial asthma, which had now become chronic, and the periods of distasteful inaction, when he had to undergo treatment in clinics were growing longer. Wherever he went he carried with him the inhalant that generally enabled him to ward off the worst paroxysms of his malady and made it possible for him to continue his social and professional life. In this he was supported not only by his own resolute determination to ignore his physical disabilities as far as he could, but also by the equal determination and devotion of his wife, who watched over him and eased his difficulties in every possible way. Of this period she wrote, 'It seemed to me that his failing bodily strength was no longer able to chain his spirit, and gradually the spirit rose out of the hampering material surroundings and became strong and free and happy'. Happy in the main he certainly was, and he radiated an atmosphere of debonair gaiety, which made it easy to forget that he was an ailing man, sick unto death. To say this is not to imply that both Paul and Margaret did not know moments of depression and discouragement, when the battle for continued existence seemed altogether too hard, so that they would both have welcomed its end. But always, after a brief period of gloom, laughter would break in, and Nash would make a joke of his latest illness in his letters to his friends. After a spell in the Acland Nursing Home in Oxford he wrote to E. H. Ramsden, 'I am tired of resting. I find it so very fatiguing', and in describing the place to Conrad Aiken, he wrote with wry amusement, 'This is more of a Maternity Home than a mental one!', and, on being discharged from the Home in December 1945, he said in a letter to his old Swanage friend, Archibald Russell, 'I am about again but sworn to paint in any but a standing position. All

kinds of mobile, volatile behaviour has been suggested but in the end I expect to become slung from the ceiling like an aggressive sort of Christmas decoration stubbing with fistfulls of brushes at the bewildered canvas'.

It was against such odds that Nash had to contend in completing his life's work, and in face of them he was to produce some of his finest oils and a number of watercolours of striking imaginative power.

Chronologically the two aspects of Nash's final phase largely coincided, but whereas the last of the official war paintings, *The Battle of Germany*, was completed in 1944, his 'personal' paintings, in which he embodied his view of nature and the universe, continued to flow from his brush until the last day of his life. The two groups are, moreover, entirely distinct in character though each owes much to the other. It is for these reasons that I have chosen to treat them separately, and to leave to the end the consideration of the culminating phase of the 'personal' paintings, with which Nash's career ended.

In 1938 he had signed a contract with Cobden Sanderson for an autobiography, to be called *Genius Loci*, a title later changed to *Outline*. He had worked on the book with considerable pleasure, though in a desultory fashion, whenever he could find the time, and more particularly when bouts of illness prevented him from standing for long hours at his easel. The task naturally involved him in a review of his life's work and a reappraisal of his approach to it at different times. For the earlier periods his photographic and other records were woefully incomplete, so that he was forced to rely upon his memory for the sequence of events, and inevitable confusions resulted. He did nevertheless succeed in reconstructing for himself a tolerably accurate picture of his artistic development and in so doing became more conscious of the significance of his life-long quest. In his writings he sometimes made reference to his 'researches', when attempting to define his artistic approach, and the significance of the word became apparent in the course of his retrospective survey. The 'researches' he had in mind were

not concerned with the technical side of his art (though to this he had always devoted the closest attention) but with the discovery of a language in which he might express the inexpressible, define the indefinable and give to the invisible a visible form. As he recalled the successive phases of his development he found in each some hint of a solution to a particular problem which had preoccupied him, and the exercise of his memory produced a sharpened awareness of the goal he sought.

Thus, I suggest, he came to the culmination of his artistic task enriched by a conscious understanding of all that had gone before, and for that reason much that he accomplished in the period between 1940 and 1946 must be seen as a summary of these 'researches', a deliberate rounding-off of the story. He now worked with an even greater confidence in his ability to achieve the end desired, not only because he was assured of a complete mastery of the technical means essential to his expression (a mastery that had been hard-won in earlier days) but also because much that had been latent in the subconscious now rose to the level of consciousness, generally without loss of spontaneity.

Furthermore he was supported by the reassuring knowledge of adequate public recognition. Although he had always been sure of himself and confident in his own ability, he had at the same time never been wholly indifferent to informed criticism, and he had greatly valued the continued support and loyalty of collectors who had gone on buying his work as it passed through different stages of development. There is in John Carter's possession an interesting group of letters to Desmond Coke, written by Nash when he was at Iden. Two of these express Nash's dismay at the fact that his friend had apparently found nothing to his taste in a recent exhibition, though it was clearly not the loss of a possible sale, but his implied failure to produce anything sufficiently significant to please Coke that troubled him. This kind of doubt no longer beset him, for by the middle of the Second War his position was so secure that Dudley Tooth, who had become his sole agent, was able to sell work before it had been painted, and on one occasion had a queue of no less than seventeen collectors lined up, all anxious to acquire examples of the latest watercolours.

A further testimony to the esteem in which Nash was held in the 1940's is afforded by the fact that he was chosen as the first artist to be represented in the paper-back series of *Penguin Modern Painters*. When approached by the editor with a request to participate

in the project, he characteristically enquired whether Ben Nicholson was to be included in the series, for though he and Nicholson had developed in very different ways since their association in Unit One, he had always admired Ben's single-mindedness and championed his painting. The reply that it was not the editor's intention to include Nicholson displeased Paul so much that he at once made his own participation conditional upon the inclusion of his old friend. He won his point, and as a result the Nash volume, with a critical introduction by Herbert Read, appeared in 1944, and that devoted to Nicholson in the following year.

Even so, there were many who misunderstood Nash's attitude to his own and other people's painting, and wrongly imagined that the various changes traceable in his style were due to repeated and not always successful efforts to adapt to his own ends the latest 'fashions' among his contemporaries. Nothing could have been further from the truth; for though like all sensitive artists he responded to the influences of his day and was prepared to experiment in a number of idioms, his complete honesty made it impossible for him to do otherwise than remain true to his personal vision and artistic purpose. In consequence any suggestion to the contrary greatly distressed him, especially when it was made by people who were in a position to inform themselves of the truth. When, for instance, Philip Hendy, then Director of the Leeds City Art Galleries, began an article on the joint exhibition of Nash's painting and Hepworth's sculpture, which he had put on at Temple Newsam, with the phrase 'Paul Nash is always in the swim', Nash was cut to the quick by what he regarded as a reflection upon his artistic probity. Of the distress which the sentence caused him I can speak with authority, since he discussed it at length with E. H. Ramsden and myself at the London Museum, and we had some correspondence on the subject afterwards.

'To thine own self be true' might, indeed, have been taken by Paul Nash as his watchword, and, in his 'personal' painting, as in his official war pictures, he observed the maxim unswervingly in his last years. It must not be supposed, however, that he maintained a strict consistency of style and that he did not continue to pursue different lines of research and development at the same time, often with visual allusions to his earlier work, probably derived from his reconsideration of his career as a basis for his autobiography and for a large 'picture book' of his paintings and

drawings, which he was preparing with the help of the young poet and publisher, Conrad Sennat.[1]

In many of the more straightforward landscapes he now began to concentrate to a greater extent upon pattern, more especially in those which recorded the views from the hotels he used in London, the Cumberland at Marble Arch, and later the Russell at the corner of Russell Square in Bloomsbury. The Hyde Park and Kensington Gardens snow scenes of 1940–41 (*Cp. Plate 112*) are excellent examples of this pattern-making approach, which should, perhaps, be regarded as a logical development from the abstract phase of the late twenties and early thirties. The abstraction is, however, romantic in intention and an element of fantasy is present in the contrast between the geometrised sweep of the roadways in the foreground and the fairy pinnacles of the Hyde Park Hotel glimpsed above the trees in the distance. The same element of fantasy appeared again in the later *Landscape of the British Museum* (*Plate 113*), where the Reading Room Dome, floating up behind the Russell Square trees, seems to suggest the beginning of some foreign adventure. The trees of the Square he rendered in various ways, some of his more successful experiments in delineating them taking the form of a surface treatment, with patches of variegated colour wash flooded on to white paper in a manner slightly reminiscent of his early Dymchurch tree studies, though on the whole they are less successful, because he largely ignored the essential structure of the trees themselves and left too few areas of white.

The reconsideration of his earlier work led him to turn his attention to the unfinished oils and watercolours stacked in the Banbury Road Studio, and it was at this time that he completed several earlier paintings, including *The Archer*, begun in 1930 and *Pillar and Moon*, begun in 1932. Of the latter he wrote, in one of the 'Picture Histories', prepared at the request of Dudley Tooth, 'No legend or history attaches to such a picture: its drama is inherent in the scene. Its appeal is purely evocatory. That is to say, its power, if power it has, is to call up memories and stir emotions in the spectator, rather than to impose a particular idea upon him.' This is, as I have pointed out elsewhere,[2] 'of the very essence of pure poetry, arousing the imagination

and provoking an instinctive response rather than a reasoned one'. It tells us much of Nash's purpose, for it is an invitation to a joint adventure, in which the beholder must play his part. The artist does not ill-manneredly seek to impose an attitude by pointing a moral and adorning a tale; he does not demand a particular response, even though he may hope for it; he is reticent in his invitation to the voyage, because he does not desire to force an acceptance. The gate to his private world has been opened, but no one is compelled to enter it.

The painting seems at first sight, a quite direct transcription of a familiar landscape. A lofty avenue of beech trees, probably leading to the site of some long vanished mansion, stretches diagonally across the left of the canvas and is approached through what was once a gateway, of which one tall pillar still stands, surmounted by a stone hall, the sphere of which is echoed by the orb of the moon above. That is all. It is a statement of simple fact, almost startling in its familiarity, yet it does stir the memory and invite the beholder to explore the strongly felt sense of equivalence, symbolised in this case by the two globes, the ball of stone and the sphere of the moon.

The year 1942, which saw the completion of these two paintings, was also the year in which Nash returned to his preoccupation with the fossil formations of the Dorset Coast. But now the fossils assumed for him the guise of ghosts from some vanished past, rather than of the object-personages they had earlier seemed to him. The imprints in the living rock became wraith-like, and in a series of misty, dreamy watercolours he traced the shapes of *The Ghost of the Turtle* (*Plate 118*), *The Ghost in the Shale* (*Plate 118*), *The Ghost of the Megaceros Hibernicus* and *Kimmeridgian Ghost*. The actual facture of these paintings is perhaps freer and more fluid than anything he had yet produced and foreshadowed a technical development of the following two years, when he frequently employed the basic pencilled outlines of his composition as an almost independent element, not necessarily delimiting the areas of colour but serving rather to reinforce them.

This free-flowing technique, in which the outlines are suggested without being strictly defined, is best seen in the 'Aerial Flowers' series and other imaginative compositions closely akin to them. It was not, however, confined to such imaginary and dream images, for he applied it with equal success to landscapes, in which it was his aim to emphasise the melting quality of aerial perspective or to render the varying effects of

[1] The project had to be abandoned, as it was on too large a scale to be adapted to the 'austerity' printing regulations in force. After Nash's death I was asked to abbreviate and edit it, and it appeared as the *Memorial Volume* in 1948.

[2] Preface to an exhibition at the Hamet Gallery in April 1970.

weather upon a well known view.

A number of these landscapes were designed in series and were connected with his visits to the open prospects of Gloucestershire, as he saw it spread out before him on the two occasions when he and his wife sought relief from the somewhat confined and low-lying atmosphere of Oxford. They stayed at the Rising Sun Hotel on Cleeve Hill, nearly a thousand feet above the plain, and it was here that he wrote, in his characteristic vein of self-mockery, 'The air that rushes around is very high quality, and usually referred to as like champagne or like wine. I need hardly say it is not in the least like either but all air of a curative or invigorating nature is always so described and *always* as if the similitude had only that moment come as an inspiration. The air my dear is like CHAMPAGNE! . . . The landscape is very lovely with far away vistas of far hills and not a few mountains. Most of the time the far views have been blotted out by mists but they too are lovely and gave me a new thing to paint in my best Chinese manner. Sunsets, too, are WONDERFUL. "Mr. Nash *did* you see the sunset this evening. It was *wonderful*, you were eating crumpets in Cheltenham? O, what a pity." And I feel I have let the hotel down. For by now of course it is well known I am an artist if not *the* artist, and indeed when I get excited over one of the sunsets I tend to erupt from the ordered decorum of afternoon tea and go splashing wild colours onto bits of awkward sized paper in the bay window.'

The views of which he thus wrote to his young friend Richard Seddon were recorded in a series which he called by the general title of *Landscapes of the Vale* (*Cf. Plates 132, 138, 142*), and in another, untitled, group, to which belong *Landscape under Rain*, *Landscape under Mist*, *Landscape under Snow*, *Landscape under Mist and Frost; Studies 1 and 2*, *Hill, Plain and Cloud*, *Landscape after Snow* and *Landscape Emerging*. He was right in likening them to the work of Chinese painters, for they possess an extraordinary evocative beauty, that depends for its magic upon the realisation of the seized moment. They cannot be described; they can only be felt. Another group associated with Cleeve is that of the *Landscapes of the Malvern Distance*, but here, on the whole, the painter was perhaps less successful, for they seem to be rather more in the nature of orthodox English watercolour-painting, and tend to lack the inner unity which comes from the instant perception of a scene as an entity. In consequence, the effect is sometimes spotty and the sense of immeasurable distance is lost.

Beside the two visits to Cleeve, he spent several short holidays at Madams with the Neilsens and at The Three Swans, an old country inn at Hungerford, which had been taken over by his cousin Nell Bethell and her husband, Major George Fairfax Harvey. He was delighted to rediscover Nell Bethell, for whom he had always had a *tendresse*, but of whom he had lost sight, and he was greatly saddened by her early death, which occurred three years before his own.

Hungerford is one of those small and wholly English market towns, which could not possibly be found anywhere else in the world. Its Englishness appealed to Paul immensely, and the watermeadows near its church were the inspiration of a very simple and lovely *Landscape Study at Hungerford*, in which it seems that Nash felt no need to pursue his quest for equivalence, for the landscape itself revealed its inner meaning without need of any symbolism in which to express it. The handling of the watercolour is reminiscent of the drawings of the canal at Hythe twenty years earlier and conveys a sense of the English landscape painter 'rediscovering' his native land.

At Madams he was more adventurous. The long prospects from its terrace were not dissimilar to those around Cleeve Hill, though they were viewed from a lesser height. The house and garden and the surrounding countryside had from his first encounter with them held a particular magic for Nash, and it was here, as we know, that he had discovered 'Monster Field'. The enchantment held. The topiary below the terrace formed for him a haunted garden, a quality which emerges, interestingly enough, no less from his photographs than from the watercolours which it inspired. Some adventure always appeared to be just round the corner there, awaiting its moment when the human beings withdrew and the *genius loci* could emerge, as it does in the *Garden of the Madamites* (*Plate 95*), where stone rick-staddles become 'object-personages', playing their part in an unexplained but nevertheless dramatic situation, while under the strange influence of the *Madamite Moon* their dramatic role is assumed by giant and menacing toadstools who have invaded and taken possession of the garden. The garden wall in his imagination took on the form of a defence against the tide, since now, as in his earlier *Stone Sea* and *Wood Sea*, he felt the analogy between the undulations of the landscape and the swell of waves, so that he arrived at a wholly convincing equivalence in *Sea Wall at Madams*. He used the same theme to

even greater effect in the beautifully fluid lines of *Wood Against the Tide*.

There were snakes in the garden at Madams, and they creep into the watercolours and paintings, though it is often difficult to determine what their exact significance was for Nash in any particular work. The manner of their rendering certainly does not bear out the suggestion of a chthonic symbol of primeval power, and though they may have been thought of by the painter as an evil element in an otherwise peaceful scene, it is not impossible that they are simply *animated* sinuous forms, providing a *visual* echo of the other curving forms in a landscape. The equation, if equation there be, is certainly never completely resolved, either in the oil paintings or in the watercolours, though the theme persists right on into the last year of Nash's life. One very curious canvas of 1943 is devoted to it. The picture is enigmatically entitled *Farewell!* (*Plate 130*) and its centre is occupied by a vast serpent, careering across the dry grass and low scrub of the hillside, and lifting its head as if about to strike at the bright clouds above the horizon—but in place of a head, there is a hand which sketches the gesture of leave-taking. In conception the painting is clearly related to the 'Monster' series, and it was in fact based upon the snake-like form of a fallen bough, which Nash had seen during a walk in the Chilterns four years earlier. When he came to finish the painting he was faced with the task of 'laying the image' as he had originally perceived it. His account of the difficulty in doing this is interesting—'One detail only baffled me in the reconstruction of the scene in its pictorial form. The head of my object personage was not a snake's head—which, as you may know, may be a flower—it was a woman's hand waving farewell. It had always been there in the original drawing and it is as much an essential part of the picture now as anything else there but, unlike the rest of the picture, I cannot explain it'. It is a pity that the original drawing, if there was one, has not survived, as in the later completion of the oil something seems to have been lost, and the painter fails to convince us of his perceived image, so that his inability to explain its meaning, while it does not surprise us, leaves us in this instance not merely baffled with him, but frustrated by him. The work is not redeemed by the balance of its composition, but the startling asperity of its acid greens does succeed in creating a sense of discomfort, which is presumably a token of the artist's own bewilderment.

Two infinitely more satisfying monsters are to be found in *Stalking Horse* and *Laocoon* (*Plate 86*), both watercolour studies of uprooted trees, whose analogical significance is sharpened by the naturalistic treatment of their landscape backgrounds. The heightened apprehension is perfectly caught, but, despite their somewhat menacing titles, their mood is gentle and serene, and their aspect seems to the beholder in no way sinister, whereas the fleeing serpent with the woman's hand is not only enigmatic, but also vicious.

In that picture, however, Nash was looking back over the past, and not forward to his new adventures, and the gesture of farewell, if it 'meant' anything, must surely have betokened a departure from the monster and object-personage themes of the preceding period. For in truth, though he still occasionally pursued his earlier researches, his real interest now lay not so much in the animation of the land as in the cosmic drama of the heavens, and it was the significance of 'that inverted bowl we call the sky' and all that it contains which was to preoccupy him to the end. He did not share FitzGerald's feeling of maddening inadequacy in face of the riddle of the universe, nor did he believe that beneath 'the inverted bowl' we merely, 'crawling, live and die'. His awareness of a wider and more basic unity gave him a wholly different view, and since, as James Laver has suggested, 'he was plainly in reaction against the classical-humanist idea of "man as the measure of all things" '[1], he had no difficulty in centering his attention upon the broader implication of natural phenomena, seeking in them the answers to the fundamental problem of existence. Hitherto he had explored the land and sea in his search and now, in the quest for equivalence, he explored the changing face of the sky, both in itself and in relation to the earth beneath it. The sun and the moon became his familiar spirits and he rejoiced in the changing seasons that followed in their train.

'More and more I wish I was able to fly and explore the mysterious domain of the air. There is but one remedy. What the body is denied the mind must achieve . . . Of one thing I was now certain; modern methods of flying were fundamentally unsatisfying, possibly even unsound. The misconception seemed to lie in making the flying apparatus heavier than air. Development along those lines led inevitably only to bigger and noisier machines, with greater capacity for crowding, whereas the essence of the virtue of flying was the escape into vast lonely spaces in complete freedom of bodily action and, above everything, in silence.'

[1] James Laver, Introduction to *Fertile Image,* a collection of photographs by Paul Nash with notes by Margaret Nash, Faber, 1951.

Thus, in his essay *Aerial Flowers*, written shortly before his death, Paul Nash announced the object of his new quest, and showed in what manner he had been led to it by his official duties as a War Artist. He goes on to explain how, in rejecting the machine as a means of imaginary flight, he had come to strew the heavens with aerial flowers, and then, most tellingly, he concludes, 'But it is death I have been writing about all this time and I make no apology for mentioning it only at the end, because anything written here is only the preliminary of my theme . . . Death, about which we are all thinking, death, I believe, is the only solution to this problem of how to be able to fly. Personally, I feel that if death can give us that, death will be good'.[1]

Looking back over the span of his all-too-short working life one is conscious how much the sky had always meant to him. As a child he had had flying dreams, and in the days of his apprenticeship his 'vision' drawings had set his dream images in the heavens, for which reason Anthony Bertram has claimed that in the final period Paul Nash 'returned to his parish' wherein, one might say, he discovered both his old self and his new. On the face of it there would appear to be some truth in this contention and it derives some support from Nash's own writings. But even if it is possible to maintain that 'in his end was his beginning', this seems to me to be true only to a limited extent. The early drawings had been the work of an immature boy who saw through other men's eyes and presented his dreams in other artists' symbols. The late works were the products of 'the single eye', the symbolic expressions of a highly personal vision embodying the rich experience of a noble and mature poetic painter. The boy may be father to the man, but in this case he shows himself to have been so at a very distant remove.

From the early days, when he had discovered his real potentialities as a landscape painter towards the end of 1911, he had been immersed in the problem of rendering the long vista under the sky. The first drawings and watercolours of Wittenham Clumps had demonstrated this immersion, and the sense of space which they conveyed had been intensified by the wheeling flocks of birds that swept through the skies, like natural embodiments of a liberated vision. A few years later his interest in the sky, not as a background to landscape, but as a unifying element in it, had been manifested in watercolours such as *Red Sky* and *Mackerel Sky*, and though in neither of these examples did he succeed in producing the effect at which he was

[1] 'Aerial Flowers', reprinted in *Outline*.

aiming, because his approach was too tentative, they nevertheless clearly indicate his intention, which was not wholly naturalistic.

With the drawings and paintings of the First World War we are often presented with the sun and the moon as commentaries on the devastated landscape they illumine. Thus, the crescent moon overhanging the trench in the tiny drawing of *St. Eloi, Ypres Salient* suggests a promise which the sinister landscape denies, and again, the westering sun sinking behind the angry red cloud bank of *We Are Making A New World*, and the long light shafts breaking from the storm wrack above *The Menin Road* perfectly convey the bitter contrast between the natural order and the man-made devastation. The sky was no longer kindly in its aspect, for it had become the aerial highway of death-dealing shells, and the pitiless rain striking *Lake Zillebecke* brought no relief to earth and man.

The sky, in a fairly naturalistic rendering, plays an important part in the long perspectives of the Dymchurch landscapes, and in the later twenties Nash began to experiment with a formalised and almost abstract rendering of clouds, in keeping with the increasingly geometrical forms he evolved for his landscapes, and this formalisation is a device which he employed—with varying degrees of success and more often in oils than in watercolours—throughout the thirties and even in some of the paintings of his last six years. Admittedly the method sometimes produces an effect that is uncomfortably at variance with the softer treatment of the land below and may in consequence be thought to distract from the sense of unity, rather than to enhance it. A case in point is the view of *Oxford in Wartime (Plate 111)*, an otherwise impressive oil of the dreaming spires seen from the steep slope of Headington, with a tank intruding its alien personality into the quiet middle distance. The unity of the whole is marred by an over-dramatisation of the sky, which is too sharply divided into areas of unequal size, the blue sky to the left being revealed, as it were, by the raising of a diagonally slung pink cloud curtain that is too solid and undifferentiated to provide the necessary aerial recession.

In the middle years the balance of interest had somewhat shifted, and though the sky still played a vital part in many but not all of the landscape studies, the heavenly bodies made but a rare appearance in them. They were sensed, but sensed as a part of the 'presence of the absent', as an animation spreading its influence over the scene while yet itself just out of sight. Thus,

it is the mirrored radiance of the westering sun that reddens the cloudlets floating over Ballard Head in *Voyages of the Fungus*, and the murky glow filtered through snow clouds that draws the slightly yellowed path across the surface of *Winter Sea*. It is a different matter, however, with the symbolist and surrealist paintings, for as early as 1930, the recurrent theme first seen in *The Voyages of the Moon* made its appearance, to be worked out in a variety of ways during the succeeding years. The symbolism of the sun had not, of course, escaped Nash, and it was consciously developed by him from the time he illustrated *The Garden of Cyrus* until his final preoccupation with it in the closing years of his life, though for a time, in his pursuit of the animated 'Object-Personage', his gaze was less constantly directed towards the skies.

It was not, however, until he became, as it were, professionally involved in the clouds and began to consider his new aerial monsters playing hide-and-seek among them, that his attention was finally riveted upon the cosmic drama of the heavens and he thus obtained his ultimate imaginative release. The very possibility of flight, albeit by means of a clumsy mechanical apparatus, brought the skies imaginatively much nearer to him, and enabled him, by sheer power of empathy, as we have seen, to project on canvas or on paper the airman's upward or downward view. The kaleidoscope of changing clouds is no less important in his war paintings than the aircraft that cleave through them, and it is presented as a perfectly apprehended meteorological study, to the understanding of which he applied himself with enthusiasm.[1] Small, Constable-like sketches of cumulus formations drawn on blue paper bear eloquent witness to his determination to master this new aspect of his researches, and his success is seen in countless watercolours of aircraft in relation to the clouds from which they descend or towards which they climb.

Yet all the time he was conscious that these drawings did not represent for him the essential virtue of flight nor fully reveal the subtle interrelationship of earth and sky. The weather studies, made in his 'best Chinese manner' at Cleeve are manifestly associated with his new approach, since they suggest an etherial evanescence very different from the more rigid and seemingly immobile statements he had earlier made in his painting of clouds and rain and snow. The point is well illustrated by the difference between even such a

lively drawing as *Sudden Storm* of 1918 and *Storm over the Landscape: Study I*, in which the rain, the wind, the clouds, involve the whole countryside in a swift, gusty movement that blows the trees apart to reveal a passing glimpse of the Wittenham Clumps, and will as swiftly change, leaving a renewed stillness behind. The drawing is a landscape study, in which the land occupies two-thirds of the paper, and yet its interest and its power lie in the weather which give it the character of an aerial vision.

In the same way, the natural 'Object-Personage' of the last years, though often resting on the ground, is there so lightly poised that it seems to have come to rest only a moment earlier, in a brief pause before taking flight once again. *Flower Resting in the Landscape*, *Landscape of the Puffball* (Plate 119) and the *Landscape of the Fungus, Gloucestershire*, all perfectly exemplify this seized moment of rest from flight. The barriers between the earth and sky are down, and the fancied gulf dividing the material and the spiritual is closing fast.

Sometimes the flowers float upwards to become the denizens of the air, from which the ground is only distantly seen or has vanished altogether. In *Dawn Flowers*, for instance, the long vista of the Malvern distance has dwindled to a narrow band at the bottom of the paper, and above it ride the grey dawn clouds, bursting into flower. The watercolour owes its origin to a sleepless night at Cleeve, when Nash, gazing from his window towards dawn, imagined enemy parachutes descending on the plain, and then transmuted them to friendly flowers. The concept was perhaps somewhat too intellectual and in transferring it to paper he made one grave error of design, when, in order to vary the possible monotony of the level cloud banks, he introduced a curious obtuse angle into the upper cloud tier at the right. A more completely realised image of the same kind, in which he makes no reference to the earth at all, is *Cloud Cuckoo Nest*. *Nocturnal Flower*, with flower and leaf floating gently down from the edge of the cloud above the moon, belongs to this same group, of which many people regard the most successful example as being *The Flight of the Magnolia* (Plate 123). The title applies to both a watercolour and an oil, but though the image is fascinating and is, as Bertram has observed, paralleled by (though probably not derived from) Wordsworth's lines,

> '*He told of the magnolia, spread*
> *High as a cloud, high over head*',

[1] His source was an excellent booklet on clouds published by the Stationery office.

yet, despite the beauty of the concept, the image may be thought to fail of its purpose by reason of an excessive definition and a relative hardness of outline, which seem inappropriate to the theme and suggest that Nash had been too conscious of the weight of the waxy petals to succeed in launching his flower freely into the clouds.

In many of the oil paintings of this final period Nash was concerned with another aspect of the relationship between land and sky, and his theme was the cosmic drama of the changing seasons, conceived as resulting from the conjunction of the heavenly bodies to which his thoughts had now returned. In all of these canvases the sun or the moon or both symbolise this union, while the actual seasonal change is expressed not only in the state of the foliage and the general character of the landscape, but often in some particular image, such as that of the fungus, which for Nash had always stood for autumn. The intention of the painter is overtly symbolic, and the use of colour to express the mood of the cosmic drama is often anti-naturalistic, though the forms are not. Nash's ability to produce such a series of canvases was, in view of his failing strength, little short of miraculous, but he knew that time was short and his iron will overcame his physical weakness.

Most of the paintings in this series are based upon the view from Hilda Harrison's garden on Boar's Hill, whither he often betook himself and from which, through binoculars, he could see the distant prospect of the Wittenham Clumps some twelve miles to the south, on the edge of the Berkshire downs. The sight of those low but eternal hills, topped by their twin coronets of trees, stirred his memory and deepened his symbolic purpose, knowing, as he did, that his life's work was sweeping back, full circle, to its close. Something of this feeling of a doom, proudly and even gladly accepted, shines through the finest paintings in the series, though they are by no means all equally successful either in conception or execution. In certain of them there is a tendency to exaggerate the weight and solidity of the Clumps, a fault particularly marked in the *Landscape of the Summer Solstice*, and not wholly lacking even in the three versions of the famous *Landscape of the Vernal Equinox (Plates 116, 117)* in which the drama of the rising moon and setting sun is presented at the season of equal day and night. There are considerable variations in the three versions, the best of which is probably that painted by Paul for Margaret and now in Edinburgh. Passages in all three are of great beauty and evocative tenderness; nevertheless the lyricism is hardly maintained, so that the unity of the dream image is not throughout perfectly sustained.

Nash wrote of the 'Boar's Hill' paintings as a series and in his account of them stated a paradox to which Anthony Bertram was quick to draw attention— 'actually there is nothing in it—the method is . . . taking visual facts in nature for visual use in a picture regardless of natural logic. Objects to me are all the same in the end, i.e. part of a picture, but primarily a pictorial part not merely symbolical. I may hunt out symbolical flowers to make a picture about the Summer Solstice but they must be useful pictorially, namely in colour and form. Thus the presence of the Orpine, a sedum, suggests the introduction of a stone. The queer pink of the flowers and the cold sea-green leaves are just what I want to build up my ochres and deep blues and give me the opportunity of tinting up my foreground of rough grass with a pink glow. Similarly the flowers of the mouse-eared hawksweed, very much exaggerated, are of great importance to echo the form of the sun and to repeat his image. The tall straight stem of St. John's Wort, with its branching fronds and jets of bright yellow petals, makes a significant division where it is absolutely needed. And yet, for all this utility procedure, I am convinced the presence of these magic flowers somehow influences the picture. That is a mystery, but I believe in it without question and without being able to explain'.

Bertram insists that 'the inconsistency of this passage is flagrant' because at the beginning Nash says that 'there is nothing in it', and ends with a mystery. But Nash was a poet, not a logician, and if I am right in thinking that there is in all his finest and most poetic work some element of genuine nature or extrovertive mysticism, then the paradox is inherent in his subject matter, because it exists in the 'common core' of all mystic experience. The Zen master, on being asked by his disciple the usual question, 'What is Zen?', turned, and pointing to the bamboo plantation by the wayside, exclaimed, 'See how tall these shoots and how short these!'. Surely that is precisely what Nash himself is saying. There is no contradiction in the words, such as Bertram would discern in them, nor is the statement about the mystery more important than the claim that 'there is nothing in it'. Both claims are true, and it is the task of the poet or the painter to express the paradox as best he may.

The truth is that if we attempt to analyse such symbolism too closely we inevitably tend to destroy

it. It is not there to be examined under the microscope of analytical psychology or logical positivism or any other equally abstruse mental exercise. It exists in itself and for itself, revealing or concealing its meaning according to the temperament of the beholder, who must accept or reject it as he will. Wordsworth expressed this fundamental truth when he said:

> '*A primrose by the river's brim*
> *A yellow primrose was to him,*
> *And it was nothing more*',

and in this context the delightful parody of the lines, composed to describe an obtuse botanist, is perhaps even more apt:

> '*A primrose by the river's brim*
> *A dicotyledon was to him,*
> *And it was nothing more*'.

What does emerge with startling clarity from Nash's description of his 'method' is that he deliberately chose a certain number of accepted symbols—in his case usually drawn from the pages of eighteenth- and nineteenth-century writers on symbolism—in order to reinforce the expression of his intuitively perceived theme, and that he was conscious that in so doing he often achieved an amalgam not only of form and content, but also of two different types of content (the intellectual and the irrational), with the result that the whole was greater than the sum of its parts, and was, as he repeatedly stated, a something which he could not explain.

With *Landscape of the Vernal Equinox* Nash again experimented with this dual presentation. His 'Picture History' is explicit with regard to his aim—'Call it, if you like, a transcendental conception: a landscape of the imagination which has evolved in two ways; on the one hand through a personal interpretation of the phenomenon of the equinox, on the other through the inspiration derived from an actual place. In each case so-called truths of knowledge and appearance have been disregarded where it seemed necessary . . . The only forms and facts that interest the painter are those which can be used pictorially; these imagination seizes upon and uses in a quite arbitrary way . . .'—and he then goes on to discuss his significant use of colour to express the ideas of time and place in this particular composition. He says of the picture that, despite the elaborate nature of his explanation, it was in fact 'painted suddenly and very quickly', but even so, in considering it, one is left with the feeling that in none

of the three versions did he completely succeed in capturing the seized moment and that the probable reason for this partial failure is to be found in his over-theoretic approach to his task. The sense of the seized moment has been partially obscured by the intrusion of his intellectual interpretation of an intuitively apprehended image.

He was undoubtedly more successful in capturing the original experience in *November Moon* (*Plate 135*), a less elaborate composition in which he did not use the image of the distant Wittenham Clumps to emphasise his meaning. It may be that the very obsessiveness of that image was too overpowering and that because for the beholder it does not and cannot possess the same significance that it possessed for the painter, the presence of the Clumps in the picture may sometimes act as a barrier to free communication.

This certainly seems to be the case in the small oil of *Sunflower and Sun*, painted in 1943, where the centre of the stage is held neither by the sunflower nor by the sun, but by the Clumps, standing between the two main symbols and crossed by the sunbeam which unites them. It is a strange picture and is the precursor of other far more important canvases devoted to the same theme. Sunflowers fascinated Nash, both by reason of their geometric form (which he had studied in connection with the Quincunx in the *Garden of Cyrus*) and because of their heliotropic movement. His sunflower was Blake's,

> '*Sunflower, weary of time,*
> *That followest the steps of the sun*',

but when he painted this first image of his theme, tired though he was, he was not yet 'weary of time' and had not yet penetrated to the core of his own symbolism.

The Boar's Hill group of paintings, though devoted to the study both of the sun and the moon, inclines towards a preference for the evening and the night, and in addition to *November Moon* it contains *Landscape of the Crescent Moon, Landscape of the Moon's First Quarter* (*Plate 120*), and *Landscape of the Moon's Last Phase*. The moon again plays an important part in some of the watercolour *Landscapes of the Vale*. This preoccupation with the lesser light that rules the night may have subconsciously reflected some spirit of gentle melancholy in the face of approaching death. But it did not express Nash's final attitude to the ultimate experience of terrestrial mortality. 'The soul had wings in Homer, which fell not, but flew out of the body into the mansions of the dead'. In his illustration of that passage

from Sir Thomas Browne, thirteen years earlier, he had conveyed a triumphant sense of quiet flight, and as he had gazed with wonder and awe upon the brilliant sunsets above Cleeve Hill, he had already identified his final flight with the descending sun. The psalmist wrote—'If I take the wings of the morning and remain in the uttermost parts of the sea, even there also shall thy hand lead me.' Paul Nash's wings were now the wings of the sunset and he felt that if death could give him the power to fly, death would be good.

In the winter of 1945–46 he suddenly burst into the sunset glow of his two last great watercolour series—*Sunset Eye* and *Sun Descending* (*cf. Plates 136, 137*). He had spent Christmas with Margaret at the hotel on Cleeve Hill and the next few months were dedicated to transcribing his vision of the glowing, dying splendour. There are seven studies in each group, and all possess a vastness of conception far transcending the narrow limits of the small sheets on which they are drawn. In the brilliance and subtlety of their colour harmonies, very different from the more muted tones Nash usually employed in watercolour, they recall the later work of Turner, though they owe nothing to Turner's technique. Once again they are a wholly personal vision, and though they are not symbolist in the accepted sense of the word, nor in the manner of so much of his later work, they possess an inner significance expressive of an acceptance of the natural sequence of dawn and dusk, rising and setting, life and death, which dissociates them from mere academic representationalism.

But even though in these paintings Nash foretold his end, his task was not complete. He had set his heart upon the execution of a final series of four great oil paintings, devoted to the symbolism of the sunflower and the sun (*Cf. Plates 125–129*), in which the flower itself should assume the role of the planet and pass through its phases. His bodily strength was, in truth, unequal to the sheer physical labour such a work involved, since his heart was at last beginning to fail under the prolonged strain of his chronic asthma. In the summer of 1945, following the completion of his sunset watercolours, he consulted Lord Horder, who took a very grave view of his condition and ordered a complete rest, which Nash refused to take until he had no alternative but to do so and was forced to go back to the Acland Nursing Home in November for a month of distasteful inactivity.

The needed rest had been delayed because of his work on the new series, of which he lived to complete only two oil paintings, though the two rough sketches for a third have survived. Of the fourth we know only the projected theme.

Before retiring to the Acland he sent the two finished paintings to Dudley Tooth, with a letter explaining the theme and describing his intentions for the series as a whole.

'Four pictures', he wrote, 'in which the image of the Sunflower is exalted to take the part of the Sun. In three of the pictures the flower stands in the sky in place of the Sun. But in the Solstice the spent sun shines from its zenith encouraging the sunflower in the dual character of Sun and firewheel to perform its mythological purpose. The Sun appears to be whipping the sunflower like a top. The sunflower wheel tears over the hill cutting a path through the standing corn and bounding into the air as it gathers momentum. This is the blessing of the Midsummer Fire'.[1]

'The Eclipse explains itself. The withered flower-head is a ghost of the flower in eclipse or just another sunflower time has destroyed and the tempest has torn up and scattered over the water.

'The other pictures are *The Sunflower Rises* and *The Sunflower Sets*.'

It would be difficult to overstate the perfection and magic of the two completed paintings. Any description of them beyond that which the artist himself gave would be pointless, since in both the image he sought had been completely realised. There is nothing tentative about either of them. They are not suggestions but statements, made with a fully assured technical mastery of the medium. The sunflowers which Nash grew in the Oxford garden and portrayed with such understanding both in delicate crayon notes and in the oil study of the *Sunflower* which he painted for his wife, come to life on the canvas in their dual role. They *are* both flower and sun. In realising the identity he had understood the nature of each, and the delicacy of the flower petals (which he had failed to capture in his earlier flower studies) here stands proclaimed in triumph and in decay.

The existing sketches for *The Sunflower Rises* (*Plate 126*), in which the dawning flower-planet breaks down the bounding wall of the Oxford garden, to reveal a long perspective beyond, suggest that this painting would have been no less lovely and commanding than its companions, and from what we know of the final sunset studies, it may be conjectured that

[1] With his accustomed thoroughness he obtained from a friend numerous literary references to folklore and ritual.

the closing picture of the series would have been endowed with equal power.[1]

But the effort was too great. After a month's rest in the nursing home Paul returned home for Christmas, under strict orders not to stand at his easel. Before January was out he had fallen victim to an extremely severe attack of pneumonia and for six or seven weeks hovered between life and death. By the middle of March he had sufficiently recovered to write to some of his friends, and in a letter to Gordon Bottomley he said, 'It was Margaret who insisted that I couldn't die when the specialist said I must. You don't know him says she hes (*sic*) a creative artist and he still has some work to do—just like that!'

Though greatly weakened by his illness, his energy and gaiety were unabated, and in May he was speaking with enthusiasm of the arrangements of the plates for his 'picture book' and of a project (which he had discussed before) for a new grouping of artists, to take the place of Unit One. It was to be what he characteristically termed 'a sort of nucleus—a nucleus with

[1] The sketch reproduced on Plate 126 is titled in Margaret Nash's hand on the back 'The Sunflower Sets'. This is manifestly incorrect, since the whole colour effect is that of dawn. The mistake must be attributed to Margaret's preoccupation with the sunset element in so much of the work produced by her husband during the year preceding his death.

antennae'. Despite the ban on standing to work, there was on his easel the beginning of a new experiment, a view of the Wittenham Clumps in a combination of oil and watercolour, in which, unexpectedly, the landscape was being rendered in the lighter medium and the sky in oil. Even in its still unfinished state it is a lovely thing, in which the boundary between the tangible and the intangible seems to have been obliterated.

When he left the nursing home in December he had written to Archibald Russell, saying how greatly he longed to see the sea once more before he died, and in July he and Margaret set out for Christchurch, close to his beloved Dorset shore. It was to be a journey of convalescence and recuperation, and the weather was kind. From Christchurch he visited one or two of his familiar haunts along the coast, and he passed some pleasant hours sketching on the balcony of the hotel.

On the evening of July 10th, 1946, after a happy day spent in working on two watercolours showing the distant prospect of the Isle of Wight, he went to bed and slept peacefully. When Margaret awoke the following morning she realised that, in the words of Sir Thomas Browne, 'The soul had found wings, which fell not' and had flown, not into the sunset, but into the splendour of the dawn.

XII

Postlude

THE LIFE OF PAUL NASH coincided with a period of gradual resurgence in English art. At the turn of the century both painting and sculpture were, in the main, of little significance and a stale academicism prevailed, untouched by the experimental movements which had already transformed the École de Paris. Forty-five years later, at the end of the Second World War, the situation had changed, and English artists of international stature had once again emerged. It is therefore fitting to ask, in this wider context, whether Nash was a leading figure in this resurgence, what was the value of his personal contribution, and what was the influence, if any, which he exerted on his contemporaries?

In considering his achievement as a whole, it must be borne in mind that his choice of a career stemmed in the first place from a poetic impulse rather than from a painterly instinct and that, because he lacked natural facility as a draftsman, his approach to the task he had set himself was in the beginning slow and laborious. Yet, once he had made up his mind what he wanted to do in life, he does not appear to have wavered in his determination nor to have been greatly discouraged by the various difficulties he encountered. This is the more curious in that he was sensitive to criticism and always felt a need to be understood. He was not coldly indifferent to the reactions of people whose judgment he valued and when, in later life, he occasionally gave the impression of almost arrogant self-confidence, that form of assertion was only elicited by what he regarded as stupid obstinacy or wilful blindness on the part of people who had the temerity to criticise work which they were not qualified to judge. He did not suffer fools gladly; but there is no particular merit in doing so, especially when too great a tolerance may lead to an appearance of weakness.

From the outset Nash was concerned with the cultivation of a purely personal vision. He wished to communicate that vision to others, but when he failed, as from time to time he did, he was not unduly discouraged, because his passionate belief in the value of his particular insight could not be shaken by misunderstanding. Such an attitude argues a considerable degree of self-sufficiency and self-reliance which, in his case, were born of the emotional isolation of his childhood. His mother's illness, his father's preoccupation with professional and family cares and his own inability to understand school subjects as they were conventionally taught, threw him back on his own resources, because they inevitably separated from him his school fellows, who were able to turn to their parents for support and sympathy. People trained in modern 'psychological' attitudes would undoubtedly blame William Harry Nash for his failure to grasp his elder son's problems; but Paul was brought up in the tougher and healthier tradition, whereby nervous and imaginative children were expected to control their fears and fantasies, and in his particular case at least the results of the discipline were far from proving inimical to his future success. He learnt to take refuge in the private world of his imagination when conditions might otherwise have proved too difficult, and later, when he was old enough to appreciate the nature of his father's sorrow and the need to protect his younger brother and sister from the full impact of Caroline Nash's nervous breakdown, he developed an almost premature sense of responsibility and human understanding, which formed the basis of the unusually close sympathy between his father and himself in later years. It is probable, moreover, that the character of his home background and his unhappy school experiences served to stimulate his natural appreciation of the kind of life lived by his grandfather and his other relatives in the still unspoilt English countryside. His innate gaiety, inevitably suppressed at home and misdirected at school, were, moreover, fostered by his delightful and robust Aunt Gussie, who, by imbuing him with her own love of Edward Lear's nonsense verse, undoubtedly gave him his first insight into the possibilities of combining outrageous fun and delicate wit, shot through with the spirit of pure poetry. It was a sphere of fantasy exactly suited to his natural bent, and

its contribution to his later attitudes cannot be ignored, since it is noticeable that he was rarely, if ever, in danger of being pompous or dogmatic, either about art or about life.

Thus, in his formative years, Nash had developed an awareness of intuitive reality, which compensated him for emotional isolation; he had acquired a sense of self-reliance; he had recognised the possibility of combining sense and nonsense with romance in a poetic form, and he had, above all, acquired a deep and lasting love and intimate understanding of the English scene.

It was, after all, no bad inheritance for an essentially English landscape painter, and it is surprising, once he had determined on an artistic career, that he failed to realise from the outset that it was to the landscape that he must turn for inspiration. The most plausible explanation for this initial mistake is to be found in his ignorance of 'art', except in the form of illustration. What he knew of illustration appeared often to correspond to the intuitions of his poetic imagination and direct contact with the theory and practice of art in the professional schools failed to divert him from his 'visions' and dream images because he was inured to some degree of mental and emotional isolation and had never learnt how to learn from masters or fellow students.

The influence of Gordon Bottomley prolonged this period of artistic immaturity, and little that Nash produced until after he left the Slade School can be accounted to be of artistic worth. The contact with Bottomley did, however, shield him, at what might otherwise have proved a vulnerable stage in his development, from the strong influence of Tonks on the one hand and Roger Fry on the other. Thus, during the time that he was struggling to learn the technical elements of his trade, he remained free to test the reliability of his intuition, instead of adopting the fashionable styles that were inappropriate to the expression of his personal vision.

It was fortunate that neither Sir William Richmond nor William Rothenstein attempted to influence him strongly towards one manner rather than another. Their encouragement was invaluable, but it left him free to follow his bent, and the surprising perceptiveness of Richmond in suggesting that he should 'go in for nature', on the evidence of the background to a single vision drawing, was undoubtedly the turning point in Nash's youthful career. From that moment he began to find himself and to produce work of real merit, marked by a freshness of approach, that

differentiated it from the academic styles of the period. His drawings were, as Richmond said, 'something new', and bore no affinity to the work of the Post-Impressionists, which was all to the good, though not for the reasons which would undoubtedly have been advanced by Richmond or Tonks. For many young painters in this country Post-Impressionism certainly provided a much needed challenge, but at the same time its manner proved fatally easy to imitate, even for those who knew little and cared less about the basic and at times revolutionary principles the movement strove to express.

Nash's avoidance of the fashionable stylistic temptations led him to develop a highly personal idiom, so that his early landscape studies in pen or watercolour possess a peculiarly individual quality. They are authentic expressions of a direct linear response to the stimulus of 'The Place', as he had first realised it during his childhood walks in Kensington Gardens and in the Buckinghamshire countryside. It is perhaps fortunate that at this early stage he felt no inclination to try his hand at oil painting, for he was, and indeed always remained, essentially a draftsman and a premature exploitation of the heavier medium might have tended to obscure the incisiveness of his rendering and involved him in a concern with surface treatment, which was foreign to his nature.

Once Nash had succeeded in freeing himself from romantic second-hand Pre-Raphaelite dreams and had, in the spring of 1911, found his true vocation in the interpretation of the landscapes he had always instinctively loved and understood, no further doubts remained. From then onwards for the next fifteen or twenty years, his unique personal contribution to English art lay in his ability to render the inner meaning of the places he drew and painted, while yet remaining faithful to their general outward appearance. The method he employed did not involve a slavish 'copying' of topographical detail. He reserved to himself the right to compose the elements of the scene, in order to produce a satisfactory pictorial unity, but that is, after all, a method which has always been adopted by great landscape painters and there was nothing new in it. What was new was his ability to make the beholder feel not only that he 'had been there before' (an impression often conveyed by the work of perceptive landscape painters from Rubens onward), but also that, though the beholder had been there before, he had in fact never fully realised the indwelling spirit of the place.

It is, of course, of the very essence of true landscape painting that it should deepen our awareness of the scene, so that we look on a familiar place with fresh eyes and encounter a new one with an enriched capacity for enjoying it. But it would be fair to say that for and in his own generation Paul Nash pushed the interpretative aspect of his art (particularly in watercolours) to its expressive limits in the years immediately preceding and following the First World War. At their best the early Iver Heath Wittenham drawings, the war studies and the Dymchurch watercolours are supreme in their own field and a number of the oils produced between 1919 and 1923 possess qualities which render them important landmarks in English art.

Although in a relatively brief space of time after leaving the Slade Nash became a master-craftsman, employing a number of different media with unerring skill and apparent ease, the impact and expressiveness of his work does not, in the first instance, depend on the degree of his technical mastery. He himself always, and rightly, attached great importance to perfection of technique, and without that perfection he would certainly have been powerless to achieve the whole range of subtle effects he sought, since much in his work depended upon precision of line and colour. But painting and drawing were never for him in any sense technical exercises to be undertaken for their own sake. For this reason one is not first struck by the actual facture of his watercolours and oils; one's first reaction is not to praise the skill of the composition or to examine the surface textures and revel in the sensuous handling of the paint. The pigment is, indeed, rarely characterised by the lushness which marks so much of French Impressionist and Post-Impressionist work. Nash's aim throughout was expressiveness, and all other considerations were coincidental to the quest for the pictorial equivalent of his reactions to given visual and emotional stimuli.

In his writings Nash laid great emphasis on pictorial values, and Bertram has understandably questioned his use of the word 'pictorial', since, as he employed it, it occasionally appears a trifle ambiguous. However, careful examination of the passages in which the word occurs makes its meaning in a particular context perfectly clear. Nash was not writing as an art historian or aesthetic philosopher, but as a professional painter, and when he wished to define the total visual effect of a watercolour or an oil, conceived as a technical whole, made up of the sum of its parts—composition, selec-

tion and exclusion of various elements, line, volume, colour, facture and so forth, he naturally used the word 'pictorial' as the proper adjective with which to define everything that for him went into the making of a picture. In other words, he employed it in relation to visual form as distinct from, though not at variance with, psychological content. Neither 'art for art's sake' nor 'meaning for meaning's sake' satisfied him, largely, I think, because he was himself so well balanced and integrated a personality that he felt the need to express his personal vision in the most complete terms of which he was capable. Such an attitude explains his failure to come to terms with the 'French style' he attempted in the late twenties and with the various forms of abstraction he tried out in the early thirties. It also provides the clue to his rejection of the purely automatic processes invariably advocated (though rarely practised) by the orthodox Surrealists. He never, on the other hand, denied the aesthetic value of an approach different from his own, and could not only appreciate, but actually defend the work of artists who chose other means for the expression of their insight. A striking example of such generous appreciation is afforded by his essay, *For But Not With*, in which he championed the work of the English abstract school, while expounding his own reasons for choosing a widely different approach to form and content.

Nash did, however, take up a highly critical position in regard to one particular aspect of English art in general and contemporary work in particular. As we have seen, he blamed the English school for its tendency to disregard the importance of technique. In advancing his strictures he presumably had in mind chiefly the kind of pictures so often exhibited in the shows of the New English Art Club and the London Group in the period following the First War. He saw the need for a basic technical discipline as a prerequisite in the arts and believed that meaning could no more be expressed in line and colour without a proper grasp of facture, than it could be in words without a basic knowledge of grammar and syntax. In this contention he was supported by other artists and it was on this theoretic basis that the short-lived Unit One group was formed.

The practical idealism which inspired the policy of the group was peculiarly English and particularly characteristic of Nash. The sturdy individualism of the chosen artists was not to be sunk in a common programme. They were not to form a recognisable 'school', but were only asked to accept certain fundamental

principles which appeared to Nash to be already common to them in the practice of their widely differing styles. Such a unity, could it have been properly understood and fully realised by the participants, might have afforded a much sounder basis for the development of English art than any other type of grouping which might have been possible in the early thirties, since it offered the prospect of a disciplined liberty eminently suited to the native genius. The fact that Nash realised the need and attempted to meet it, is in itself a tribute to his perceptivity and far-sightedness. The failure of Unit One may be said to have postponed a revival of the visual arts in England, for though much was achieved by the abstract painters, sculptors, and architects, who joined in the publication of *Circle*, their aims were more international. Much of their direct inspiration was drawn from Naum Gabo (a joint editor of *Circle*) and from Piet Mondrian, who worked closely with them.

The Surrealist Exhibition of 1937 was, again, international in character, and though it attracted a certain number of English followers, its continental origins and quasi-political theories rendered it unpalatable to many of the painters, sculptors and poets who had been initially attracted by the poetic elements it embodied. In consequence, a true revival of artistic consciousness had to await the impact of the Second World War, when, cut off from direct contact with the vital elements of the foreign schools, English painters and sculptors were forced to evolve their individual styles in an isolation which proved wholly beneficial to them. The conditions of war were, moreover, strangely favourable to precisely that kind of disciplined liberty which Nash had sought in his Unit One group.

A reasonable degree of isolation was always essential to Nash himself, as is proved by his successive rejection of the various contemporary idioms. Though he could derive inspiration from the work or the theories of many different groups, he could never remain content with the results of assimilating his style to theirs. He took what he needed from Post-Impressionism and Futurism, from abstract art and Surrealism, and passed on to the development of his personal vision, strengthened by his contact with others but unswayed in his determination to pursue his own researches in his own way.

All his life he was a seeker, and though the immediate objects of his quest naturally varied from time to time, they were always consistent with his basic attitude to art and life. As early as 1919 he had reached the con-clusion that his aim must be to interpret rather than to reproduce nature, a conclusion which his work as a war artist had done much to clarify. Ten years later he had come to see that interpretation alone did not suffice him and that the liberated intuition must play a larger part in his work, since he might otherwise stand in danger of lapsing into a mere repetition of an established mode. On the face of it, his resolution to explore the metaphysical and the unconscious might appear to have divorced him from the main tradition of English landscape painting, of which he had become a leading exponent. And yet it did not. The English-ness of English art had long been acknowledged by many authorities to lie in a certain poetic over-plus, an implicit awareness of transcendental or metaphysical values that cannot be explicitly rendered either in words or visual forms.

Thus, in extending his imaginative interpretation of landscape into the field of more metaphysical adventure, and in giving free rein to his sense of humour, while yet retaining his over-riding seriousness of purpose, Paul Nash was not departing from the English tradition, but developing it. He enriched the tradition by demonstrating the possibility of taking the physically perceived as a point of departure for psychological or spiritual journeys of exploration. In this, and in his ability to take into account an irrational or nonsense element in experience, he certainly showed himself to be nearer to the Surrealists than to the Cubists or the Abstractionists, but his insistence on 'pictorial' values and his method of producing a completely conscious statement of mystical or subconscious phenomena distinguished his work from theirs.

From his brief incursion into the more objective and 'painterly' experiments of the late twenties and early thirties, Nash therefore returned in the Rye and Swanage periods to his true bent, which, as I have endeavoured to show, was a conscious development of the English tradition at its most imaginative. From then on until the end of his life his quest was continuous and consistent. Yet he never ceased to experiment, and he always retained a willingness to assimilate into his own attitudes and styles elements which he derived from contacts with other minds.

The problem of influences always poses an interesting question in the study of an artist's work, though it is often given undue weight by theorists who forget that painters and sculptors are no less human than their fellow men. No one, however solitary by nature, can in fact work in total isolation. Even the anchorite and

the recluse are at some period of their lives subject to the influence of other human minds. On the other hand, an artist or a writer whose receptivity is so great that his work is nothing but a reflection of existing styles, has no claim to be considered as more than a copyist. A balance must be struck between what is received and what is offered in return.

In the case of Nash, as we have seen, the influence of both older and of contemporary schools can be traced in his paintings, but it is always transmuted by the power of his imagination into something intensely personal to himself. No less potent than his contacts with the visual arts of the past and the present were his contacts with men working in other fields. Literature, and in particular poetic literature, exerted an enormous influence on him, and he had a peculiar sympathy with its practitioners. To this may be attributed his outstanding success as an illustrator, for he entered intuitively into his subject and understood the mind of its creator because his own skill with words fitted him to interpret the words of others. He had, moreover, a need for the stimulus of understanding sympathy at critical moments in his career. When that support and understanding came from writers, it proved of double value. Many of his friends were writers, and in the study of his development their influence must be taken into account. Gordon Bottomley, John Drinkwater, John Cournos, Edward Thomas, Sacheverel and Osbert Sitwell, Herbert Read and, perhaps above all, the American poet, Conrad Aiken, all played their part either directly or indirectly. Each of these men represented for him aspects of that liberated imagination which was of supreme importance to him, and Aiken in particular encouraged him to trust to the promptings of his intuition at a moment when he stood in greatest need of such guidance, for Aiken, like Read, derived his metaphysical inspiration from the inner meaning of the land around him. The poet's response to his early encounters with Nash is interestingly summed up in his autobiographical narrative, *Ushant*, in which he says that the painter brought into his house in Rye,

'not only the feline grace and the Persian eye, or the arched light-years of his *Hanging Gardens*, the ethereal vanishings of the *Mansions of the Dead*, but also the unsleeping and amusedly affectionate and immortal watchfulness of a mind half man's half satyr's, the love of beauty that was oddly both animal and mineral and could be as soft as a cobweb (as in his drawing for the Garden of Cyrus) or the flesh of a woman, or as hard as one of the flints in his *Nest of Wild Stones*.'

Another facet of Nash's character, which evoked an equally understanding response, is described in Lance Sieveking's *The Eye of the Beholder*,

'He had', wrote Sieveking, 'a quick and amazingly *orderly* mind, and it was necessary for him to find out and grasp every detail connected with anything he undertook right at the outset. It was so when later he took up photography and stage designing; when he embarked on lithography; and when he organised such things as Unit One. . . . He had in his art and no less in his life a quality of disciplined integrity above everything else.'

Both these passages in their different ways provide an insight into the workings of Nash's mind and make it clear that it was from the combination of extreme perceptiveness and concentrated precision, amused detachment and passionate involvement that the particular quality of his work was derived.

The full realisation of an underlying Unity in all things, which is finally seen as the goal towards which he had always striven, could never have been attained by Nash without the progressive stages of the imaginative release, nor could he have expressed it in formal terms without evolving a personal symbolic idiom. Some of his symbols were consciously fashioned, others were—wholly consciously—derived from folklore and myth, while others appear to have sprung spontaneously from the storehouse of the unconscious and to have been employed intuitively, with an intellectual understanding of their significance. It is interesting to observe that the validity of a particular image (as for instance in some of the works deriving from the Avebury stones, in a number of the 'flight' studies, whether of aircraft or of flowers, and in the earlier *Harbour and Room*) is frequently better and more convincingly conveyed in the original drawings or watercolours than in the oils based on them. The explanation is not far to seek. 'Paul is a Poet', Ben Nicholson had said, and the poetry was essentially of the lyric rather than the epic variety. 'Jewels five words long that, on the stretch'd forefinger of all Time, Sparkle for ever' may lose something of their brilliance when placed in too heavy a setting.

Nash's was a poetry of the seized moment, of the sudden glimpse of an inner reality, when the veil is for a second lifted and the muted glory is revealed. Sometimes the vision can be so intense that it remains long enough to allow of a fuller rendering. Such was the case in the great oils such as *Winter Sea, Event on the*

Downs and perhaps above all, *Eclipse of the Sunflower* and *Solstice of the Sunflower*. Much thought went into their making, and yet they retain the clarity of the original inspiration. At their best, Nash's oil paintings are magnificent; at their worst they are dull. Between the two extremes there is a wide range of work that is important and often fine, but yet lacks that fire of inspiration more often to be found in his watercolours.

Essentially, then, the greatness of Paul Nash lies in his watercolours. It is in these that his sense of 'immortal longings' shines forth most clearly. The scale is small, but that, as Herbert Read so eloquently argued, is no demerit. The virtue of a picture does not reside in its size, but in the quality of its execution and in the worth and immediacy of the insight it conveys. Since Nash was not merely a fine painter, but also a great and noble spirit in the full meaning of the words, and since he had the power to convey the intensity of his perception and the integrity of his character in visual terms, his personal contribution to the art of this century is one of real importance.

In the fear-ridden, vulgar and noisy years that have passed since Nash's death in 1946 that importance has been somewhat overlooked. A generation tainted with American barbarism, haunted by a feeling of insecurity, and dominated by violence, has failed to grasp the fundamental values of the purely contemplative art, that expressed the basic qualities of Nash both as man and as painter. He possessed in both capacities the inestimable quality of grace. It is quiet virtue, born of contemplation. He had the divine gift of laughter as well as of tears. His irony and wit were tempered with deep human and spiritual understanding; he loved nature, both for its outward form and its inner meaning. His passionate seriousness was balanced by a debonair gaiety of manner and a fastidious elegance of appearance and taste. All these facets of his personality can be found in his art, which was the intensely personal expression of a wholly integrated man. Though he founded no 'school' and his imitators were few, because his style was not a technical trick but an integral part of his own vision, the lasting importance of his finest work cannot be doubted and is, indeed, already being increasingly realised. The contribution of Paul Nash, the Master of the Image, is and will remain one of the important landmarks of the English School.

Catalogue of Plates

Colour Plates are indicated by an asterisk

The list given below is intended to serve both as an index of the Plates and as a catalogue of the works illustrated. It therefore includes not only the details of date, medium and size, which are also given in the chronological section, but also information regarding the principal exhibitions in which the works were shown, the names of owners, and other supplementary details, where appropriate.

The catalogue, for reasons of space, is necessarily brief, and no mention is made of mixed exhibitions, nor are bibliographical details included. In certain instances it has been impossible to ascertain the present whereabouts of a painting and the collector's name has therefore had to be omitted or to be placed in brackets, indicating the ownership listed by Mrs. Paul Nash in her Photographic Record, compiled prior to 1960. Some owners who have kindly supplied details of works in their possession have requested that their names should be withheld, and in such cases the paintings and drawings are given as being in a 'Private Collection'.

The details of each work are given in the following order: Title, alternative title if the work has been variously listed elsewhere, dates, medium, size, method of signature, collection, principal exhibitions in which it was shown, and supplementary details or explanatory notes.

Sizes are stated in inches, the height being given before the width. The method of signature is abbreviated as follows: S. = signed; S.F. = signed in full; U.S. = unsigned; S.Mon. = signed with monogram; S.D. = signed and dated; T. = top; B. = bottom; L. = left; R. = right; M. = middle. Thus S.Mon.D.1924M.R. indicates that a painting is signed with the monogram and dated '1924' in the middle of the right side.

1 a *Our Lady of Inspiration*, 1910
Ink & chalk, 6¾ × 9 ins. U.S.
Private Collection
Newcastle, 1971
The ideal head which also figures, full face, in *Vision at Evening*, drawn by P. N. when studying at Bolt Court.
See *Poet & Painter*

b *Angel and Devil*, or *The Combat*, 1910
Pencil, pen & ink & wash, 14 × 10⅛ ins.
S. Mon. B.L.
Victoria and Albert Museum, presented by the Nash Trustees.
Oxford, 1931; Newcastle, 1971
See *Outline; Poet & Painter*

2 a *Crier by Night*, 1910
Pen & pencil, 7¼ × 5½ ins. S.Mon.B.L.
Carlisle Public Library, presented by Mrs. Paul Nash.
Illustration on a blank page of Gordon Bottomley's Verse Play of the same name. The subject of the first letters in the Nash-Bottomley correspondence.

b *Lavengro teaching Armenian to Isopel in the Dingle*, 1912
Watercolour & chalk, 17½ × 14 ins.
S.F. & Mon.B.R.
Ex. colls: The late Sir Michael Sadler; the late Sir Gerald Kelly, R.A.
Dorien Leigh Gall., 1914; Tate Gall., 1948
See *Outline; Poet & Painter*

95

3 a *Night Landscape* (formerly *The Archer*), *c.* 1911–1914
Watercolour, pen & ink, 15 × 12 ins. U.S.
Arts Council of Great Britain
Dorien Leigh Gall., 1914
The figure of the Archer, though later obliterated,
is still faintly visible.

b *Falling Stars*, *c.* 1911
Pen, pencil, wash & chalk, 12¼ × 8¾ ins. U.S.
Ex. coll. The Late Sir William Rothenstein
Sir John Rothenstein, C.B.E., LL.D., and Lady
Rothenstein

4 a *Peacock Path*, 1912
Black ink & watercolour, 18 × 15 ins. Titled,
S.F. & Mon.B.R.
Benedict Read, Esq.
Carfax Gall., 1912; Tate Gall., 1948

b *Under the Hill* (Wittenham Clumps) 1912
Ink & blue wash, 15½ × 12¾ ins. S.Mon.B.R.
Carlisle Museum & Art Gallery (Bottomley be-
quest)
Carfax Gall., 1912

5 a *Green Hill*, *c.* 1913
Watercolour, chalk & pen, 13¾ × 18¼ ins.
S.Mon. & 'Nash'B.R.
Ex coll. The late Sir Michael Sadler. (Miss Selby)
Dorien Leigh Gall., 1914

b *Wittenham Clumps*, 1912
Watercolour, crayon, pencil & ink, 12⅛ × 15⅝ ins.
S.Mon. & 'Nash'B.R.
Carlisle Museum & Art Gallery (Bottomley be-
quest)
Newcastle, 1971
See *Poet & Painter*

6 a *Trees in Bird Garden*, 1913
Watercolour, pen & chalk, 16¼ × 12¼ ins. S.F.B.L.
Ex. coll. The late Sir Edward Marsh
Birmingham City Museum & Art Gallery
Dorien Leigh Gall., 1914

b *Barbara in the Garden* (*Landscape with three figures*),
c. 1913 or 1911
Pencil, pen & wash, 14⅛ × 19¼ ins. S.F.B.L.
Carlisle Museum & Art Gallery (Bottomley be-
quest)
Newcastle, 1971
See *Poet & Painter*

7 *Trees and Shrubs*, 1914
Watercolour, 12⅞ × 19 ins. S.F.D.B.R.
Manchester City Art Gallery (Rutherston Loan
Collection)
Newcastle, 1971

8 *Lake in a Wood*, 1916
Watercolour, pen & chalk, 9¾ × 13¼ ins. S.'Nash'
twice B.L.
Ex coll. Sir Michael Sadler. (Mrs. Kathleen Dodd)
Birmingham, 1917; Oxford, 1931; Tate Gall., 1948

★9 *Outside a Wood*, *c.* 1915
Watercolour, ink & chinese white, 11¼ × 14½ ins.
S.Mon. &'Nash' B.L.
Manchester City Art Gallery (Rutherston Loan
Collection)

★10 *Desolate Landscape, Ypres Salient*, 1917
Ink & watercolour, 7¾ × 10¼ ins. S.B.R.
Manchester City Art Gallery (Rutherston Loan
Collection)
Goupil Gall., 1917

11 *Wytschaete Woods*, 1917
Ink, chalk & watercolour, 7¾ × 10¼ ins. S.B.R.
Manchester City Art Gallery (Rutherston Loan
Collection)
Leicester Gall., 1918

12 a *Graveyard in Ruined Orchard near Vimy*, 1918
Pen, ink & wash, 9 × 11⅝ ins. S.B.L.
National Gallery of Canada
Leicester Gall., 1918

b *Chaos Decoratif*, 1917
Pencil, pen & watercolour, 10 × 8 ins. U.S.
Manchester City Art Gallery (Rutherston Loan
Collection)
Goupil Gall., 1917

13 a *Broken Trees*, 1918
Ink & wash, 10½ × 14 ins.
Ex coll. J. B. Priestley, Esq.

b *Leaving the Trenches*, 1917
Watercolour, pen & chalk, S.B.R.

14 a *Company Headquarters*, 1918
Pen & wash, 9¾ × 13¾ ins. U.S.
Leicester Gall., 1918

b *In the Tunnels*, 1918
Pen, wash & chalk, U.S.
Ex coll. The late John Drinkwater
Leicester Gall., 1918

15 *Broken Trees, Wytschaete*, 1918
Indian ink & white chalk, 10⅛ × 14 ins. S.F.B.R.
Victoria & Albert Museum
Leicester Gall., 1918; Tate Gall., 1948

16 *We are Making a New World*, 1918
 Oil, 28 × 36 ins. U.S.
 Imperial War Museum
 Leicester Gall., 1918; Venice, 1938; South Africa,
 1947–8

17 a *Dumbarton Lakes*, 1918
 Pen & wash, $10\frac{1}{8}$ × 14 ins. U.S.
 National Gallery of Canada
 Leicester Gall., 1918

 b *Landscape, Year of Our Lord*, 1917
 Pen, chalk & wash on brown paper, $10\frac{1}{8}$ × $14\frac{1}{8}$ ins.
 National Gallery of Canada
 Leicester Gall., 1918

18 *Void*, 1918
 Oil, 28 × $36\frac{1}{8}$ ins. S.F.B.R.
 National Gallery of Canada
 Leicester Gall., 1918

★19 *The Menin Road*, 1919
 Oil, 72 × 125 ins. S.F.
 Imperial War Museum
 Tate Gall., 1948

★20 *Old Front Line, St Eloi, Ypres Salient*, 1917
 Watercolour, $8\frac{3}{4}$ × 8 ins. U.S.
 Victoria & Albert Museum
 Goupil Gall., 1917; Birmingham, 1917; Oxford.,
 1931; Tate Gall., 1948

21 a *The Field Path*, 1918
 Watercolour, 10 × $10\frac{3}{4}$ ins. S.F.D.B.L.
 Carlisle Museum & Art Gallery (Bottomley bequest)
 Newcastle, 1971

 b *Wooded Hills in Autumn*, 1921–2
 Pen, ink & watercolour, $15\frac{1}{8}$ × 22 ins. S.F.D.B.R.
 Whitworth Art Gallery, Manchester

22 a *The Canal*, 1920
 Ink, crayon & watercolour, 14 × $20\frac{3}{4}$ ins. U.S.
 Ex coll. Sir Michael Sadler
 Leeds City Art Gallery
 Design for projected mural in Leeds Town Hall,
 not executed

 b *The Quarry*, 1920
 Ink, crayon & watercolour, 14 × 21 ins. U.S.
 Ex coll. Sir Michael Sadler
 Leeds City Art Gallery
 Design for projected mural in Leeds Town Hall,
 not executed

23 *The Backwater*, 1919
 Watercolour, $10\frac{5}{8}$ × 15 ins. S.F.D.B.L.
 (Mrs. Christopher Powell)
 Fitzroy St., 1919

24 a *The Lake*, 1921/27
 Oil, $40\frac{1}{2}$ × $50\frac{1}{4}$ ins. S.B.L.
 Leicester Gall., 1924; Oxford, 1931
 See *Outline*

 b *Chestnut Waters*, 1921/27/38
 Oil, $40\frac{1}{2}$ × $50\frac{1}{4}$ ins. S.B.L.
 National Gallery of Canada (Massey Foundation)
 Tate Gall., 1946; Ottawa, 1946; Sydney, 1949
 The painting in its original form was designed in
 1921, shortly after the death of Claude Lovat Fraser,
 and was probably finished about 1927. The nude
 appears to have been painted out in 1938.

25 a *Whiteleaf Cross*, 1922
 Watercolour, $20\frac{5}{8}$ × 15 ins. U.S.
 British Council
 Redfern Gall., 1949

 b *Red Night*, 1919
 Watercolour, pencil & ink, $11\frac{1}{8}$ × $15\frac{1}{4}$ ins. S.F.B.L.
 Manchester City Art Gallery (Ruthers Loan Collection)
 Fitzroy St., 1919

26 *Wind in the Beeches*, 1918
 Watercolour, $20\frac{1}{2}$ × $15\frac{3}{4}$ ins. S.F.D.B.R.
 Aberdeen Art Gallery and Industrial Museum
 See *Paul Nash*, Anthony Bertram, Fleuron, 1927

27 *Tench Pond in a Gale*, 1921–2
 Pen, pencil & water-colour, $22\frac{3}{4}$ × $15\frac{1}{2}$ ins.
 S.F.D.B.R.
 Tate Gallery. Ex coll. The late Sir Edward Marsh
 Tate Gall., 1948

28 *The Willow Pond*, c. 1925
 Watercolour, 18 × 14 ins. S.F.D.B.R.

★29 *The Walnut Tree*, 1924
 Pencil & crayon on card, $15\frac{1}{8}$ × $21\frac{5}{8}$ ins. S.F.D.B.L.
 Manchester City Art Gallery (Rutherston Loan
 Collection)

★30 *Bridge Over the Dyke*, 1924
 Watercolour, $15\frac{1}{2}$ × $21\frac{3}{4}$ ins.
 Ex coll. the Late Desmond Coke
 John Carter, Esq.

31 *Roadside*, 1921–23
Watercolour, $15\frac{3}{8} \times 21\frac{3}{4}$ ins. S.F.D.B.L.
Manchester City Art Gallery (Rutherston Loan Collection)
Leicester Gall., 1924

32 *Coast Scene, Dymchurch*, 1921
Oil
Ex coll. The late Colonel T. E. Lawrence; (The Hon. Mrs. St. Leger)
Oxford, 1931

33 *The Wall against the Sea*, 1922
Oil, 24 × 35 ins. S.F.D.B.R.
Ex coll. Carnegie Institute, Pittsburgh U.S.A.
Victor Spaak, Esq.
Pittsburgh 1941

34 *'Margaret on the Steps'*, c. 1920/23
Oil, 20 × 24 ins.
Ex coll. Ralph Smith, Esq.

35 *Night Tide, Dymchurch*, 1922
Watercolour & black lead, 15 × 22 ins.
Ex coll. Colonel Robert Adeane
Oxford, 1931; Redfern Gall., 1937; Venice, 1938; Cambridge, 1939; Leeds, 1943; Cheltenham, 1945; Tate Gall., 1948

36 *Genesis*, 1923/4
Original drawings approx. $5 \times 3\frac{1}{2}$ ins. on loose notebook pages, pencil (36 b has the addition of blue crayon). The designs appear in the order in which they are printed in 'The First Chapter of Genesis in the Authorised Version', Nonesuch Press, 1924, but the designs for *The Void* and *The Stars Also* are missing. 36 a,b,c,d,e, and 37 a,b,c have pencilled notes on the bottom margin of the paper.
Ex colls. The late Mrs. Paul Nash: The Paul Nash Trustees
The British Museum

a *The Face of the Waters*
Insc. 'crystal tent'

b *The Division of the Light from the Darkness*
Insc. 'prism straight intersection'

c *The Creation of the Firmament*
Insc. 'elipse'

d *The Dry Land Appearing*
Insc. 'Pyramid angular'

e *The Sun and the Moon*
Insc. 'sphere'

37 *Genesis* (cont.)

a *The Fish and the Fowl*
Insc. 'arc & spiral rhythm'

b *Vegetation*
Insc. 'Dome, con & tube' [*sic*]

c *Cattle and Creeping Things*
Insc. 'rectangle box form' [*sic*]

d *Man and Woman*

e *Contemplation*

38 *The Shore*, 1923
Oil, $26\frac{1}{2} \times 37\frac{1}{2}$ ins. S.F.D.B.R.
Leeds City Art Gallery
Leicester Gall., 1924; Leeds, 1943; Tate Gall., 1948; British Council, 1962

★39 *Dymchurch Wall*, 1923
Watercolour, $14\frac{1}{2} \times 21\frac{1}{2}$ ins. S.F.M.R.
Private Collection
Redfern Gall., 1942; Tate Gall., 1948

★40 *Winter Sea*, 1925–37
Oil, 28 × 38 ins. S.F.D.B.L.
York City Art Gallery. Ex coll. Mrs. Charles Grey
Leicester Gall., 1938; National Gall., 1940; Leeds, 1943; Tate Gall., 1948

41 a *Winter Sea*, 1925–37
Conté & watercolour, $14\frac{3}{8} \times 21$ ins. S.F.D.B.L.
Graves Art Gallery, Sheffield
Redfern Gall., 1937

b *Downs*, 1924
Pencil & watercolour on brown paper, $14\frac{1}{2} \times 20$ ins. S.F.D.B.L.
Manchester City Art Gallery (Rutherston Loan Collection)
Leicester Gall., 1924.

42 a *Cros de Cagnes, Study*, c. 1926
Pencil & chalk, $8\frac{1}{2} \times 13$ ins. Insc. 'Original drawing for a painting not carried out. P.'
Ex coll. The late Lancelot de G. Sieveking
Hamet Gallery

b *Boats at Cagnes*, c. 1926
Crayon, $5\frac{1}{2} \times 8$ ins. S.Mon.B.R.
Ex coll. The late Lancelot de G. Sieveking
Hamet Gallery

43 *Riviera Window, c.* 1926
Oil, 20½ × 19½ ins. U.S.
Glasgow Art Gallery
Leeds, 1943

44 *Mimosa Wood,* 1926
Oil, 21½ × 25¾ ins. S.F.B.R.
National Art Gallery of New South Wales, Sydney

45 *Rick Flat, (Stack Yard), c.* 1925/6
Oil, 24 × 20 ins. U.S.
City Art Gallery, Coventry
Ex coll. The late Sir Edward Marsh

46 *Sandling Park, Kent,* 1924
Oil, 35½ × 27½ ins. S.F.D.B.R.
Manchester City Art Gallery (Rutherston Loan Collection)
Leicester Gall., 1924; Leeds, 1943; Tate Gall., 1948

47 *Savernake,* 1927
Oil, 30 × 20 ins. S.Mon.B.L.
R. D. Girouard, Esq.
Tate Gall., 1948

48 *St Pancras Lilies,* 1927
Oil, 25 × 17½ ins. U.S.
Royal Ulster Museum & Art Gallery, Belfast
Tate Gall., 1948

49 *Bog Cotton,* 1926/7
Oil, 36 × 28¼ ins. U.S.
Leeds City Art Gallery
Tate Gall., 1948

50 a *Still Life,* 1926
Oil, 33 × 26 ins. S.F.B.L.

 b *Still Life, Iden,* 1926
Watercolour, S.F.B.R.
(Rex de C. Nankivell)

51 a *Coronilla (The Flowering Room),* 1929
Oil, 24 × 20 ins. S.Mon.B.R.
(Dr. J. E. O. Moyne)
Unit One, 1934; Leicester Gall., 1938

 b *Dead Spring,* 1929
Oil, 19½ × 15½ ins. S.Mon.B.R.
Charles Kearley, Esq.
Tate Gall., 1948

52 a *Group of Beeches,* 1929
Watercolour, 9¾ × 12¾ ins. S.Mon.B.R.
National Gallery of Victoria, Melbourne

 b *Wood on the Downs,* 1929
Oil, 28 × 36 ins. S.B.R.
Aberdeen Art Gallery
Leeds, 1943; Tate Gall., 1948

53 a *Woodstacks at Iden,* 1931
Watercolour, 26½ × 18½ ins. S.F.D.B.R.
Private Collection

 b *Month of March,* 1929
Oil, 36 × 28 ins. S.Mon. & F.R.
(Felix Salmon, Esq.)
Tate Gall., 1948

54 *February,* 1927
Oil, 20 × 24 ins. S.F.B.L.
Ex coll. The late Lord Sandwich

55 *Swan Song,* 1928
Oil, 16½ × 20½ ins. S.Mon.B.R.
(Mrs. C. J. Evershed)
Leeds, 1943

56 *Opening,* 1931
Oil, 32 × 20 ins. S.F.D.B.R.
Private Collection (Ex coll. The late Lady Ludlow; Miss Sandra Wernher)
Leeds, 1943; Tate Gall., 1948

★57 *Northern Adventure,* 1929
Oil, 36 × 28½ ins. S.F.B.L.
Aberdeen Art Gallery and Industrial Museum
Unit One, 1934–5; Leicester Gall., 1938; Paris, 1938; Leeds, 1943; Cheltenham, 1945; Tate Gall., 1948; Newcastle, 1971

★58 *Glass Forest (Voyages of the Moon) (Globes floating in many-pillared Room), c.* 1930–1934
Watercolour, 12 × 8¾ ins. S.Mon.
Edward James Foundation (on loan to Brighton Art Gallery)
Newcastle, 1971

59 a *Formal Dream, (*1st version of *Voyages of the Moon),* 1934
Oil, 28 × 21¼ ins. S.F. & Mon.D.B.R.

 b *Voyages of the Moon,* 1934–37
Oil, 28 × 21¼ ins. S.F. & Mon.D.B.R.
Tate Gallery
Tate Gall., 1948

60 *Harbour and Room*, 1931
Oil, 36 × 28 ins.
Edward James Foundation (on loan to Brighton Art Gallery)
The date of the watercolour study throws doubt on the accepted date of 1930 for the oil version.

61 *Nest of the Siren*, 1930
Oil, 30 × 20 ins. U.S.
Department of the Environment
Tate Gall., 1948

62 *Night Piece, Toulon*, 1930
Watercolour, 21½ × 15 ins. U.S.
Richard Attenborough, Esq.
Tate Gall., 1948; Hamet Gall., 1970

63 *'Day Piece', Toulon*, c. 1930/36
Pencil & watercolour, 20¼ × 15¼ ins. S.
Hamet Gallery
Hamet Gall., 1970
No title is known, but the work is a companion piece to No. 62. The small figure at the bottom may be a later addition made in the Hampstead period.

64 *Atlantic*, 1932
Watercolour, 22 × 15¼ ins. S.F.D.B.R.
Lord Croft
Leicester Gall., 1932; Peking, 1963; East Berlin, 1963

65 *The Soul Visiting the Mansions of the Dead* (*Mansions of the Dead*) 1932
Watercolour, 8½ × 6¼ ins. Titled B.L.
British Council
Batsford Gall., 1931; National Gall., 1941; Tate Gall., 1948; Canada, 1949–50; Newcastle, 1971
Original design for Urne Buriall, Version A. Nash later called the watercolour by the full title given here.

66 *Convolvulus*, 1933
Watercolour, S.F.B.R.
From design for 'Urne Buriall and The Garden of Cyrus' by Sir Thomas Browne, Cassells, 1932

*67 *Quincunx*, 1932
Watercolour, 21 × 14 ins. S.F.B.R.
From a design for 'Urne Buriall & the Garden of Cyrus'.
Private collection
Tate Gall., 1948

*68 a *The Three Rooms*, c. 1936–7
Watercolour, 15½ × 11½ ins.
Edward James Foundation (on loan to Brighton Art Gallery)
Redfern Gall., 1937; Leicester Gall., 1938; Arts Council, 1951; Newcastle, 1971

 b *Forest and Room*, 1936–7
Watercolour, 8¼ × 9½ ins. S.Mon. & insc. to Edward James
Edward James Foundation (on loan to Brighton Art Gallery)
Preliminary design for No. 69. Also connected with Nos. 58 and 59

69 *Metamorphosis*, 1937/8
Oil, 25 × 30 ins. S.F.B.L.
Ex coll. Gordon Onslow Ford, Esq.
Gallery of Western Australia, Adelaide

70 *The Archer Overthrown*, (first state) 1931/8
Oil, 27½ × 36 ins. S.F.B.L.
Guy Dixon, Esq.
Redfern, 1961; Bath, 1962
The illustration shows the painting in its first state in 1931

71 *Summer*, 1933
Oil, 21 × 30 ins. S.Mon.R.
(Mrs. Ian MacPherson)
Leeds, 1943
The design is related to the illustrations to 'Urne Buriall and the Garden of Cyrus'

72 a *Druid Landscape*, 1938
Oil, 23 × 16 ins. S.B.L.
British Council

 b *Landscape of the Megaliths*, 1934
Oil, 19⅜ × 28¾ ins. S.B.L.
British Council
Surrealist Exhib. 1936; Leicester Gall., 1938; New York, 1939; Tate Gall., 1948; Canada, 1949–50; Marlborough Gall., 1965; Newcastle, 1971

73 *Equivalents for the Megaliths*, 1934
Oil, 19⅜ × 28¾ ins. S.F.B.L.
Ex coll. The late Lancelot de G. Sieveking
Tate Gall., 1948

74 *Landscape of the Megaliths*, 1937
Watercolour, pen & body colour, 19¾ × 29¾ ins. S.F.B.L.
Allbright Art Gallery, Buffalo, U.S.A.
Redfern Gall., 1937; Tate Gall., 1948

75 a *Cloud and Two Stones,* 1935
Oil, 20 × 15 ins. S.Mon.B.R.
Cyril Sweett
Leicester Gall., 1938

b *Nest of the Wild Stones,* 1937
Watercolour & pencil, 15 × 22 ins. S.B.L.
Arts Council of Great Britain. Ex coll. Miss Welby
Redfern Gall., 1937; Leicester Gall., 1938; New York, 1939; Boston, 1940; Tate Gall., 1948; Redfern, 1961

76 *Event on the Downs,* 1934
Oil, 20 × 24 ins. S.B.L.
Department of the Environment
Ex coll. Mrs. Charles Neilson
Venice, 1938; Cheltenham, 1945; Tate Gall., 1948

*77 *Nocturnal Landscape,* 1938
Oil, $30\frac{1}{8}$ × $40\frac{5}{8}$ ins. S.F.B.L.
Manchester City Art Gallery
Leicester Gall., 1938; New York, 1939; Tate Gall., 1948; Marlborough Gall., 1965; Newcastle, 1971

*78 *Stone Forest,* 1937
Pencil, crayon & watercolour, $23\frac{1}{8}$ × $15\frac{3}{4}$ ins. S.F.B.R.
Whitworth Art Gallery, University of Manchester
Redfern Gall., 1937; New York, 1939; Tate Gall., 1960; Newcastle, 1971

79 a *Stone Sea,* 1937
Watercolour, 15 × 22 ins. U.S.
(Mrs. Malcolm McBride, U.S.A.)
Redfern Gall., 1937

b *Wood Sea,* 1937
Watercolour, $15\frac{1}{2}$ × 23 ins. S.B.L.
Ex coll. Lord Eccles
Redfern Gall., 1937; Cambridge, 1939; Tate Gall., 1948

80 *Strange Coast,* 1937
Oil, 19 × 28 ins. S.F.B.L.
(Lt. Col. B. R. McNicholl, Melbourne)
Cambridge 1939

81 *Environment of Two Objects,* 1937
Oil, $20\frac{1}{2}$ × $30\frac{1}{2}$ ins. S.B.L.
Leicester Gall., 1938; Tate Gall., 1948

82 a *Denizens of the Forest of Dean,* 1939
Watercolour, 11 × $15\frac{1}{2}$ ins.
(Dr. Gwendoline Brown)
Redfern Gall., 1942

b *Object at Scarbank,* 1939
Watercolour, 11 × $15\frac{1}{2}$ ins. S.B.L.
Ex coll. R. Thesiger, Esq.
National Gall., 1941

83 *Sunset at Worth Matravers,* 1937
Watercolour, 7 × 10 ins. U.S.
Peter W. Cochrane, Esq.
Leeds, 1943; Tate Gall., 1948; Redfern Gall., 1961; Bath, 1962

84 *Worth Matravers, Dorset,* 1936
Watercolour, 15 × 20 ins. S.F.B.R.
Private Collection
Redfern Gall., 1961; Hamet Gall., 1970

85 *Sea Wall, Swanage,* 1934
Pencil & watercolour, $14\frac{3}{4}$ × $21\frac{3}{4}$ ins. S.F.B.L.
C. L. Brook, Esq.

86 *Laocoon,* 1941
Watercolour, $10\frac{1}{4}$ × $15\frac{1}{4}$ ins. S.F.B.R.
Ex coll. Lord Eccles
Redfern Gall., 1961

*87 *Voyages of the Fungus, (Voyage of the Fungus),* 1937
Watercolour, $11\frac{1}{4}$ × $15\frac{1}{2}$ ins. U.S.
Edward James Foundation (on loan to Brighton Art Council)
Leicester Gall., 1938; New York, 1939; Arts Council, 1951; Newcastle, 1971

*88 *Empty Room,* 1937
Watercolour, $14\frac{3}{4}$ × 22 ins. U.S.
Private collection
Cambridge, 1939; Northampton, 1939; Hamet Gall., 1970; Newcastle, 1971

89 *Landscape from a Dream,* 1936–38
Oil, $28\frac{1}{2}$ × 40 ins. S.F.B.L.
Tate Gallery
Leicester Gall., 1938; Cambridge, 1939; New York, 1939; Boston, 1940; Tate Gall., 1948

90 a *Different Skies,* 1939
Watercolour, 15 × 11 ins. U.S.
Ex coll. Mrs. Charles Neilson
Tooth Gall., 1939; Cheltenham, 1945; Redfern Gall., 1961

b *Monster Field, Study 2,* 1939
Watercolour, $11\frac{1}{2}$ × 16 ins. S.F.B.L.
Lord Croft
Tooth Gall., 1939; Redfern Gall., 1961
Study for the oil painting at Durban Art Gallery

91 *Monster Shore*, 1939
 Oil, 28 × 36 ins. S.F.B.L.
 Hamilton Art Gallery, Ontario
 Leeds, 1943

92 a *Forest of Dean*, 1938
 Watercolour, 11 × 16 ins.
 (R. D. Morse)
 One of the large group of studies

 b *Gregynog*, 1939
 Watercolour, 15½ × 22½ ins. S.F.B.L.
 (Miss Davies)

93 a *Minotaur*, 1939
 Watercolour, 11¼ × 15 ins. S.F.B.L.
 Ex coll. the late Sir Herbert Read
 Redfern Gall., 1942; Cheltenham, 1945; Newcastle,
 1971

 b *Monster Pond*, 1941
 Watercolour, 11½ × 15⅝ ins. S.F.B.L.
 Richard Smart, Esq.
 Tate Gall., 1948; Hamet Gall., 1970

94 *Incident at Madams*, 1943
 Watercolour, 15½ × 22½ ins. U.S.
 Mrs. Clare Neilson
 Cheltenham, 1945; Redfern, 1961

95 *Garden of the Madamites*, 1941
 Watercolour, 15½ × 22 ins. S.F.B.L.
 Charles Kearley, Esq.

96 *Grotto in the Snow*, 1939
 Oil, 28 × 19 ins. S.F.B.R.
 Tate Gallery
 Tate Gall., 1948

*97 *'Hampstead Garden'*, 1938
 Watercolour, 15 × 22 ins.
 Nash Trustees

*98 a *Totes Meer*, 1940–41
 Oil, 40 × 60 ins. S.F.B.R.
 Tate Gallery (presented by War Artists Advisory
 Committee)
 Leeds, 1943; Tate Gall., 1948

 b *Under the Cliff*, 1940
 Watercolour, & chalk, 15 × 22 ins. S.F.B.L.
 Ashmolean Museum (presented by War Artists
 Advisory Committee)
 National Gall., 1945

99 a *Lunar Rainbow*, 1941
 Pencil & watercolour, 15¼ × 22½ ins. S.F.B.L.
 City of Leicester Art Gallery
 Study for *Totes Meer*

 b *Bomber in the Wood*, 1940
 Watercolour, 15¼ × 22⅜ ins. S.B.L.
 Leeds City Art Gallery (presented by War Artists
 Advisory Committee)
 New York, 1941; Newcastle, 1971

100 a *Rose of Death*, 1939
 Collage & watercolour
 Destroyed

 b *Lebensraum*, 1939
 Collage & watercolour, 15 × 22½ ins. Titled B.L.
 (Maurice Cardiff)

101 a *Follow the Führer: Into the Skies*, 1942
 Collage & watercolour, 15¼ × 22¼ ins.
 Ex coll. Major George Holt
 Leicester Gall., 1942; Hamet Gall., 1970

 b *Follow the Führer: Under the Seas*, 1942
 Collage & watercolour, 15¼ × 22¼ ins.
 Ex coll. Major George Holt
 Leicester Gall., 1942; Hamet Gall., 1970

102 *Wellington Bomber Watching the Skies*, 1940
 Pencil & watercolour, 11¼ × 15⅜ ins. S.B.R.
 Leeds City Art Gallery (presented by War Artists
 Advisory Committee)
 Newcastle, 1971

103 *Whitleys at Sunrise*, 1940
 Watercolour, 12 × 16½ ins. S.F.B.R.
 Brighton Art Gallery (presented by War Artists
 Advisory Committee)

104 a *The Flare Path*, 1940
 Watercolour, 15 × 22 ins. S.F.B.L.

 b *Flying against Germany*, 1940
 Oil, 28 × 36 ins. S.F.B.L.
 National Gallery of Canada

105 a *Day Fighter*, 1940
 Oil, 39⅞ × 20 ins. S.F.B.L.
 National Gallery (Massey Foundation)

 b *Night Fighter*, 1940
 Oil, 39⅞ × 20 ins. S.B.R.
 National Gallery of Canada (Massey Foundation)

106 *Raider on the Shore*, 1940
Watercolour, $15\frac{13}{16} \times 22\frac{5}{16}$ ins. S.F.B.L.
Corporation Art Gallery, Glasgow

107 *Down in the Channel*, 1940
Watercolour, 15 × 22 ins. S.F.B.L.

108 *Target Area, Whitley Bombers over Berlin*, 1941
Watercolour, 26 × 36 ins. S.F.B.R.
Imperial War Museum
Royal Academy 1945

109 *The Augsburg Raid*, 1942
Watercolour, $15\frac{1}{4} \times 26\frac{1}{4}$ ins. S.Mon.B.R.
Richard Attenborough, Esq.

110 *Hampdens at Sunset*, 1940
Watercolour & chalk 11, × 15 ins. S.B.L.
Brighton Art Gallery (presented by War Artists
Advisory Committee)
Royal Academy, 1945

111 *Oxford in Wartime*, 1943
Oil, 45 × 40 ins.
Worcester College, Oxford

112 a *Bayswater Landscape*, 1940
Watercolour, $15\frac{1}{2} \times 22\frac{1}{2}$ ins. S.F. & 'London' L.
(Miss Patricia Raeburn)
Tate Gall., 1948

 b *London Snow (Landscape at Marble Arch)*, 1940
Watercolour, 11 × 15 ins. S.B.R. & 'London'
Private collection

113 a *Landscape of the British Museum*, 1944
Watercolour, 12 × $15\frac{1}{2}$ ins. S.F.B.L.
Fitzwilliam Museum, Cambridge

 b *Design of Trees*, 1943
Watercolour, 22 × 15 ins. S.Mon.
Ex coll. the late A. J. L. McDonnell
Tate Gall., 1948

114 *Oxford from Hinksey*, 1943
Watercolour, $11\frac{3}{4} \times 15\frac{3}{4}$ ins. S.F.B.L. & 'Study
Worcester College Panel'
Study for part of *Oxford in Wartime*

★115 *March Woods, Study II*, 1944
Watercolour, 15 × 22 ins.
Private Collection

★116 *Landscape of the Vernal Equinox*, 1944
Oil, 25 × 30 ins.
Scottish National Gallery of Modern Art. Ex coll.
Mrs. Paul Nash: The Nash Trustees
Cheltenham 1945,
Insc. on verso '*Landscape of Vernal Equinox 2nd
version 1944. Paul Nash*'
Painted for the artist's wife.

117 a *Landscape of the Vernal Equinox*, 1943–4
Oil & watercolour on board, $15\frac{1}{2} \times 22\frac{1}{2}$ ins.
(Ex coll. Sir Allen & Lady Lane)

 b *Landscape of the Vernal Equinox*, 1943–4
Oil, $27\frac{1}{2} \times 36$ ins. S.F.B.R.
H.M. The Queen Mother
Paris, 1945; Prague, 1946; Arts Council, 1946;
Tate Gall., 1948

118 a *Ghost of the Turtle (Kimmeridgian Ghost, the Turtle)*,
1942
Watercolour, 15 × 22 ins. S.F.B.R.
Private Collection
Redfern Gall., 1942; Tate Gall., 1948

 b *Ghost in the Shale*, 1942
Watercolour, $15\frac{1}{2} \times 22\frac{1}{2}$ ins. S.F.B.L.
(H. J. Patterson)
Redfern, 1942; Tate Gall., 1948; Redfern, 1961

119 a *Landscape of the Puff Ball*, 1943
Watercolour, 15 × 22 ins. S.F.B.R.
Private Collection. Ex coll. Sir Allen & Lady Lane
Tate Gall., 1948

 b *Flower resting in the Landscape*, 1945
Watercolour, $15\frac{1}{2} \times 22\frac{1}{2}$ ins. S.F.D.B.L.
Private Collection
Tooth Gall., 1945; Tate Gall., 1948

120 *Landscape of the Moon's First Quarter*, 1943
Oil, 20 × 30 ins. S.F.B.R.
(E. O. Kay)
Tate Gall., 1948

121 *Wooded Landscape*, 1942
Oil on paper board, 20 × 36 ins. S.B.R.
National Gallery of Canada (Massey Foundation)
Ottawa 1946; Sydney, 1949

122 a *Sunset Flower*, 1944
Watercolour, 19 × 14 ins.
(Private Collection, U.S.A.)

 b *Hydra Dandelion*, 1946
Watercolour, $15\frac{1}{2} \times 11\frac{1}{2}$ ins. S.F. & titled B.L.
H.M. The Queen

123 *Flight of the Magnolia*, 1944
Oil, 19½ × 29½ ins. S.F.B.L.
Cdr. Sir Michael Culme-Seymour, Bt.
Paris & Prague 1945 & 46; Tate Gall., 1948

124 *Sunflower and Sun*, 1943
Watercolour, 22 × 15 ins. S.B.R.
British Council
Tate Gall., 1948

*125 *Sunflower and Sun, Study, c.* 1945
Oil, 25 × 20 ins.
Private collection. Ex coll. Mrs. Paul Nash
Painted for the artist's wife

*126 a *The Sunflower Rises*, 1945
Watercolour, 17 × 22¾ ins.
Nash Trustees
Unfinished watercolour study for projected oil,
squared for enlargement.

b *Preliminary Sunflower Studies, c.* 1944/5
& c Crayon
The Paul Nash Trustees.

127 *Eclipse of the Sunflower*, 1945
Watercolour, 16½ × 22½ ins.
Victoria & Albert Museum, bequeathed by Mrs.
Paul Nash

128 *Eclipse of the Sunflower*, 1945
Oil, 28 × 36 ins. S.B.L.
British Council
Tooth Gall., 1945; Tate Gall., 1948; Redfern, 1961

129 *Solstice of the Sunflower*, 1945
Oil, 28 × 36 ins. S.F. & Mon.B.L.
National Gallery of Canada (Massey Foundation)
Tooth Gall., 1945; Tate Gall., 1948

130 *Farewell*, 1944
Oil, 21 × 24 ins. S.F.B.R.
Lord Croft
Tooth Gall., 1946; Tate Gall., 1948; Redfern Gall.,
1961

131 *Portrait of a Landscape Painted for Two Ladies*, 1944
Oil, 20 × 30 ins. S.F.B.L.
Ex coll. the late Mrs. Hilda Harrison

132 *Landscape of the Vale, Dawn*, 1943
Watercolour, 14⅞ × 21⅞ ins. S.F.B.R.
Birmingham City Museum and Art Gallery

133 *Sunrise over the Valley*, 1943
Watercolour, 15½ × 22½ ins. S.F.B.R.
The late Dudley Tooth

134 *Road to the Mountains*, 1944
Watercolour, 15½ × 22½ ins. S.F.R.
(Mrs. N. K. Lewis)
Tooth Gall., 1945; Tate Gall., 1948

*135 *November Moon*, 1942
Oil, 30 × 20 ins.
Fitzwilliam Museum, Cambridge, Ex. coll. the late
Sir Edward Marsh
Tate Gall., 1948

*136 *Sunset Eye, Study 5*, 1945
Watercolour, 11¼ × 15 ins. S.F.B.L.
Private collection

137 *Sunset over the Plain, Study 2*, 1944
Watercolour, 11 × 15½ ins. S.F.L.
Richard Walker, Esq.

138 *Hill, Plain & Cloud, Study 1*, 1945
Watercolour, 11¾ × 15½ ins. S.Mon.B.R.
(Rt. Hon. Vincent Massey)
Tooth Gall., 1945

139 *Landscape Fading*, 1945
Watercolour, 11 × 15½ ins. S.B.L.
Ex coll. Mrs. Charles Neilson

140 *March Storm*, 1944
Watercolour, 15 × 22 ins. S.F.B.R.

141 *Study in Pale Tones*, 1943
Watercolour, 15½ × 22½ ins. S.B.L.
(Royan Middleton, Esq.)

142 *Landscape after Frost*, 1945
Watercolour, 15½ × 22½ ins. S.F.D.B.R.
(Rt. Hon. Vincent Massey)
Tooth Gall., 1945

143 *Sunset over the Plain, Study 1*, 1944
Watercolour, 14 × 24 ins. S.F.B.L.
Sir Michael Culme Seymour, Bt.
Tooth Gall., 1945

144 *Landscape, Isle of Wight, Study 3*, 1946
Watercolour, 15½ × 22½ ins. U.S.
Private Collection
Painted on the last day of the artist's life

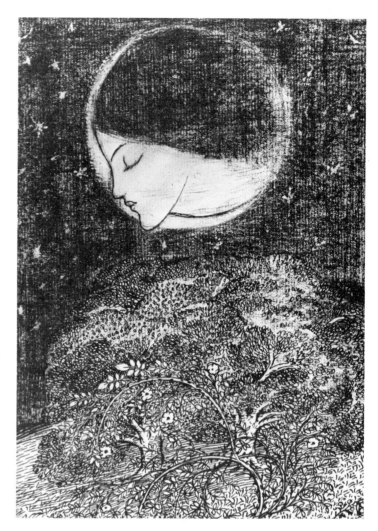

1a. OUR LADY OF INSPIRATION, *1910, ink and chalk, 6¾ × 9 ins.*

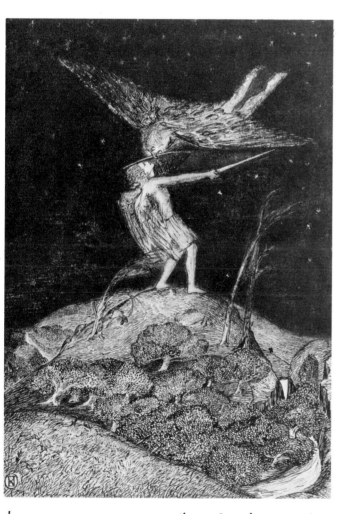

1b. ANGEL AND DEVIL, *1910, pencil, pen & wash, 14 × 10⅛ ins.*

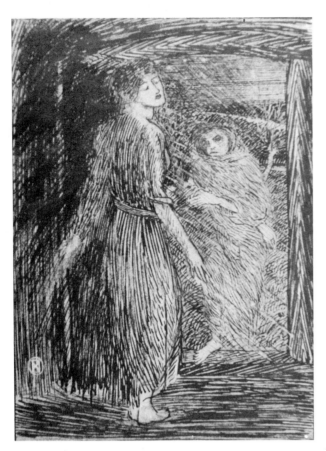

2a. CRIER BY NIGHT, *1910, pen & pencil,* $7\frac{1}{4} \times 5\frac{1}{2}$ *ins.*

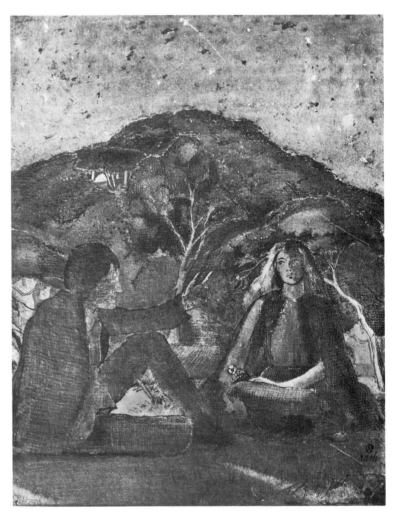

2b. LAVENGRO & ISOPEL IN THE DINGLE, *1912,*
watercolour & chalk, $17\frac{1}{2} \times 14$ *ins.*

3a. NIGHT LANDSCAPE, *1914,*
watercolour, pen & ink, 15 × 12 ins.

3b. FALLING STARS, *c. 1911,*
pen, pencil, wash & chalk, 12¼ × 8¾ ins.

4a. PEACOCK PATH, *1912, black ink & watercolour, 18 × 15 ins.*

4b. UNDER THE HILL, *1912, ink & blue wash, 15½ × 12¾ ins.*

5a. GREEN HILL, *1913,*
watercolour, chalk &
pen, 13¾ × 18¼ ins.

5b. WITTENHAM CLUMPS, *1912, watercolour, crayon, pencil & ink, 12⅛ × 15⅝ ins.*

6a. TREES IN BIRD GARDEN, *1913,*
watercolour, pen & chalk, 16¼ × 12¼ ins.

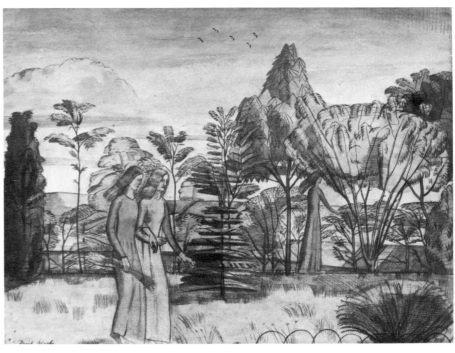

6b. BARBARA IN THE GARDEN, *1913,*
pencil, pen & wash, 14⅛ × 19¼ ins.

7. TREES AND SHRUBS, *1914, watercolour, 12⅞ × 19 ins.*

8. LAKE IN A WOOD, *1916, watercolour, pen & chalk, 9¾ × 13¼ ins.*

9. OUTSIDE A WOOD, *c. 1915, watercolour, ink & chinese white, $11\frac{1}{4} \times 14\frac{1}{2}$ ins.*

10. DESOLATE LANDSCAPE, YPRES SALIENT, *1917, ink & watercolour, 7¾ × 10¼ ins.*

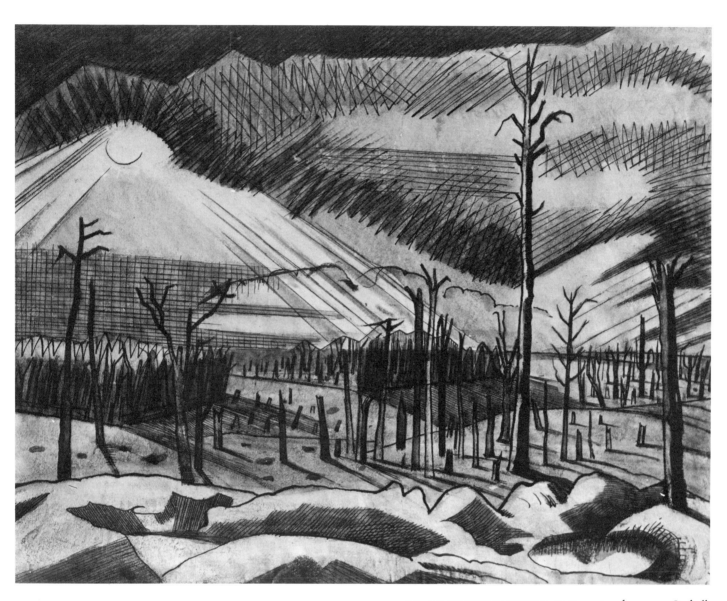

11. WYTSCHAETE WOODS, *1917, watercolour, pen & chalk*

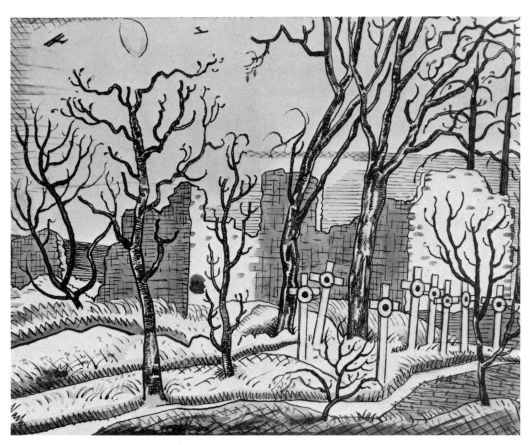

12a. GRAVEYARD IN RUINED ORCHARD NEAR VIMY, *1918,*
pen & ink, 9 × 11⅝ ins.

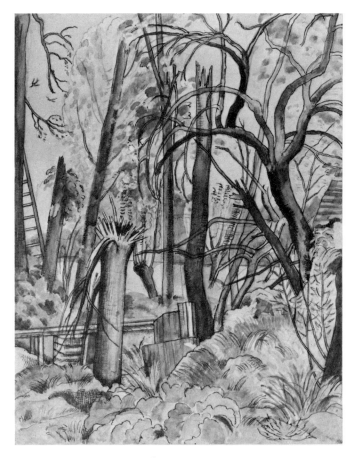

12b. CHAOS DECORATIF, *1917, pencil,*
pen & watercolour, 10 × 8 ins.

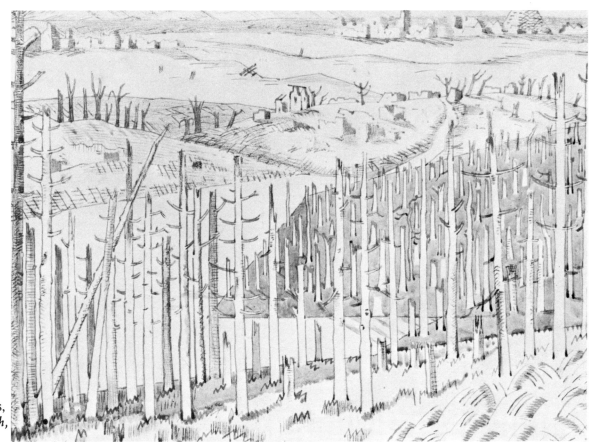

13a. BROKEN TREES,
1918, ink & wash,
10½ × 14 ins.

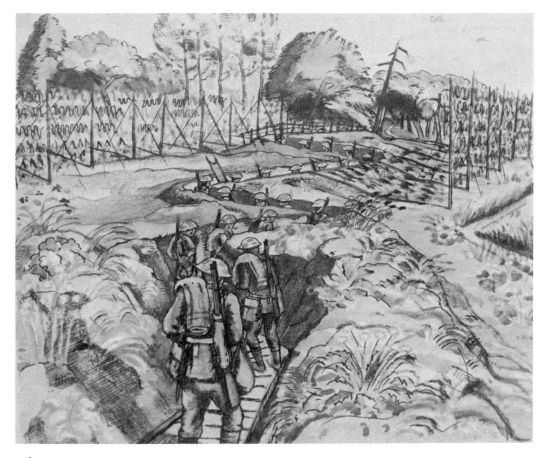

13b. LEAVING THE TRENCHES, 1917, watercolour, pen & chalk

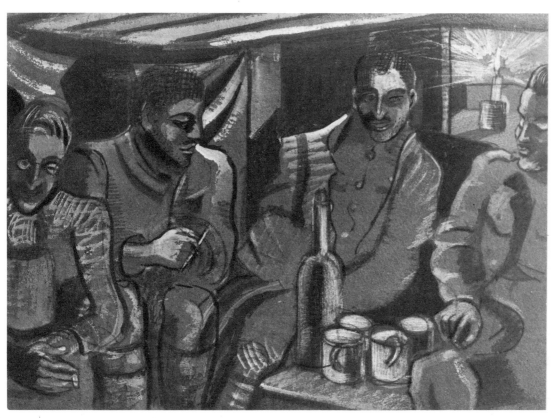

14a. COMPANY HEADQUARTERS, *1918, pen & wash, 9¾ × 13¼ ins.*

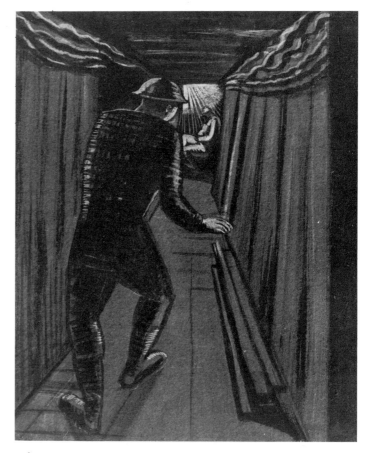

14b. IN THE TUNNELS, *1918, pen, wash & chalk*

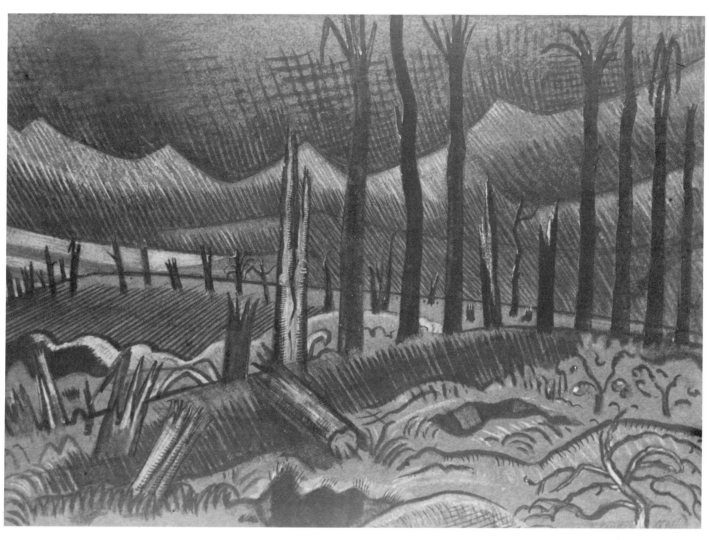

15. BROKEN TREES, WYTSCHAETE, *1918, indian ink & white chalk, 10⅛ × 14 ins.*

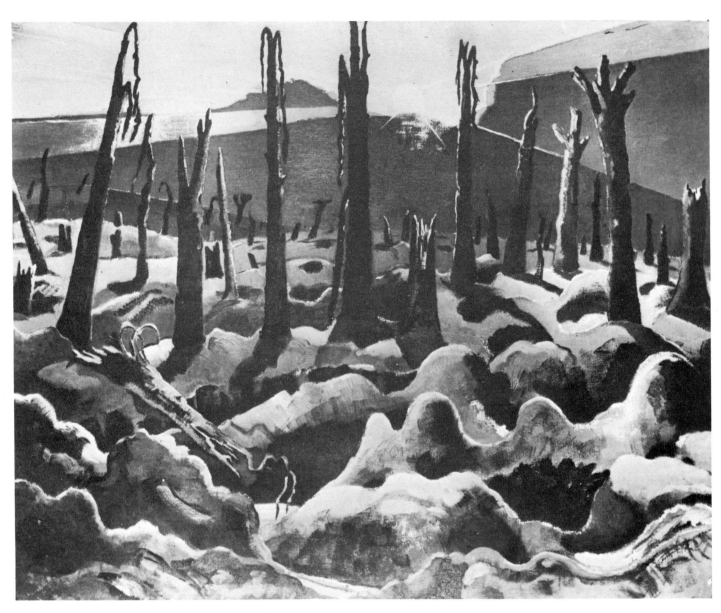

16. WE ARE MAKING A NEW WORLD, *1918, oil, 28 × 36 ins.*

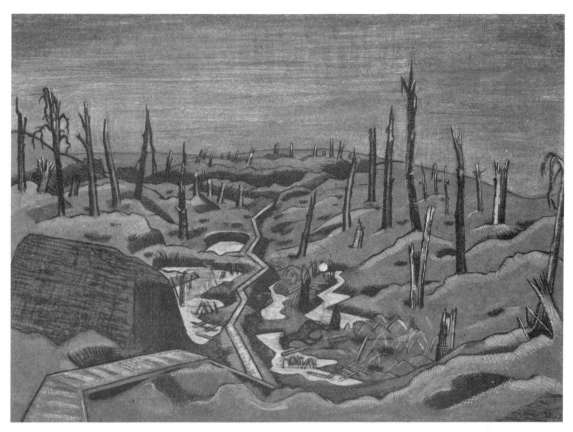

17a. DUMBARTON LAKES, *1918, pen & wash, 10⅛ × 14 ins.*

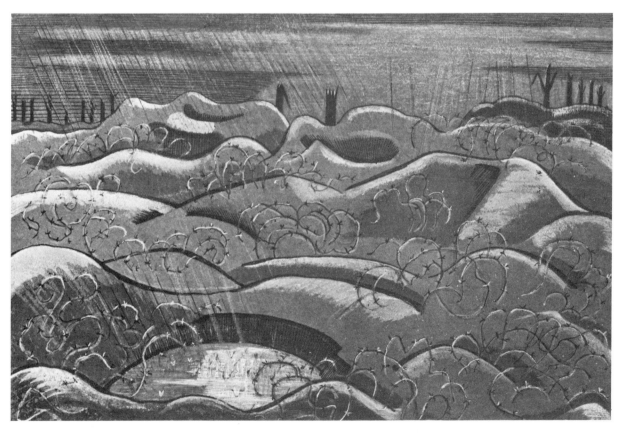

17b. LANDSCAPE, YEAR OF OUR LORD, *1917, pen, chalk & wash on brown paper, 10⅛ × 14⅛ ins.*

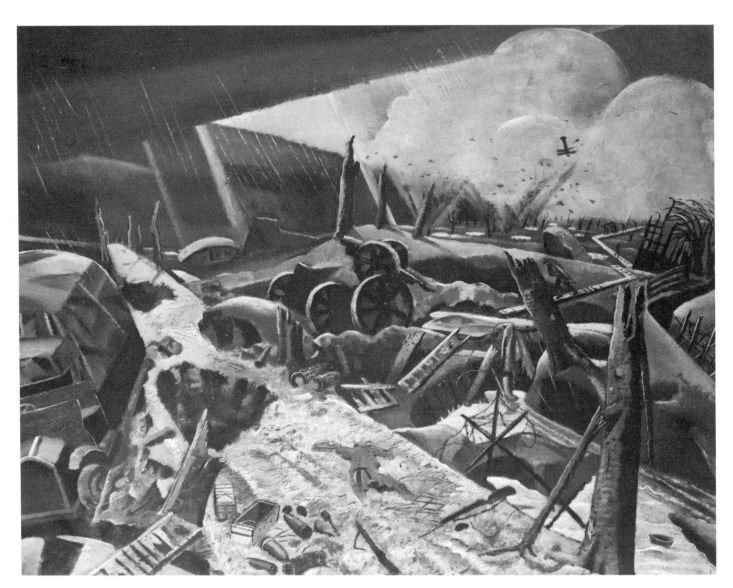

18. VOID, *1918, oil, 28 × 36⅛ ins.*

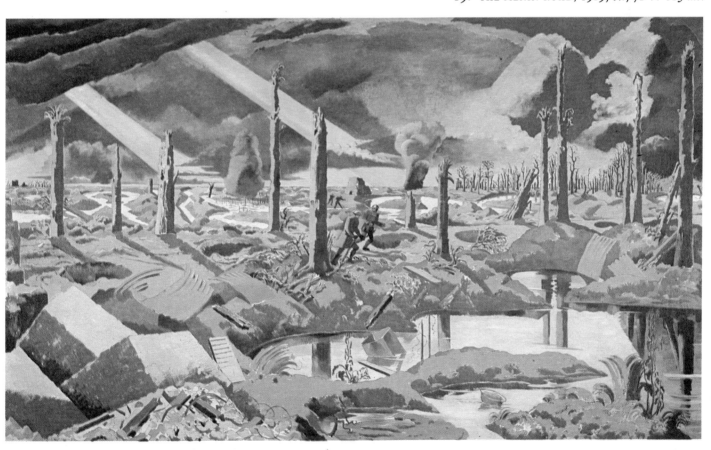

19. THE MENIN ROAD, *1919, oil, 72 × 125 ins.*

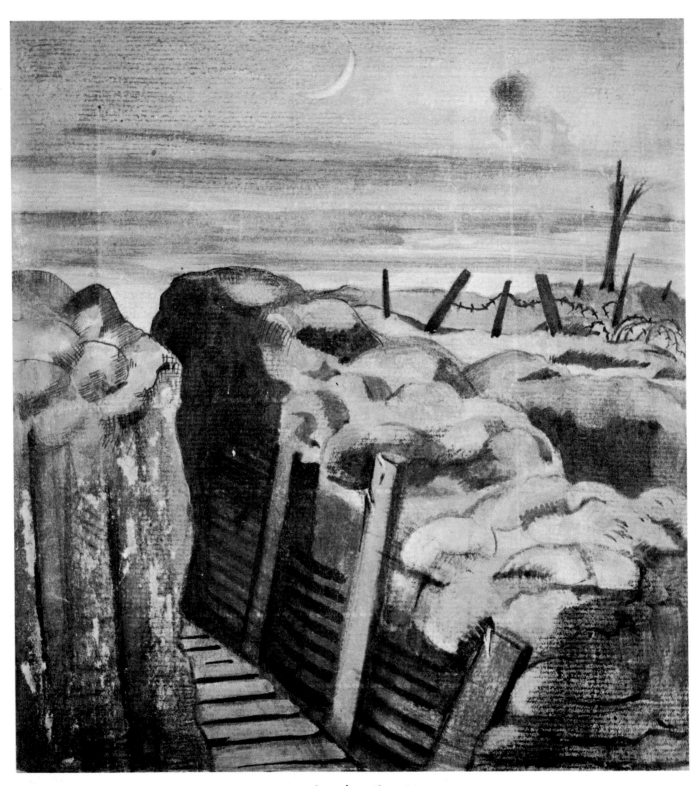

20. OLD FRONT LINE, ST ELOI, YPRES SALIENT, *1917, watercolour,* 8¾ × 8 *ins.*

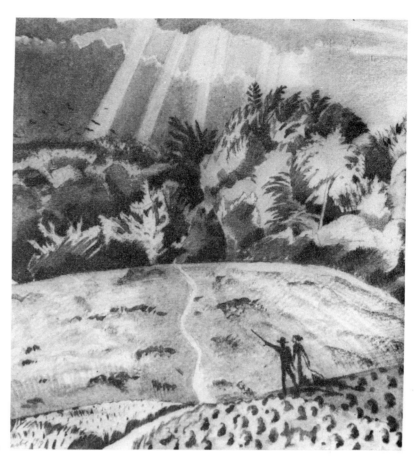

21a. THE FIELD PATH, *1918, watercolour, 10 × 10¾ ins.*

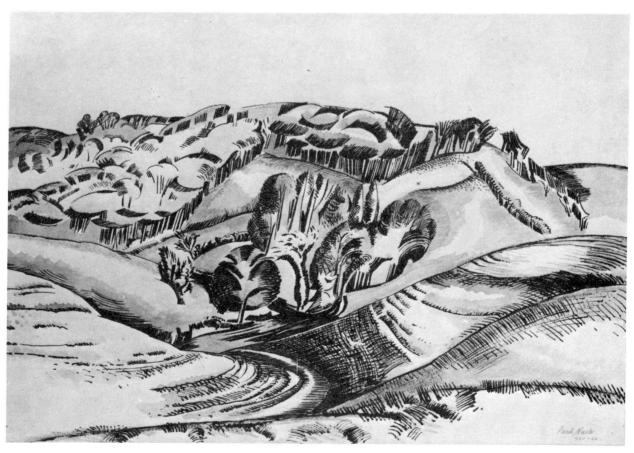

21b. WOODED HILLS IN AUTUMN, *1921–2, pen, ink & watercolour, 15⅛ × 22 ins.*

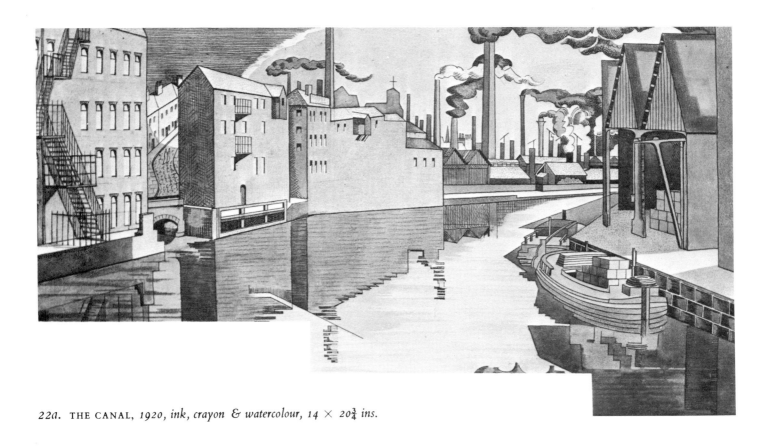

22a. THE CANAL, *1920, ink, crayon & watercolour, 14 × 20¾ ins.*

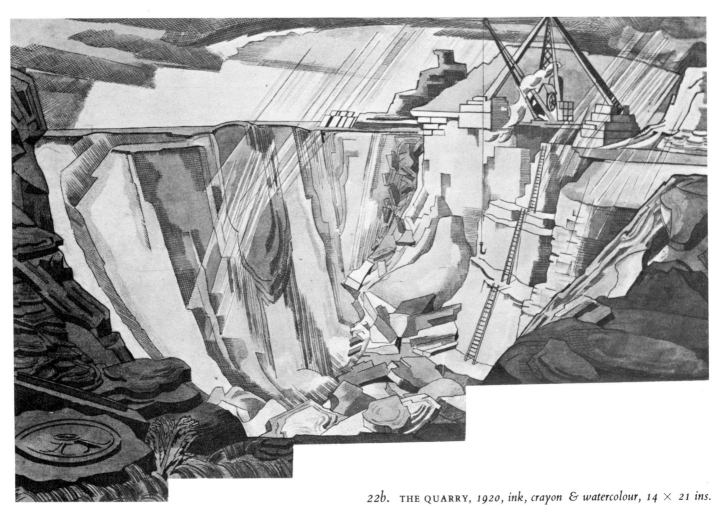

22b. THE QUARRY, *1920, ink, crayon & watercolour, 14 × 21 ins.*

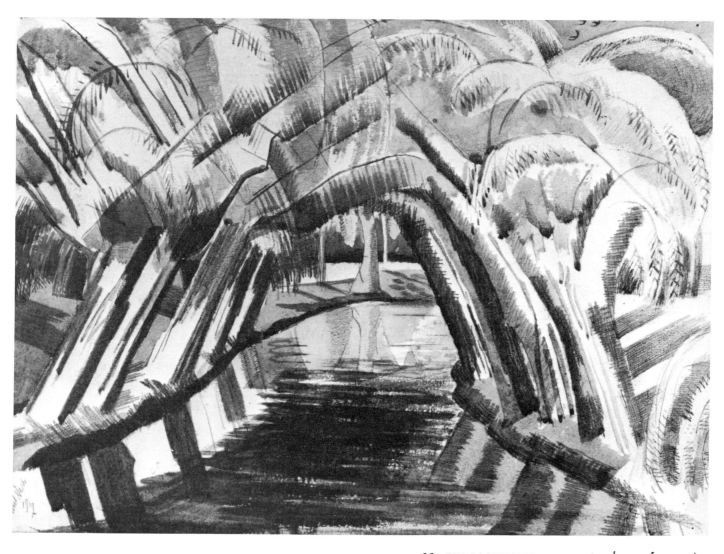

23. THE BACKWATER, *1919, watercolour, 10⅝ × 15 ins.*

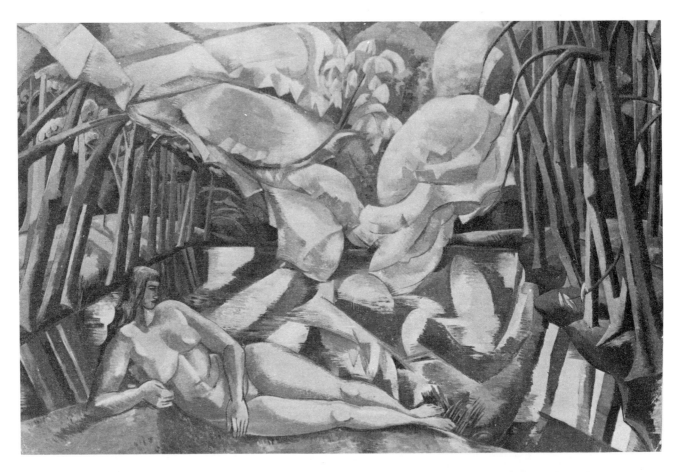

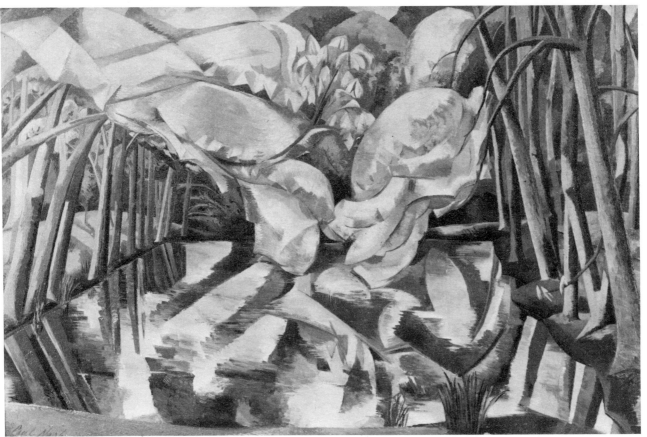

24a. & b. THE LAKE, 1921, and CHESTNUT WATERS, 1921/27/38, oil, 40½ × 50¼ ins.

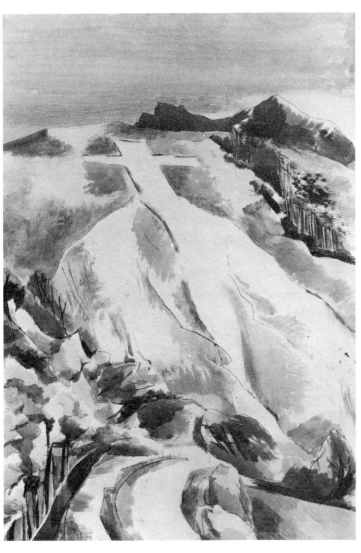

25a. WHITELEAF CROSS, *1922, watercolour, $20\frac{5}{8} \times 15$ ins.*

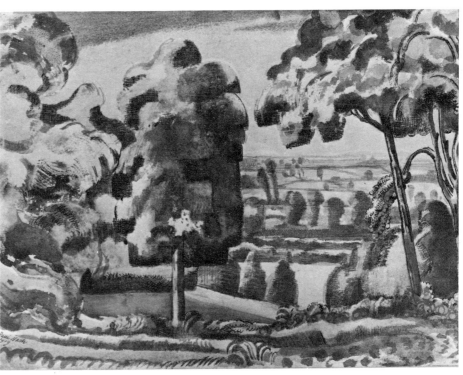

25b. RED NIGHT, *1919, watercolour, pencil & ink, $11\frac{1}{8} \times 15\frac{1}{4}$ ins.*

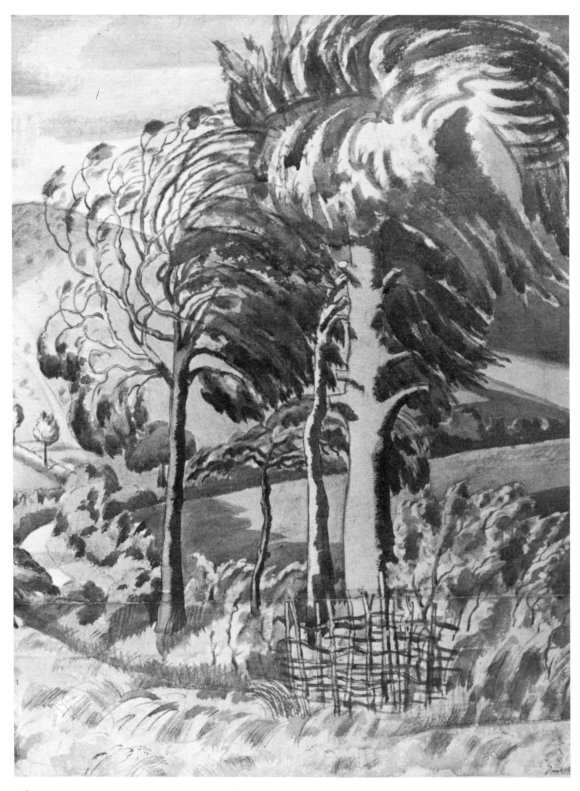

26. WIND IN THE BEECHES, *1918, watercolour, 20½ × 15¾ ins.*

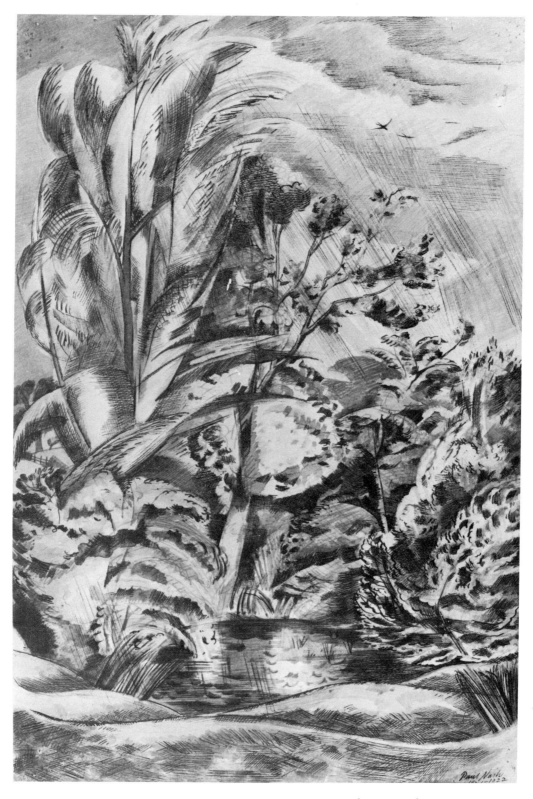

27. TENCH POND IN A GALE, *1921–2, pen, pencil & watercolour, 22¾ × 15½ ins.*

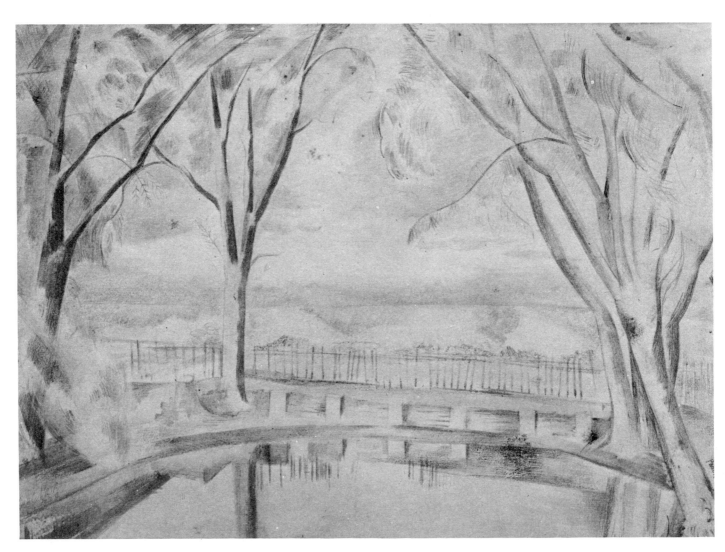

28. THE WILLOW POND, *1925, watercolour, 18 × 14 ins.*

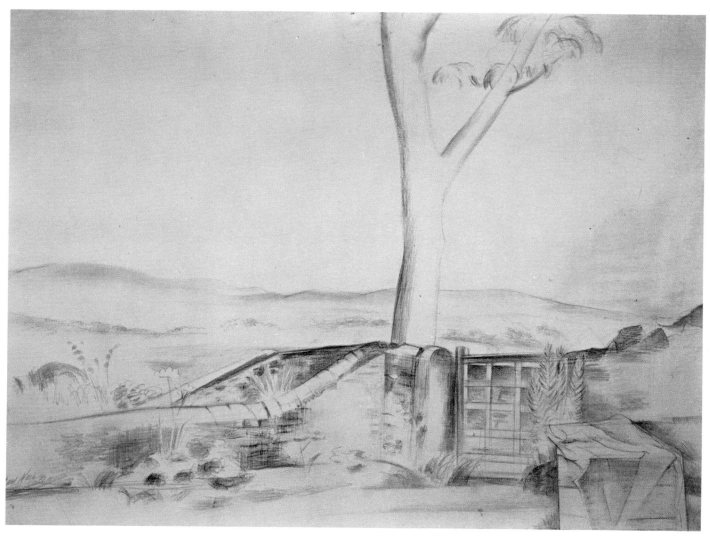

29. THE WALNUT TREE, *1924, pencil & crayon on card,* 15⅛ × 21⅝ *ins.*

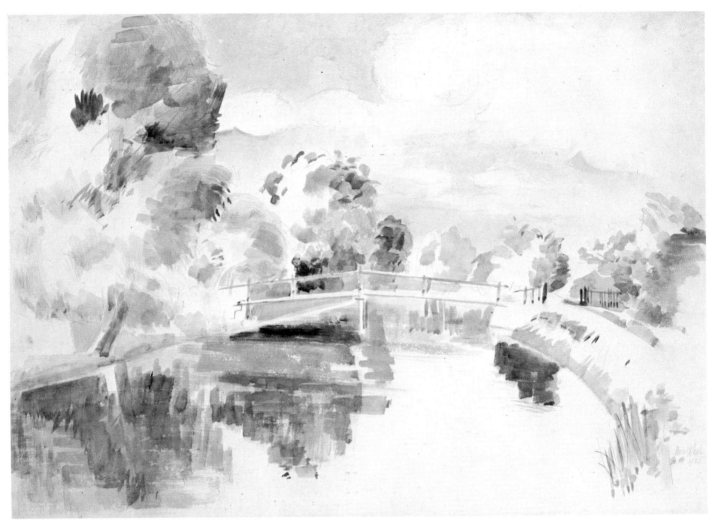

30. **BRIDGE OVER THE DYKE,** *1924, watercolour,* $15\frac{1}{2} \times 21\frac{3}{4}$ *ins.*

31. ROADSIDE, *1921–3, watercolour, 15⅜ × 21¾ ins.*

32. COAST SCENE, DYMCHURCH, *1921, oil*

33. THE WALL AGAINST THE SEA, *1922, oil, 24 × 35 ins.*

34. MARGARET ON THE STEPS, *c. 1920/23, oil, 20 × 24 ins.*

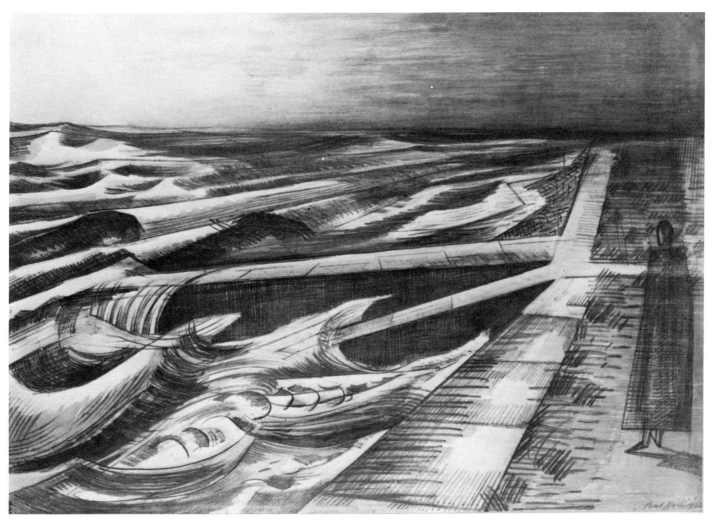

35. NIGHT TIDE, DYMCHURCH, *1922, watercolour & black lead, 15 × 22 ins.*

a. *The Face of the Waters* b. *The Division of Light*

c. *The Creation of The Firmament* d. *The Dry Land Appearing* e. *The Sun and The Moon*

36. GENESIS, *1923–4, Preliminary Sketches for the Illustrations; pencil*

a. The Fish and The Fowl *b.* Vegetation

c. Cattle and Creeping Things *d.* Man and Woman *e.* Contemplation

37. GENESIS, *Preliminary Sketches for the Illustrations; pencil*

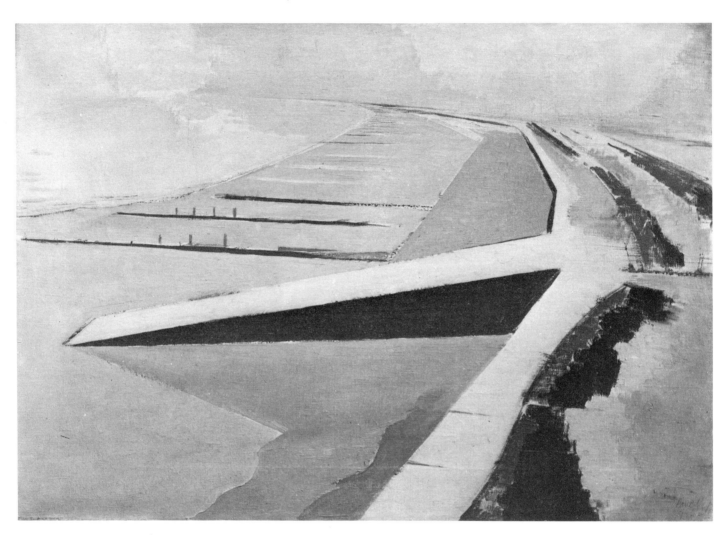

38. THE SHORE, *1923, oil, 26½ × 37½ ins.*

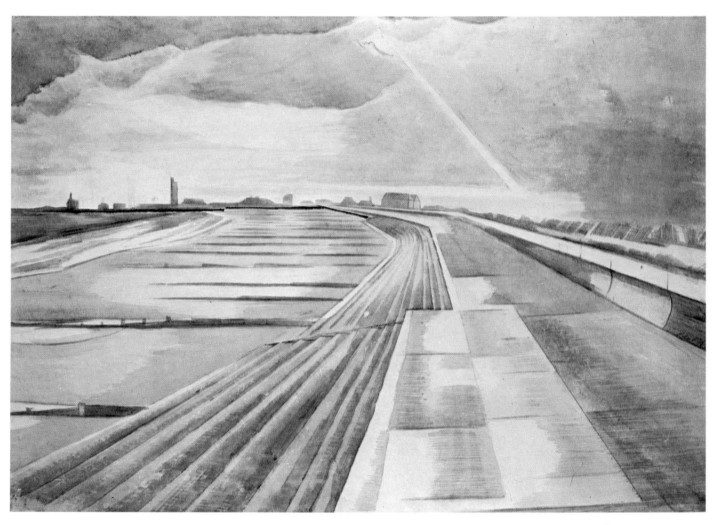

39. DYMCHURCH WALL, *1923, watercolour,* 14½ × 21½ *ins.*

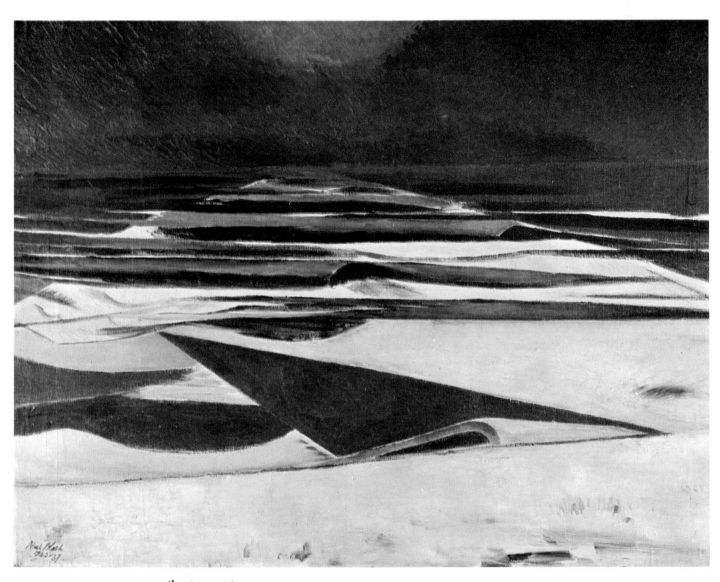

40. WINTER SEA, *1925–37, oil, 28 × 38 ins.*

41a. WINTER SEA, 1925–37, conté & watercolour, 14⅜ × 21 ins.

41b. DOWNS, 1924, pencil and watercolour, 14½ × 20 ins.

42a. CROS DE CAGNES, STUDY, *c. 1926, pencil & chalk, 8½ × 13 ins.*

42b. BOATS AT CAGNES, *c. 1926, crayon, 5½ × 8 ins.*

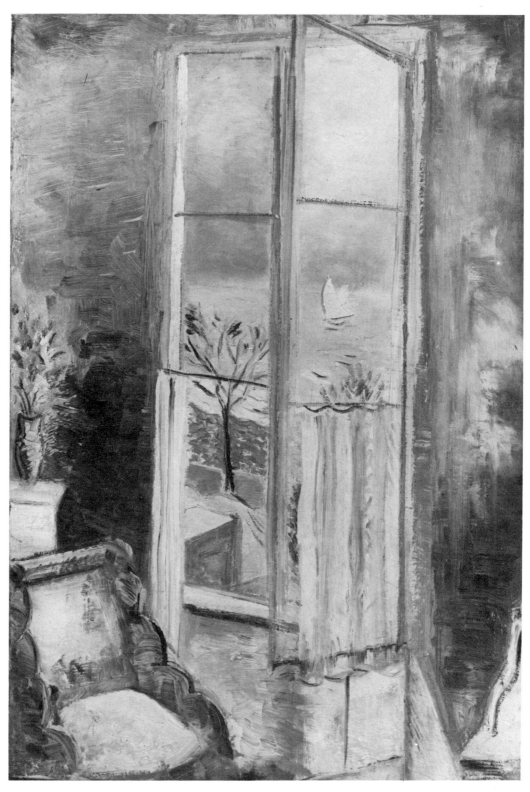

43. RIVIERA WINDOW, *c.1926, oil, 20½ × 19½ ins.*

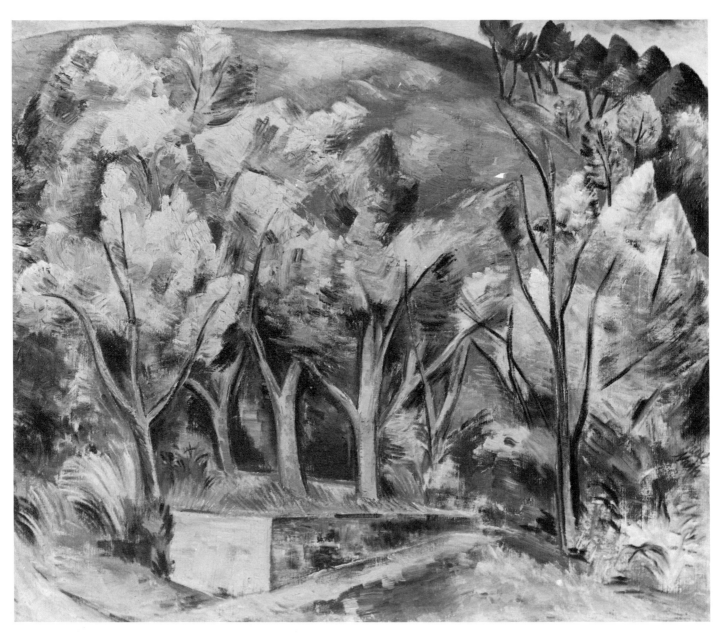

44. MIMOSA WOOD, *1926, oil, 21½ × 25¾ ins.*

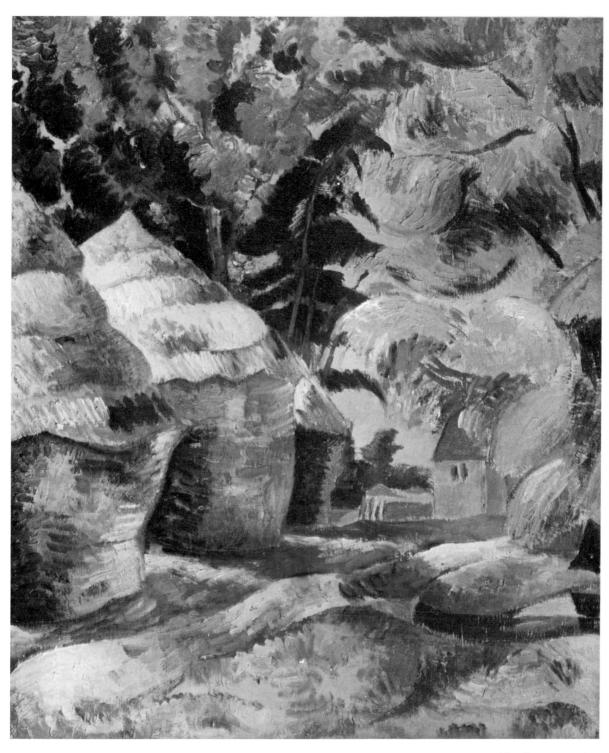

45. RICK FLAT, *c. 1925/6, oil, 24 × 20 ins.*

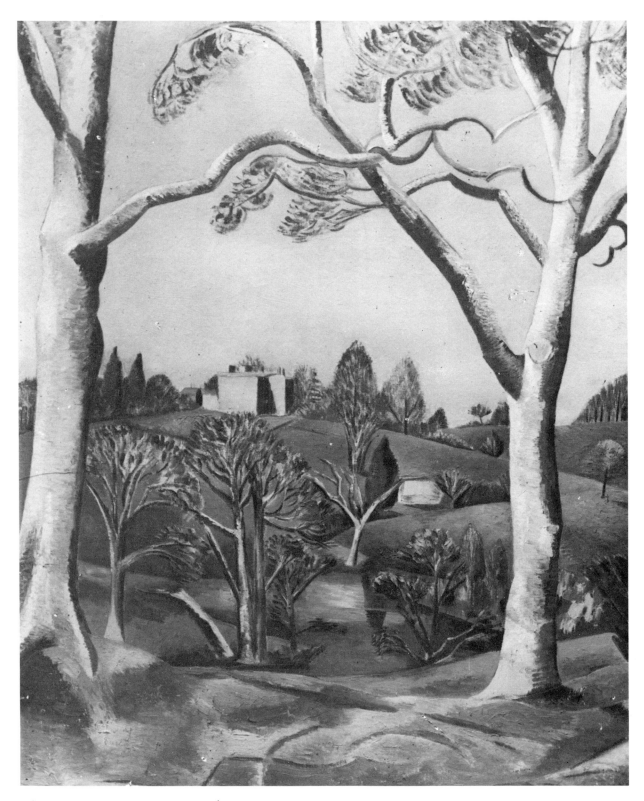

46. SANDLING PARK, KENT, *1924, oil, 35½ × 27½ ins.*

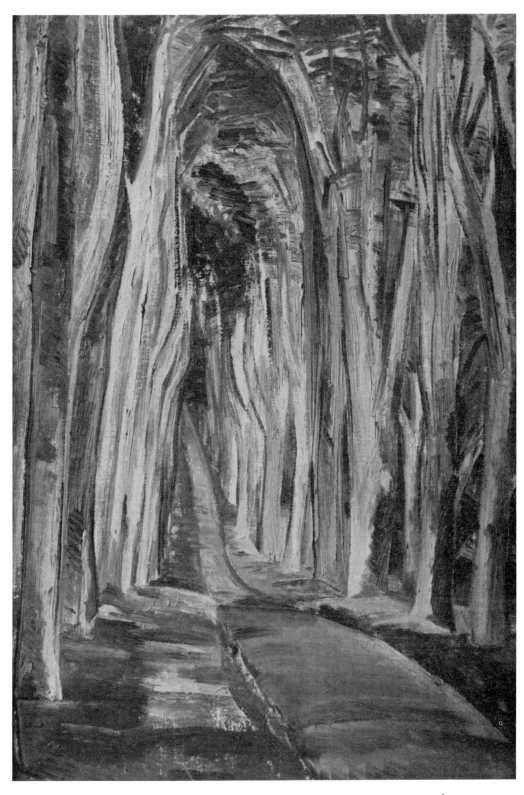

47. SAVERNAKE, *1927, oil, 30 × 20 ins.*

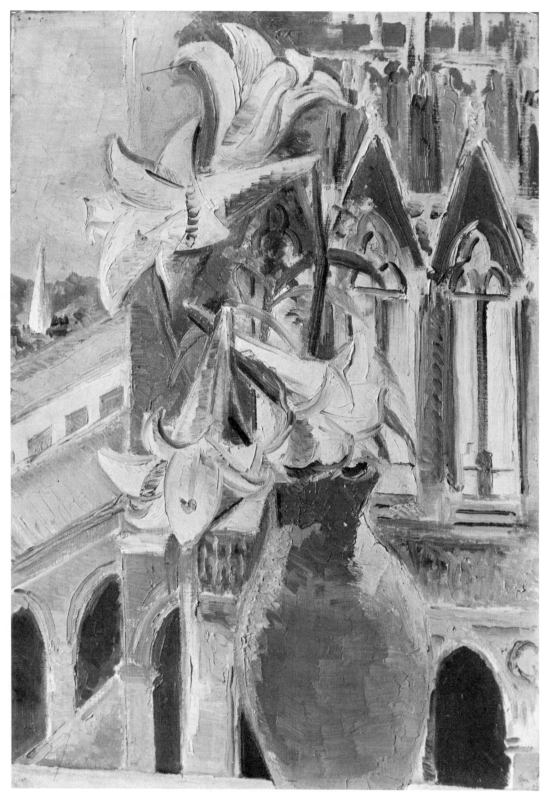

48. ST PANCRAS LILIES, *1927, oil, 25 × 17½ ins.*

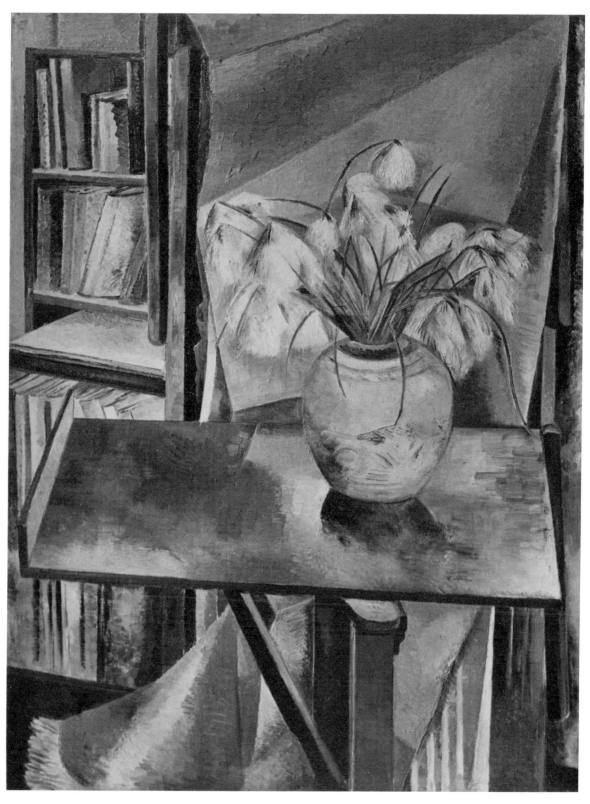

49. BOG COTTON, *1926/7, oil, 36 × 28¼ ins.*

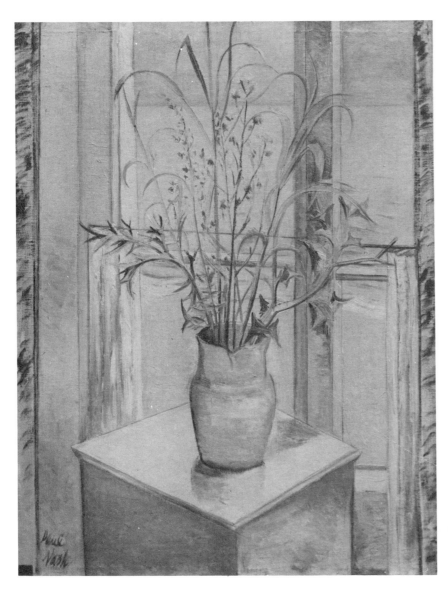

50a. STILL LIFE, *1926, oil, 33 × 26 ins.*

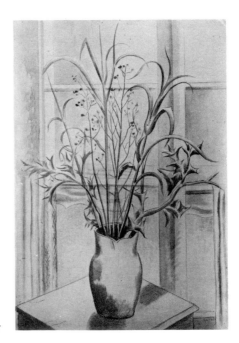

50b. STILL LIFE, IDEN, *1926, watercolour*

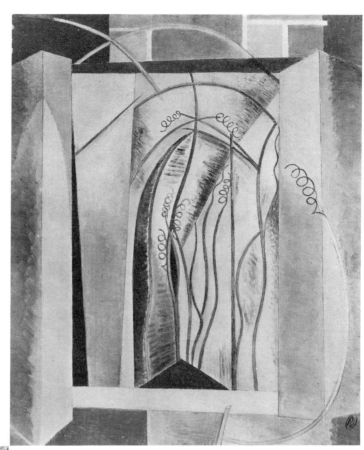

51a. CORONILLA, *1929, oil, 24 × 20 ins.*

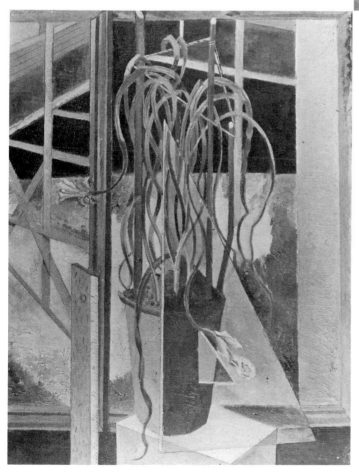

51b. DEAD SPRING, *1929, oil, 19½ × 15½ ins.*

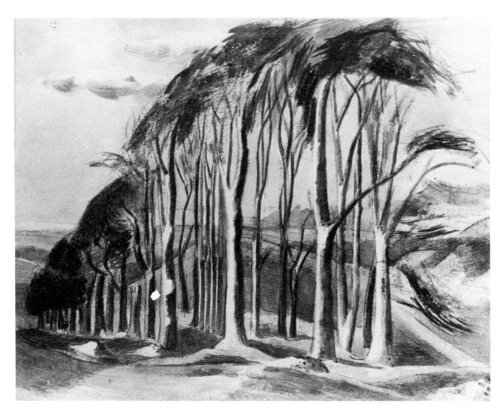

52a. GROUP OF BEECHES, *1929,*
watercolour, 9¾ × 12¾ *ins.*

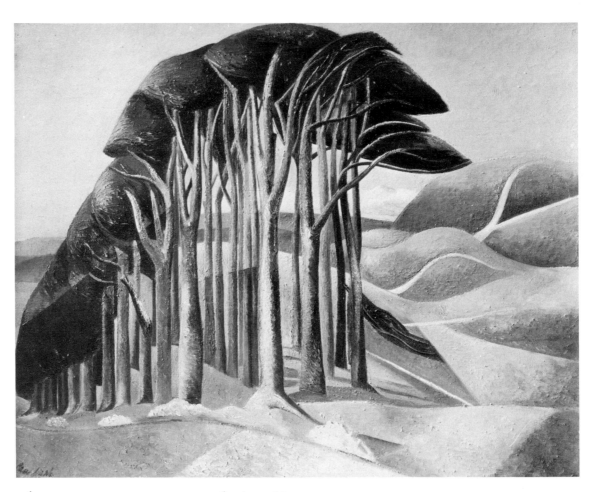

52b. WOOD ON THE DOWNS, *1929, oil, 28* × *36 ins.*

53a. WOODSTACKS AT IDEN, *1931, watercolour, 26½ × 18½ ins.*

53b. MONTH OF MARCH, *1929, oil, 36 × 28 ins.*

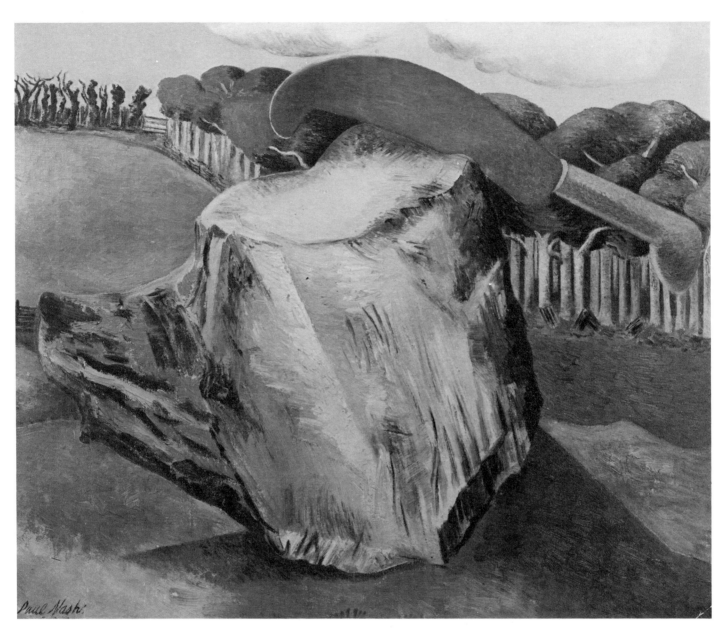

54. FEBRUARY, *1927, oil, 20 × 24 ins.*

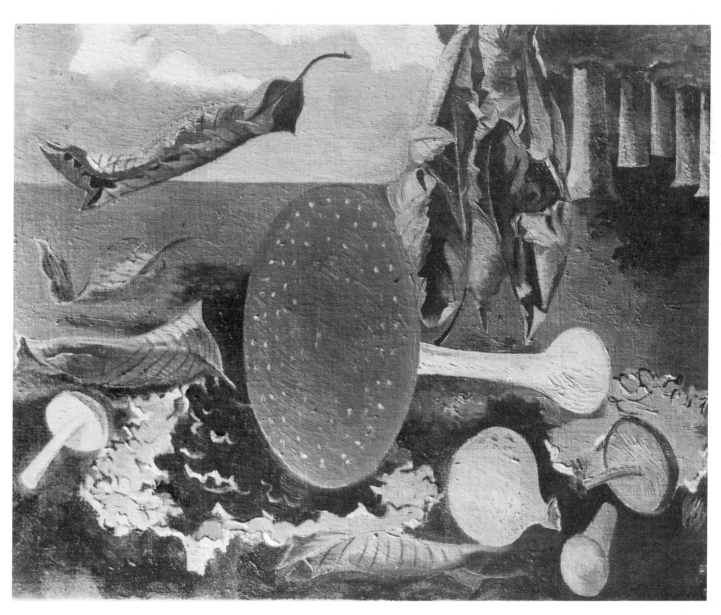

55. SWAN SONG, *1928, oil, 16½ × 20½ ins.*

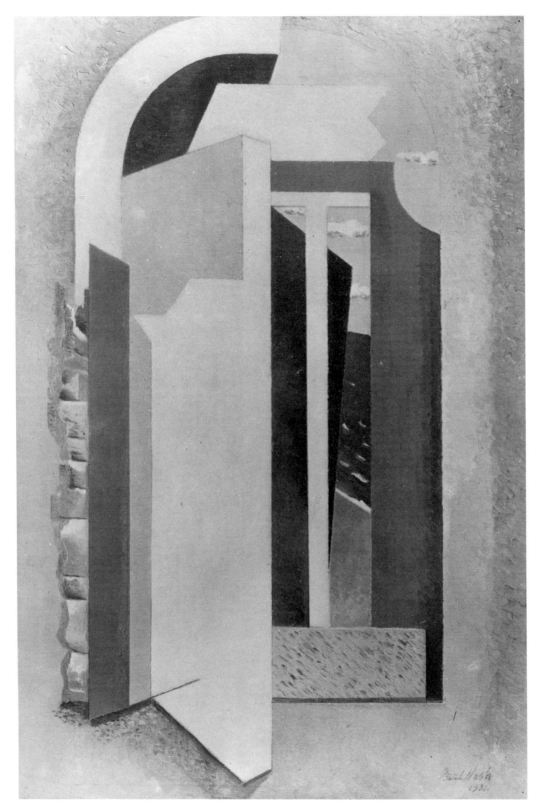

56. OPENING, *1931, oil, 32 × 20 ins.*

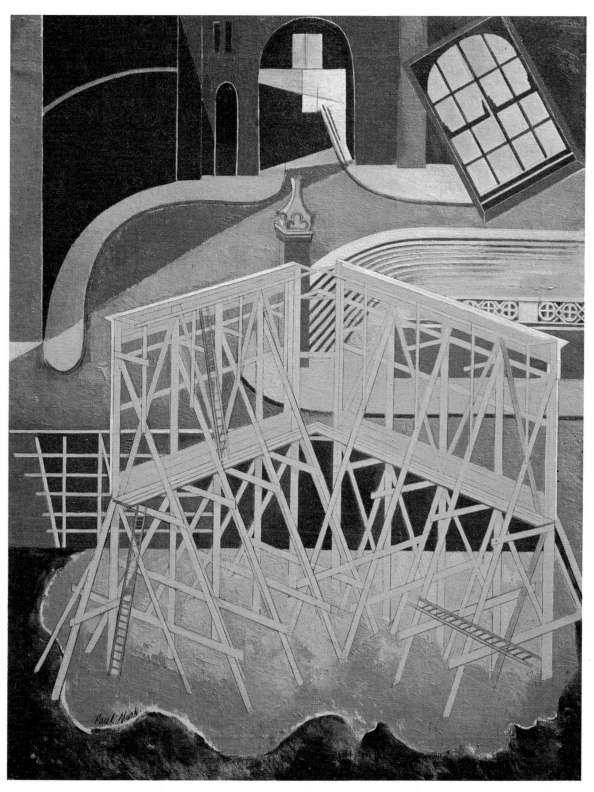

57. NORTHERN ADVENTURE, *1929, oil, 36 × 28½ ins.*

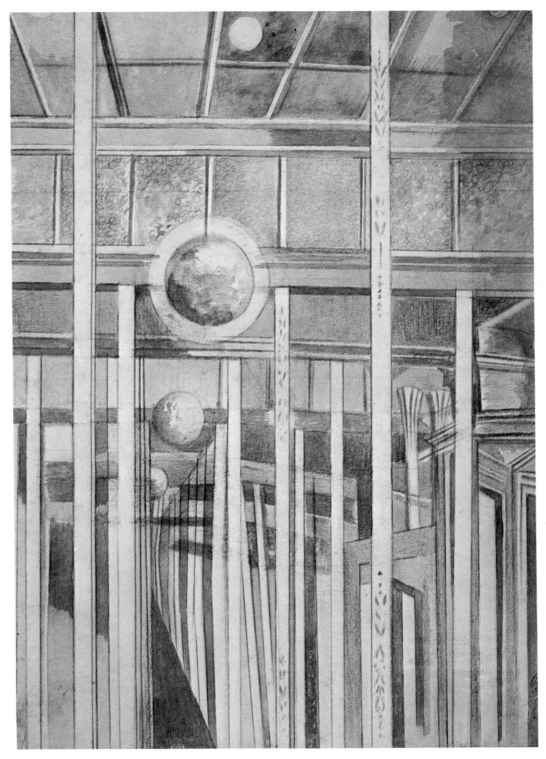

58. GLASS FOREST (VOYAGES OF THE MOON), *c. 1930, watercolour, 12* × *8¾ ins.*

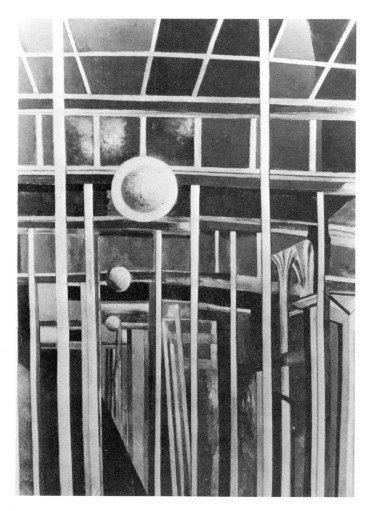

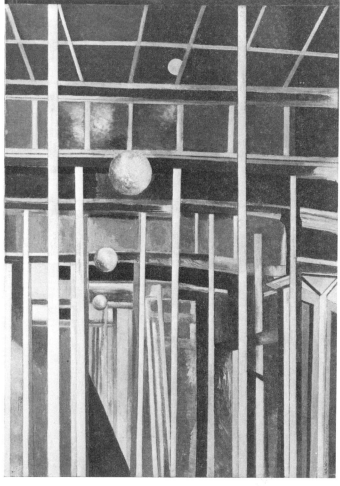

59a.
FORMAL DREAM, (*1st* version of VOYAGES OF THE MOON), *1934*

59b. VOYAGES OF THE MOON, *1934–37, oil, 28 × 21¼ ins.*

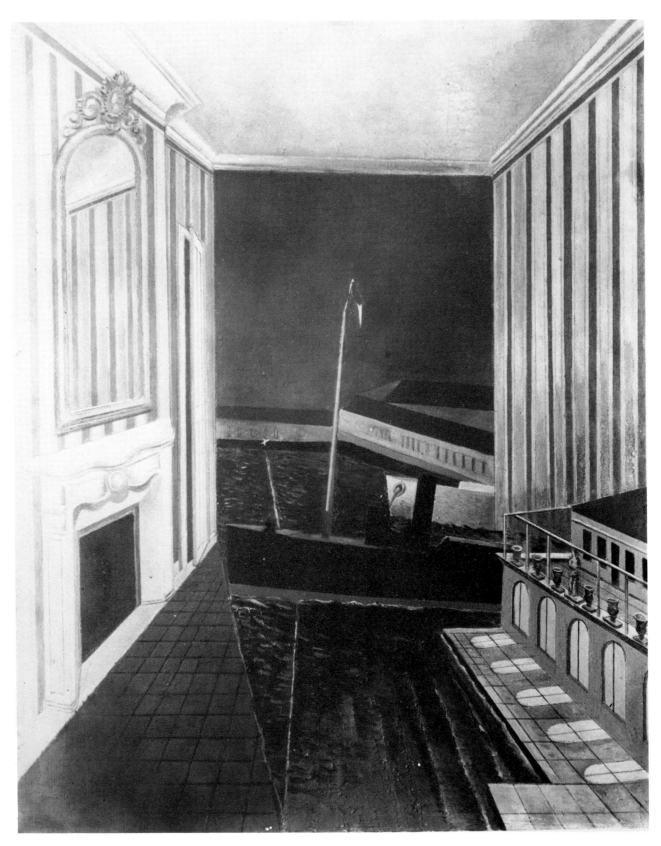

60. HARBOUR AND ROOM, *1931, oil, 36 × 28 ins.*

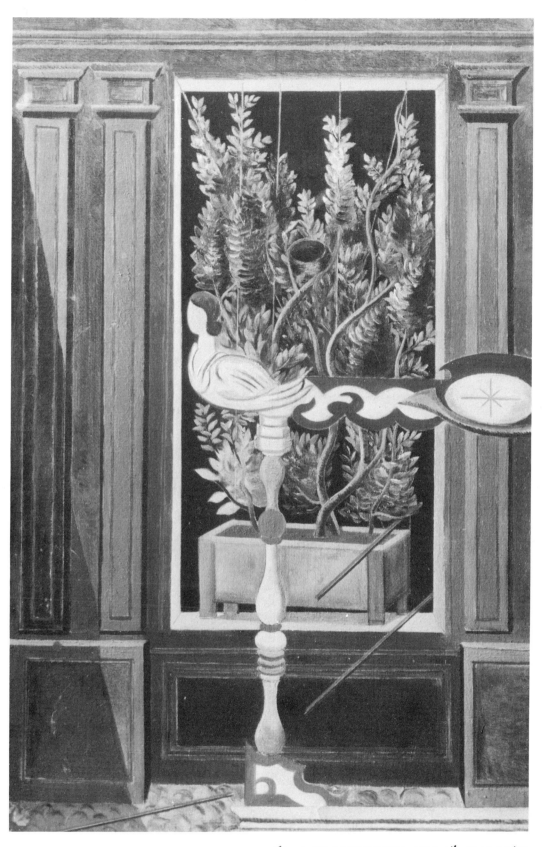

61. NEST OF THE SIREN, *1930, oil, 30 × 20 ins.*

62. NIGHT PIECE, TOULON, *1930, watercolour, 21½ × 15 ins.*

63. DAY PIECE, TOULON, *c. 1930/36, pencil & watercolour, 20¼ × 15¼ ins.*

64. ATLANTIC, *1932, watercolour, 22 × 15¼ ins.*

65. THE SOUL VISITING THE MANSIONS OF THE DEAD, *1932, watercolour, 8½ × 6¼ ins.*

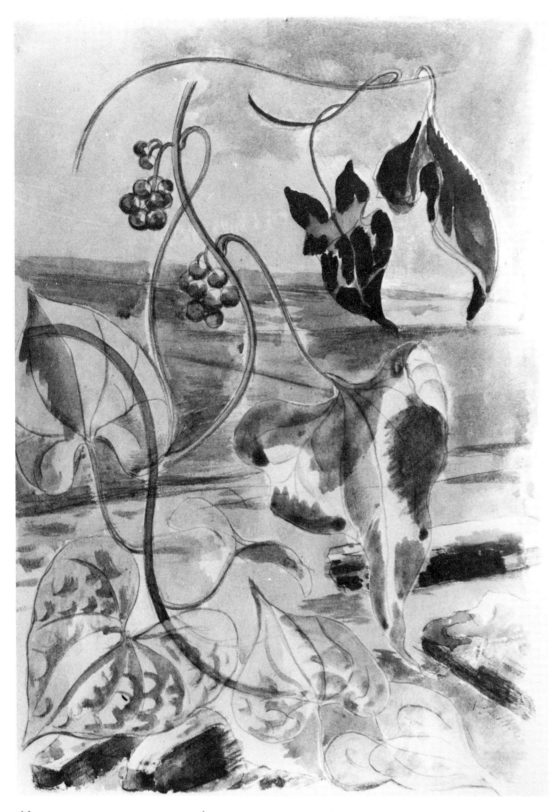

66. CONVOLVULUS, *1933, watercolour*

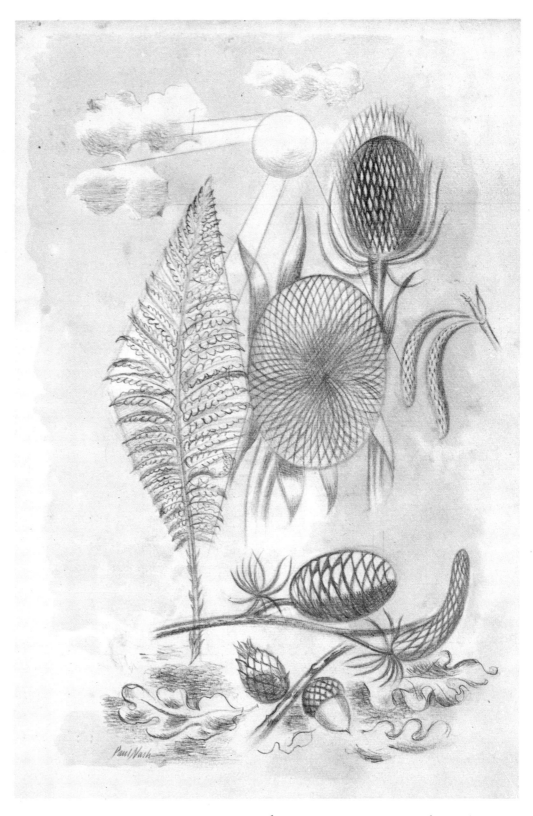

67. QUINCUNX, *1932, watercolour, 21 × 14 ins.*

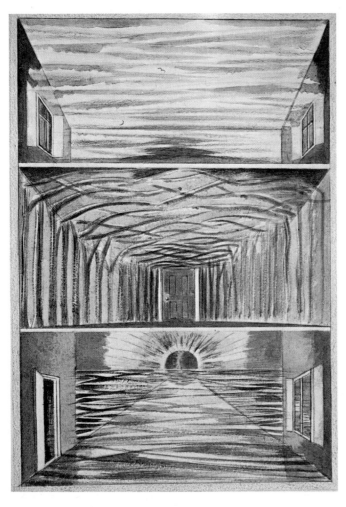

68a. THE THREE ROOMS, *c. 1936–7, watercolour, 15½ × 11½ ins.*

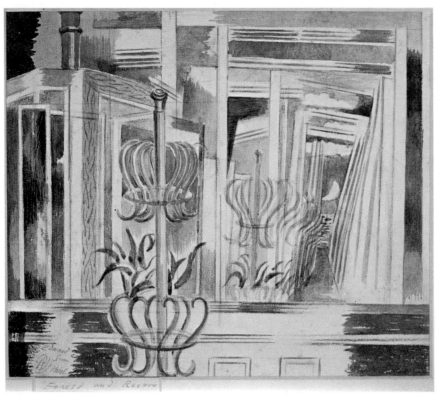

68b. FOREST AND ROOM, *1936–7, watercolour, 8¼ × 9½ ins.*

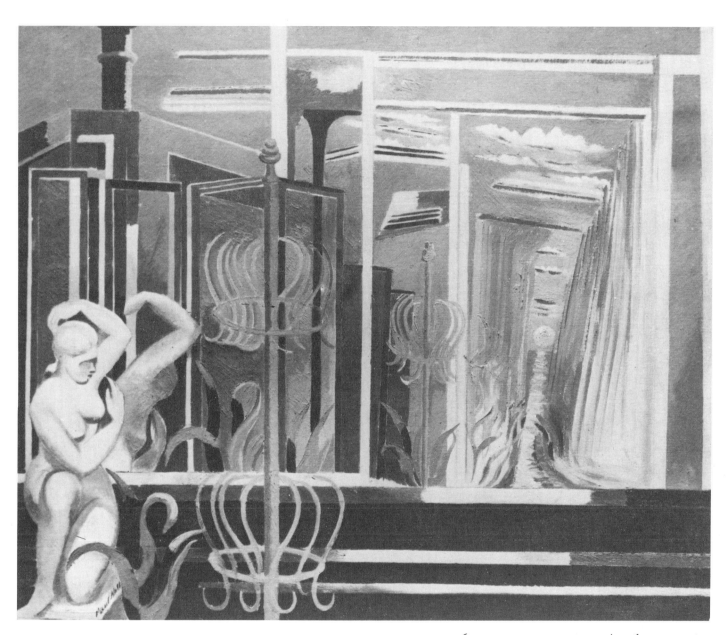

69. METAMORPHOSIS, *1937/8, oil, 25 × 30 ins.*

70. THE ARCHER OVERTHROWN, (*first state*), 1931/8, oil, 27½ × 36 ins.

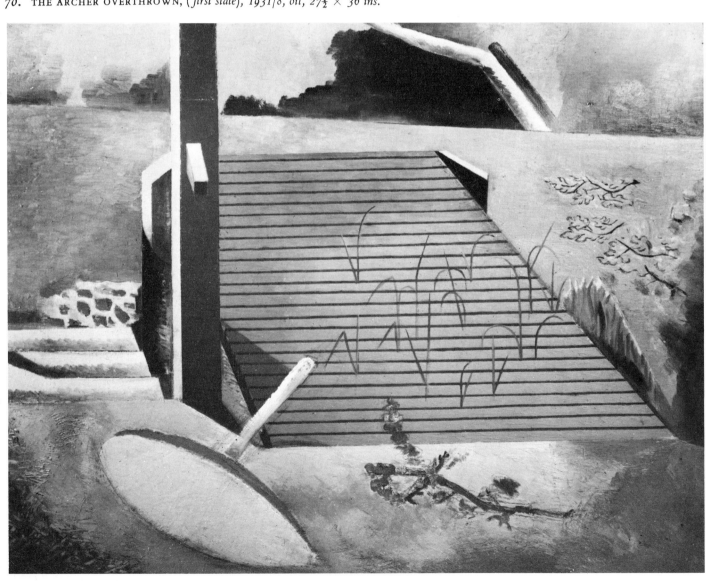

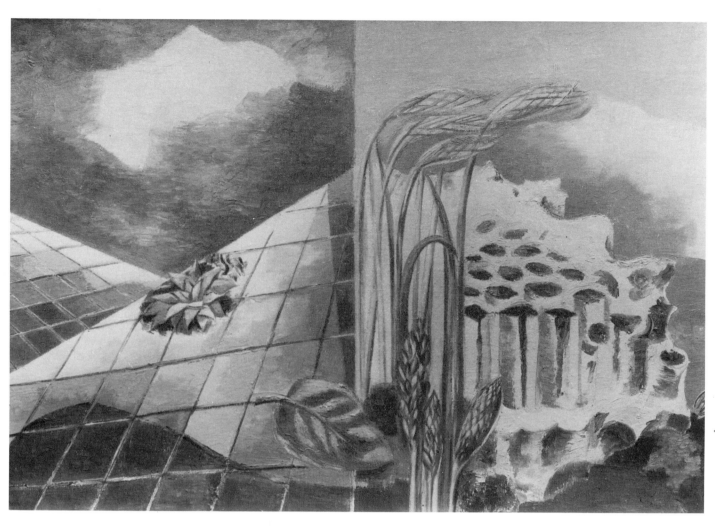

71. SUMMER, *1933, oil, 21 × 30 ins.*

72a.
DRUID LANDSCAPE, *1938, oil, 23 × 16 ins.*

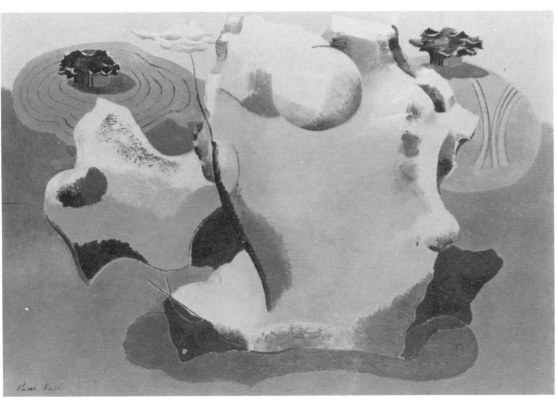

72b. LANDSCAPE OF THE MEGALITHS, *1934, oil, 19⅜ × 28¾ ins.*

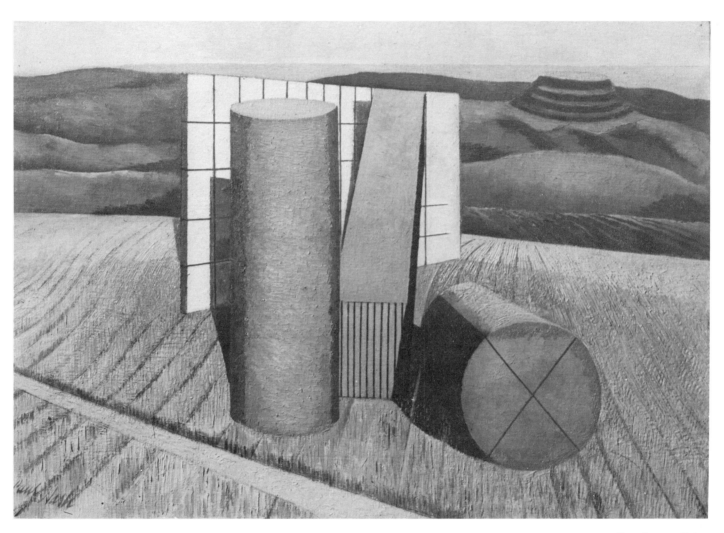

73. EQUIVALENTS FOR THE MEGALITHS, *1934, oil,* 19⅜ × 28¾ *ins.*

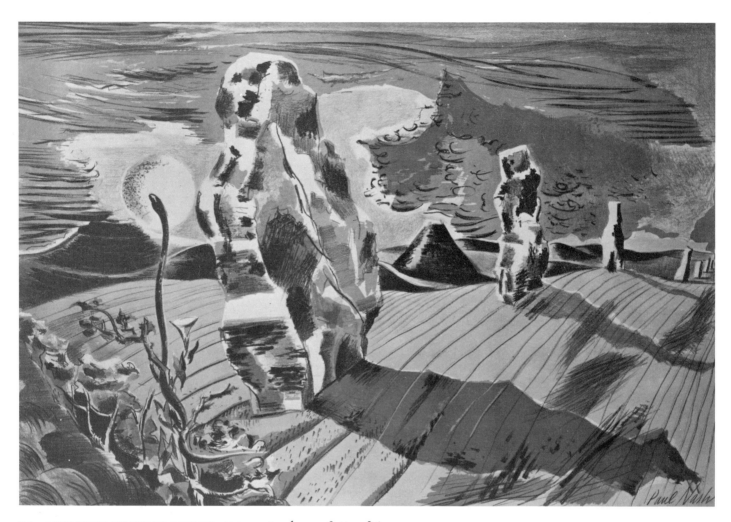

74. LANDSCAPE OF THE MEGALITHS, *1937, watercolour, 19¾ × 29¾ ins.*

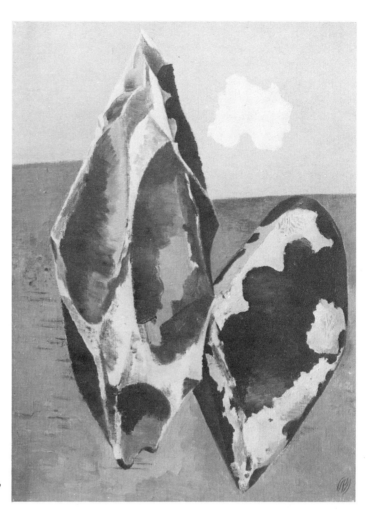

75a. CLOUD AND TWO STONES, *1935,*
oil, 20 × 15 ins.

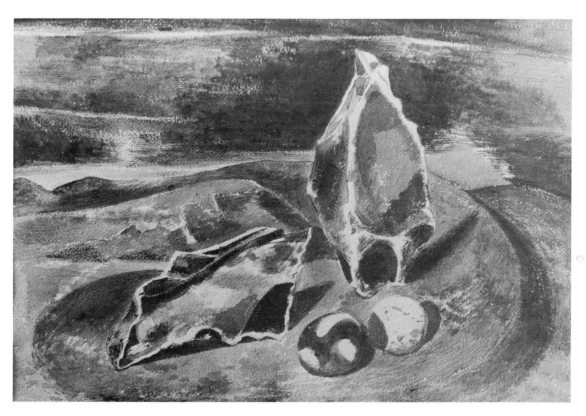

75b. NEST OF THE WILD STONES, *1937, watercolour & pencil, 15 × 22 ins.*

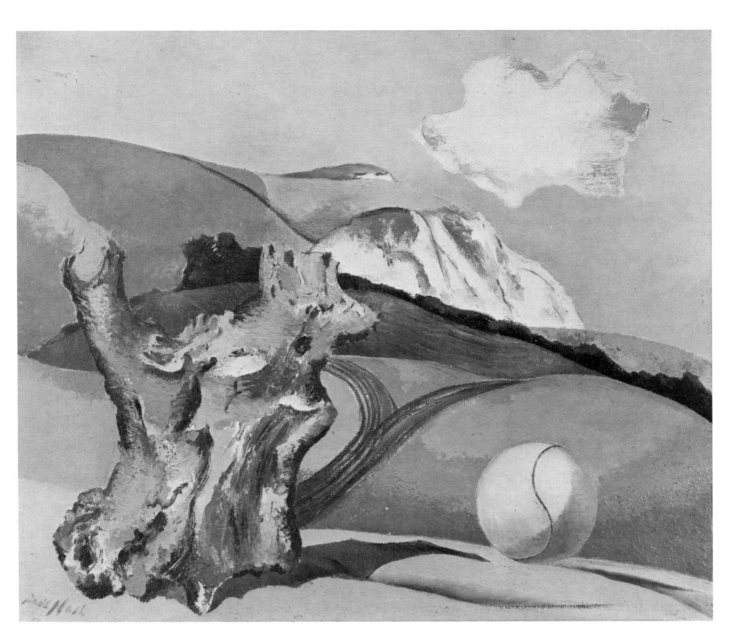

76. EVENT ON THE DOWNS, *1934, oil, 20 × 24 ins.*

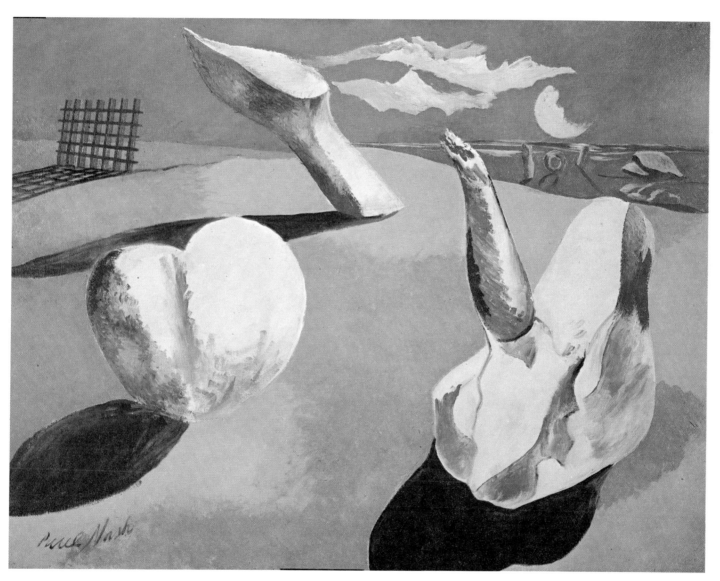

77. NOCTURNAL LANDSCAPE, *1938, oil, 30⅛ × 40⅝ ins.*

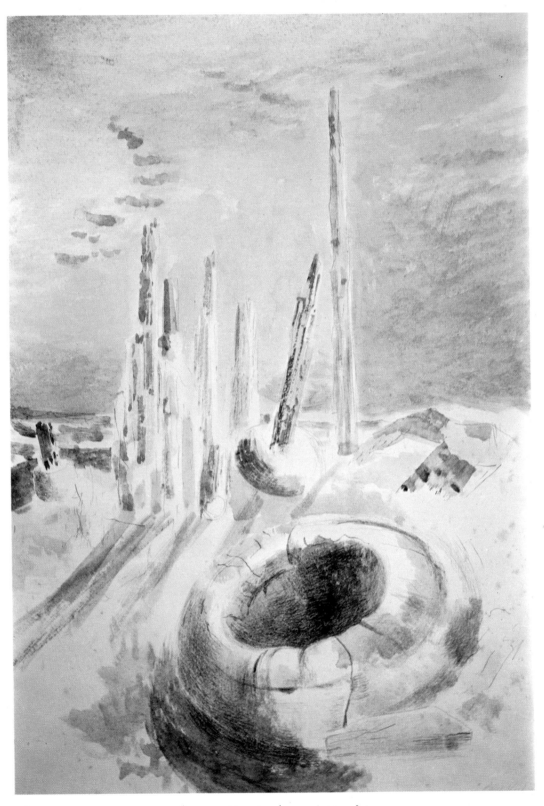

78. STONE FOREST, *1937, pencil, crayon & watercolour, 23⅛ × 15¾ ins.*

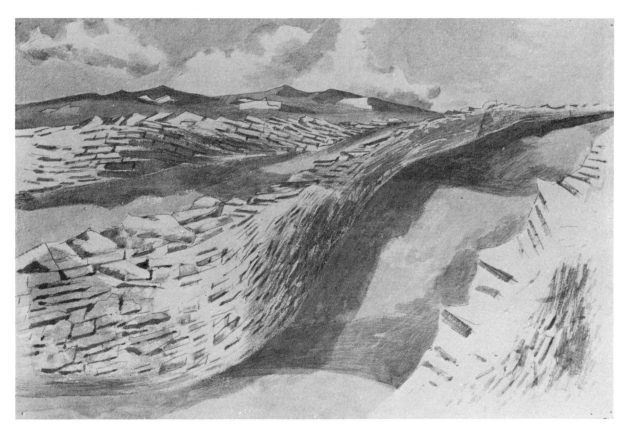

79a. STONE SEA, *1937, watercolour, 15 × 22 ins.*

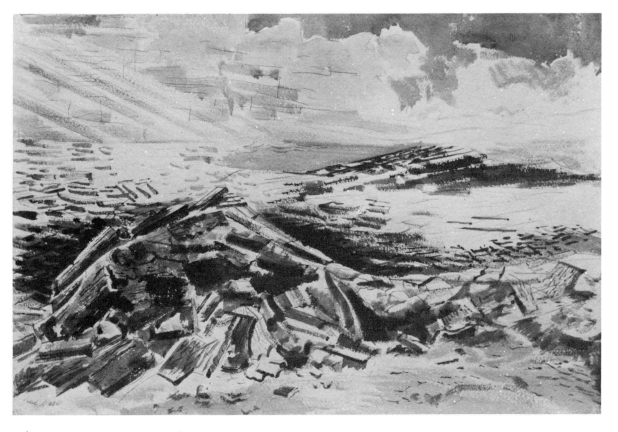

79b. WOOD SEA, *1937, watercolour, 15½ × 23 ins.*

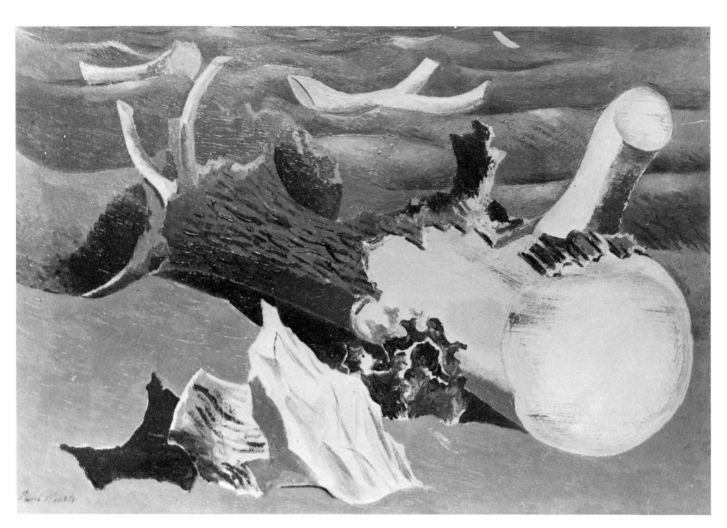

80. STRANGE COAST, *1937, oil, 19 × 28 ins.*

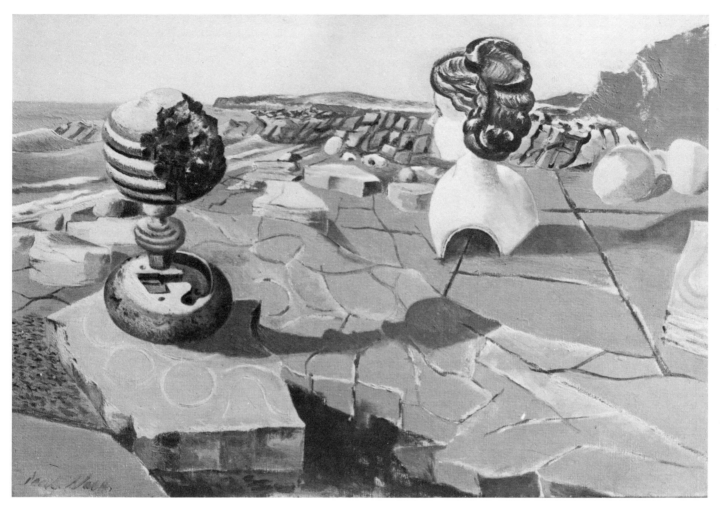

81. ENVIRONMENT OF TWO OBJECTS, *1937, oil, 20½ × 30½ ins.*

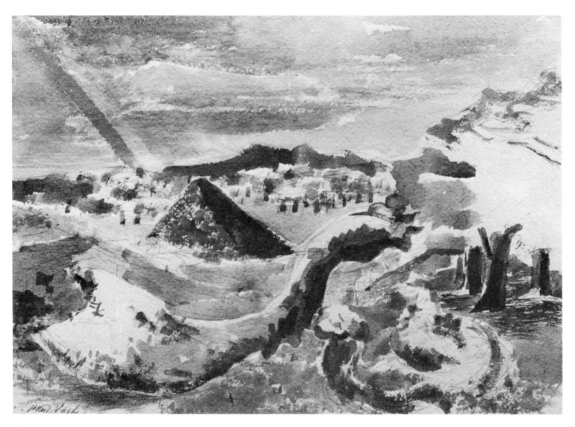

82a. DENIZENS OF THE FOREST OF DEAN, *1939, watercolour, 11 × 15½ ins.*

82b. OBJECT AT SCARBANK, *1939, watercolour, 11 × 15½ ins.*

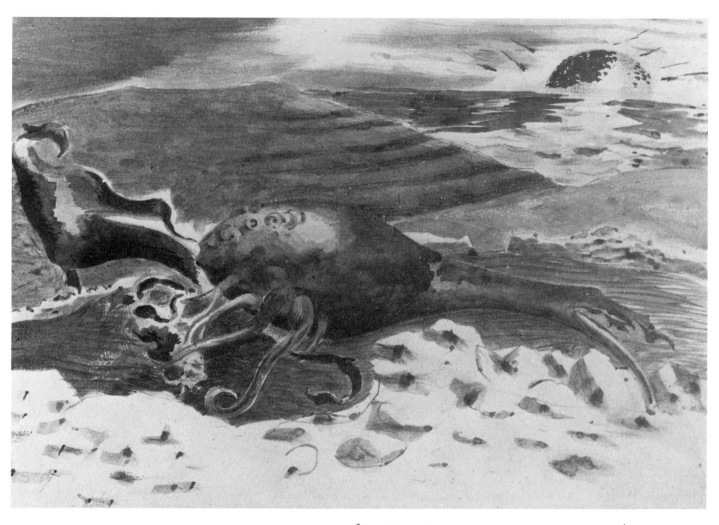

83. SUNSET AT WORTH MATRAVERS, *1937, watercolour, 7 × 10 ins.*

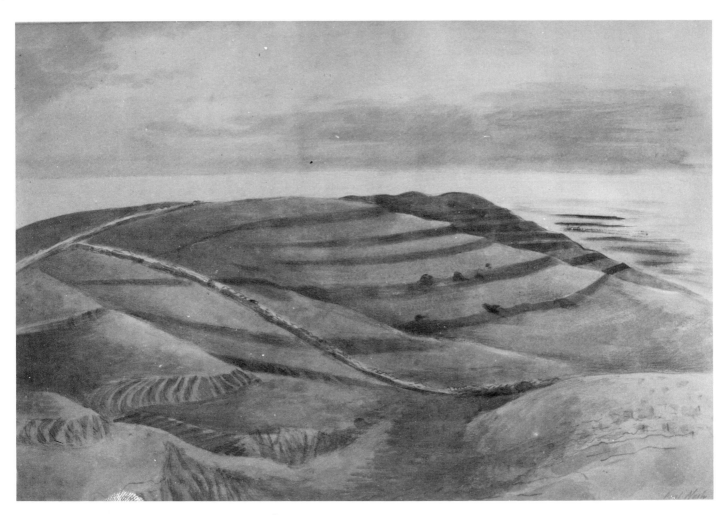

84. WORTH MATRAVERS, DORSET, *1936, watercolour, 15 × 20 ins.*

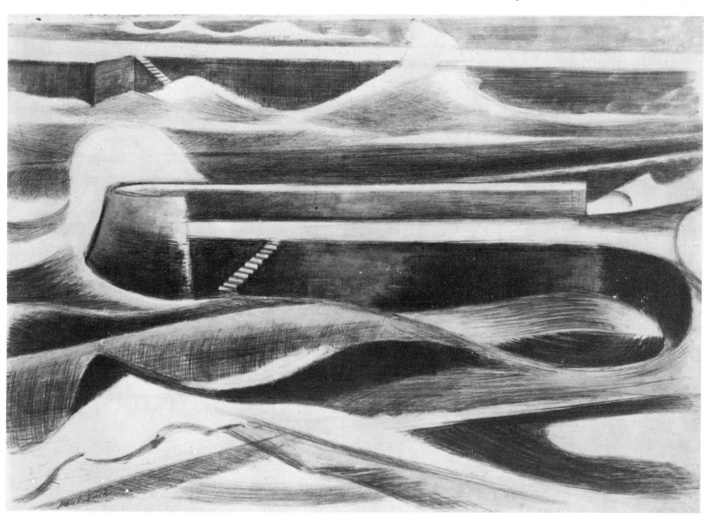

85. SEA WALL, SWANAGE, *1934, pencil & watercolour,* 14¾ × 21¾ *ins.*

86. LAOCOON, *1941, watercolour,* $10\frac{1}{4} \times 15\frac{1}{4}$ *ins.*

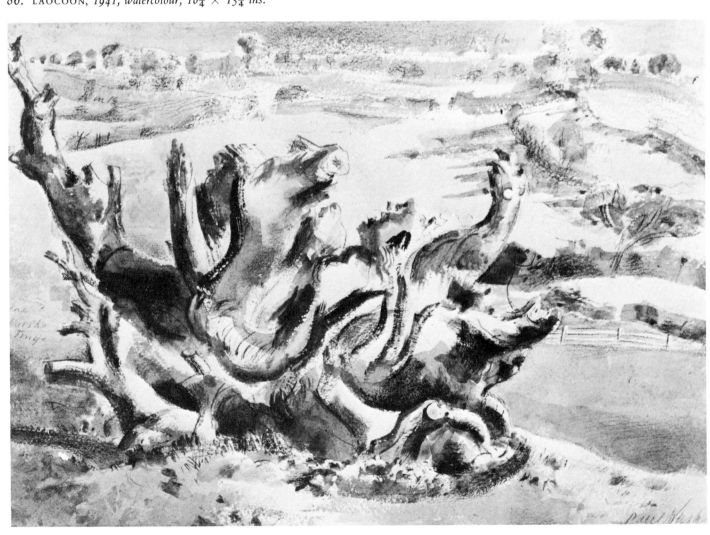

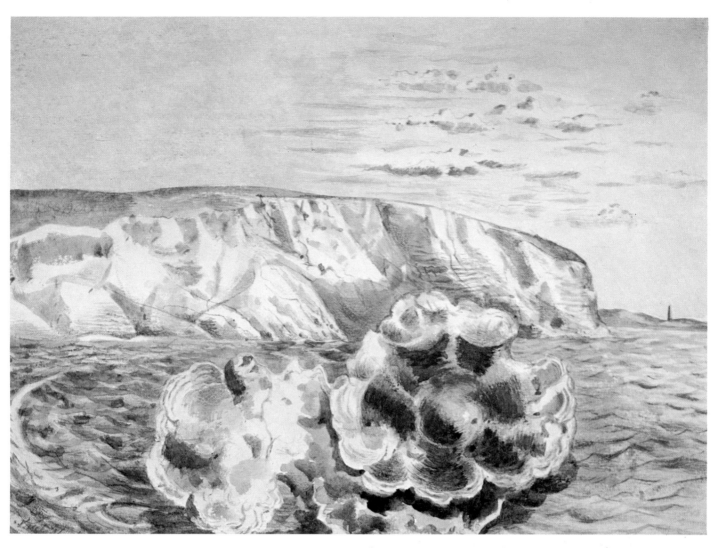

87. VOYAGES OF THE FUNGUS, *1937, watercolour,* $11\frac{1}{4} \times 15\frac{1}{2}$ *ins.*

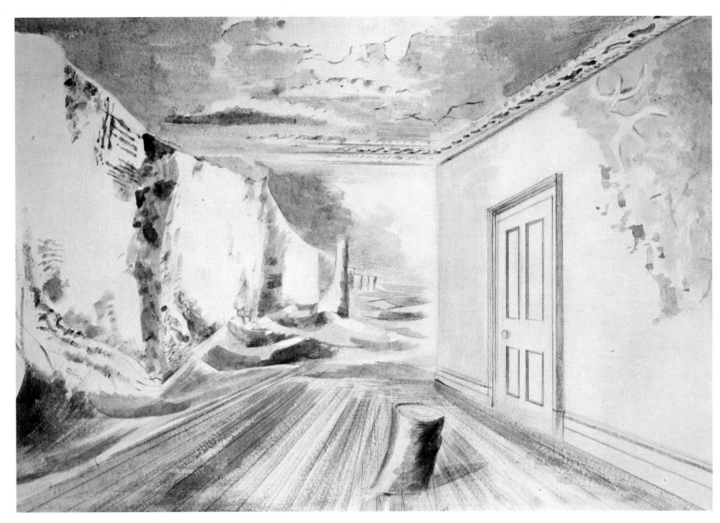

88. EMPTY ROOM, *1937, watercolour, 14¾ × 22 ins.*

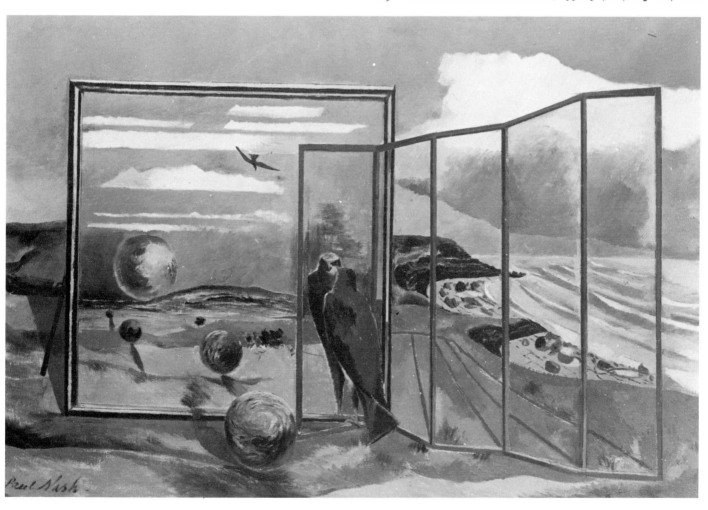

89. LANDSCAPE FROM A DREAM, *1936–38, oil, 28½ × 40 ins.*

90a. DIFFERENT SKIES, *1939,*
watercolour, 15 × 11 ins.

90b. MONSTER FIELD, *watercolour, 1939, 11½ × 16 ins.*

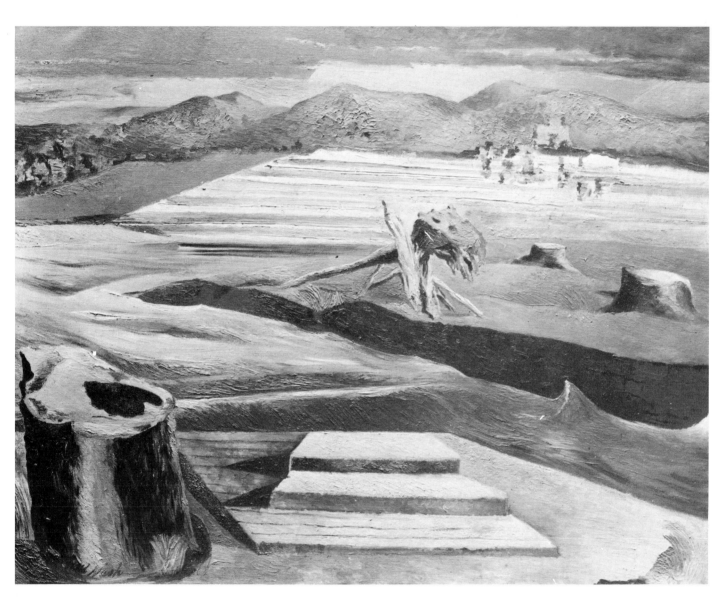

91. MONSTER SHORE, *1939, oil, 28 × 36 ins.*

92a.
FOREST OF DEAN,
1938, watercolour,
11 × 16 ins.

92b.
GREGYNOG,
1939, watercolour,
15½ × 22½ ins.

93a.
MINOTAUR,
1939, watercolour,
$11\frac{1}{4} \times 15$ *ins.*

93b.
MONSTER POND,
watercolour, 1941,
$11\frac{1}{2} \times 15\frac{5}{8}$ *ins.*

94. INCIDENT AT MADAMS, *1943, watercolour, 15½ × 22½ ins.*

95. GARDEN OF THE MADAMITES, *1941, watercolour, 15½ × 22 ins.*

96. GROTTO IN THE SNOW, *1939*,
oil, 28 × 19 ins.

97. HAMPSTEAD GARDEN, *1938, watercolour, 15 × 22 ins.*

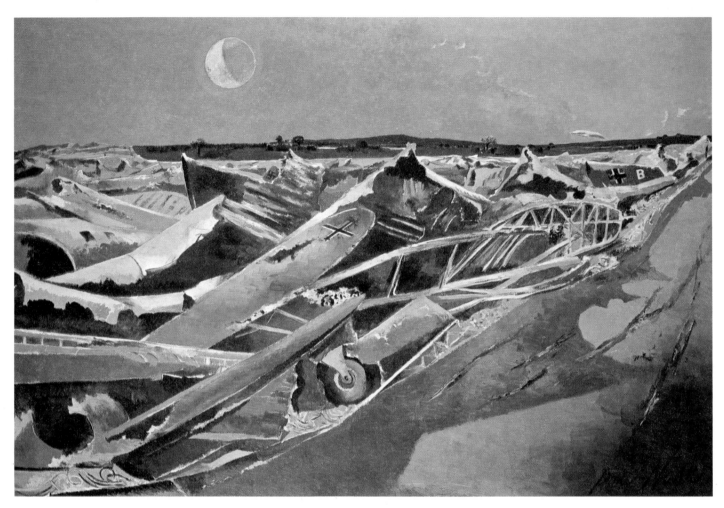

98a. TOTES MEER, 1941,
oil, 40 × 60 ins.

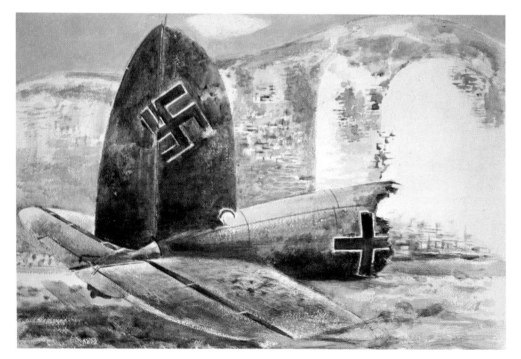

98b. UNDER THE CLIFF, 1940, watercolour, 15 × 22 ins.

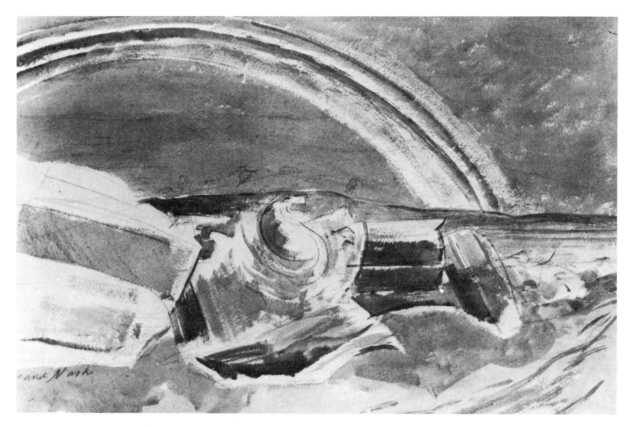

99a. LUNAR RAINBOW, *1941, pencil & watercolour, 15¼ × 22½ ins.*

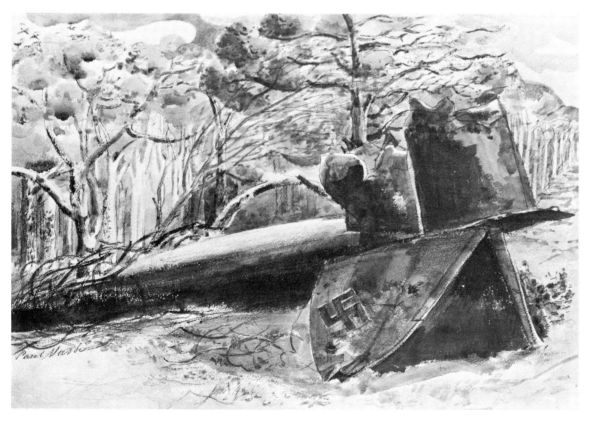

99b. BOMBER IN THE WOOD, *1940, watercolour, 15¼ × 22⅜ ins.*

100a.
ROSE OF DEATH, *1939,*
collage & watercolour

100b. LEBENSRAUM, *1939, collage & watercolour, 15 × 22½ ins.*

101a. & b. FOLLOW THE FUHRER, *1942, watercolour & collage* (a) INTO THE SKIES, (b) UNDER THE SEAS

102. WELLINGTON BOMBER WATCHING THE SKIES, *1940, pencil & watercolour,* $11\frac{1}{4} \times 15\frac{3}{8}$ *ins.*

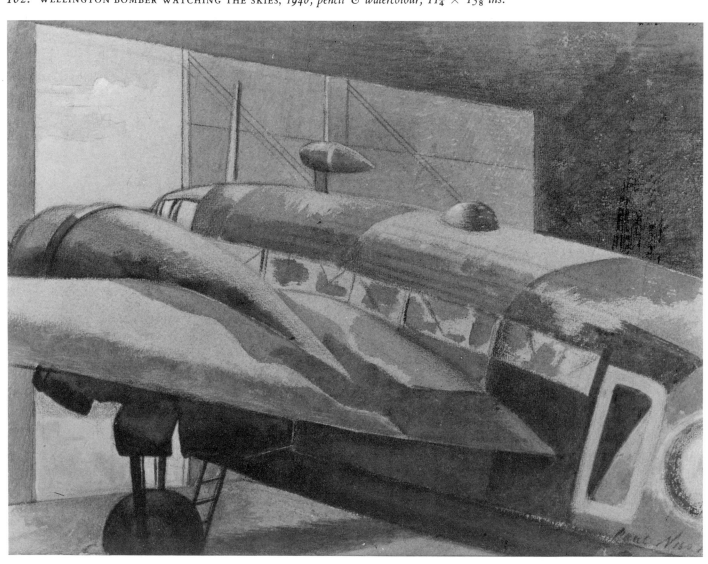

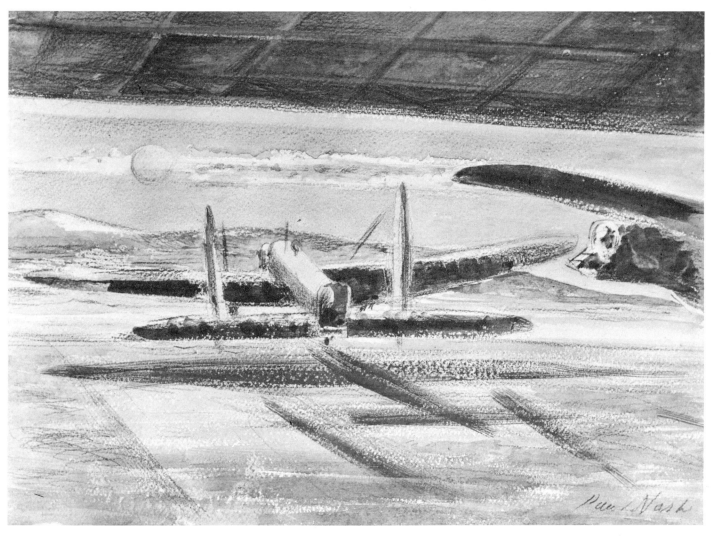

103. WHITLEYS AT SUNRISE, *1940, watercolour, 12 × 16½ ins.*

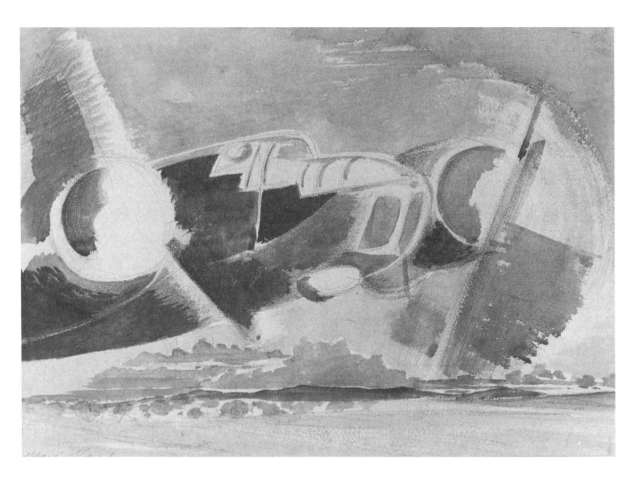

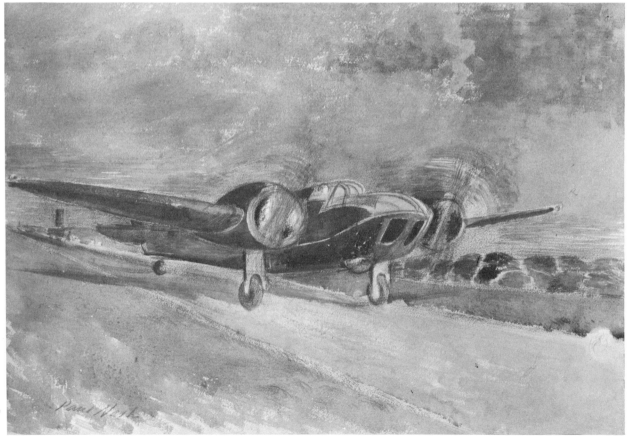

104a. & b. THE FLARE PATH, *1940, watercolour, 15 × 22 ins.* FLYING AGAINST GERMANY, *1940, oil, 28 × 36 ins.*

105a. DAY FIGHTER, *1940, oil, 39⅞ × 20 ins.*

105b. NIGHT FIGHTER, *1940, oil, 39⅞ × 20 ins.*

106. RAIDER ON THE SHORE, *1940, watercolour,* $15\frac{13}{16} \times 22\frac{5}{16}$ *ins.*

107. DOWN IN THE CHANNEL, *1940, watercolour, 15 × 22 ins.*

108. TARGET AREA, WHITLEY BOMBERS OVER BERLIN, *1941, watercolour, 26 × 36 ins.*

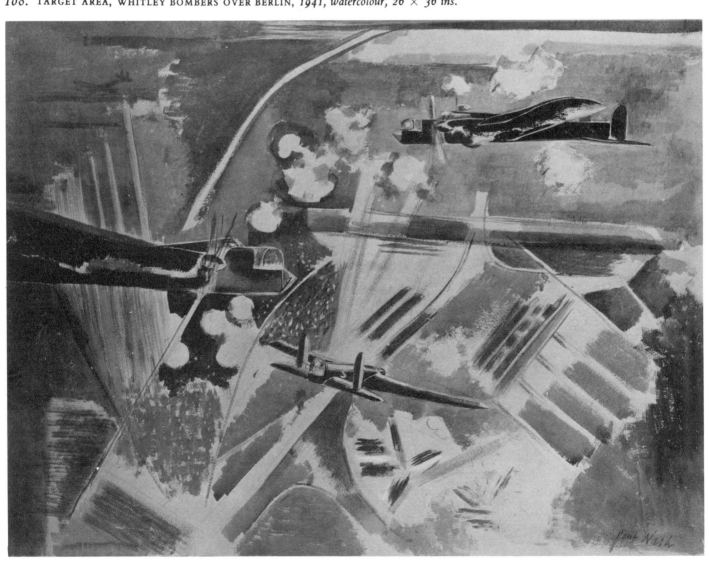

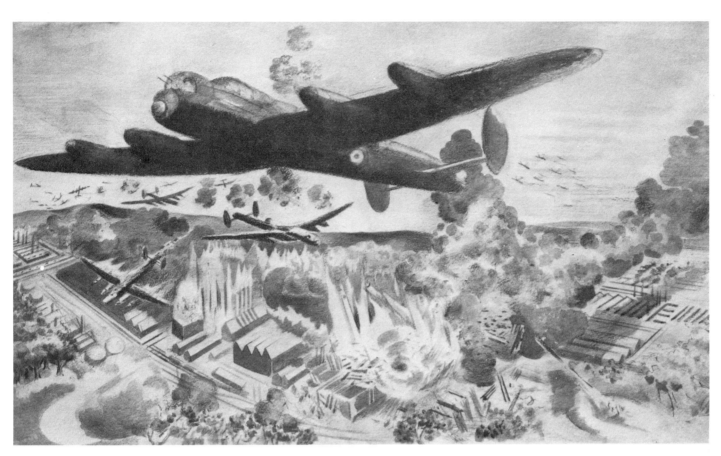

109. THE AUGSBURG RAID, *1942, watercolour* $15\frac{1}{4} \times 26\frac{1}{4}$ *ins.*

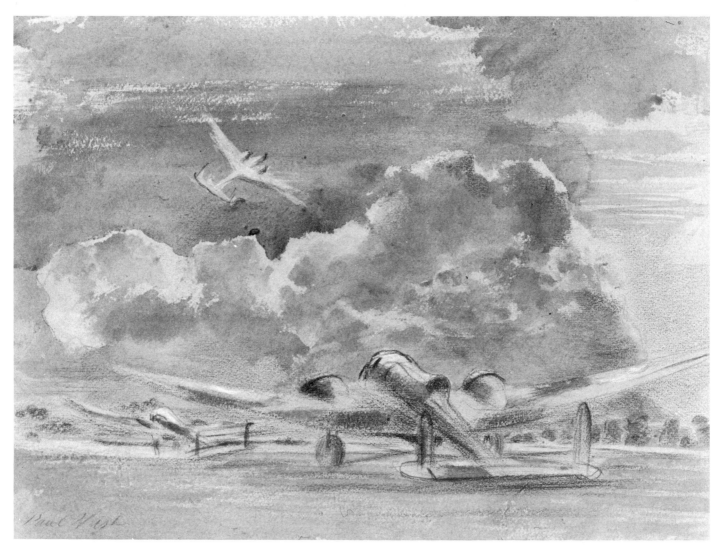

110. HAMPDENS AT SUNSET, *1940, watercolour, 11 × 15 ins.*

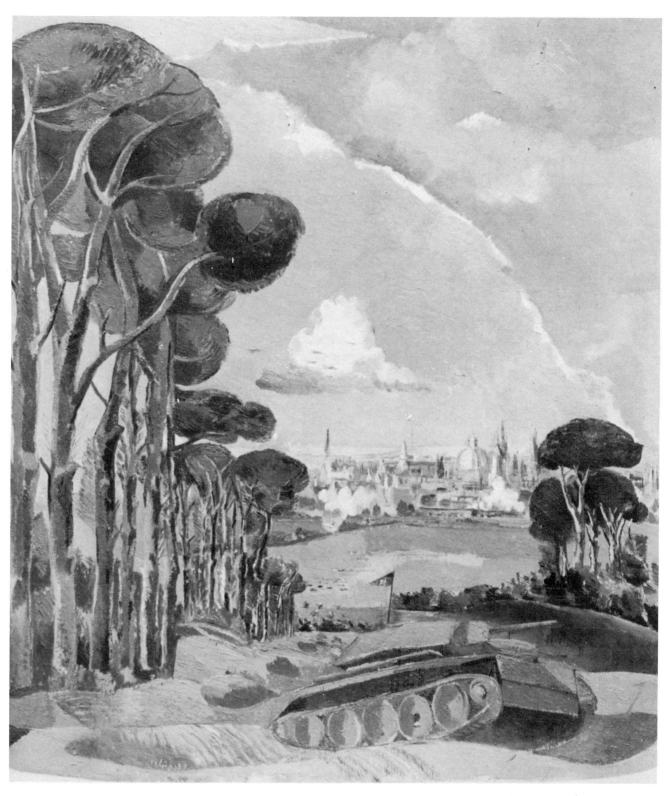

111. OXFORD IN WARTIME, *1943, oil, 45 × 40 ins.*

112a. BAYSWATER LANDSCAPE, *1940, watercolour, 15½ × 22½ ins.*

112b. LONDON, SNOW, *1940, watercolour, 11 × 15 ins.*

113*a*. LANDSCAPE OF THE
BRITISH MUSEUM, *1944,*
watercolour, 12 × 15½ ins.

113*b*. DESIGN OF TREES, *1943,*
watercolour, 22 × 15 ins.

114. OXFORD FROM HINKSEY, *1943, watercolour, 11¾ × 15¾ ins.*

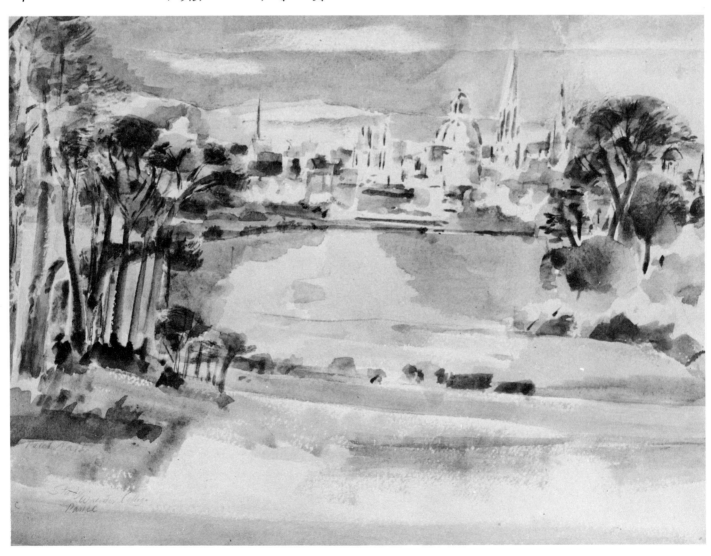

115. MARCH WOODS, STUDY II, *1944, watercolour, 15 × 22 ins.*

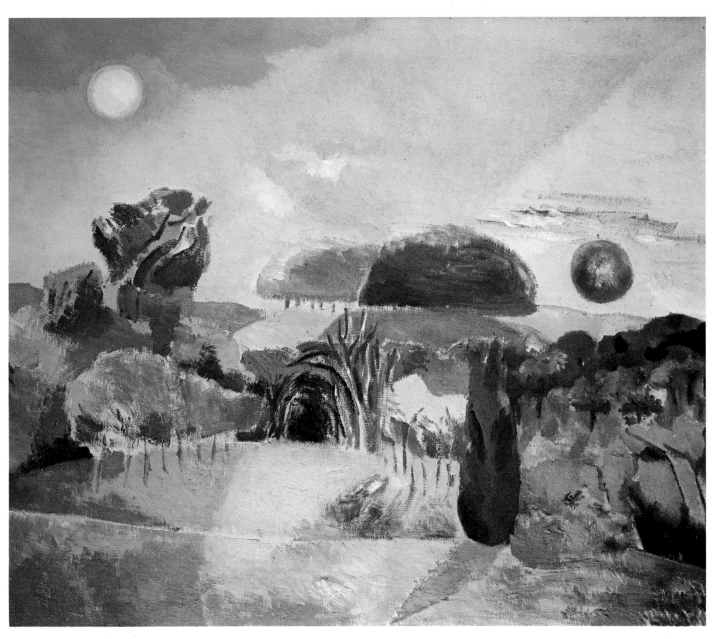

116. LANDSCAPE OF THE VERNAL EQUINOX, *1944, oil, 25 × 30 ins.*

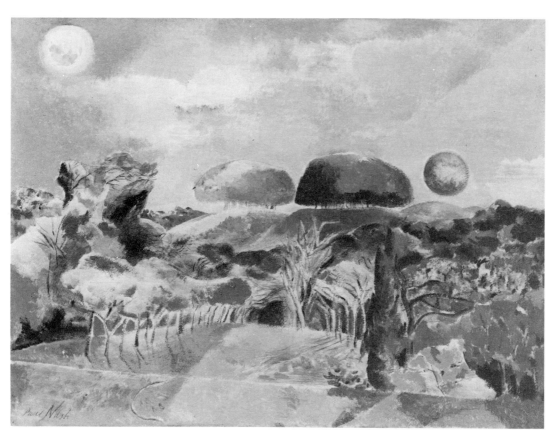

117a. LANDSCAPE OF THE VERNAL EQUINOX, *1943–4, oil & watercolour on board, 15½ × 22½ ins.*

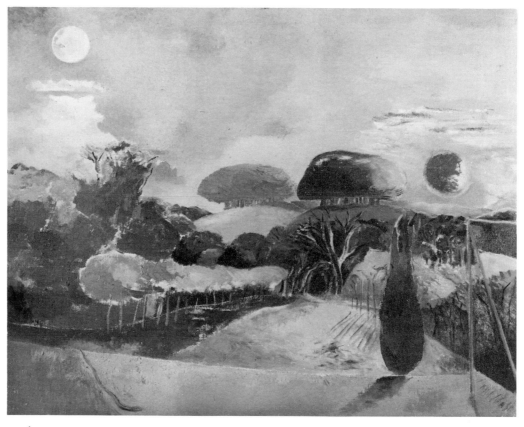

117b. LANDSCAPE OF THE VERNAL EQUINOX, *1943–4, oil, 27½ × 36 ins.*

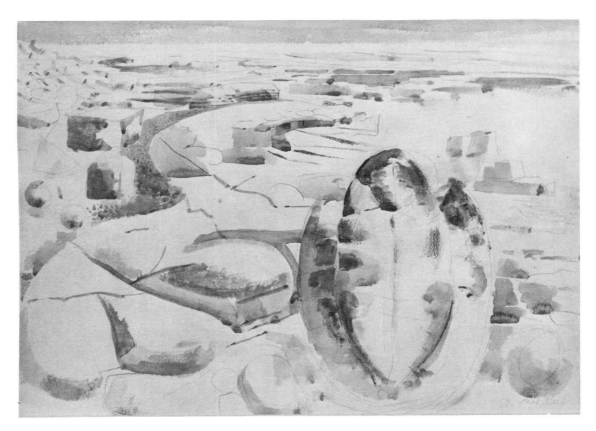

118a. GHOST OF THE TURTLE, *1942, watercolour, 15 × 22 ins.*

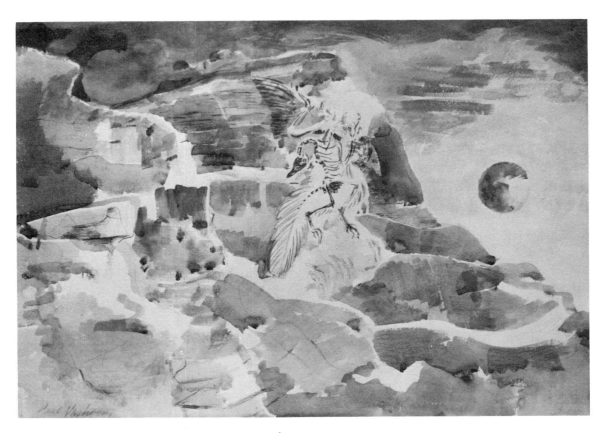

118b. GHOST IN THE SHALE, *1942, watercolour, 15½ × 22½ ins.*

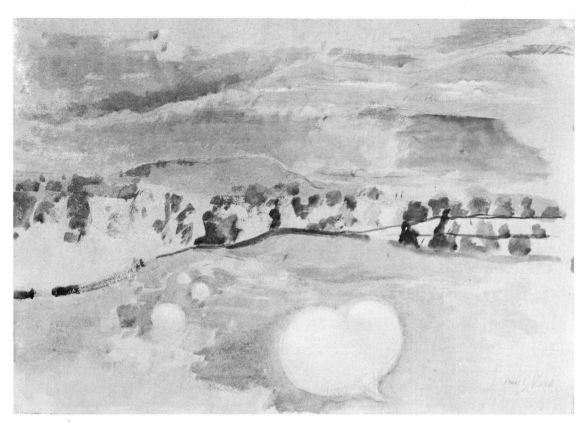

119a. LANDSCAPE OF THE PUFF BALL, *1943, watercolour, 15 × 22 ins.*

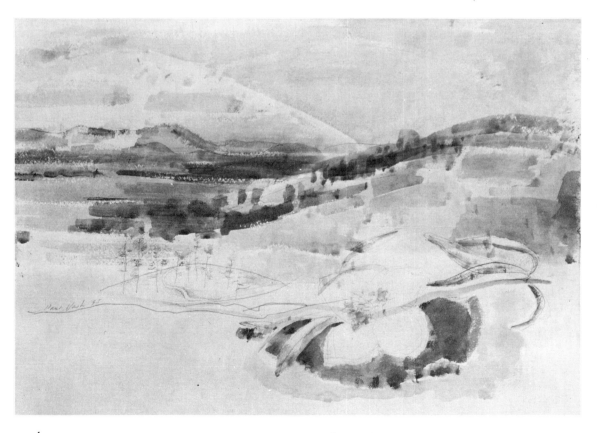

119b. FLOWER RESTING IN THE LANDSCAPE, *1945, watercolour, 15½ × 22½ ins.*

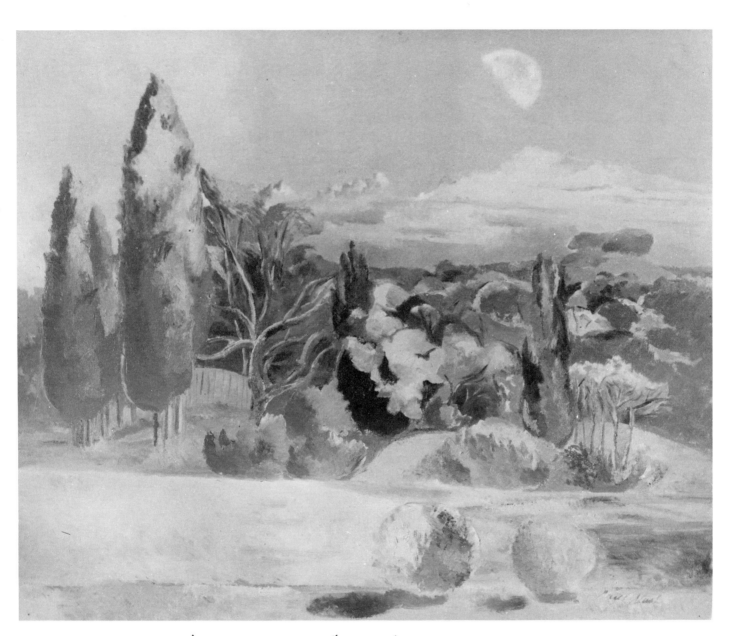

120. LANDSCAPE OF THE MOON'S FIRST QUARTER, *1943, oil, 20 × 30 ins.*

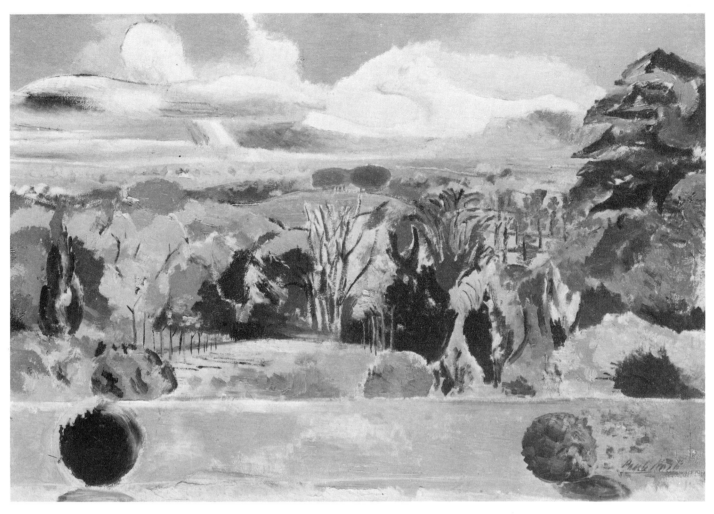

121. WOODED LANDSCAPE, *1942, oil on paper board, 20 × 36 ins.*

122a. SUNSET FLOWER, *1944,*
watercolour, 19 × 14 ins.

122b. HYDRA DANDELION, *1946,*
watercolour, 15½ × 11½ ins.

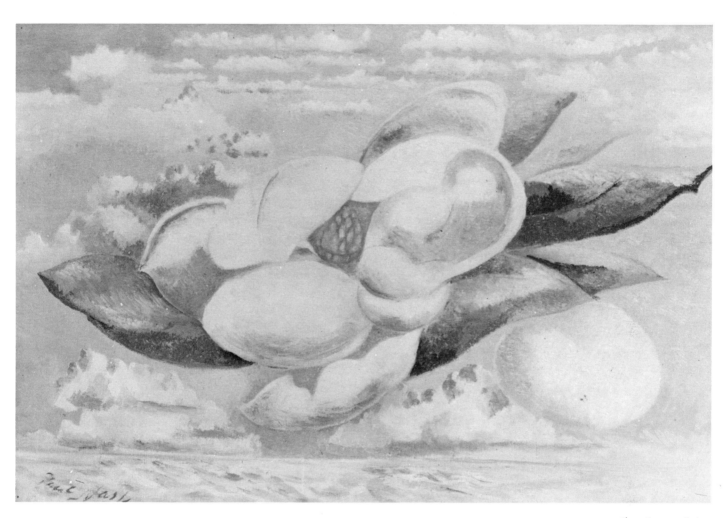

123. FLIGHT OF THE MAGNOLIA, *1944, oil, 19½ × 29½ ins.*

124. SUNFLOWER AND SUN, *1943, watercolour, 22 × 15 ins.*

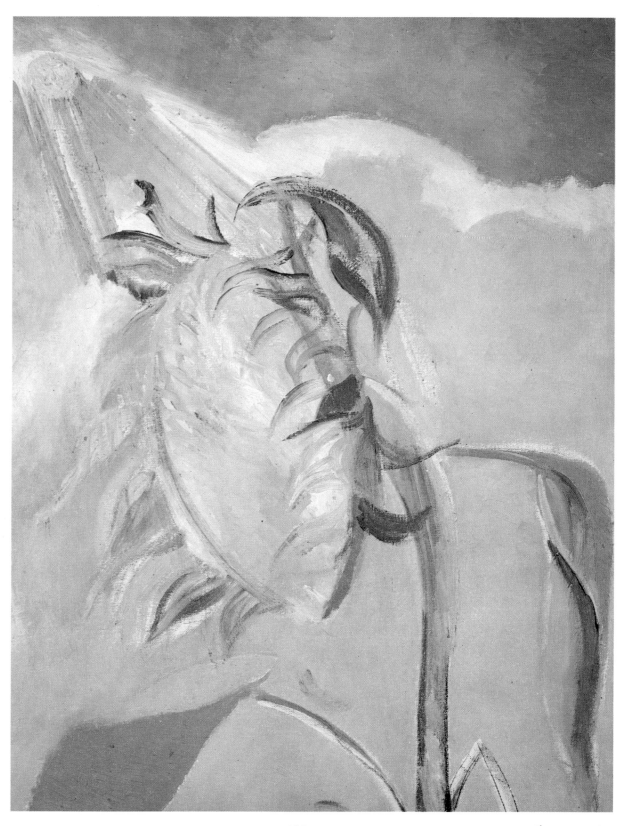

125. SUNFLOWER AND SUN, STUDY, *c. 1945, oil, 25 × 20 ins.*

126a. THE SUNFLOWER RISES (*preliminary sketch*), 1945, *watercolour, 17 × 22¾ ins.*

126b. TWO SKETCHES OF SUNFLOWERS, *c.*
1944/5, *crayon*

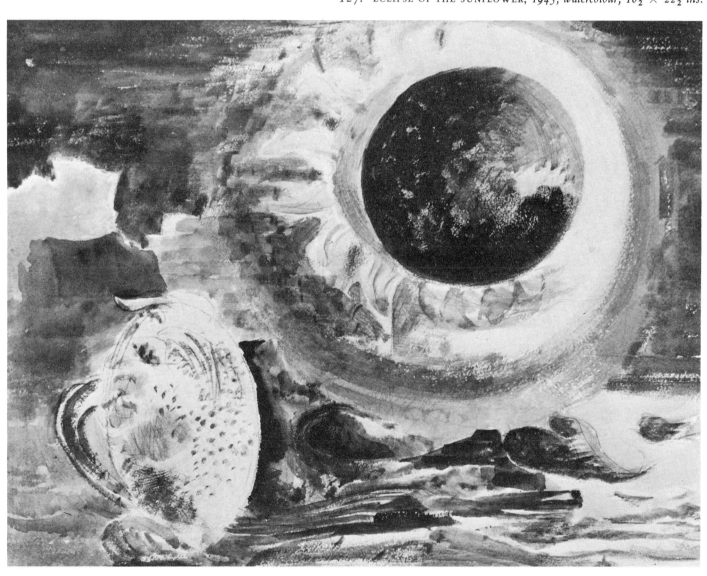

128. ECLIPSE OF THE SUNFLOWER, *1945, oil, 28 × 36 ins.*

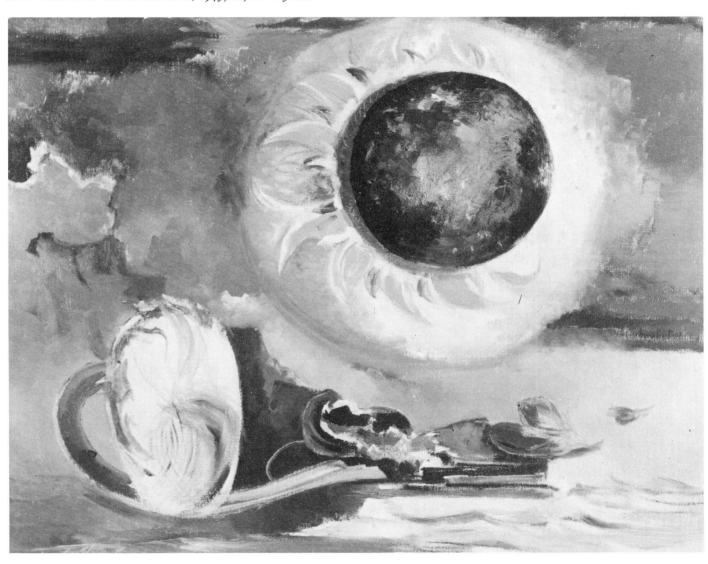

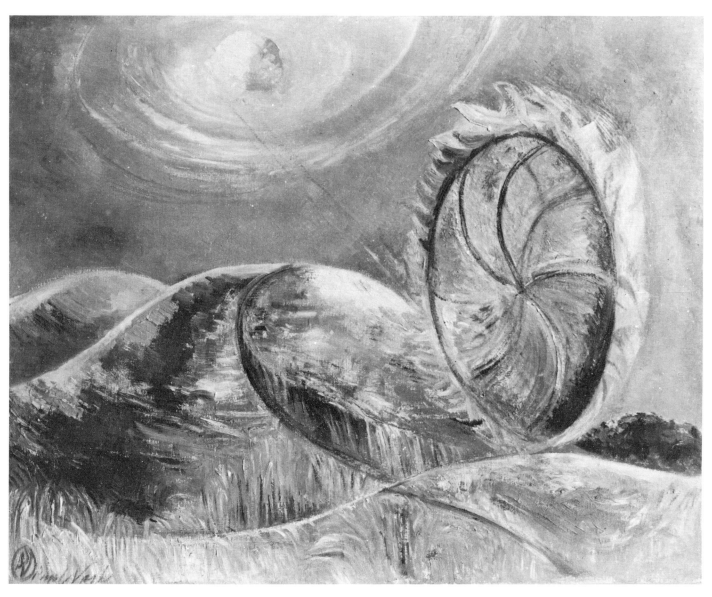

129. SOLSTICE OF THE SUNFLOWER, *1945, oil, 28 × 36 ins.*

130. FAREWELL, *1944, oil, 20 × 24 ins.*

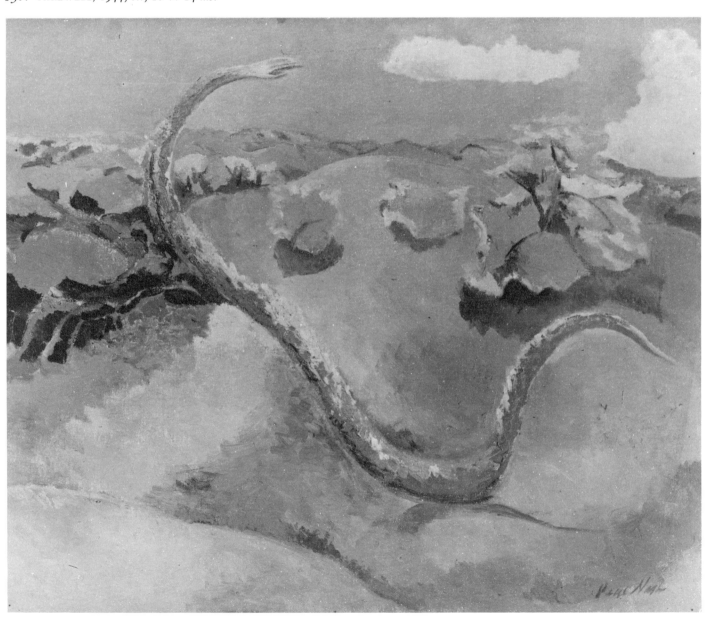

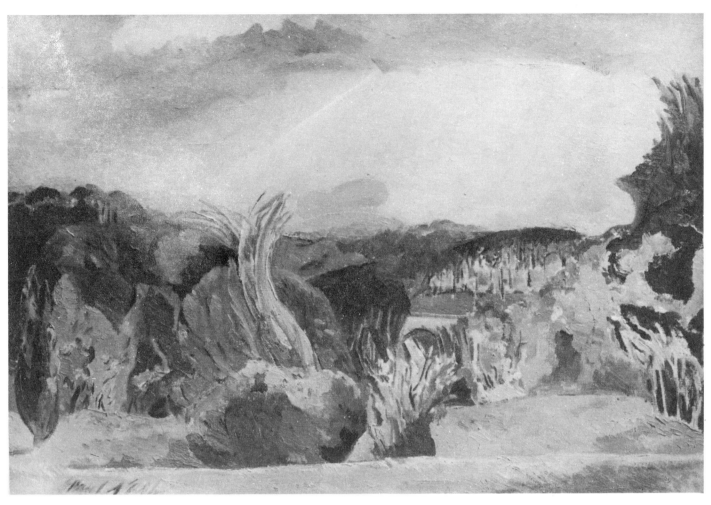

131. PORTRAIT OF A LANDSCAPE PAINTED FOR TWO LADIES, *1944, oil, 20 × 30 ins.*

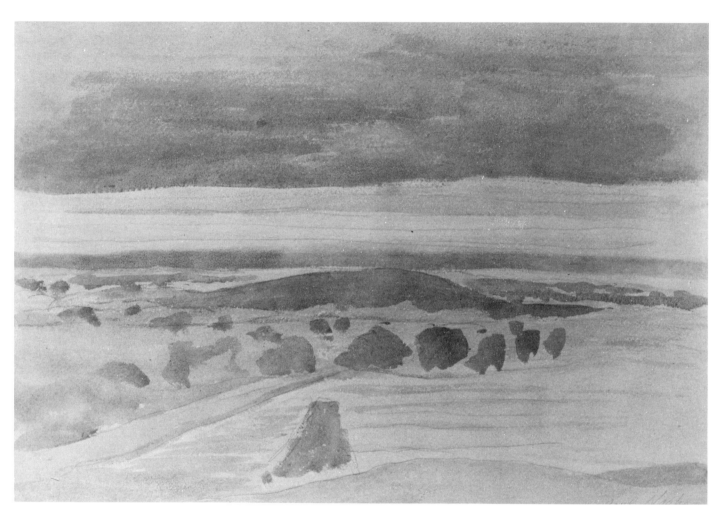

132. LANDSCAPE OF THE VALE, DAWN, *1943, watercolour,* 14⅞ × 21⅞ *ins.*

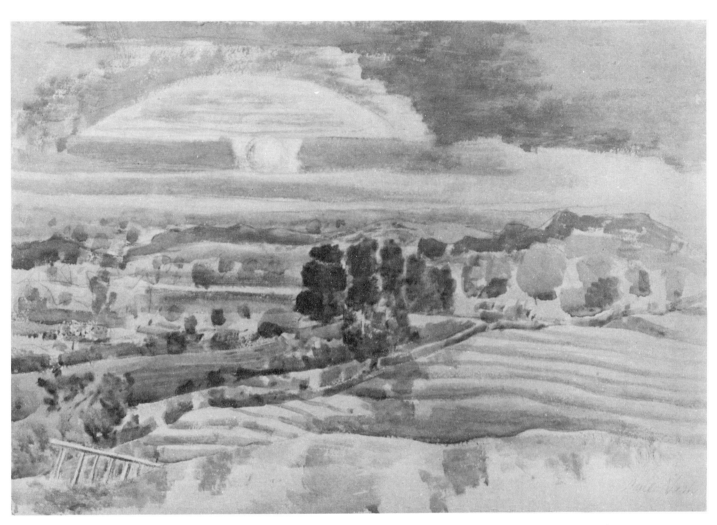

133. SUNRISE OVER THE VALLEY, *1943, watercolour, 15½ × 22½ ins.*

134. ROAD TO THE MOUNTAINS, *1944, watercolour, 15½ × 22½ ins.*

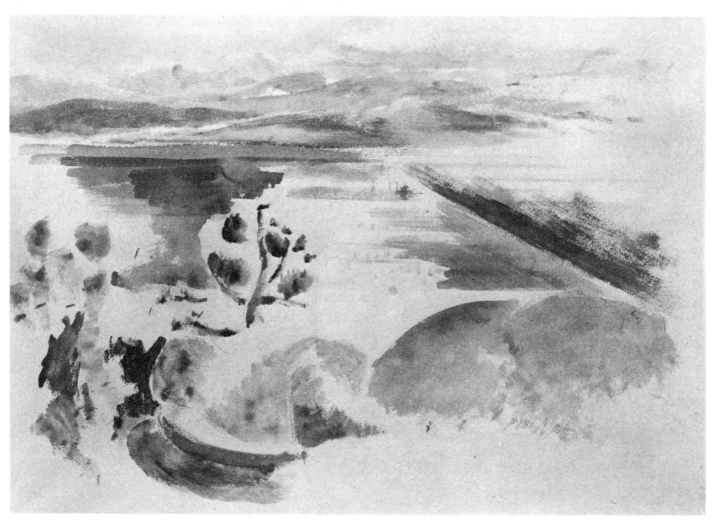

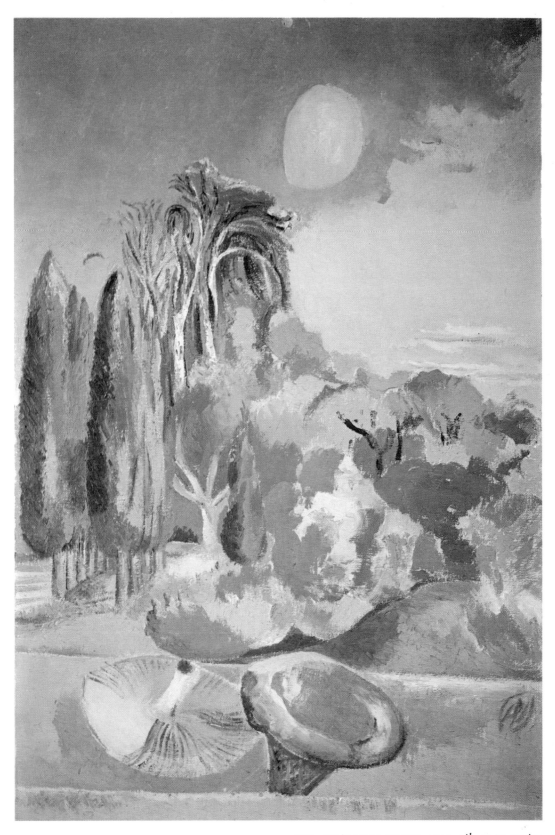

135. NOVEMBER MOON, 1942, oil, 30 × 20 ins.

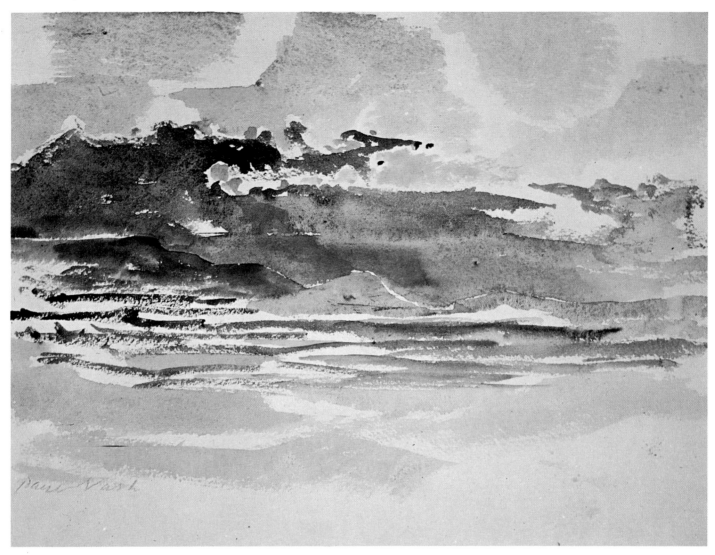

136. SUNSET EYE, STUDY 5, 1945, *watercolour, 11¼ × 15 ins.*

137. SUNSET OVER THE PLAIN, STUDY *2, 1944, watercolour, 11 × 15½ ins.*

138. HILL, PLAIN & CLOUD, STUDY *1, 1945, watercolour,* $11\frac{3}{4} \times 15\frac{1}{2}$ *ins.*

139. LANDSCAPE FADING, *1945, watercolour, 11 × 15½ ins.*

140. MARCH STORM, *1944, watercolour, 15 × 22 ins.*

141. STUDY IN PALE TONES, *1943, watercolour,* $15\frac{1}{2} \times 22\frac{1}{2}$ *ins.*

142. LANDSCAPE AFTER FROST, *1945, watercolour, 15½ × 22½ ins.*

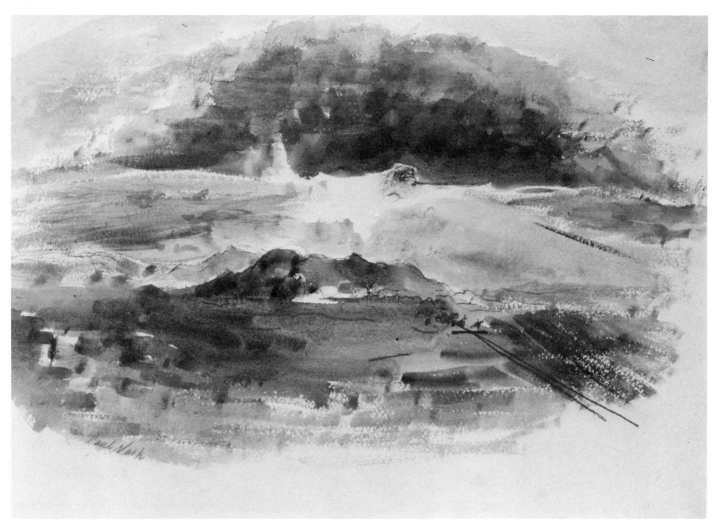

143. SUNSET OVER THE PLAIN, STUDY *1, 1944, watercolour, 14 × 24 ins.*

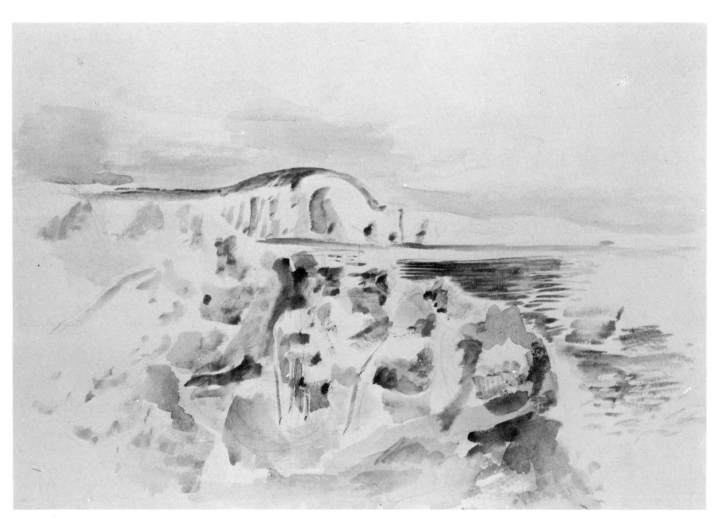

144. LANDSCAPE, ISLE OF WIGHT, *1946, watercolour, 15½ × 22½ ins.*

APPENDIX

A Chronology of Paul Nash's Life and Work

THE ESTABLISHMENT of a workable chronology is always desirable in the consideration of any artist's œuvre. When one is dealing with the painting or sculpture of the old masters one is naturally prepared to accept the lack of precise dates, even though this lack diminishes the possibility of accurate assessment. It is more disconcerting to find the same difficulties of dating works and movements when studying the production of artists who died no more than twenty-five or fifty years ago. It ought to be relatively simple, one would think, to follow the exact course of Paul Nash's development, considering that he lived a not very eventful life, that he held many exhibitions the catalogues of which have been kept, that he was personally concerned in later life with the compilation of various photographic records of his work, and that he was the subject of five monographs published during his lifetime. In addition a biography and other studies appeared shortly after his death, and he was the author or the subject of numerous articles. Yet even so, many chronological problems exist for the whole of his production.

Unfortunately the greater number of his oils, water-colours and drawings are undated, even when they are signed, and they have accordingly to be dated on the evidence of exhibitions, correspondence, topography and, finally, of style and technique. For all artists this kind of evidence tends to be fallible, and it is particularly so for Nash.

The dates of exhibitions do, of course, provide a *terminus ante quem*, but even then only to a limited extent. An immediate element of uncertainty arises when we realise that Nash not infrequently altered the form of a painting, or its title, or both, and that on the evidence available to us it is not always possible to determine whether we are dealing with two works or with one when we encounter an earlier drawing or oil under a new title in a later exhibition, or, conversely, when all trace of an early work, exhibited shortly after it was executed, is apparently lost, until it is realised that it has reappeared much later in a different guise. A notable example of this disconcerting phenomenon is to be found in *Chestnut Waters*, first exhibited under that title at Tooth's in 1939 and now in the National Gallery of Canada. It was originally shown at the Leicester Galleries in 1924, when it was called *The Lake*, and had in the foreground a semi-recumbent nude, which was subsequently painted out.

Correspondence, except when it passed between his agents and himself and referred to specific works under their correct titles, may be equally misleading, simply because the drawings and paintings which were currently worked on were not necessarily mentioned under the names which they acquired when finished, and the descriptions and allusions may well fit more than one painting executed during the period covered by the exchange of letters.

Again, though topography may afford the clue to the dating of a landscape, it is no certain guide. Broadly speaking, the periods into which Nash's work may be divided correspond to the places where he lived and his paintings and drawings can mostly be referred to the Dymchurch Period, the Iden Period, the Swanage Period and so forth. But though he was mainly resident in one place during each of these periods and his work was largely based upon the landscape that surrounded him, he visited friends, stayed with members of his family in different parts of southern England and went abroad during the time that he was settled in a particular studio, and each excursion was productive of paintings reflecting a wholly different topography. The problem of identifying one particular visit out of several and relating it to a specific work may in consequence prove insoluble. Thus, until his father's death, he produced numerous sketches of the country round his childhood home at Iver Heath, to which he constantly returned; he paid many visits to Hillingdon and various parts of the Chilterns. In later life he was often a guest at the Neilsen's house in Gloucestershire. The resultant paintings are difficult to date exactly and the task is complicated by his practice of using original sketches or photographs taken on the spot as a basis for paintings and watercolours which were later worked on in the studio intermittently, because the actual landscape increasingly became no more than a point of departure for the expression of his personal imagery.

Devotees of style criticism will object that all these, to them, trifling difficulties can easily be resolved by a close study of Nash's style and technique. But like so many style critics before them, they would be self-deceived were they to place over-much reliance on such criteria. The sad truth is that Nash frequently anticipated a 'later style' or technique in a much earlier painting, and equally harked back to an earlier manner in a later work. Even during the period of his novitiate before the First World War he sometimes

treated a landscape in a manner suggestive of his middle period, and amongst the landscapes executed during the Second War there are occasional studies which might, in the absence of other evidence, be reasonably regarded as 'typical' of a previous phase. There is, for example, an early hill study, *Downs*, clearly dated 1922, which so closely resembles his drawing of Maiden Castle, made during one of his two visits in 1935 and 1937, that it is hard to believe that they are separated by a period of some fifteen years. Even the technique is identical. Indeed it would be true to say that his actual handling of oils, and to a lesser extent of watercolour and pen and ink, from the end of the First World War onwards shows no steady progression and that, apart from a few specific methods that can be related to work produced up to the middle twenties, he was always liable to revert to an earlier technique, if it served his expressive purpose. This is excellently demonstrated in an oil of *March Woods*, of 1921, from the collection of his widow, where the rendering of the trees and the selection of pigments is closely paralleled by the treatment of the long tunnel of trees leading towards Wittenham Clumps in the background of *The Landscape of the Vernal Equinox* in the version belonging to the Queen Mother.

In view of these difficulties it is of importance to try as far as possible to provide a firmly dated sequence of work, and then to relate to them undated works, ascribed to periods rather than to actual years, the ascription being based on all the available evidence, not excluding criteria of style and technique.

The task of dating a large number of works has been thrice attempted, once by Margaret Nash and myself, once by Margaret Nash, and once by Anthony Bertram. In the first instance, while preparing the *Memorial Volume* for publication, Mrs. Nash and I tried, with very partial success, to assign dates to many of the paintings and drawings listed in the catalogues of exhibitions, held during the artist's lifetime. It was an over-ambitious project, since time did not permit of a careful examination of the records and there was no opportunity for a critical assessment of probabilities. A re-examination of our conclusions therefore reveals a number of errors.

After the publication of the book, Margaret Nash, with unexampled energy and devotion, undertook a more systematic review of the evidence, and over some seven or eight years compiled a photographic record and accompanying catalogue, which is now lodged in the Victoria and Albert Museum. This record contains the photographs of six hundred and thirty oils, watercolours and drawings.

The third attempt to provide a dated series was made by Anthony Bertram in the Index of Pictures at the end of the *Biography*, where he lists the three hundred and sixty three works mentioned in the text.

Both Margaret Nash and Anthony Bertram assigned dates to all the works they listed, Bertram's conjectures being on the whole the more reliable, because they are more tentative. Where Margaret Nash had no certain evidence to go upon she usually assigned a definite date, without indicating whether it was conjectural or certain. Her method of classification by years rather than by periods probably rendered this inevitable, though it is regrettable that she was thereby forced to assume an air of infallibility which neither she nor anyone else could justifiably claim to possess. One of her main difficulties was Nash's own habit of pencilling dates on the backs or mounts of record photographs. He seems to have despised the pusillanimity of '*circa*' and may even have been anxious to give the impression that exact record of every work had been kept. Because of this, in working over much of the ground covered by Mrs. Nash, I have on more than one occasion been faced by the bewildering problem of a choice of several different years, all unhesitatingly accorded to a single painting by the artist himself. Anthony Bertram wisely eschewed the claim to infallibility, and where he felt that any measure of doubt existed, prefaced his conjecture with a discrete '*c*'. When his dates have not coincided with those given by Mrs. Nash, I have therefore generally chosen to accept his conjectures, unless I had good reason to differ from them.

The difficulties occasionally presented by titles are scarcely less hard to resolve, not only by reason of Paul Nash's habit of changing his mind about them, but also because in some cases works never received any title at all while they were still in the artist's possession. Inclusion in an exhibition nearly always means that a picture acquired a name, even though it might be a vague one, such as 'Landscape' or 'Abstract', which is hardly traceable at a later date. If a picture was sold without passing through the hands of one of his regular agents or being catalogued in a one-man show or a mixed exhibition, the purchaser may have been given the title verbally (particularly if the work was unmounted or unframed) and unless he then wrote it on the back of the work himself, all record of the title may be lost. I have therefore sometimes had cause for suspicion, as in the case of the important watercolour study for the original state of *Voyages of the Moon*. This drawing, on loan to the Brighton City Art Gallery from the Edward James Collection, now masquerades under the title of *Globes Floating in a Many Pillared Room*, a name, as Ruth Clark (Paul and Margaret Nash's closest friend) has rightly observed, much more characteristic of James than of Nash, although in fact it appears that the title may have been 'invented' by the Gallery.

In this matter of titles Margaret Nash herself was sometimes arbitrary, for there can be no doubt that several of the names in her lists were invented by herself. For this she can hardly be blamed, since she so well understood the train of thought which had produced Nash's evocative titles, and she was therefore qualified to invent others which would

have appealed to her husband and which certainly succeed in conveying the inner meaning of the works. Occasionally confusions arose, as in the case of *Night Piece, Toulon*, a title accorded to one work by Mrs. Nash, and to a completely different one by Bertram, whose choice I have preferred to follow. Here, however, I should confess that I myself have not been wholly guiltless of 'title-making', for I have called the apparently untitled and unrecorded companion watercolour '*Day Piece*', though I have taken the precaution of adding inverted commas to the title in the Catalogue of Plates.

Such confusions are the more unfortunate in that names played so important a role in Nash's artistic life. From the very beginning his poetic approach led him to the use of evocative titles which are essentially literary concepts. Some of his earliest drawings were illustrations to his own poems at a time when his youthful ambition centred on becoming a poet-painter in the Rossetti tradition. Although this ambition was short-lived, it left a lasting mark upon him, and the knowledge of the exact title he chose for a painting therefore frequently affords the clue to its understanding and hence to its full enjoyment. The names of *Bird Garden, The Three in the Night, Their Hill*, all drawings included in his first exhibition in 1912, precisely express a poetic feeling which far transcends the mere painterly transcription of a seen landscape. At certain periods of his work, and notably in the years immediately following the First World War, the practice of evocative titling was partly in abeyance, largely because he was producing rather more straightforward landscapes, though even in these the poetic overtones were rarely lacking. His successive encounters with abstract and surrealist influences in the later twenties and early thirties of the century, however, caused him to return to his more overtly poetic practice, and from then on until the end of his life the titles of his oils and watercolours often assume a paramount importance.

Faced with these difficulties, I realised from the outset that it was impossible to produce anything in the nature of a *catalogue raisonné*, and in the course of collecting the material for the following lists numbers of other problems have arisen.

All trace of many earlier watercolours and drawings has been lost, because they were bought by old family friends, who died before Nash and his wife made any attempts, however unsystematic, to maintain some record of his work. Other paintings (even including some of the larger oils) which were listed in exhibition catalogues, photographed or entered in dealers' records, have subsequently changed hands more than once and have been temporarily lost sight of. A number of owners mentioned by Anthony Bertram in his index of pictures, or by Margaret Nash in the catalogue to her 'Photographic Record' cannot now be traced, and others have ignored letters asking for information, perhaps on the assumption that the publication of their names in a catalogue would shortly lead to the theft of their most treasured possessions.

To have eschewed all attempt to present some general record of Paul Nash's production during the course of his working life would, nevertheless, have been an admission of defeat, and would have rendered the present study even less complete than it need be. I have therefore chosen a middle course, and have 'listed' those works of which some record exists in Margaret Nash's catalogue, in Nash's photographic albums, in Anthony Bertram's index, in my own Memorial Volume, and in exhibition catalogues, in addition to the more fully documented paintings and drawings about which I have been able to obtain direct information from private collectors and public galleries and institutions. Sometimes it has proved impossible to supply more than a title and an approximate date. In other cases the information is fuller and more accurate. Except for those works which have been acquired by public collections, I have not given the names of past or present owners, not only because many of them might choose to remain anonymous, but also because today works of art change hands so frequently that no published list of names can have more than a temporary validity. Owner's names, when known, are noted in my card-catalogue, which will be available in the archives of the Tate Gallery. Information received too late for inclusion in the Chronology is also noted there.

Each section of the lists of paintings and drawings has been prefaced by a biographical chronology, as an aid to future students who wish to dispute my conjectural dating of Nash's work, and the material is supplemented by the lists of exhibitions, publications, and other activities in which Nash was engaged.

The chronological lists of paintings which follows the Biographical Chronologies and the lists of exhibitions, arranged according to period, include works of which full details can be given as well as those for which the only existing record is the name of the painting given in exhibition catalogues of the relevant date.

In indicating the size of paintings height is given before width. All dates, unless there is firm evidence, are approximate. In cases where works are known to be signed, the position of the signature or monogram is indicated as 'bottom right', 'middle left' in abbreviated form. The word 'inscribed' is occasionally used. Sometimes it signifies that Nash wrote the date, the title and possibly the name of the recipient, in addition to his signature, sometimes, however, it may merely indicate that the work is signed in full. An asterisk following a title indicates that the work has been discussed in the text. Where the work was included by Mrs. Nash in her Photographic Record, her catalogue number is given in brackets. The accuracy of much of this information cannot be guaranteed, since I have been largely dependant on the kindness of owners, who have supplied details of

works in their possession. Occasionally, therefore, both size and method of signature may not conform to standard exactitude, and dates seem to be more in the nature of inspired guesses than precise statements of fact.

BIOGRAPHICAL CHRONOLOGY 1889–1910

1889	Paul Nash born 11th May at Ghuznee Lodge, Kensington, London, eldest son of William Henry Nash, Recorder of Abingdon, and Caroline Maude, daughter of Captain Milbourne Jackson, R.N.
1898–1903	Attended Colet Court, the preparatory school for St. Paul's. Made frequent visits to his grandfather's home at Langley Marish, Bucks. Also stayed in Hampshire and at Swanage.
1900	Death of John Nash, Paul Nash's grandfather.
1901	Family moved to Wood Lane, Iver Heath, Bucks, for the benefit of Mrs. Nash's deteriorating health. Paul Nash became a boarder at Colet Court.
1903	Entered the senior school of St. Paul's, then transferred to a tutorial establishment at Greenwich.
1904	Failed naval entrance, returned to St. Paul's in autumn term.
1906	Left St. Paul's. Rejected his father's suggestion that he should work in a bank. In December registered as a part time student at Chelsea Polytechnic.
1907	Became full time student at Chelsea Polytechnic.
1908	Left Chelsea, became an evening student at Bolt Court, Fleet Street, where he won acclaim from William Rothenstein for *Flumen Mortis*.
1909	Saw the Wittenham Clumps for the first time on a visit to his uncle at Sinodun House, Berks.
1910	Death of Nash's mother in February. April, beginning of correspondence with Gordon Bottomley. Left Bolt Court in July. Visited Normandy with his uncle and aunt in August. Entered the Slade School in October.

PAINTINGS, WATERCOLOURS AND DRAWINGS 1907–1910

1910 *Angel & Devil (The Combat),*★ pencil, pen & ink wash, 14 × 10⅛ ins. monogram b.l. 1910 Victoria & Albert Museum. (MN 3/1910)

Crier by Night,★ (illustration to Gordon Bottomley play) pen, pencil, 7¼ × 5½ ins. monogram b.l. 1910. (MN 4/1910)

Flumen Mortis,★ pen, 6⅞ × 13 ins. unsgd. 1910. (probably destroyed)

Landscape with Trees, watercolour, 14 × 16 ins. sgd. 'Nash' b.r. *c.* 1910–1912

Our Lady of Inspiration,★ ink & chalk, 6¾ × 9 ins. unsgd. 1910

The Sleeping Beauty, watercolour, 7⅛ × 6¼ ins. cartouche b.r. 1910 Carlisle Museum and Art Gallery

OTHER WORK

1907–10 Various book plates

BIOGRAPHICAL CHRONOLOGY 1911–1916

1911	October, took rooms in Paultons Square. December, left Slade. Met Sir William Richmond, R.A.

1912 May, left Chelsea.
 November, held first one-man exhibition at Carfax Gallery. Met Gordon Bottomley.

1913 Regular contributor to New English Art Club exhibitions.
 February, met Margaret Theodosia, daughter of Rev. N. Odeh. Became engaged in March.
 November, exhibition of watercolours with brother, John Nash, at Dorien Leigh Galleries, attracted considerable notice including that of Charles Rutherston, Sir Michael Sadler, and also Roger Fry, who asked Nash to design for the Omega workshops.

1914 Met Sir Edward Marsh.
 September, enlisted as a private in Artists' Rifles. Detailed for home service.
 Married Margaret Odeh at St. Martin in the Fields, December 17th.

1916 Gazetted 2nd Lieutenant in 3rd Hampshire Regiment.

PRINCIPAL EXHIBITIONS

1912 Carfax Gallery, St. James's, London, S.W. 'Drawings by Paul Nash'

1914 Dorien Leigh Gallery, South Kensington, London, S.W.3. 'Drawings by Paul and John Nash'

PAINTINGS, WATERCOLOURS AND DRAWINGS 1911–1916

1911

Between the Trees (*Wood Lane, Iver Heath*), pencil & colour wash, $13\frac{1}{2} \times 11$ ins. unsgd. 1911 (MN 8/1911)

Bird Chase,★ wash, pen & pencil, $13\frac{1}{2} \times 11$ ins. unsgd. 1911 (MN 5/1911)

Bird Garden,★ pen, wash & chalk, $15\frac{1}{2} \times 14$ ins. monogram b.l. 1911 (MN 6/1911)

The Dark Garden, pen & wash. 1911

Falling Stars,★ pen, pencil, wash & chalk, $12\frac{1}{4} \times 8\frac{3}{4}$ ins. unsgd. *c.* 1911 (MN 2/1912)

Field Before the Wood, pencil, ink & wash, $14\frac{1}{4} \times 11\frac{3}{4}$ ins. monogram b.r. 1911 (MN 2/1911)

In a Garden under the Moon,★ pen, pencil, body colour, $13\frac{3}{4} \times 9\frac{3}{4}$ ins. cartouche b.r. and inscr. title & sgd. on mount. 1911

Landscape. 1911

Landscape at Aston Tyrold. 1911

Landscape under the Moon. 1911

A Lane in Blue, watercolour, pencil & chalk, $13\frac{5}{8} \times 9\frac{3}{4}$ ins. sgd. in full. Probably 1911

Path across the Field, pencil, pen & wash. Probably 1911 (MN 3/1911)

Pyramids in the Sea,★ wash, pen & chalk, $13 \times 11\frac{1}{8}$ ins. unsgd. 1911–12 (MN 11/1912)

The Three,★ pen, ink, wash, $15\frac{1}{2} \times 11$ ins. monogram & date b.r. 1911

The Three,★ pen wash & chalk. unsgd. 1911 (MN 4/1911)

The Trees and the Birds. 1911

Vision at Evening,★ watercolour & chalk, $7\frac{1}{8} \times 13\frac{7}{8}$ ins. monogram b.r. 1911 (7/1911) Victoria & Albert Museum

The Wanderer. 1911

1912

Dr. Gordon Bottomley, ink & watercolour, $13\frac{3}{4} \times 11\frac{1}{2}$ ins. cartouche b.r. 1911 (MN 8/1912) Carlisle Art Gallery

Group of Trees (Iver Heath), chalk & monochrome wash, $15\frac{3}{4} \times 13$ ins. cartouche b.l. 1912

Landscape with Rooks, watercolour, $10\frac{3}{16} \times 11\frac{3}{16}$ ins. sgd. *c.* 1912 Fitzwilliam Museum, Cambridge

Lavengro & Isopel in the Dingle,★ watercolour & chalk, $17\frac{1}{2} \times 14$ ins. S.F. & monogram b.r. 1912 (MN 7/1912)

Lavengro & Isopel (Study 2), ink & wash, $11 \times 8\frac{3}{4}$ ins. *c.* 1912

Night in Bird Garden,★ wash, pen & pencil, 20×17 ins. sgd. b.r. in full. 1912 (MN 9/1912)

Peacock Path,★ black ink and watercolour, 18×15 ins. insc. 'Paul Nash' with monogram b.r. 1912 (MN 3/1912)

Spring at the Hawks Wood,★ watercolour, $21\frac{3}{4} \times 14\frac{1}{2}$ ins. monogram b.r. & inscr. '1912', & 'To dear Audrey in compensation, 1911'. 1911–12. (MN 4/1912)

Their Hill,★ pen, wash & chalk, $9\frac{5}{8} \times 13\frac{1}{8}$ ins. monogram b.r. 1912 (MN 10/1912)

Under the Hill (*Wittenham Clumps*), ink & blue wash, 15½ × 12¾ ins. cartouche b.r. *c.* 1912
Carlisle Museum & Art Gallery

Wittenham Clumps,★ watercolour, crayon, pencil & ink, 12⅛ × 15⅝ ins. 'Nash' and cartouche b.r. (MN 5/1912)
Carlisle Art Gallery

Wood on the Hill,★ pen, chalk & wash, 22 × 14½ ins. unsgd. 1911 or 1912 (MN 6/1912)

Barbara in the Garden,★ pencil, pen & wash, 14⅛ × 19¼ ins. sgd. b.l. *c.* 1911/13 (MN 1/1911)
Carlisle Museum & Art Gallery

1913 *The Cliff to the North*, pen, wash & chalk, 15 × 11½ ins. sgd. on mount. 1913 (MN 3/1913)
Fitzwilliam Museum, Cambridge

The Elms watercolour, 27 × 18¾ ins. unsgd. *c.* 1913
Manchester City Art Gallery

Green Hill,★ watercolour, chalk & pen, 13¾ × 18¼ ins. monogram and 'Nash', b.r. *c.* 1913 (MN 1/1913)

In Andrew's Field (Study 1), watercolour, chalk & pen, 9¾ × 13¼ ins. sgd. in full b.r. 1913 or 1914 (MN 8/1914)

A Landscape at Wood Lane, watercolour, 22 × 14½ ins. inscr. 'Nash' and monogram b.r. Probably 1913 (MN 6/1914)
Manchester City Art Gallery

Over the Hill, pen & watercolour. 1913 (destroyed by fire, 1946)

Portrait of Barbara Nash, watercolour over pencil & chalk, 17¾ × 13 ins. full name b.l. & cartouche. *c.* 1913

The Rose Cloud, watercolour? 1913

Sunset in Corn Valley, watercolour, chalk & Indian ink, 14 × 17½ ins. 1913 (destroyed by fire)

The Three in the Night,★ Indian ink, wash & chalk, 20¾ × 13½ ins. unsgd. 1913 (MN 2/1913)

Tree Study, watercolour, pen & pencil, 21¾ × 8¾ ins. unsgd. 1913 (MN 5/1913)

Trees in Bird Garden,★ watercolour, pen & chalk, 16½ × 12½ ins. unsgd. 1913 (MN 7/1913)
Birmingham City Museum & Art Gallery

William Harry Nash (Paul Nash's Father), pencil, chalk & watercolour, 11⅛ × 8½ ins. monogram & 'Nash'. 1913 (MN 6/1913)
Victoria & Albert Museum

1914 *The Elms*, pen & ink, watercolour, gouache & chalk, 26⅜ × 18¾ ins. inscr. 'Nash' b.r. 1914 (MN 7/1914)
Walker Art Gallery

Foliage (View from the Sheiling, Silverdale, nr. Carnforth), watercolour, 16 × 22 ins. unsgd. 1914 (MN 3/1914)

Lake Thirlemere, watercolour, pen & chalk. 1914

Landscape with Nymph, watercolour, Indian ink & chalk. sgd. b.r. 'Nash'. 1914 (MN 2/1914)

Landscape with Rooks, watercolour & pencil, 10³⁄₁₆ × 11³⁄₁₆ ins. sgd. b.r. *c.* 1914
Fitzwilliam Museum, Cambridge

Mackerel Sky, watercolour. Probably 1914

Margaret in the Garden, Iver Heath, ink & wash, 11½ × 9 ins. sgd. & dated b.r. 1914 (MN 9/1914)

The Monkey Tree, pencil, pen & ink, wash, 15 × 17¾ ins. monogram b.l. 1914

Monkey Tree (Grange over Sands) (Study 1), watercolour, 15 × 19 ins. unsgd. 1914 (MN 4/1914)

Moonrise over Orchard, watercolour, pen & chalk, 14¼ × 16½ ins.

Night Landscape★ (*The Archer*), watercolour, pen & ink, 15 × 12 ins. unsgd. 1911–14
Arts Council of Great Britain

Sombre Landscape, watercolour, pen & chalk. 1914

Summer Garden, watercolour, pen & chalk. 1914 (MN 10/1914)

Thirlmere, watercolour, 14 × 14¾ ins. sgd. 'Nash'. 1914 (MN 5/1914)

Trees and Shrubs,★ watercolour, 12⅞ × 19 ins. insc. in full + 1914 b.r. 1914
Manchester City Art Gallery

Under the Sky, pen, wash & chalk. 1914 (destroyed 1939)

Winter Country, watercolour & pen. 1914

1915 *Outside a Wood,*★ watercolour, ink and Chinese white, 11¼ × 14½ ins. inscr. 'Nash' & monogram b.l. *c.* 1915
Manchester City Art Gallery

Tree Group, Iver Heath, Bucks, watercolour, Indian ink & chalk, 20¾ × 11¼ ins. 1915 (MN 1915)

Tree Tops, watercolour, indian ink & chalk, 15 × 12 ins. unsgd. 1915 (MN 1/1915)

1916 *Danae* (Portsmouth), watercolour, pen & chalk, unsgd. 1916 (MN 4/1916)

Lake in a Wood★ (Iver Heath), watercolour, pen & chalk, 9¾ × 13¼ ins. sgd. 'Nash' twice, b.l. 1916 (MN 2/1916)

Monkey Tree (Grange over Sands), (Study 2), watercolour, 15 × 18 ins. monogram b.l. 1916 (or possibly 1914) (MN 5/1916)

Orchard, watercolour, pen & chalk, 10 × 10½ ins. unsgd. 1916 (MN 3/1916)

A Place, watercolour, 14½ × 15¼ ins. 1916
Quince, watercolour & chalk, 22 × 15 ins.
 1916 (MN 1/1916)
Richmond Park Encampment: Artists Rifles, pencil

& watercolour on pale grey paper, 10¾ × 14
ins. insc. on back of mount 'First war draw-
ing' & title. 1916

ILLUSTRATIONS & BOOK DESIGNS

1910 Various Book Plates

LITERARY WORK

1911 'Under a Picture' a poem. U.C.L. Magazine (The students' magazine of University College, London)

BIOGRAPHICAL CHRONOLOGY 1917–1918

1917 Posted to 15th Hampshire Regiment for service in Ypres Salient,
 February. Invalided to London, June. Finally discharged from hospital,
 August. As a result of the 'Ypres Salient' Exhibition seconded to Ministry
 of Information for special duty as War Artist. Sent to France, November,
 returned in December.
 Began painting in oils.

1918 April, *Menin Road* commissioned. Shared a studio with his brother in
 Chalfont St. Peter.
 May, gained wider reputation with the exhibition of war drawings at
 the Leicester Galleries.
 First publication on Nash's work in series 'British Artists at the Front'.

PRINCIPAL EXHIBITIONS

1917 The Goupil Gallery, Regent Street, London,
 W.1.
 'Drawings made in the Ypres Salient by Paul
 Nash'

1917 The Birmingham Repertory Theatre, 'Drawings

 by Paul Nash'

1918 The Leicester Galleries, Leicester Square, London,
 W.C.2.
 'Void of War: An exhibition of pictures by
 Lieutenant Paul Nash.'

PAINTINGS, WATERCOLOURS & DRAWINGS 1917–1918

1917 *The Bluff* (The Battlefield near Ypres Salient),
 pen & watercolour, 5 × 8¾ ins. 1917
 Imperial War Museum
 The Cemetery, watercolour, pen & chalk. 1917
 (MN 16/1917)
 Chaos Decoratif,★ pencil, ink & watercolour,
 10 × 8 ins. 1917 (2/1917)
 Manchester City Art Gallery
 A Close, watercolour. 1917
 Cotswold Landscape, watercolour, 13 × 21 ins. 1917
 The Dead Tree, watercolour. 1917
 Desolate Landscape, Ypres Salient,★ watercolour &

 ink, 7¾ × 10¼ ins. insc. 'Nash' b.r. 1917 (MN
 12/1917)
 Manchester City Art Gallery
 Devastation (*Mud Flats*), gouache & chalk, 10 ×
 14 ins. c. 1917
 Dunedin Public Art Gallery
 A Farm, Wytschaete, pastel & watercolour, 10 ×
 14 ins. 1917 (MN 4/1918)
 Landscape, Year of our Lord, 1917,★ pen, chalk &
 wash on brown paper, 10⅛ × 14⅛ ins. 1917
 (MN 18/1917)
 National Gallery of Canada.

111

Leaving the Trenches,★ Ypres Salient, watercolour, pen & chalk s.b.r. 1917 (MN 4/1917)

Margaret at the Piano, Iver Heath, pencil, 15 × 12 ins. dated b.r. 'August 1917'

Mount St. Eloi, pastel, 11½ × 15½ ins. 1917 (MN 9/1917)
> Imperial War Museum

Mud, watercolour, pen & chalk, 10¼ × 13½ ins. insc. in full b.r. 1917 (MN 6/1917)

Old Front Line, St. Eloi, Ypres Salient, watercolour, 8¾ × 8 ins. unsgd. 1917 (MN 1/1917)
> Victoria & Albert Museum

The Pool, Ypres Salient, watercolour, 5⅝ × 9½ ins. unsgd. 1917 (MN 8/1917)
> Victoria & Albert Museum

Preliminary Bombardment, Ypres Salient, watercolour, pen & chalk, 8½ × 11 ins. 1917 (MN 5/1917)

Reinforcement Camp, pen, wash & chalk. 1917

The Ridge, Wytschaete, pen, ink & watercolour, 9⅝ × 7⅝ ins. 1917 (MN 14/1917)

The Ruin, Voormezeele, watercolour, pen & chalk. 1917 (MN 15/1917)

The Salient, (British Trenches, Ypres Salient), watercolour, pen & chalk, 9¼ × 7½ ins. 1917 (MN 17/1917)

Shell Holes, drawing with watercolour, 8 × 8½ ins. insc. 'Nash' b.r. 1917
> Hamilton Art Gallery, Ontario

Study, Voormezeele, pen, wash & chalk. 1917

Tiriel, Indian ink & chalk, 8 × 11 ins. 1917 (MN 19/1917)

Trench in a Wood, Ypres Salient, watercolour and ink, 10¼ × 8 ins. 1917 (MN 10/1917)

Wytschaete Woods, watercolour, pen & chalk. 1917 (MN 11/1917)

1918 *After the Battle*, pen & watercolour, 18¼ × 23½ ins. sgd. 1918–19
> Imperial War Museum

Air Fight over Hill 60, watercolour, pen & chalk. 1918 (MN 15/1918)

Air Fight over Wytschaete, watercolour, pen & chalk, 10 × 14 ins. 1918 (MN 32/1918)

Barley Field, watercolour, pen & chalk. 1918 (MN 54/1918)

Beeches in the Wind (*Wind in the Beeches*),★ watercolour, 20½ × 15¾ ins. insc. 'Paul Nash'. 1918
> Aberdeen Art Gallery

Broken Trees,★ ink & wash, 10½ × 14 ins. *c.* 1918

Broken Trees, Wytschaete,★ indian ink & white chalk, 10⅛ × 14 ins. insc. 'Paul Nash' b.r. 1918 (MN 3/1918)
> Victoria & Albert Museum

Caterpillar Crater, watercolour, pen & chalk,

8¾ × 11¼ ins. 1918 (MN 48/1918)

Chinese Working in a Quarry, coloured chalks, watercolour & ink, 10¾ × 14 ins. 1918 (MN 9/1918)
> Imperial War Museum

Company Headquarters.★ (Ypres Salient), pen & wash, 9¾ × 13¾ ins. 1917 or 1918 (MN 14/1918)

Contrast, Inland Water Transport, pen & wash. 1917 or 1918 (MN 11/1918)

Crater Pools, watercolour, pen & chalk. 1918 (MN 41/1918)

Crater Pools, Ypres Salient, watercolour, pen & chalk. 1918 (MN 51/1918)

Desolation, watercolour, pen & chalk, 10½ × 15½ ins. 1918 (MN 28/1918)

Down from the Line, pastel on brown paper, 10¼ × 14¼ ins. 1917–18 (MN 10/1918)
> Imperial War Museum

Dumbarton Lakes,★ pen & wash, 10⅛ × 14 ins. 1918
> National Gallery of Canada

Eruption, Decline Copse, Passchendaele, watercolour, pen & chalk. 1918 (MN 37/1918)

Existence, black chalk & watercolour on brown paper, 19 × 12¾ ins. insc. 'Nash'. 1918 (MN 12/1918)
> Imperial War Museum

The Field of Passchendaele, pastel on brown paper, 10¼ × 14¼ ins. inscr. 'Nash'. 1918 (MN 39/1918)
> Imperial War Museum

The Field Path,★ watercolour, 10 × 10¾ ins. insc. 'Paul Nash 1918' (MN 55/1918)
> Carlisle Museum & Gallery

Field of Passchendaele, watercolour, ink & crayon, 9⅝ × 13⅝ ins. 1918 (MN 43/1918)
> Manchester City Art Gallery

Gheluvelt Village, German Front Line, pastel on brown paper, 10 × 14 ins. insc. 'Paul Nash'. 1918 (MN 5/1918)
> Imperial War Museum

Graveyard in Ruined Orchard near Vimy,★ pen, ink & wash, 9 × 11⅝ ins. 1918 (MN 1/1918)
> National Gallery of Canada

Hill 60, watercolour, pen & chalk. 1918

A Howitzer Firing, oil on canvas, 28 × 36 ins. insc. 'Paul Nash' b.r. 1918 (MN 21/1918)
> Imperial War Museum

Howitzer Battery Firing at Night, watercolour, pen & chalk. 1918 (MN 47/1918)

Study for a Howitzer Firing, pen, coloured chalks & watercolour, 5¼ × 7¼ ins. 1918
> Imperial War Museum

In the Tunnels,★ pen, wash & chalk. 1918 (MN 16/1918)

Indians in Belgium, watercolour, 13 × 19¼ ins. 1918 (MN 34/1918)
Imperial War Museum

Lake Zillebecke, Nightfall,★ watercolour, pen & chalk. 1918 (MN 29/1918)

Landscape, Hill 60, pencil, pen & watercolour, 15½ × 19½ ins. insc. 'Paul Nash' b.r. 1918 (MN 6/1918)
Imperial War Museum

Landscape, Hill 60, watercolour, pastel & ink, 9⅞ × 14 ins. insc. in full b.r. 1918 (MN 30/1918)
Manchester City Art Gallery

Lorries, pen & wash, 9 × 11¾ ins. 1917 or 1918 (MN 13/1918)

Meadow with Copse, Tower Hamlets District, watercolour, pen & chalk, 10 × 14 ins. 1918 (MN 33/1918)

Study for the Menin Road, pen, chalk & wash, 16 × 22¾ ins. 1918 (MN 42/1918)
Imperial War Museum

The Menin Road II, ink, wash on brown paper, 10¼ × 14 ins. insc. 'Paul Nash' b.l. 1918
National Gallery of Canada

Monument to Fallen Canadians on Vimy Ridge, watercolour, 11⅝ × 15 ins. insc. on verso in pencil 'passed by Censor, 2/ × 11/21', on recto 'Paul Nash' b.l. 1918 (MN 45/1918)
National Gallery of Canada

Mud Heaps after Shelling, monochrome & watercolour on brown paper. 1918

The Mule Track, oil on canvas, 24 × 36 ins. insc. 'Paul Nash'. 1918 (MN 19/1918)
Imperial War Museum

Sketch for 'The Mule Track', pen & watercolour, 5 × 8¾ ins. 1918 (MN 20/1918)
Imperial War Museum

Night Bombardment, watercolour, pen & chalk. 1918 (MN 35/1918)

Nightfall, Zillebecke District, pen & pastel on brown paper, 10¼ × 14 ins. 1918 (MN 50/1918)
Imperial War Museum

Noon, Shelling the Duckboards, watercolour, pen & chalk. 1918

Obstacle, watercolour, pen & chalk. 1918 (MN 44/1918)

Over Arras, watercolour, pen & chalk. 1918

Passchendaele, oil on canvas. 1918

Ruined Country, (Old Battlefield, Vimy), water-colour, 11 × 15¼ ins. 1918 (MN 46/1918)
Imperial War Museum

Ruins of a Church in Flanders, watercolour, gouache & pencil, 7½ × 10 ins. 1918 (MN 49/1918)
Carlisle Museum & Art Gallery

Sanctuary Wood, Dawn, watercolour, chalk & pen, 10 × 14 ins. 1918 (MN 7/1918)
Blackpool City Art Gallery

Shell Bursting, Passchendaele, watercolour, pen & chalk. 1918 (MN 31/1918)

Spring in the Trenches, oil on canvas, 24 × 30 ins. insc. 'Nash'. c. 1918 (MN 2/1917)

Sketch for Spring in the Trenches, pen & water-colour, 5¼ × 4 ins. 1918
Imperial War Museum

Stand To, oil on canvas, 27 × 28 ins. 1918 (MN 17/1918)

Sudden Storm,★ watercolour, pen & chalk, 11 × 15½ ins. sgd. & dated in full b.l. 1918 (MN 56/1918)

Sunrise over Inverness Copse,★ pastel on brown paper, 9¾ × 13¾ ins. 1918 (MN 22/1918)
Imperial War Museum

Sunset, Ruin of the Hospice, Wytschaete, pastel on brown paper. 1918 (MN 40/1918)
Imperial War Museum

Tortured Earth, watercolour, pen & chalk. 1918 (MN 53/1918)

Tower Hamlets, 1918

The Very Lights, watercolour, pen & chalk, 9¼ × 11½ ins. 1917 or 1918 (MN 7/1917)

Void,★ oil on canvas, 28 × 36⅛ ins. sgd. on right 'Paul Nash'. 1918 (MN 27/1918)
National Gallery of Canada

We Are Making a New World,★ oil on canvas, 28 × 36 ins. 1918 (MN 18/1918)
Imperial War Museum

Wire, ink, pastel and watercolour, 18¾ × 24½ ins. insc. 'Paul Nash' b.r. 1918–1919
Imperial War Museum

Wood Interior, watercolour, pen & chalk, 12 × 11 ins. 1918–1919 (MN 4/1919)

Wounded, Passchendaele, oil on canvas, 18 × 20 ins. insc. in full b.r.
Manchester City Art Gallery

The Ypres Salient at Night, oil on canvas, 28 × 36 ins. insc. 'Paul Nash'. 1918 (MN 38/1918)
Imperial War Museum

ILLUSTRATIONS AND BOOK DESIGNS

1918 *Loyalties*, a book of poems by John Drinkwater, illustrations by Paul Nash. Beaumont Press 1918

OTHER WORK

1918 Several war lithographs, including a design for a poster for 'Void of War' exhibition

———————

BIOGRAPHICAL CHRONOLOGY 1919–1924

1919 January, returned to London. Released from service, February. Finished *Menin Road* in April.
 Edited the *Sun Calendar*, a collection of poems and illustrations.
 Visited Whiteleaf, in Chiltern hills. Also visited Dymchurch.
 November, held an exhibition in a borrowed studio in Fitzroy Street.

1920 October, became a visiting lecturer at the Cornmarket School of Drawing and Painting at Oxford. Visited Dymchurch. Became closely acquainted with Claude and Grace Lovat Fraser.
 Commissioned to undertake theatre designs for *The Truth about the Russian Dancers* by J. M. Barrie.

1921–24 Rented a cottage at Dymchurch.

1921 June, death of Claude Lovat Fraser.
 September, Nash visited his father and found him unconscious. Soon after he himself collapsed. Admitted to the Hospital for Nervous Diseases. State diagnosed as suppressed war strain aggravated by recent strain and shocks.
 November, returned to Dymchurch. Began to work again.

1922 Went on a short visit to Paris.
 September, commissioned by T. E. Lawrence to provide landscape illustrations for *Seven Pillars of Wisdom*.
 Published first book *Places*.
 First general book on Nash by Anthony Bertram.

1923 Commissioned to illustrate a limited edition of the Creation Story, as in the first chapter of *Genesis*. Resigned teaching post at the end of Summer Term.

1924 Successful exhibition at Leicester Galleries.
 Designed set and costumes for *Midsummer Night's Dream*.
 September, appointed an Assistant in School of Design at the Royal College of Art.
 December, visited Paris, accompanied by Margaret Nash.

PRINCIPAL EXHIBITIONS

1919 Fitzroy Street, London S.W. 'Drawings by Paul Nash'

1924 The Leicester Galleries, Leicester Square, London W.C.2. 'Paintings and Watercolours by Paul Nash'

PAINTINGS, WATERCOLOURS & DRAWINGS 1919–1924

1919 *The Backwater,*★ watercolour, 10⅝ × 15 ins. sgd. & dated. 1919 (MN 5/1919)
 Chiltern Landscape. 1919
 The Conical Hill. 1919
 Copse and Garden, Whiteleaf, oil on canvas, 20 × 24 ins. unsgd. 1919 (MN 9/1919)
 The Corner, Whiteleaf, Bucks,★ watercolour, pen

& chalk, 21¾ × 15¾ ins. unsgd. 1919 (MN 11/1919)
Epsom Downs. 1919
Hayfield. 1919 (destroyed)
Landscape at Fulmer, watercolour & ink, 11 × 16 ins. insc. 'Paul Nash, 1919' b.r. (MN 6/1919)
Littlestone, watercolour & chalk. 1919

Portrait of Margaret Nash, watercolour, $14\frac{3}{8}$ × $10\frac{1}{8}$ ins. sgd. t.r. 1919
 Victoria & Albert Museum

Portrait of Margaret Nash, pencil and wash, 19 × 13 ins. insc. 'Bunty Margaret' b.l. 1919 (MN 12/1919)

Marjorie, watercolour, pen & chalk, 14 × 10 ins. 1919 (MN 7/1919)

The Menin Road,★ oil on canvas, 84 × 168 ins. insc. 'Paul Nash'. 1919 (MN 1/1919)
 Imperial War Museum

Night Bombardment,★ oil on canvas, 72 × 84 ins. sgd. 'Paul Nash' b.r. 1919 (MN 2/1919) (verso, another picture of the same scene)
 National Gallery of Canada

Overhanging Branches, pencil & wash, $4\frac{3}{4}$ × $7\frac{3}{4}$ ins. Probably 1919

The Plain, Bledlow Ridge, pen, wash, pencil & faint colour. 1919

The Ponies. 1919

Red Night,★ watercolour, pencil & ink, $11\frac{1}{8}$ × $15\frac{1}{4}$ ins. insc. in full b.l. 1919
 Manchester City Art Gallery

River Study, Green & White. 1919

Rough Scheme for Black Costume for Mlle. Collignan watercolour, 11 × 16 ins. insc. with title & 'crystal necklace' r. c. 1919

The Sands. 1919

Snow, watercolour. c. 1919 (MN 10/1919)

Snow Landscape with Figures (White Woods, Whiteleaf),★
 watercolour, $10\frac{3}{4}$ × $15\frac{1}{8}$ ins. insc. in full + '1919' b.r. (MN 8/1919)
 National Gallery of Victoria

Summer Rain (Landscape from the Inn), pen, wash, pencil & faint colour. c. 1919

Tree Garden. c. 1919

Tree Study in Blue. c. 1919

Walnut Tree, watercolour & pen. c. 1919

War Scene, charcoal & watercolour, $8\frac{1}{2}$ × $10\frac{1}{2}$ ins. c. 1919

Wave, watercolour (?). c. 1919 (destroyed)

White Cross, watercolour (?). c. 1919

The White Woods, watercolour. c. 1919

Whiteleaf, watercolour (?). c. 1919

The Wind, watercolour (?). c. 1919

Windy Hill, Whiteleaf, Bucks, watercolour, $11\frac{1}{4}$ × $15\frac{1}{4}$ ins. c. 1919 (MN 3/1919)

1920 *The Canal*,★ ink, crayon & watercolour, 14 × $20\frac{3}{4}$ ins. unsgd. 1920. Project for Leeds Town Hall mural
 Leeds City Art Gallery

Hill and Tree, watercolour & pencil, 16 × 12 ins. insc. 'Paul Nash 1920' b.r. (MN 2/1920)

The Lady from the Sea, pen, watercolour & pencil, $7\frac{5}{8}$ × $7\frac{1}{4}$ ins. insc. 'Paul Nash' b.r. 1920

The Lake, Black Park, Iver Heath, pencil & crayon, 7 × 9 ins.
 Carlisle Museum and Art Gallery

Landscape with House and Tree, crayon & ink on tracing paper, 9 × $11\frac{3}{4}$ ins. c. 1920

Margaret's Head (notebook sketch), pencil, 9 × 7 ins. c. 1920

Margaret on the Steps, oil, 20 × 24 ins. c. 1920–23

Platform Facing the Sea, (stage design for Ibsen's *Lady from the Sea*)
 pencil & ink, 8 × $9\frac{1}{2}$ ins. 1920

The Quarry,★ ink, crayon & watercolour, 14 × 21 ins. unsgd. 1920. Project for Leeds Town Hall Mural
 Leeds City Art Gallery

Whiteleaf (or The Village), watercolour, 14 × $18\frac{7}{8}$ ins. sgd. in full b.l. c. 1920 (MN 1/1920)

Whiteleaf Woods, oil on canvas, 20 × 24 ins. 1920 (MN 3/1920)
 St Leonard's School, Fife

1921 *Alice*,★ oil on canvas, 24 × 18 ins. 1921 (MN 3/1921)

Chestnut Waters★ (*The Lake*), oil on canvas, $40\frac{1}{2}$ × $50\frac{1}{4}$ ins. sgd. b.l. 1921–27–38 (MN 18/1938)
 National Gallery of Canada

Coast Scene, Dymchurch,★ oil on canvas, 1921

The Hills, pen & watercolour. c. 1921 (MN 7/1921)

Landscape, watercolour, 11 × 15 ins. insc. in full b.r. c. 1921

Claude Lovat Fraser Working, pencil, $7\frac{1}{2}$ × 4 ins. insc. 'Alan from Paul'. 1921

March Woods, Whiteleaf,★ oil on canvas, 20 × 24 ins. 1921 (MN 1/1921)

Margaret at Dymchurch, pencil, crayon & watercolour on board, 22 × 15 ins. sgd. and dated June 1921 b.r.

Margaret, Dymchurch, wash, pencil & crayon, 10 × 8 ins. cartouche b.r. 1921 (MN 4/1921)

Margaret on the Parade at Dymchurch (unfinished), pencil & watercolour, 9 × 15 ins. c. 1921

Pink Hyacinth, oil on canvas, 20 × 30 ins. c. 1921 (MN 6/1921)

Pyramid by Dymchurch Sea Wall, pencil, 9 × $13\frac{7}{8}$ ins. c. 1921

Sea Wall, Dymchurch, watercolour & pencil, 11 × 15 ins. insc. in full b.l. 1921 (MN 57/1918)
 Lady Margaret Hall, Oxford

Stone Cliff, watercolour, 15 × $21\frac{5}{8}$ ins. sgd. & dated b.l. 1921 (MN 5/1921)
 British Council

Towards Stone, pencil, watercolour & crayon, 14¼ × 19¾ ins.
insc. & dated in full. 1921 (MN 15/1924)
Whitworth Art Gallery

1922 *Alice by the Sea* (Dymchurch Sea Wall), Indian ink & pencil, 15 × 20 ins. 1922 (MN 4/1922)

At Oxenbridge, watercolour & pencil, 14 × 19¼ ins. insc. 'for Esil Elmshe from Paul Nash 1922' b.l.
Manchester City Art Gallery

Behind the Inn, oil on canvas, 25 × 30 ins. sgd. in full & dated b.r. 1919–22 (MN 18/1922)
Tate Gallery

Berkshire Downs, oil on canvas, 30 × 22 ins. *c.* 1922–23 (13/1922)

Black Farm on the Marsh, pencil & watercolour, 13¾ × 19¼ ins. insc. 'A. B. Clifton from Paul Nash'. 1922

Caunter Sands, watercolour & pencil, 14 × 19 ins. insc. in full b.r. 1922

Dr. Gordon Bottomley, crayon & pencil, 13 × 9 ins. cartouche b.r. 1922 (MN 15/1922)
Carlisle Museum and Art Gallery

Dyke by the Road, watercolour, 15 × 21 ins. 1922 (MN 17/1922)

Dymchurch Wall, watercolour, pencil & wash, 15 × 22½ ins. sgd. in full b.r. *c.* 1922

Dymchurch Strand,★ watercolour, 15 × 21¾ ins. insc. in full + 1922 b.l. (MN 6/1922)
Manchester City Art Gallery

End of the Steps, Dymchurch, oil on canvas, 20 × 24 ins. sgd. & dated. 1922 (MN 11/1922)

Group of Figures, pencil, 9¾ × 14½ ins. *c.* 1922

Night Tide, Dymchurch,★ watercolour & black lead, 15 × 22 ins. 1922 (MN 12/1922)

Study for Nostalgic Landscape, Dymchurch, pencil, watercolour & crayon, 7 × 5 ins. 1922

The Orchard, pen drawing, 16 × 22 ins. insc. 'Paul Nash 1922' (MN 19/1922)
Birmingham City Art Gallery

Path in a Wood, oil on canvas. *c.* 1922 (MN 10/1922)

Promenade, watercolour, 14¾ × 21¾ ins. insc. 'Paul Nash 1922' b.l. (MN 14/1923)
Arts Council of Great Britain

Romney Marsh, watercolour, 14 × 20 ins. sgd. in full & dated b.r. 1922

Sheepfold on Romney Marsh, watercolour, Indian ink & chalk. *c.* 1922 (MN 8/1922)

Study of Sluice Gates on the Marsh (notebook sketch), pencil, 4¾ × 8 ins. *c.* 1922

Tench Pond in a Gale,★ pen, pencil & watercolour, 22¾ × 15½ ins. insc. in full & dated b.r.

1921–22 (MN 7/1922)
Tate Gallery

Titania Asleep, ink touched with white, 6½ × 6¼ ins. cartouche. Said to be 1922
Carlisle Art Gallery & Museum

Tree over the Pond, watercolour, 15½ × 21 ins. *c.* 1922–23 (MN 2/1923)

The Wall against the Sea,★ oil on canvas, 24 × 35 ins. insc. in full & dated 1922 (MN 9/1922)

Whiteleaf Cross,★ oil on canvas. *c.* 1922 (MN 6/1922)

Whiteleaf Cross,★ watercolour, 20⅝ × 15 ins. 1922 (or 1921) (MN 14/1922)
British Council

Whiteleaf Village, Bucks, oil on canvas. *c.* 1922 (MN 1/1922)

Wood Against the Hill, oil on canvas. 1921–22 (MN 2/1922)

Wooded Hills in Autumn (*Long Down*),★ pen, black ink, crayons & watercolour, 15¼ × 22 ins. insc. in full b.r. with date on back 1921–22 (MN 3/1922)
Whitworth Art Gallery

Yvonne, pencil, 24 × 18 ins. 1922 (MN 5/1922)

1923 *Aquarelle*, watercolour. *c.* 1923 (MN 15/1923)

The Canal Bank, black ink pen drawing, 14¾ × 22 ins. insc. 'Paul Nash 1923' + title b.r. 1923
Southampton Art Gallery

Canal under Lympne, watercolour. *c.* 1923 (MN 16/1923)

The Chilterns, oil on canvas, 22 × 30 ins. *c.* 1923 (MN 7/1923)

Dymchurch Beach, watercolour, 13½ × 19½ ins. sgd. & dated 1923

Dymchurch Wall,★ watercolour, 14½ × 21½ ins. insc. in full ⅔ way down r.s. 1923 (MN 3/1923)

The Edge of the Lake, pencil, 21 × 14¼ ins. sgd. in full & date b.r. 1923
Victoria & Albert Museum

The Farm, watercolour, 14 × 19¼ ins. insc. in full & dated b.l. 1923

Haystack by Moonlight, watercolour, 22 × 14½ ins. 1923

Landscape, oil on canvas, 20 × 24 ins. *c.* 1923 (MN 10/1923)

Landscape with Trees and Fence, pencil & watercolour, 15 × 22 ins. sgd. in full b.l. *c.* 1923 (MN 12/1923)

Magnolia Study, pencil & wash, 16 × 22¼ ins. sgd. & dated b.l. 1923 (MN 1/1923)

'Margaret on the Steps',★ Oil, 20 × 24 ins. *c.* 1920/3

Mirror and Window, watercolour.
 1923 (MN 6/1923)
Nostalgic Landscape, oil on canvas, 28 × 20 ins.
 insc. in full b.l. 1923–38 (MN 4/1923)
 City of Leicester Museum & Art Gallery
Oast Houses, watercolour, sgd. & dated 1923
The Pine Pond, watercolour and pencil, 22 × 14¾
 ins. 1923 (MN 9/1923)
Pond at Kimble, ink, pencil & watercolour. 1923
Roadside,★ watercolour, 15⅜ × 21¾ ins.
 insc. in full 1921–23 b.l.
 Manchester City Art Gallery
The Sea, Dymchurch, oil on canvas.
 c. 1923 (13/1923)
The Shore,★ oil on canvas, 26½ × 37½ ins.
 sgd. 'Paul Nash 1923' b.r. 1923 (MN 4/1923)
 Leeds City Art Gallery
Souldern Church, watercolour, 15 × 22 ins.
 sgd in full b.l. *c.* 1923
Souldern Court Garden, watercolour, 20 × 14½
 ins. sgd, in full b.r. *c.* 1923
Souldern Pond, watercolour, 15 × 20 ins.
 sgd. in full b.r. *c.* 1923 (MN 8/1923)
Spring Woods, watercolour, 15¾ × 12¾ ins.
 1923 (MN 5/1923)
Tel Site (The Mountains), ink & watercolour,
 14 × 19½ ins. dated 1923
 Illustration for *The Seven Pillars of Wisdom*
Trees, pencil & chalk, 5⅖ × 4³⁄₁₀ ins.
 'P.N.' b.r. insc. on mount: 'Anthony Bertram
 from Paul Nash, Christmas 1923'
 c. 1923
The Willow Pond, pencil, crayon & watercolour,
 15⅛ × 21⅝ ins. insc. in full twice b.l. & b.r.
 1923
 Whitworth Art Gallery
Winter Landscape, (Chilterns under Snow), oil on
 canvas, 25 × 30 ins. unsgd. 1923 (MN 11/1923)

1924 *The Angle*, watercolour, 20 × 14⅜ ins.
 insc. in full & dated b.l. 1924
 Manchester City Art Gallery
April, oil on canvas.
 c. 1924 (destroyed)
At Litlington, watercolour, 22½ × 15½ ins.
 sgd. b.l. *c.* 1924
Audrey Withers (portrait), pencil & crayon,
 14½ × 10 ins. unsgd. 1924
Avenue in the Fields (Hillingdon), watercolour,
 15 × 22 ins. insc. 'Paul Nash, autumn 1924'
 b.l. 1924 (MN 4/1925)
Berries, oil on canvas, 26 × 20 ins.
 1924 (MN 8/1924)
Bridge over the Dyke,★ watercolour, 15½ × 21¾
 ins. 1924

Bullrushes, oil on canvas, 35 × 26 ins.
 insc. in full b.l. 1924 (MN 7/1924)
 Carnegie Institute of Chicago
Cumberland Scene, pencil & chalk, 9 × 12 ins.
 insc. in full b.r. 1924
Design of Trees, watercolour.
 c. 1924–25 (MN 10/1924)
Downs,★ pencil & watercolour on brown paper,
 14½ × 20 ins. insc. in full & dated b.l. 1924
 Manchester City Art Gallery
Dymchurch Steps, oil on canvas, 26⅛ × 40⅛ ins.
 insc. in full + 1924–44 b.r. (MN 10/1944)
 National Gallery of Canada (Massey Founda-
 tion)
End of the Canal, watercolour, sgd. b.r. *c.* 1924
Garden of Souldern Court (unfinished) watercolour,
 15 × 20 ins. insc. in full b.r. + 'for Mary
 Withers, a shocking mess of her gardens I'm
 afraid'. *c.* 1924
Genesis,★ (designs for illustrations to the *First
Chaper of Genesis*) 1924
 The Face of the Waters, pencil, 5 × 3½ ins.
 The Division of the Light from the Darkness,
 pencil, 5 × 3½ ins.
 The Creation of the Firmament, pencil, 5 × 3½
 ins.
 The Dry Land Appearing, pencil, 5 × 3½ ins.
 The Sun and the Moon, pencil, 5 × 3½ ins.
 The Fish and the Fowl, pencil, 5 × 3½ ins.
 Vegetation, pencil, 5 × 3½ ins.
 Cattle and Creeping Things, pencil, 5 × 3½ ins.
 Man and Woman, pencil, 5 × 3½ ins.
 Contemplation, pencil, 5 × 3½ ins.
 British Museum
Haystack on the Downs, pencil, 14¾ × 22¾ ins.
 insc. in full + date b.r. 1924
 Leeds City Art Gallery
Interior, watercolour.
 c. 1924
Landscape near Chequers, pencil & watercolour,
 14½ × 21¼ ins. insc. twice in full + title. *c.* 1924
 Whitworth Art Gallery
London Garden, watercolour. *c.* 1924
Margaret, oil on canvas (destroyed). *c.* 1924
Margaret at Dymchurch, watercolour, 12½ × 20
 ins. sgd. & dated in red & insc. 'Dymchurch'
 in pencil b.l. 1924
A Midsummer Night's Dream (designs for staging
 & costumes) watercolour, various sizes
 monogram 'P.N.' 1924 (published)
 Victoria & Albert Museum
Mirror and Window, oil on canvas. *c.* 1924
The Oasts Field at Owley, oil on canvas.
 c. 1924

Orchard at Peasemarsh, watercolour.
 c. 1924 (MN 16/1924)
The Pond, Iden, oil on canvas, 30 × 26 ins.
 sgd. b.r. 1924 (MN 19/1924)
Sandling Park, Kent,★ oil on canvas, $35\frac{1}{2}$ × $27\frac{1}{2}$
 ins. insc. in full & dated. 1924 (MN 6/1924)
 Manchester City Art Gallery
Snow, watercolour. *c.* 1924
Spring Orchard, watercolour, 15 × 22 ins.
 c. 1924 (MN 13/1924)
Spring Woods, pencil, watercolour & black chalk,
 $15\frac{3}{4}$ × $11\frac{1}{2}$ ins.
 insc. in full b.r. title insc. on back. 1924
 Whitworth Art Gallery
Still Life, watercolour. *c.* 1924

The Stream, watercolour. *c.* 1924
Thatched Cottage, Souldern, watercolour over
 pencil, $15\frac{1}{8}$ × $19\frac{15}{16}$ ins.
 sgd. b.r. 'Paul Nash 1924'. 1924
Valley, watercolour. *c.* 1924
The Viaduct,★ watercolour, 14 × $21\frac{3}{4}$ ins.
 insc. in full & dated. 1924
The Wall, Dymchurch, watercolour.
 1924 (MN 2/1924)
The Walnut Tree,★ pencil & crayon on card,
 $15\frac{1}{8}$ × $21\frac{5}{8}$ ins. insc. in full & dated b.l. 1924
 Manchester City Art Gallery
Whistler's Garden, watercolour. 1924 (MN 9/
 1924)
Winter Pond, watercolour. 1924 (MN 12/1924)

ILLUSTRATIONS AND BOOK DESIGNS

1919	*Images of War*, A book of poems by Richard Aldington with 11 illustrations by Paul Nash. Beaumont Press. 1919.
1921	*Cotswold Characters* by John Drinkwater, with five engravings on wood by Paul Nash. Yale University Press, London, Humphrey Milford, O.U.P. 1921.
1923	*Mister Bosphorus and the Muses* by Ford Madox Ford with 12 wood engravings by Paul Nash.

Duckworth 1923.

1924 *Genesis*. 12 Woodcuts by Paul Nash with the First Chapter of Genesis in the Authorised Version. The Nonesuch Press 1924.

1924 *Shakespeare's 'A Midsommer Nights Dreame'* (newly printed from the first Folio of 1623) with illustrations by Paul Nash. Ernest Benn, London 1924.

LITERARY WORK

1919	Regular contributions made by Paul Nash to *New Witness*, signed Robert Derriman or R.D. Edited *Dressing Gowns and Glue* by Captain L. de G. Sieveking.
1920	Contributions to *Arts Gazette* and *Theatrecraft*.
1922	*Places*, Seven Prints reproduced from wood-

blocks, designed & engraved by Paul Nash, with illustrations 'in prose'. William Heinemann 1922.

Contributions to *Evening Standard*, *English Review* (Theatrecraft Supplement) and *Drama*.

OTHER WORK

1919–24	Various woodcuts.

1920 Stage designs for *The Truth about Russian Dancers* by J. M. Barrie at the Theatre.

BIOGRAPHICAL CHRONOLOGY 1925–1929

1925	Spent the winter in Cros de Cagnes. March, visited Genoa, Florence and Siena. Resigned from the Royal College of Art in the Summer Term. Moved to Oxenbridge Cottage, Iden, Sussex.

1928 Death of Margaret Nash's mother.
July, exhibition of wood engravings.
November, exhibition of oils and watercolours.

1929 February, death of Nash's father. Sale of the Iver Heath House.

PRINCIPAL EXHIBITIONS

1925 The Mayor Gallery, Sackville Street, Piccadilly, London, W.1.
'Watercolours and Drawings by Paul Nash'

1927 The Warren Gallery, Maddox Street, London, W.1.
'Recent Watercolours & Drawings by Paul Nash'
The Leicester Galleries, Leicester Square, London, W.C.2.

'Exhibition of the London Artists' Association'

1928 The Leicester Galleries, Leicester Square, London, W.C.2.
'Paintings and Watercolours by Paul Nash'
The Redfern Gallery, Old Bond Street, London, W.1.
'Engravings on Wood by Paul Nash'

PAINTINGS, WATERCOLOURS AND DRAWINGS 1925–1929

1925 *Abstract Design*, watercolour (?). *c.* 1925

Abstraction, chalk. *c.* 1925

Avenue by the Stream, watercolour, pen & chalk, $12\frac{1}{2} \times 18\frac{1}{2}$ ins. *c.* 1925 (MN 10/1925)

The Avenue, Savernake Forest, watercolour, $22 \times 14\frac{1}{2}$ ins. *c.* 1925 (MN 13/1925)

Bank of Trees (destroyed). *c.* 1925

Boat at Cros de Cagnes, crayon & pencil, 5×8 ins. cartouche b.r. *c.* 1925

Boats at Cagnes, crayon, $5\frac{1}{2} \times 8$ ins. insc. 'P.N.' b.r. *c.* 1925

Boats at Cagnes (no. 2), pencil & crayon. 1925

Boats by the Shore, Cros de Cagnes, (notebook sketch), watercolour & crayon, $5\frac{1}{4} \times 8\frac{1}{4}$ ins. *c.* 1925

Cagnes, pencil & watercolour, 6×11 ins. insc. & monogrammed. *c.* 1925

Camber Castle, watercolour (destroyed). *c.* 1925

The Colne, watercolour. 1925 (MN 2/1925)

Corner, Cros de Cagnes, pencil, watercolour & chalk, $5\frac{3}{4} \times 8\frac{3}{4}$ ins. 1925 (MN 3/1924)

Cros de Cagnes (notebook study), watercolour, $5\frac{1}{4} \times 8\frac{1}{4}$ ins. *c.* 1925

Cros de Cagnes, pencil wash & crayon, $5\frac{1}{5} \times 8\frac{1}{10}$ ins. *c.* 1925

Drawing at Owley, watercolour (?). *c.* 1925

Drawing at Oxenbridge. *c.* 1925

Edge of the Marsh, oil on canvas, $25 \times 26\frac{7}{8}$ ins. insc. in full & dated. 1925 (MN 6/1925)
National Gallery of Victoria

Garden, watercolour (?). *c.* 1925

Garden Gate, Iden, oil on canvas. *c.* 1925

Gateway, Cros de Cagnes (notebook sketch), pencil, watercolour & crayon, $5\frac{1}{4} \times 8\frac{1}{4}$ ins.

c. 1925

Group (Meadle), watercolour, $12\frac{1}{2} \times 18$ ins. insc. in full & dated b.r. 1925 (MN 3/1925)

In a Wood, watercolour on blue paper, $12\frac{3}{4} \times 19\frac{1}{2}$ ins. *c.* 1925 (MN 8/1925)

Interior, Pantile Cottage, Dymchurch, oil on canvas, 20×16 ins.
1925 (MN 7/1925)

Isle of Oxney, watercolour (?). *c.* 1925

Open Landscape and Hills, watercolour, $15\frac{1}{2} \times 22$ ins. insc. in full b.l. *c.* 1925

Oxenbridge Barn,★ crayon & watercolour, $10\frac{3}{4} \times 14\frac{3}{4}$ ins. sgd. & dated. 1925

Panorama of Cagnes, pencil & ink, $8\frac{1}{2} \times 13$ ins. insc. 'original drawing for a painting not carried out'. 1925

Path through a Wood, watercolour & pencil, 20×12 ins. sgd. b.r. 'Paul Nash 1925'. 1925

Pont Royale, pencil drawing, $9\frac{1}{4} \times 12\frac{3}{4}$ ins. 1925 (MN 9/1925)

Pont Royale, pencil & watercolour, $9\frac{1}{4} \times 12\frac{1}{2}$ ins. 1925

River, watercolour, 22×35 ins. 1925 (MN 12/1925)

River & Trees, pencil & chalk, 15×22 ins. sgd. *c.* 1925

Souldern Pond, watercolour, 14×21 ins. insc. 'souvenir of Souldern for Percy & Mamie, Paul Nash 1925–42'

Tower, Cros de Cagnes, pencil & crayon, $8\frac{3}{4} \times 5\frac{3}{4}$ ins. monogram b.r. 1925 (MN 5/1924)

Trees, pencil, crayon & watercolour, $13\frac{1}{4} \times 20$ ins. insc. in full b.r. & dated. 1925
Whitworth Art Gallery

The Wall, watercolour (?). *c.* 1925

The Willow Pond,★ watercolour, 18 × 14 ins.
sgd. & dated b.l. 1925 (MN 5/1925)

Window, Iver Heath, watercolour, 22½ × 16 ins.
sgd. & dated b.l. 1925 (MN 1/1925)

Window, Iver Heath, Bucks, oil on canvas, 30 ×
20 ins. 1925 (MN 14/1925)

Window of the Morning Room, Iver Heath, Bucks,
watercolour & pencil, 11⅞ × 17¾ ins.
insc. in full & dated. 1925 (MN 11/1925)
Whitworth Art Gallery

Winter Sea,★ oil on canvas, 28 × 38 ins.
insc. in full & dated b.l. 1925–37 b.l. (MN 3/
1937)
York Art Gallery

Winter Sea, watercolour, conté & pencil, 14⅜ ×
21 ins. insc. in full & dated. 1925–37 b.l.
(MN 2/1937)
Graves Art Gallery, Sheffield

1926 *Boat on the Plage*, crayon (?). *c.* 1926

Boats at Cagnes,★ crayon, 5½ × 8 ins.
insc. 'P.N.' b.r. *c.* 1926

Canary, watercolour, 11¾ × 16¾ ins.
1926 (MN 16/1926)

Cap Ferrat, Mediterranean, watercolour
c. 1926 (MN 3/1926)

Convolvulus, oil on canvas. *c.* 1926 (MN 10/1926)

Côte d'Azur, crayon, 11 × 17½ ins.
monogram & dated. 1926.

Design for Setting of the Play Scene in 'The Seagull',
pen & ink, 8¼ × 4¼ ins. *c.* 1926

French Farm,★ oil on canvas, 21¼ × 28¾ ins.
insc. in full b.l. 1926 (MN 2/1926)
Toledo Museum, Ohio

Garden, Meadle, Bucks, oil on canvas, 16¾ × 21
ins. *c.* 1926 (MN 9/1926)

Mediterranean Window, watercolour, 13½ × 13
ins. insc. in full & dated. 1926 (MN 1/1926)

Mimosa Wood,★ oil on canvas, 21½ × 25¾ ins.
insc. in full b.r. 1926 (MN 6/1926)
National Gallery of New South Wales, Sydney

Pond in the Field, oil on canvas, 26 × 36 ins.
1926 (MN 7/1926)

The Quiet Garden, oil on canvas, 20 × 16 ins.
insc. with monogram in cartouche, b.l. 1926

Rick Flat,★ oil on canvas, 24 × 20 ins.
c. 1925/6 (MN 8/1926)
City Art Gallery, Coventry

Riviera Landscape, oil on canvas, 25¾ × 44¼ ins.
initialled b.l. *c.* 1926 (MN 5/1926)

Study for Riviera Landscape, pencil & wash, 8¼ ×
5¼ ins. *c.* 1926

Riviera Window,★ oil on canvas, 20½ × 19½ ins.

c. 1926 (MN 11/1926)
Glasgow Art Gallery and Museum

Souvenir of Florence,★ oil on canvas, 27 × 17¼
ins. sgd. with monogram. 1926 (MN 17/1926)
Edward James Foundation, on loan to
Brighton Art Gallery

Stems & Convolvulus (Study), pencil, 10 × 6⅞
ins. *c.* 1926

Still Life,★ oil on canvas, 33 × 26 ins.
sgd. in full b.l. 1926 (MN 13/1926)

Still Life, Iden,★ watercolour. 1926 (MN 14/
1926)

The Thatched Cottage, oil on canvas, 19¾ × 24
ins. *c.* 1926 (MN 4/1926)

Villa. c. 1926

Wood by the Sea, oil on canvas, 24 × 20 ins.
c. 1926 (15/1926)

1927 *Balcony, Cros de Cagnes*,★ oil on canvas, 29 × 19
ins. monogram b.l. 1927 (MN 11/1927)

Bird (Canary), watercolour, 17½ × 11¾ ins.
sgd. 'P.N.' & dated b.r. 1927

Blue House on the Shore, oil on canvas, 16½ × 29
ins. insc. in full b.l. *c.* 1927–29

Bog Cotton,★ oil on canvas, 36 × 28¼ ins.
unsgd. *c.* 1926–27 (MN 18/1926)
Leeds City Art Gallery

Bulbeggar Wood. c. 1927

Cactus in Bloom, oil on canvas, 19½ × 15½ ins.
insc. with monogram b.l. 1927 (12/1927)
Harrogate Borough Library and Museum

Cagnes, oil on canvas, 27 × 36 ins.
1927 (MN 14/1927)
Galleria Nazionale d'Arte Moderna, Rome

Canary, watercolour, 11 × 7¼ ins.
1927 (MN 9/1927)

Canterbury Bell, oil on canvas, 29 × 19 ins.
1927 (MN 12/1926)

Canterbury Bell, pencil, 25 × 17 ins.
insc. with monogram b.l. 1927 (study for
oil)

Cros de Cagnes, pencil & chalk, 8½ × 13 ins.
insc. 'Original drawing for a painting not
carried out, P.' 1927

Cros de Cagnes, oil on canvas, 20 × 30 ins.
1927 (MN 13/1927)

Cyclamen, watercolour, 20½ × 14¾ ins.
1927 (MN 2/1927)

Dahlias,★ oil on canvas, 15½ × 19¾ ins.
1927 (MN 16/1927)

February,★ oil on canvas, 20 × 24 ins.
1927 (MN 7/1927)

Landscape, oil on canvas, 24½ × 30 ins.
monogram b.r. 1927

Marigolds, oil on canvas. 1927 (MN 5/1927)

Opening (Abstract design for the oil), chalk, 27¼
 × 19 ins. insc. 'P.N.' b.l. 1927
The Orchard, oil on canvas, 20 × 30 ins.
 monogram b.r. 1927 (MN 6/1927)
Period Interior, Iver Heath, oil on canvas, 24 × 20
 ins. 1927 (MN 4/1927)
Pond in the Marshes, watercolour(?). *c.* 1927
St Pancras, oil on canvas, 17 × 24 ins. 1927
St Pancras Lilies,★ oil on canvas, 25 × 17½ ins.
 1927 (MN 15/1927)
 Ulster Museum, Belfast
Savernake,★ oil on canvas, 30 × 20 ins.
 initialled b.l. 1927 (MN 17/1927)
Sea Holly, oil on canvas. 1927 (MN 3/1927)
Spinney. c. 1927
Steps under Trees. c. 1927
Still Life, oil on canvas. 1926–27 (MN 1/1927)
Sussex Landscape, watercolour, (study for oil),
 unsgd. 1927 (MN 10/1927)
View of Garden. c. 1927

1928 *Aldington*, watercolour. *c.* 1928
Autumn Crocus,★ oil on canvas,
 monogram & date b.r. 1928 (MN 3/1928)
Bouquet, oil on canvas, 25½ × 19 ins.
 sgd. b.l. 1928 (MN 14/1928)
 University College of North Wales, Bangor
Chilterns, Snow, watercolour. *c.* 1928
The Diving Stage,★ oil on canvas, 33 × 21 ins.
 unsgd. 1928 (MN 12/1928)
 British Council
Doorway, watercolour. *c.* 1928
Farm in Provence, oil on canvas, 21 × 28 ins.
 1928 (MN 10/1928)
Figure, oil on canvas (destroyed). *c.* 1928
From a Window, oil on canvas, 20 × 23¾ ins.
 sgd. with monogram b.l. 1928 (MN 5/1928)
 On loan to Manchester City Art Gallery
Frozen Lake, Iden, watercolour, 21 × 29½ ins.
 full name & 1928 b.l. (MN 16/1928)
Gateway, watercolour. *c.* 1928
Head, oil. *c.* 1928
Iden, Spring, watercolour, 12½ × 14½ ins.
 sgd. in full b.r. *c.* 1928
Iver Heath, Snow, oil on canvas, 27 × 19½ ins.
 1927–28 (MN 1/1928)
Jardin Public, Caen, watercolour, 19¾ × 13 ins.
 sgd. 'P.N.' & dated b.l. & 'Jardin Public,
 Caen,' in pencil b.r. 1928
The Lake, Black Park, Iver Heath, pencil drawing,
 15 × 20 ins. unsgd. 1928 (MN 11/1928)
Lambourne, watercolour. *c.* 1928
Landscape at Iden,★ oil on canvas, 27½ × 35¾ ins.
 insc. in full b.l. 1928 (MN 19/1928)
 Tate Gallery

Mantelpiece,★ oil on canvas.
 c. 1928 (MN 20/1928)
Nude, oil on canvas. *c.* 1928
Oxenbridge Pond, oil on canvas, 39¼ × 34½ ins.
 monogram b.l. 1928 (9/1928)
 Birmingham City Art Gallery
Paling. c. 1928
The Pond, Iden, oil on canvas, 28 × 33 ins.
 1928 (MN 17/1928)
Rouen. c. 1928
Souvenir, Cros de Cagnes, oil on canvas, 21 × 33½
 ins. 1928 (MN 13/1928)
Steps, watercolour. *c.* 1928 (MN 6/1928)
Still Life, Winter, oil on canvas.
 c. 1928 (MN 8/1928)
Sussex Landscape, oil on canvas, 44 × 60 ins.
 1928 (18/1928)
Swan Song,★ oil on canvas, 16½ × 20½ ins.
 monogram b.r. 1928 (MN 4/1928)
The Tower, (*Cros de Cagnes*), oil on canvas,
 28¼ × 19½ ins. 1928 (MN 21/1928)
Verandah, oil on canvas. 1927–28 (MN 2/1928)
Window, Iver Heath, oil on canvas, 34 × 24½ ins.
 initials b.r. *c.* 1928 (MN 7/1928)
 British Broadcasting Corporation
Winter Landscape, oil on canvas.
 c. 1928 (MN 15/1928)
Wood Shed (later completed as *The Two Serpents*),
 oil on canvas, 36 × 28 ins. sgd. b.r. 1928–38

1929 *Cafe Window*, watercolour. 1929
Coronilla★ (*The Flowering Room*), oil on canvas,
 24 × 20 ins. monogram b.r. 1929 (MN 6/1929)
Dead Spring,★ oil on canvas, 19½ × 15½ ins.
 monogram b.r. 1929 (MN 8/1929)
Fields, sepia & blue wash, 10¾ × 14½ ins.
 insc. in full b.r. *c.* 1929
Garden, watercolour, 20 × 15 ins.
 c. 1929 (12/1929)
Garden Landscape, oil on canvas, 20 × 27 ins.
 c. 1929 (MN 5/1929)
Group of Beeches★ (Study for *Wood on the Downs*),
 watercolour, 9¾ × 12¾ ins. monogram b.l.
 c. 1929 (MN 4/1930)
 National Gallery of Victoria
Hampden Woods, watercolour. *c.* 1929
Iver Heath. c. 1929
Landscape, oil on canvas, 20 × 30 ins.
 c. 1929–30 (MN 2/1930)
Landscape 1929, watercolour, 21¾ × 15 ins.
 sgd. and dated in full b.r. 1929
Lares,★ oil on canvas, 24½ × 15½ ins.
 monogram b.r. 1929 (MN 3/1929)
Margaret's Piano, pencil drawing & wash, 15 ×
 22½ ins. *c.* 1929 (MN 10/1929)

Marseilles, watercolour, 7 × 10 ins.
1929 (MN 2/1929)
Month of March,* oil on canvas, 36 × 28 ins.
monogram r. 1929 (MN 7/1929)
Two Studies for Northern Adventure
(other studies on reverse), pencil, 9⅛ × 12 ins.
insc. with various notes. 1929
Northern Adventure,* oil on canvas, 36 × 28½ ins.
sgd. b.l. 1929 (MN 19/1929)
Aberdeen Art Gallery
Nostalgic Landscape (*St Pancras Station*), oil on
canvas, 20 × 24 ins. *c.* 1929 (MN 1/1929)

Objects in a Studio (Abstract Study), watercolour,
5½ × 7⅛ ins. monogram b.l. *c.* 1929
Park Entrance, watercolour, 15½ × 23 ins. 1929
Studio, Iden,* watercolour, 21¾ × 14¾ ins.
sgd. & dated t.l. 1929 (MN 4/1929)
Study, watercolour, 22 × 15 ins.
sgd. in full & dated b.r. 1929
Toulon Harbour, watercolour. 1929 or 1930
Wood on the Downs,* oil on canvas, 28 × 36 ins.
sgd. b.r. 1929 (MN 11/1929)
Aberdeen Art Gallery

ILLUSTRATIONS AND BOOK DESIGNS

1925 *Wagner's Music Drama of the Ring* by L. Archier
Leroy with four Wood Engravings and patterned
paper binding by Paul Nash. Noel Douglas
(Preface dated 1925).
Welchman's Hose by Robert Graves, with five
wood engravings by Paul Nash. Fleuron 1925.

1926 *Seven Pillars of Wisdom* by T. E. Lawrence.
Landscape illustrations by Paul Nash. Private
publication 1926.

1927 *Shakespeare's the Tradgedie of King Lear*, newly
printed from the First Folio of 1623. Ernest Benn,

London 1927.
Nativity by Siegfried Sassoon. Designs and paper
cover by Paul Nash. Faber & Gwyer 1927.

1928 *Abd-er-Rhaman in Paradise* by Jules Tellier.
Translated by Brian Rhys with wood engravings
by Paul Nash. Golden Cockerel 1928.

1929 *A Song about Tsar Vasilyevitch, his young Body-
guard, and the Valiant Merchant Kalashnikov*, by
Mikhail Yurievitch Lermontov, translated by
John Cournos, with four decorations by Paul
Nash, who also designed the binding and format.

LITERARY WORK

1927 Contribution to *The Woodcut: an Annual, No. 1.*
ed. Herbert Furst. Fleuron Press. Bound in
pattern paper designed by Paul Nash.

1928 Introduction to *A Specimen Book of Pattern Papers:
Designed for and in use at The Curwen Press.*
Fleuron Press 1928. Reprinted in *Room and Book.*

OTHER WORK
1925–29 Wood engravings, theatre designs

BIOGRAPHICAL CHRONOLOGY 1930–1933

1930 Visited Paris, Toulon, Nice, Marseilles and Cros de Cagnes, accompanied
by Margaret Nash, Ruth Clark and Edward Burra, between February
and April.
Returned to work at Iden.
Bought New House, Rye, in the autumn and moved into it in December,
with Margaret Nash's father, the Rev. N. Odeh.

1931 Visited the United States, accompanied by Margaret Nash, as British
Representative on the International Jury for the Carnegie Exhibition at
Pittsburgh. Left England on the S.S. Mauretania in September. Visited
New York, Washington, Pittsburgh and Philadelphia. Returned to Rye
in October.

1932 Death of Mr. Odeh in August.

1933 Contracted influenza in March, followed by the first serious attack of bronchial asthma.

Announced the formation of the *Unit One* group in a letter to *The Times*, June 12th.

Sold New House, Rye, and moved out in July.

PRINCIPAL EXHIBITIONS

1931 Oxford Arts Club, Oxford: 'Retrospective Exhibition of work by Paul Nash, 1910–1931'. Oils, watercolours, wood engravings and war lithographs

1932 The Batsford Gallery, North Audley Street, London, W.1. 'Page and Scene Designs by Paul Nash'. Wood engravings for book decoration, sketch-designs for *Urne Burialle* and *The Garden of Cyrus*, book-jacket and binding designs, illustrations for Genesis, Costume and stage designs, etc.

1932 The Leicester Galleries, Leicester Square, London, W.C.2. 'Watercolours and Drawings by Paul Nash'

PAINTINGS, WATERCOLOURS AND DRAWINGS 1930–1933

1930 *The Archer,*★ oil on canvas, 28½ × 36 ins. sgd. and dated b.l. 1930–37–42 (MN 8/1942) Southampton Art Gallery

'Day Piece, Toulon',★ watercolour, 21½ × 15 ins. unsgd. *c.* 1930, probably with later additions

Glass Forest (later called *Globes in a Many-Pillared Room*.
 (Study for *Voyages of the Moon*), watercolour, 12 × 8¾ ins. sgd. with monogram. *c.* 1930
 Edward James Foundation, on loan to Brighton Art Gallery

Interior Study, Toulon, pencil & watercolour, 15¼ × 22¼ ins. 1930

March Woods, watercolour & pencil, 11½ × 15¾ ins. *c.* 1930
 Brighton Art Gallery

Nest of the Siren,★ oil on canvas, 30 × 20 ins. unsgd. 1930 (MN 5/1930)
 Department of the Environment

Night Piece, Toulon,★ watercolour, 21½ × 15 ins. unsgd. Probably 1930 (MN 3/1930)

Night Window, watercolour, unsgd. Probably 1930 (MN 6/1930)

Study for Opening, pencil & crayon, squared, 12 × 8¼ ins. 1930

Orford, Suffolk, watercolour. 1930

Study at Toulon, No. 6, pencil & wash, 6¾ × 9⅞ ins. insc. in full. 1930

Tamaris, oil on canvas, 25 × 30 ins. 1930 (MN 1/1930)
 H.M. The Queen

The Three Rooms,★ watercolour, 15½ × 11½ ins. (between 1930 and 1936) unsgd.
 Edward James Foundation, on loan to Brighton Art Gallery

Token, oil on canvas, 19¾ × 23¾ ins. insc. in full b.l. 1930 (MN 7/1930)

Well at Tamaris, pencil, coloured chalk & watercolour, squared, 8¾ × 11¾ ins. insc. 'for Richard from Paul'. 1930 (study for oil *Tamaris*)

1931 *The Archer Overthrown,*★ oil on canvas, 27½ × 36 ins. full name b.l. 1931–38 (MN 8/1938)

Boat Deck, watercolour, 9¾ × 7 ins. 1931

The Circus Horse, watercolour, 15½ × 22½ ins. insc. in full b.l. 1931 (MN 4/1931)

Group for a Sculptor, watercolour, 15½ × 23 ins. sgd. in full b.l. 1931 (MN 3/1931)
 (gift to Henry Moore in exchange for a sculpture)

Harbour and Room, watercolour, 20 × 15 ins. insc. in full b.r. & dated. 1931
 (*The recently discovered date throws doubt on the usually accepted date for the oil of the same subject*)

Harbour and Room,★ oil on canvas, 36 × 28 ins. unsgd. Probably 1931 (MN 13/1929)
 Edward James Foundation, on loan to Brighton Art Gallery

Hudson (Atlantic Voyage), watercolour. 1931 (MN 1/1931)

Kinetic Feature,★ oil on canvas, 26 × 20 ins. insc. in full & dated. 1931 (MN 19/1931)
 Tate Gallery

Landscape Near Rye, watercolour, 6¾ × 9¾ ins. unsgd. *c.* 1931–33

Landscape Study, watercolour. *c.* 1931 (MN6/1931)

Mickey, Son of Nicotina (The Nash's cat at Rye), pencil & wash, 15¾ × 22½ ins. insc. with title. *c.* 1931

Monuments (Sheldonian, Oxford), watercolour.
1931 (MN 8/1931)

Opening,★ oil on canvas, 32 × 20 ins.
insc. in full b.r. 1931 (MN 2/1931)
(watercolour study is dated 1927)

Rock Garden, watercolour, 11¾ × 19¾ ins.
c. 1931 (7/1931)

Study for Sun Deck, SS Mauretania, pencil, squared,
12 × 9¼ ins. 1931

Woodstacks at Iden,★ watercolour, 26½ × 18½ ins.
insc. in full b.r. 1931

Zeppelin from Winchelsea Beach, watercolour with
pencil, 7 × 10 ins. cartouche b.r. *c.* 1931

1932 *Atlantic,*★ watercolour, 22 × 15¼ ins.
sgd. in full & dated b.r. 1932 (MN 18/1932)

Study for Atlantic, pencil, squared, 10 × 6¾ ins.
1932

Barbara Bertram (1), pencil & crayon, 6¾ × 9½ ins.
insc. b.r. 'Barbara, souvenir from Paul' &
autograph *c.* 1932

Barbara Bertram (2), pencil, crayon & coffee.
circular, 4¾ ins. in diameter
autograph on mount, 1932

Café Window, Toulon, watercolour, 20¼ × 15
ins. sgd. & dated. 1932.

Dungeness, Kent, watercolour, 12½ × 17¾ ins.
c. 1932 (MN 5/1932)

Fantasy, pencil & watercolour, 14 × 22 ins.
1932

Garden of Cyrus (15 designs for illustrations)
Birmingham City Museum & Art Gallery

Icknield Way, Bucks, watercolour, 15½ × 22½
ins. *c.* 1932 (MN 16/1932)

Liner (*Atlantic Voyage*), watercolour.
dated 1932 (MN 19/1932)

Study for Liner, Atlantic Voyage, pencil & wash,
squared, 9½ × 12 ins. 1932

Mansions of the Dead (study for oil), pencil,
crayon & wash on tracing paper, squared, 12
× 8¼ ins. 1932

Order of Five (Urne Buriall design), pencil &
watercolour, 21 × 14¼ ins.
full name b.r. 1932 (MN 19/1932)

Path, watercolour.
monogram & date b.r. 1932 (MN 10/1932)

Pillar and Moon,★ oil (begun), 20 × 30 ins.
insc. in full b.r. 1932–42 (MN 11/1942)
Tate Gallery

Quincunx★ (design for Urne Buriall), water-
colour, 21 × 14 ins.
insc. in full b.r. 1932 (MN 12/1932)

Rotary Objects, watercolour, 22¼ × 15 ins.
full name b.l. 1932 (MN 3/1932)

Rye, watercolour, 15½ × 22½ ins.
insc. 'Paul Nash 1932–37' b.l. & 'Rye' b.r.
Victoria & Albert Museum

Salome, oil on canvas.
1932 (MN 1/1932)

St Pancras & Fairground Skeleton, pencil & water-
colour, 13¼ × 20 ins. 1932

Ship Interior, watercolour, 21½ × 14¾ ins.
full name & date b.r. 1932

Shipyard at Rye, watercolour, indian ink &
chalk, 15 × 22 ins. 1932 (11/1932)

Skeleton, watercolour, 22 × 15 ins.
sgd. & dated b.r. 1932 (MN 2/1932)
Musée de l'Art Moderne, Paris

The Soul Visiting the Mansions of the Dead★ (orig-
inal design for Urne Buriall, version A),
watercolour, 8½ × 6¼ ins.
insc. with title b.l. 1932 (MN 9/1932)
British Council

The Studio, New House, Rye, watercolour, 15¾ ×
22⅝ ins. sgd. b.r. 1932 (MN 8/1932)
Victoria & Albert Museum

The Swan, oil on canvas, 27½ × 19½ ins.
1932 (MN 6/1932)

Swings, Rye Marshes, watercolour, 15⅛ × 22¼
ins. sgd. in full. 1932 (MN 7/1932)

Totems,★ pencil & watercolour, 22⅜ × 15¼ ins.
sgd. in full. 1932 (MN 17/1932)
Graves Art Gallery, Sheffield

Tree Landscape, watercolour.
c. 1932 (MN 15/1932)

Whiteleaf Cross, oil on canvas, 21¾ × 30 ins.
c. 1932 (MN 14/1932)

1933 *Convolvulus*★ (design for Urne Buriall), water-
colour. 1933 (MN 3/1933)

Egg, Leaf and Stone, watercolour & pencil, 7 ×
10 ins. 1933 sgd. with cartouche b.r. insc.
below: 'for Richard's New Year card 1945'.

Fallen Trees, Savernake Forest, watercolour, 10¼ ×
14⅝ ins. insc. in full b.l. (probably 1933)
Whitworth Art Gallery

Mandrake (after *Garden of Cyrus* illustration),
oil on canvas. *c.* 1933

Mediterranean, watercolour, pencil & crayon,
12⅜ × 18⅛ ins.
insc. with monogram b.r. *c.* 1933
Whitworth Art Gallery

Poised Objects, watercolour, 22 × 14½ ins.
insc. in full b.r.
St. Anne's College, Oxford

Snow on Romney Marsh, Seen From Lympne (view
from Kenneth Clark's house at Lympne),
watercolour, 6½ × 9¾ ins. unsgd. *c.* 1933

Spreading Tree, watercolour. *c.* 1933

Summer★ (design for Urne Buriall), oil on canvas,
 21 × 30 ins. 1933 (MN 1/1933)

Summer (study for oil), pencil & watercolour,
 13 × 21½ ins. insc. in full b.l. 1933

ILLUSTRATIONS AND BOOK DESIGNS

1930–33 *Dark Weeping*, A.E. designs by Paul Nash. Faber

1932 *Urne Buriall and the Garden of Cyrus*, by Sir

Thomas Browne, with 30 drawings by Paul Nash. Cassell, 1932

LITERARY WORK

1930 Contributions to *Weekend Review* and *Theatre Arts Monthly* (U.S.A.)

1931–33 Regular contributions to *Weekend Review*, *The*

Listener

Occasional contributions to *The Stencil*, Curwen Press, *Journal of Careers*. Letters to *The Times*.

INDUSTRIAL DESIGN

1930–33 Poster designs, textile designs (no reliable records of the date and range of this work have been traced)

BIOGRAPHICAL CHRONOLOGY 1933 (July)–1935

1933 July, visited Avebury accompanied by Ruth Clark while staying at Marlborough.
 November, went to France, stayed at Avignon to recover from renewed attack of bronchial asthma, then moved on to Nice.

1934 April, publication of *Unit One* and exhibition of members' work at Mayor Gallery.
 April–May, Nashes left Nice, visited Spain, Gibraltar and North Africa.
 June, returned to London then, after a short stay at Owley, moved to a cottage near Small Hythe, Romney Marsh. Met Charles and Clare Neilsen.
 August, discovered object which became *Marsh Personage*.
 October, moved to Mrs. Hilda Felce's house on Ballard Down near Swanage. Became closely acquainted with Archibald Russell.

1935 February, took lodgings at No. 2 The Parade, Swanage.
 Commissioned by Jack Beddington to undertake compilation of *The Shell Guide to Dorset*.
 June, exhibition of watercolours at Redfern Gallery.
 Disintegration of *Unit One*.

PRINCIPAL EXHIBITIONS

1934 City Museum & Art Gallery, Hanley
 '*Unit One* exhibition including oils & watercolours by Paul Nash'

1935 The Redfern Gallery, Old Bond Street, London, W.1
 'Watercolours and Drawings by Paul Nash'

PAINTINGS, WATERCOLOURS AND DRAWINGS 1934–1935

1934 *Algeciras*, watercolour. *c.* 1934
 Arishmel Gap, watercolour. *c.* 1934

Avebury,★ watercolour, 14¼ × 10¼ ins.
 c. 1934 (MN 15/1934)

Baie des Anges, Nice, watercolour, 7 × 10 ins.
 1934 (MN 1/1934)
The Blue Pool, Dorset, watercolour, 22½ × 15½
 ins. *c.* 1934
Cerne Giant, Dorset, watercolour, 11¾ × 15½ ins.
 1934 (or 1935) (MN 5/1934)
Channel, watercolour (?). *c.* 1934
The Château, Nice, watercolour (?). *c.* 1934
Coast Near Gibraltar, watercolour, 7 × 10 ins.
 sgd. b.r. 1934 (MN 3/1934)
Coast Scene, watercolour.
 1934 (destroyed by enemy action 1944)
Convent, Avignon, watercolour (?). *c.* 1934
Country Scene, Owley, nr. Tenterden, Kent, oil on
 canvas, 23 × 15 ins. 1934 (MN 9/1934)
Design for Today, oil on canvas.
 1934 (MN 12/1934)
Design of Trees, watercolour. 1934
Equivalents for the Megaliths,★ oil on canvas, 19⅜
 × 28¾ ins. s.f.b.l. 1934 (MN 4/1934)
Event on the Downs,★ oil on canvas, 20 × 24 ins.
 sgd. b.l. 1934 (MN 20/1934)
 Department of the Environment
Landscape of the Megaliths,★ oil on canvas, 19⅜ ×
 28¾ ins. sgd. b.l. 1934 (MN 4/1934)
 The British Council
Mansions of the Dead, oil on canvas, 30 × 20 ins.
 1934 (MN 17/1934)
Megalith, Avebury (Study for), pencil & ink.
 c. 1934
Monolith, pencil & ink (?). *c.* 1934
Moorish Ruin, Ronda, watercolour, 7 × 10 ins.
 1934 sgd.
Peveril Point, Dorset, watercolour, 7¾ × 11¼ ins.
 1934 (MN 6/1934)
The Pier, Swanage, watercolour, 10 × 14 ins.
 1934 (MN 18/1934)
Reef, watercolour, 7 × 11¼ ins. 1934
Rocks, watercolour. *c.* 1934
Sea Birds, watercolour. *c.* 1934
Sea Study, watercolour. *c.* 1934
Seaside, watercolour. *c.* 1934
Sea Wall, Swanage,★ pencil & watercolour,
 14¾ × 21¾ ins.
 sgd. in full b.l. 1934 (MN 10/1934)
Seaweed in Surf, watercolour, 10 × 14 ins.
 insc. in full b.r. *c.* 1934
Shore, watercolour. *c.* 1934
Souvenir, Marseilles, watercolour. *c.* 1934
Spanish Coast, watercolour, 7 × 12¼ ins.
 sgd. b.l. 'Spanish Coast for Clare, Paul Nash,
 Christmas 1934'
Sun Deck (SS Mauretania), watercolour.
 1934 (MN 2/1934)

Swanage, The Jetty, watercolour, 11½ × 15½ ins.
 1934 (MN 11/1934)
Tide, watercolour, 14 × 22 ins. 1934
Tree on the Marsh, watercolour. *c.* 1934
Trees, watercolour. *c.* 1934
View 'R'★ (Hotel des Princes, Nice), oil on canvas,
 24½ × 17½ ins. 1934 (MN 7/1934)
View 'S'★ (Hotel des Princes, Nice), oil on canvas,
 15¾ × 17½ ins. monogram b.r. 1934
Voyages of the Moon★ (first title: *Formal Dream*),
 oil on canvas, 28 × 21¼ ins.
 insc. in full & dated & monog. b.r.
 1934–37 (MN 14/1934)
 Tate Gallery
Wood Fetish, pencil, 27 × 14½ ins.
 1934 (MN 19/1934)

1935

Abstraction, pencil & watercolour, 11 × 7¾ ins.
 1935
Andante, pencil & watercolour, 11¼ × 15 ins.
 monogram b.l. 1935 (MN 5/1935)
Ballard Phantom, watercolour, 16 × 23 ins.
 1935 (15/1935)
Bitter Sweet, watercolour, 6½ × 9½ ins.
 c. 1935
Cloud and Two Stones,★ oil on canvas, 20 × 15
 ins. cartouche b.r. 1935 (MN 6/1935)
Comment on Leda, watercolour, 4¾ × 3½ ins.
 1935 (MN 9/1935)
Corfe Castle from the Heath, watercolour, 10¾ ×
 14¾ ins. sgd. & dated. 1935
Creech Folly, Dorset, watercolour.
 1935 (MN 11/1935)
Dorset Coast (Kimmeridge Shore), watercolour,
 11¼ × 15¼ ins. *c.* 1935 (MN 1/1935)
Dorset Landscape, watercolour, 15¼ × 22½ ins. 1935
Easter, watercolour, 14¾ × 22 ins.
 c. 1935 (MN 16/1935)
Fossil Shells (notebook study), pencil & water-
 colour, 5½ × 8¼ ins. *c.* 1935
Hill Architecture, watercolour, 11¼ × 15½ ins.
 1935–37 (MN 14/1935)
Ironmaster's Folly, watercolour, 15 × 22½ ins.
 1935
Landscape of Bleached Objects,★ oil on canvas,
 15 × 20 ins. 1935 (lost in France 1940 through
 enemy action)
Maiden Castle, Dorset, watercolour, 12 × 16 ins.
 1935 (MN 18/1935)
Maiden Castle, pencil study on tracing paper,
 14½ × 15¾ ins. *c.* 1935
Mineral Objects (Kimmeridge), oil on canvas,
 20 × 24 ins. unsgd. 1935 (MN 13/1935)
No. 2 The Parade, Swanage, watercolour, 11¼ ×
 15½ ins. 1935

Objects in Relation,★ oil on canvas, 20 × 24 ins.
 sgd. b.l. 1935 (MN 7/1935)
 St Paul's School
Object on the Shore, watercolour.
 1935 (MN 10/1935)
Pavement, watercolour. *c.* 1935
Shiprail, watercolour, 9¾ × 6¾ ins.
 c. 1935 (MN 3/1935)
Shore Study (notebook study), watercolour,
 7¼ × 10 ins. *c.* 1935
Striptease Object, watercolour. *c.* 1935
Tide, watercolour, 14 × 22 ins.
 1935 (MN 2/1935)

Trees on the Wiltshire Downs, pencil & grey wash,
 6¾ × 9¾ ins.
 sgd. b.l. 'from Paul'. 1935 (MN 12/1935)
 British Council
View from Epwell Mill, watercolour, 15 × 22 ins.
 sgd. in full b.l. 1935
The Waves, watercolour & pencil, 16 × 23 ins.
 sgd. in full b.r. *c.* 1935
 Victoria & Albert Museum
Winchelsea Beach, watercolour & pencil, 6¾ ×
 9¾ ins. insc. in full. *c.* 1935?

LITERARY WORK

1935 *Dorset, Shell Guide* compiled and written by Paul
 Nash. Architectural Press. Preface dated 1935
1934–35 Contributions to *The Listener, Unit One, Sermons*

by *Artists, Axis no. 1, Architectural Review, Signature no. 1*, Letters to *The Observer*.

BIOGRAPHICAL CHRONOLOGY 1936–1939

1936 Moved to 3 Eldon Grove, Hampstead.
 Invited to be one of the members of the English Committee responsible
 for the organisation of the International Surrealist Exhibition in London.

1937 Despite constant attacks of asthma, prepared a large exhibition, held at
 the Redfern Gallery in April.
 August, forced by illness to go into a clinic in Hertfordshire.
 September, visited Dorset then, on his return home, prepared an exhibition of industrial designs which opened in October at the Curwen Press.

1938 January, resumed teaching at the Royal College of Art for two periods a
 week as Assistant in the School of Design.
 Prepared for exhibition of oils and watercolours held at the Leicester
 Galleries in May.
 June, visited *Madams*, the Neilsens' house near Newent in Gloucestershire.

1939 March, stayed in Bristol.
 Left Eldon Grove for Oxford in August.
 September, moved to rooms in Beaumont Street, Oxford.
 Signed a contract with Cobden Sanderson for an autobiography to be
 called *Genius Loci*; title later changed to *Outline*.
 Organised and became the Chairman of the Arts Bureau in Oxford for
 War Service.

PRINCIPAL EXHIBITIONS

1936 New Burlington Galleries, Burlington Gardens,
 London, W.1.
 'The International Surrealist Exhibition, including oils, collages & objects by Paul Nash'
1937 Redfern Gallery, Cork Street, Burlington Gardens, London, W.1.

'Watercolours, drawings, collages, and objects
by Paul Nash'
Exhibition Rooms of the Curwen Press, Great
Russell Street, London, W.C.1.
 'Industrial Designs and Book Decorations by
 Paul Nash'

1938 The Leicester Galleries, Leicester Square, London, W.C.2.
> 'Exhibition of Recent Work by Paul Nash'
>Biennale Exhibition, Venice.
>> 'Exhibition of British Section, including oils and watercolours by Paul Nash'

1939 Gordon Fraser Gallery, Portugal Place, Cambridge.
> 'Oils and watercolours and Exhibits by Paul Nash'

Arthur Tooth & Sons Ltd., New Bond Street, London, W.I.
> 'New Paintings by Eve Kirk and Paul Nash'
>British Pavilion, New York World's Fair (1939)
>> 'Exhibition of Contemporary British Art organised by The British Council, including watercolours and oils by Paul Nash'

PAINTINGS, WATERCOLOURS AND DRAWINGS 1936–1939

1936 *Aerial Aspics*, watercolour, $5\frac{1}{2} \times 8$ ins. insc. 'From Paul'. *c.* 1936

Study for Ballet Scene, watercolour. 1936

Bird in a Cage, watercolour, $15\frac{1}{2} \times 22\frac{1}{2}$ ins. sgd. b.l. *c.* 1936
St Paul's School

Cold Collation, collage. 1936

Study of Distant Hill, watercolour, $7 \times 10\frac{1}{4}$ ins. *c.* 1936

Encounter in the Afternoon, oil on canvas, 20×30 ins. sgd. 1936 (MN 1/1936)
Edward James Foundation, on loan to Brighton Art Gallery

Encounter on the Downs, pencil & watercolour, $7\frac{1}{2} \times 11$ ins. insc. in full b.l. & 'Souvenir for Herbert from Paul'. *c.* 1936

Landscape at Large, collage. 1936

Landscape from a Dream, watercolour (study for oil). *c.* 1936 (MN 15/1937)

Souvenir of Worth, pencil, crayon & watercolour. sgd. & inscribed. 1936

Swanage, photographic collage with watercolour. background, $14\frac{1}{8} \times 16\frac{1}{2}$ ins. titled b.r. *c.* 1936

Window Bird, watercolour. *c.* 1936

Worth Matravers, Dorset,★ watercolour, 15×20 ins. full name b.l. *c.* 1936 (MN 2/1936)

1937 *Ballard Landscape*, watercolour, $15\frac{1}{2} \times 22\frac{1}{2}$ ins. 1937? (MN 17/1935)

Study of a Bell-Cote (notebook sketch), crayon. *c.* 1937

Changing Scene, oil on canvas, 30×20 ins. sgd. in full b.l. 1937 (MN 24/1937)

Conquest of the Stratosphere, collage. 1937
The British Council

Earth Sea, watercolour, 15×24 ins. 1937

Empty Room,★ watercolour, $14\frac{3}{4} \times 22$ ins. unsgd. 1937 (MN 19/1937)

Encounter of Two Objects, oil on canvas, 15×20 ins. sgd. & dated b.r. 1937 (MN 17/1937)

Environment of Two Objects,★ oil on canvas, $20\frac{1}{2} \times 30\frac{1}{2}$ ins. sgd. b.l. 1937 (14/1937)

Forest and Room,★ watercolour, $8\frac{1}{4} \times 9\frac{1}{2}$ ins. sgd. with monogram & insc. to Edward James. Probably 1936–37
Edward James Foundation, on loan to Brighton Art Gallery

Ilsley Downs, watercolour, 7×10 ins. full name b.l. 1937

Inhabited Landscape, watercolour, 5×9 ins. unsgd. *c.* 1937 (MN 12/1937)

Landscape at Bledlow, watercolour, $15\frac{1}{2} \times 22\frac{1}{2}$ ins. Probably 1937 (MN 12/1938)

Landscape of the Megaliths, watercolour, $19\frac{3}{4} \times 29\frac{3}{4}$ ins. sgd. in full b.l. 1937 (MN 23/1937)
Albright-Knox Art Gallery, Buffalo, U.S.A.

Leaf Resting, watercolour. 1937

London Landscape, Winter (3, Eldon Grove, Hampstead), watercolour, 18×24 ins. 1937 (MN 10/1937)

Maiden Castle, watercolour, $21\frac{1}{2} \times 30$ ins. insc. in full & 1937 b.r. 1937
Vermont University

The Mollusc Winning, watercolour. 1937 (MN 9/1937)

Nest of the Phoenix, oil on canvas, $34\frac{1}{2} \times 33$ ins. unsgd. 1937 (25/1937)

Nest of the Wild Stones,★ watercolour & pencil, 15×22 ins. sgd. b.l. 1937 (MN 5/1937)
Arts Council of Great Britain

Objects at Rye, watercolour. 1932–37

Objects in a Field, watercolour, $12\frac{1}{2} \times 22$ ins. 1937 (13/1937)

Only Egg, object collage. *c.* 1937

Polar Object, pencil & watercolour, $13\frac{1}{2} \times 19\frac{1}{4}$ ins. sgd. in full b.l. 1937

Portrait of a Lunar Hornet, collage. 1937

The Room of the Shooting Stars, collage. 1937

Sea Coast Folly, watercolour. *c.* 1937

Self Portrait, collage. 1937

Stone Forest,★ pencil, black crayon & water-
 colour, $23\frac{1}{8} \times 15\frac{3}{4}$ ins.
 insc. in full b.r. 1937 (MN 20/1937)
 Whitworth Art Gallery
Stone Sea,★ watercolour, 15 × 22 ins.
 unsgd. 1937 (MN 8/1937)
Strange Coast,★ oil on canvas, 19 × 28 ins.
 1937 (MN 6/1937)
Sunset at Worth Matravers,★ watercolour, 7 × 10
 ins. unsgd. 1937 (MN 16/1937)
Trees in Sunlight (study). *c.* 1937
Voyage of the Fungus,★ watercolour, $11\frac{1}{4} \times 15\frac{1}{2}$
 ins. unsgd. (Completed) 1937 (MN 1/1937)
 Edward James Foundation, on loan to
 Brighton Art Gallery
Voyages of the Moon★ (*Formal Dream*), oil, 28 ×
 $21\frac{1}{4}$ ins. sf & mon & date b.r. 1934–7
 Tate Gallery
Window, Eldon Grove, watercolour, 21 × $14\frac{1}{2}$ ins.
 c. 1937 (MN 11/1937)
Winter Garden, watercolour. 1937
Winter Sea★ (completion of), conté, pencil &
 watercolour, $14\frac{3}{8} \times 21$ ins.
 insc. in full & dated b.l. 1925–37 (MN 2/1937)
 Graves Art Gallery, Sheffield
Winter Sea★ (completion of), oil on canvas, 28 ×
 38 ins.
 insc. in full & dated 1925–37 b.l. (MN 3/1937)
 York City Art Gallery
Wood of the Nightmares' Tales, watercolour with
 body colour, 7 × 10 ins.
 monogram b.l. 1937 (MN 18/1937)
Wood on the Hill, watercolour, 22 × 15 ins.
 unsgd. 1937 (MN 21/1937)
Wood Sea,★ watercolour, $15\frac{1}{2} \times 23$ ins.
 sgd. b.l. 1937 (MN 7/1937)

1938 *The Archer Overthrown*★ (completed), oil on
 canvas, $27\frac{1}{2} \times 36$ ins.
 full name b.l. 1931–37–38 (MN 8/1938)
The Blue Pool (study 3), watercolour, 15 × $22\frac{1}{2}$
 ins. *c.* 1938
Chestnut Waters (former title: *The Lake*),★ oil on
 canvas, $40\frac{1}{2} \times 50\frac{1}{4}$ ins.
 sgd. b.l. 1921–27–38 (MN 18/1938)
 National Gallery of Canada
Circle of the Monoliths,★ oil on canvas, 31 × 41
 ins. sgd. mid l. 1938 (MN 1/1938)
 Leeds City Art Gallery
Druid Landscape,★ oil, 23 × 16 ins, s.b.l. 1938
 The British Council
Forest of Dean (study 1), watercolour, 15 × 22
 ins. 1939 (MN 13/1939)
Forest of Dean,★ watercolour, 11 × 16 ins.
 1938 (MN 11/1938)

From Capel Carig (study, notebook sketch), blue
 & brown crayon, $7\frac{1}{8} \times 10\frac{1}{8}$ ins.
 insc. with title b.l. *c.* 1938
Garden Under Snow, watercolour, $11\frac{3}{8} \times 15\frac{1}{8}$
 ins. 1938–39
The Grotto at Eldon Road, watercolour, 22 × $15\frac{1}{2}$
 ins. 1938
 Edward James Foundation, on loan to
 Brighton Art Gallery
Grotto in Snow, watercolour, $22\frac{1}{2} \times 15\frac{1}{2}$ ins.
 1938–39 (MN 8/1939)
Hampstead Garden,★ watercolour, 15 × 22 ins.
 1938
Image of the Stag, watercolour, 11 × 13 ins.
 sgd. in full b.l. *c.* 1938 (MN 16/1938)
In the Marshes, collage, bark, sticks, bamboo,
 $9\frac{1}{2} \times 14\frac{1}{4}$ ins. *c.* 1938
Landscape at Penn Pitts, watercolour, $15\frac{5}{8} \times 23$
 ins. sgd. b.l. *c.* 1934–38?
 Victoria & Albert Museum
Landscape from a Dream,★ oil on canvas, $28\frac{1}{2} \times$
 40 ins. insc. in full b.l. 1936–38 (MN 2/1938)
 Tate Gallery
Landscape of the Death Watch,★ watercolour, 11 ×
 $15\frac{1}{2}$ ins. sgd. in full b.l. 1938 (MN 15/1938)
Llyn y Dinas (notebook sketch), brown & blue
 crayon, $7\frac{1}{8} \times 10$ ins. *c.* 1938
Metamorphosis,★ oil on canvas, 25 × 30 ins.
 1937 or 1938 (MN 10/1938)
 (related to the watercolour *Forest & Room*)
Nocturnal Landscape,★ oil on canvas, $30\frac{1}{8} \times 40\frac{5}{8}$
 ins. insc. in full b.l. 1938 (MN 5/1938)
 Manchester City Art Gallery
Nostalgic Landscape (completion of), oil on canvas,
 28 × 20 ins. insc. in full b.l. 1923–38 (MN
 4/1938)
 City of Leicester Museum & Art Gallery
Silbury Hill, watercolour, 15 × 22 ins.
 sgd. in full in pencil, b.l. *c.* 1938 (MN 19/1938)
Silbury Hill, oil on canvas, 19 × $28\frac{1}{2}$ ins.
 1938 (MN 7/1938)
Spring at Fawley Bottom, watercolour.
 c. 1938 (destroyed 1944)
Stone Tree, oil on canvas, 22 × 15 ins.
 sgd. in full b.r. 1938 (MN 20/1938)
Swan Sea Piece, collage, 20 × 13 ins. *c.* 1938
The Two Serpents★ (*The Wood Shed*), 36 × 28
 ins. sgd. b.r. 1928–38 (MN 17/1938)
Welsh Mountain (study, notebook sketch), crayon,
 $6\frac{3}{8} \times 10$ ins. *c.* 1938
Woods on the Avon Shore, pencil & watercolour,
 $7\frac{1}{2} \times 10\frac{1}{2}$ ins. sgd. & dated 'Paul Nash 1938'
 b.l. (MN 14/1938)
 Graves Art Gallery, Sheffield

1939 *Aberystwyth*, watercolour, $10\frac{7}{8} \times 14\frac{3}{4}$ ins.
 1939 (MN 15/1939)
 Clifton Gorge (study 1), watercolour, $10\frac{3}{4} \times 14\frac{1}{2}$
 ins. sgd. in full, 1939 (MN 6/1939)
 Clifton Gorge (study 2), watercolour, $16\frac{1}{2} \times 22\frac{1}{2}$
 ins. 1939 (MN 7/1939)
 Denizens of the Forest of Dean,★ watercolour, $11 \times$
 $15\frac{1}{2}$ ins. 1939 (MN 12/1939)
 Different Skies, watercolour, 15×11 ins.
 unsgd. 1939 (MN 20/1939)
 Earth Home (or *The Fortress*), oil on canvas,
 $27\frac{1}{2} \times 35\frac{1}{2}$ ins.
 insc. in full b.l. 1939 (MN 9/1939)
 Giant's Stride,★ watercolour, 11×15 ins.
 1939 (MN 9/1938)
 Gregynog,★ watercolour, $15\frac{1}{2} \times 22\frac{1}{2}$ ins.
 c. 1939 (MN 11/1939)
 Grotto in the Snow,★ oil on canvas, 28×19 ins.
 1939 (MN 14/1939)
 Tate Gallery
 Hillside at Bristol, watercolour, 7×10 ins.
 1939
 Landscape at Epwell Mill, watercolour, 16×22
 ins. *c.* 1939 (MN 10/1939)
 Lebensraum,★ collage & watercolour, $15 \times 22\frac{1}{2}$
 ins. 1939 (19/1939)
 London, Winter Landscape, watercolour, $15\frac{1}{2} \times$
 $22\frac{1}{2}$ ins. 1939 (MN 4/1939)
 Madams, watercolour, 11×15 ins. 1939
 Minotaur,★ watercolour, $11\frac{1}{4} \times 13$ ins.
 insc. in full b.l. 1939 (MN 16/1939)
 Monster Field, oil on canvas, $30\frac{1}{4} \times 40$ ins.

 sgd. in full b.l. 1939 (MN 3/1939)
 Durban Art Gallery
 Monster Field (study 1), watercolour, $11\frac{1}{2} \times 16$
 ins. sgd. in full b.l. 1939 (MN 1/1939)
 Monster Field (study 2),★ watercolour, $11\frac{1}{2} \times 16$
 ins. sgd. in full b.l. 1939 (MN 2/1939)
 Monster Shore, oil on canvas, 28×36 ins.
 insc. in full b.l. 1939 (MN 5/1939)
 Hamilton Art Gallery, Hamilton, Ontario
 Object at Scarbank,★ pencil & watercolour, $11 \times$
 $15\frac{1}{2}$ ins. sgd. 1939
 On the Severn, pencil & watercolour, $7 \times 9\frac{3}{4}$ ins.
 insc. in full. 1939
 Penn Pitts before the Woods, watercolour, 23×16
 ins. 1939 (18/1939)
 Rose of Death, collage (destroyed). 1939
 The Severn, watercolour, 11×16 ins.
 c. 1938–9 (MN 13/1938)
 The Severn Bore, watercolour, 11×16 ins.
 c. 1938–9 (MN 6/1938)
 Souvenir, Forest of Dean, watercolour, $11 \times 15\frac{1}{4}$
 ins. insc. b.r. 'for Clare from Paul, souvenir'.
 1939
 Souvenir of Bristol, watercolour, 7×10 ins.
 sgd. in full b.l. 1939
 Stalking Horse, watercolour, 15×22 ins.
 1939 (MN 17/1939) (destroyed by fire)
 The Two Caterpillars, watercolour, $11 \times 8\frac{3}{4}$ ins.
 1939
 View from Window, Double Image, pencil &
 watercolour, $9\frac{3}{4} \times 6\frac{3}{4}$ ins. 1939

LITERARY WORK

1937–39 Contributions to *Manchester Evening News*, *Signature* nos. 5 & 9, *Country Life*, *News Chronicle*, *Architectural Review*, *The Painter's Object*, *Art and Education* & *The Listener*

BIOGRAPHICAL CHRONOLOGY 1940–1946

1940 Resigned teaching post at the Royal College of Art when the school was evacuated from London.

 March, Arts Bureau completed handing over its dossiers to other organisations, and ceased to function.

 Recommended by War Artists Advisory Committee to undertake work as official artist and appointed to the Air Ministry.

 July, Nashes moved to a flat at 106 Banbury Road, Oxford.

 December, termination of appointment with Air Ministry.

1941 January, began working as official artist for Ministry of Information.
Battle of Britain and *Defence of Albion* commissioned.

1944 Sale of 3 Eldon Grove.
April, publication of *Paul Nash*, in the first paperback series of 'Penguin Modern Painters'.
Spent October and Christmas at Cleeve Hill, Cheltenham.

1946 Taken seriously ill in January. Visited Boscombe to recuperate in July, where he died on July 11th. Buried in the churchyard of Langley Parish Church, July 17th.

PRINCIPAL EXHIBITIONS

1940 National Gallery, London
'British Painting since Whistler'
Museum of Fine Arts, Boston
'Exhibition of Contemporary British Art Organised by The British Council'

1941 National Gallery, London
'Six Watercolour Painters of Today'

1942 Redfern Gallery, Cork Street, Burlington Gardens, London, W.1
'Watercolours by Paul Nash'

1943 C.E.M.A.
'An Exhibition of Applied Design (1908–42) by Paul Nash.' (Circulating Exhibition)
Temple Newsam House, Leeds
'Paintings and Drawings by Paul Nash & Sculpture & Design by Barbara Hepworth'

1945 Arthur Tooth & Sons Ltd, Bruton Street, London, W.1
'New Watercolours by Paul Nash'
Cheltenham Art Gallery
'Paintings, Drawings & Designs by Paul Nash'
Royal Academy of Arts
'War Artists' Advisory Committee Exhibition of National War Pictures'
Buchholz Gallery, East 57th Street, New York
'Contemporary British Artists'

1945 & 1946 British Council, Paris & Prague
'Exhibition of Contemporary British Art organised by The British Council'

1946 Tate Gallery
'The Vincent Massey Collection of Contemporary English Painting'
Musée D'art Moderne, Paris
'Unesco Exhibition of International Modern Art'
The Arts Council of Great Britain
'British Painters 1939–45.' (Circulating Exhibition)

PAINTINGS, WATERCOLOURS AND DRAWINGS 1940–1946

1940 *Bayswater Balloon*, watercolour, 11 × 15 ins. 1940 (MN 12/1940)
Bayswater Landscape,★ watercolour, 15½ × 22½ ins. 1940
Botanical Gardens, Oxford, watercolour. *c.* 1940
Cloud Study with Meteorological Notes, pencil & wash, 5 × 7⅞ ins. *c.* 1940
4 *Cloud Studies*, watercolour on blue paper, 5¾ × 9 ins. 1940
Cloud and Sun Study, watercolour & pencil, 5¾ × 9 ins. insc. (with various meterological notes). 1940
Study of *Cottage on Cliffs* (on reverse, study of an aeroplane), pencil & crayon on buff paper, 7¾ × 11 ins. *c.* 1940–46
Cumulus Floating above Layers of C (notebook sketch), pencil, 7 × 10½ ins. insc. with title. *c.* 1940

Encounter in the Afternoon, watercolour, 15 × 22¾ ins. insc. 'Paul Nash' b.r. 1940 (MN 40/1940) Manchester City Art Gallery
Gull Field, pencil & watercolour, 11½ × 15¾ ins. sgd. in pencil b.r. 'London, Paul Nash' Bristol Art Gallery
Hyde Park Landscape (Thaw), watercolour, 15½ × 22½ ins. 1940 (MN 5/1940)
Landscape under Snow (Hyde Park), watercolour, 7¾ × 9¾ ins. 1940 (MN 16/1940)
London Snow (Landscape at Marble Arch), watercolour, 11 × 15 ins. 1940 (MN 4/1940)
London, Winter Landscape, watercolour, 15½ × 22½ ins. 1940 (MN 1/1940)
London Winter Scene, No. 1, watercolour, 11 × 15 ins. 1940 (MN 14/1940)
London Winter Scene, No. 2, pencil & watercolour, 11⅜ × 15½ ins.

1940 (MN 15/1940) title on reverse
Tate Gallery

Madamite Moon,★ watercolour, $11\frac{1}{2} \times 15\frac{1}{2}$ ins.
sgd. in full b.r. 1940 (MN 7/1940)

Marble Arch (study), watercolour, $15\frac{1}{2} \times 22\frac{1}{2}$ ins.
1940 (MN 2/1940)

Marble Arch (*Snow*), watercolour, $15\frac{1}{2} \times 11\frac{1}{2}$ ins.
1940

Marble Arch Defence, watercolour.
c. 1940

Oxford (*Radcliffe Camera*), watercolour, $22\frac{1}{2} \times 15\frac{1}{2}$ ins. insc. in full b.l. 1940 (MN 13/1940)

Oxfordshire Landscape, watercolour.
c. 1940

The Park Gates, watercolour, $22\frac{1}{2} \times 15\frac{1}{2}$ ins.
insc. 'London Paul Nash' b.r.

Winter Park (*Hyde Park*), watercolour, 11×15 ins. 1940 (MN 3/1940)

WAR PAINTINGS

About to Fly (studies no. 5), watercolour.
1940 (MN 23/1940)

Aircraft Engine (study), watercolour & pencil on fawn paper, $12\frac{3}{4} \times 9\frac{1}{2}$ ins. 1940

Blenheim Bomber, chalk & watercolour, $12 \times 16\frac{1}{2}$ ins. insc. in full b.l. 1940–44 (MN 25/1940)
Brighton Art Gallery

Bomber Facing the Downs, watercolour.
1940 (MN 22/1940)

Bomber in the Corn, crayon & watercolour, 15×22 ins. sgd. in full b.r. & title on verso. 1940
Tate Gallery

Bomber in the Wood,★ watercolour, $15\frac{1}{4} \times 22\frac{3}{8}$ ins. sgd. b.r. 1940 (MN 44/1940)
Leeds City Art Gallery

Bomber Lair (No. 5), watercolour, $11 \times 15\frac{1}{4}$ ins. sgd. in full. 1940 (MN 49/1940)
City Art Gallery, Birmingham

Bomber Lair, Egg and Fin, watercolour, $11\frac{1}{4} \times 15\frac{3}{8}$ ins. sgd. in full. 1940 (MN 31/1940)
City Art Gallery, Birmingham

Day Fighter,★ oil on canvas, $19\frac{7}{8} \times 20$ ins. sgd. b.l. 1940 (MN 5/1941)
National Gallery of Canada

Dead March, Dymchurch, watercolour, 15×22 ins. 1940 (Lost at sea by enemy action)

Death of the Dragon, watercolour & chalk, 15×22 ins. sgd. in full b.l. 1940 (MN 39/1940)
Ashmolean Museum, Oxford

Down in the Channel,★ watercolour, 15×22 ins.
1940 (MN 47/1940)

The Flare Path,★ watercolour, 15×22 ins.
1940 (MN 28/1940)

Flying against Germany,★ oil on canvas, 28×36 ins. sgd. in full. 1940 (24/1940)

National Gallery of Canada

Ghost of the Heinkel, chalk & watercolour, $14\frac{3}{4} \times 21\frac{3}{4}$ ins. sgd. & dated. 1941

Hampden Bomber Flying against Germany, watercolour, $11 \times 15\frac{1}{2}$ ins.
insc. 'Paul Nash' b.l. 1940 (MN 27/1940)
National Gallery of Canada

Hampdens at Sunset,★ watercolour, 11×15 ins.
Begun 1940
Brighton Art Gallery

Long Nosed Blenheim, chalk & watercolour, $10\frac{3}{4} \times 15\frac{1}{2}$ ins. sgd. b.l. 1940 (MN 36/1940)
Leeds City Art Gallery

Messerschmitt in Windsor Great Park,★ pencil, chalk & watercolour, 15×22 ins. 1940
Tate Gallery

Moonlight Voyage, watercolour & chalk, 22×31 ins. 1940 (MN 26/1940)

Night Fighter,★ oil on canvas, $39\frac{7}{8} \times 20$ ins. sgd. b.r. 1940 (MN 5/1941)
National Gallery of Canada

Objective: Blenheim Bombers Bombing Barges at Le Havre, watercolour, $22\frac{1}{2} \times 30\frac{1}{4}$ ins.
insc. 'Paul Nash' b.r. 1940–41 (MN 32/1940)
Ferens Art Gallery

Portrait—Head of a Whitley Bomber, watercolour.
1940 (MN 19/1940)

Portrait of Short-Nosed Blenheim, watercolour, 15×22 ins. 1940 (MN 50/1940)

Raider on the Moors,★ watercolour & chalk, 15×22 ins. sgd. b.r. in full. 1940 (MN 41/1940)
Ashmolean Museum, Oxford

Raider on the Shore,★ watercolour, $15\frac{3}{16} \times 22\frac{5}{16}$ ins. sgd. in full b.l. 1940 (MN 41/1940)
Glasgow Art Gallery

Totes Meer,★ oil on canvas, 40×60 ins.
insc. in full b.r. 1940–41 (MN 1/1941)
Tate Gallery

Under the Cliff,★ watercolour & chalk, 15×22 ins. sgd. in full b.l. 1940 (MN 34/1940)
Ashmolean Museum, Oxford

Wellington about to Fly, watercolour, $11 \times 15\frac{3}{4}$ ins. insc. in full b.l. 1940 (MN 35/1940)
National Gallery of Victoria

Wellington Bomber, watercolour, 11×15 ins.
1940 (MN 29/1940)

Wellington Bomber Watching the Skies,★ pencil & watercolour, $11\frac{1}{4} \times 5\frac{3}{8}$ ins.
sgd. b.r. 1940 (MN 43/1940)
Leeds City Art Gallery

Wellingtons about to Fly, watercolour, 11×15 ins. 1940 (MN 35/1940)

Wellingtons—Bombers in the Open, No. 1, watercolour, 15×22 ins. 1940 (MN 20/1940)

Wellingtons Waiting (Bomber Lairs No. 2), chalk & watercolour, 12 × 16⅛ ins.
 insc. in full b.l. 1940 (MN 21/1940)
 Brighton Art Gallery

Whitley Bombers Sunning, watercolour, 11¼ × 15⅜ ins. sgd. 1940 (MN 48/1940)
 Birmingham City Museum & Art Gallery

Whitley Taking Off, watercolour, 15 × 22 ins. 1940 (MN 45/1940)

Whitleys at Play★ (Studies 1), watercolour. 1940 (MN 17/1940)

Whitleys at Sunrise,★ watercolour, 12 × 16½ ins.
 insc. 'Paul Nash' b.r. 1940 (MN 46/1940)
 Brighton Art Gallery

Wreckage (study 1), watercolour & pencil, 14½ × 22 ins. 1940 (MN 37/1940)

Wreckage (study 2), watercolour & crayon, 15 × 22½ ins.
 sgd. b.l. 1940 (MN 38/1940)
 National Gallery of Canada

Wreckage Landscape, watercolour & crayon, 15 × 22 ins. 1940 (MN 30/1940)
 National Gallery of Canada

1941 *Bright Cloud*, watercolour & crayon, 15¼ × 22¼ ins. sgd. in full b.l. 1941

Epwell, watercolour, 16 × 22½ ins.
 insc. in full & dated b.r. 1941

Epwell Mill (unfinished), watercolour & ink, 15¼ × 10 ins. monogram & date b.r. 1941

Forest of Dean, watercolour, 15½ × 22 ins. 1941 (MN 8/1941)

Garden of the Madamites,★ watercolour, 15½ × 22 ins. sgd. in full b.l. 1941 (MN 7/1941)

Haunted Garden, Oxfordshire, watercolour, pencil & chalk, 15½ × 22 ins.
 sgd. in full mid left. 1941–42 (MN 6/1941)
 Ashmolean Museum, Oxford

Landscape in the Afternoon, watercolour, 11½ × 15½ ins. sgd. in full. 1941 (MN 11/1941)

Laocoon,★ watercolour, 10¼ × 15¼ ins. 1941 (MN 12/1941)
 City of Leicester Art Gallery

Monster Pond,★ watercolour, 11½ × 15⅝ ins.
 sgd. in full b.l. 1941 (MN 14/1941)

Park Study, watercolour. 1941

Sea Wall at Madams, watercolour, 14 × 22 ins.
 insc. in full b.r. 1941 (MN 9/1941)

Study—Window View, watercolour, 11 × 16 ins.
 insc. 'Paul Nash' b.l. 1941 (MN 10/1941)

Walled Garden by a River, watercolour. 1941

WAR PAINTINGS

Battle of Britain,★ oil on canvas, 48 × 72 ins.

1941 (MN 3/1941)

Bomber at St Paul's (captured German Messerschmitt), note book study, pencil, 8 × 10 ins. 1941

The Return—Hampdens Coming Home at Dawn (Flying against Germany no. 6), watercolour, 15¼ × 22½ ins. insc. in full. b.r. 1941
 Manchester City Art Gallery

Target Area—Whitley Bombers over Berlin★ *(Flying against Germany)*
 insc. in full b.r. 1941 (MN 13/1941)
 Imperial War Museum

Wreckage—Lunar Rainbow (study for *Totes Meer*), pencil & watercolour, 15¼ × 22½ ins.
 insc. in full b.l. (MN 2/1941)
 City of Leicester Art Gallery

1942 *The Archer* (completion), oil on canvas, 28½ × 36 ins. sgd. b.l. 1930–37–42 (MN 8/1942)
 Southampton Art Gallery

Avenue, watercolour. 1942

Field by the Wood, watercolour, 15½ × 22½ ins. 1942 (MN 7/1942)

Ghost of the Hellebore & the Thornapple Escaping from the Woods, collage. c. 1942

Ghost of the Monster about to Rise, collage. c. 1942

Ghost in the Shale,★ watercolour, 15½ × 22½ ins. s.f.b.l. 1942 (MN 3/1942)

Ghost of the Turtle,★ watercolour, 15 × 22 ins.
 insc. in full b.r. 1942

Ghost of the Megaceros Hibernicus,★ watercolour, 15½ × 22½ ins. 1942 (MN 4/1942)

Kimmeridgian Ghost,★ watercolour, 15 × 22 ins. 1942 (MN 5/1942)

Landscape at Stow-on-the-Wold, watercolour, 15½ × 22½ ins. 1942

Landscape in Blue, watercolour. 1942

Landscape in Wiltshire, watercolour. 1942

Landscape with Aeroplane, watercolour, 7 × 10 ins. insc. b.l. 'for Zillah from Paul 1942'

The Leigh Woods, watercolour. 1942

London Landscape, Russell Square, watercolour. 1942

November Moon,★ oil on canvas, 30 × 20 ins. 1942 (MN 6/1942)
 Fitzwilliam Museum, Cambridge

Pillar & Moon (study for oil), watercolour, 6½ × 9½ ins. c. 1942

Pillar and Moon★ (completion), oil on canvas 20 × 30 ins.

insc. in full b.r. 1932–42 (MN 11/1942)
Tate Gallery
Russell Square, watercolour.
1942
The Senate House, watercolour, 10½ × 8 ins.
insc. 'A Russell Square souvenir for K' +
monogram. 1942
Sir Michael Sadler's Monster, watercolour.
1942
Sun Descending over Mountains (unfinished study),
watercolour & pencil with pen study of valley
on verso, 7 × 10¼ ins. *c.* 1942
Sunflower and Sun, oil on canvas, 20 × 30 ins.
monogram b.r. 1942 (MN 12/1942)
New South Wales Art Gallery
Trains over the Marshes, watercolour.
c. 1942?
Tree Study (bookmark—fragment of *Tree Study*
done from a window of the Russell Hotel),
watercolour, 10 × 3⅝ ins.
sgd. with cartouche r. 1942?
Trees, Oxford, watercolour & pencil, 15¼ × 11
ins. *c.* 1942
Vale of the White Blackbird, oil on paper board,
20 × 30 ins. sgd. b.l. 1942 (MN 9/1942)
National Gallery of Canada
Wiltshire Landscape, watercolour, 15 × 22 ins.
sgd. in full. 1942
Wood against the Tide, watercolour, 15½ × 22½
ins. *c.* 1941/42
Wooded Landscape,★ oil on paper board, 20 × 36
ins. sgd. b.r. 1942 (MN 8/1943)
National Gallery of Canada

WAR PAINTINGS

The Augsburg Raid (attack by Lancasters),★ water-
colour, 15¼ × 26¼ ins. 1942
Defence of Albion, watercolour & pencil, 21 × 31
ins. 1942
Defence of Albion, oil on canvas, 48 × 72 ins.
1941–42 (MN 1/1942)
Don't Forget the Diver, collage, pencil, ink &
watercolour, 11 × 15¼ ins.
title insc. on verso. *c.* 1942
Sketch of German Mine for Don't Forget the Diver,
pencil with rough sketch notes on verso.
c. 1942
Follow the Führer (series).
Into the Skies
Over the Snows
Under the Seas
watercolour & collage, 15¼ × 22¼ ins. 1942

1943 *Box Garden*, watercolour, 15½ × 22½ ins.
c. 1943 (MN 15/1943)

Bredon, Summer, watercolour, 11½ × 15½ ins.
sgd. in full & inscribed. 1943–44
Chesil Bank, Abbotsbury, Dorset, watercolour,
11¾ × 15½ ins. 1943 (MN 24/1943)
Clematis (notebook sketch), pencil & mono-
chrome wash, 12¼ × 10 ins. *c.* 1943–45
Design of Trees, Russell Square,★ watercolour,
22 × 15 ins.
sgd. with monogram. 1943 (MN 34/1943)
Early Sky, Salisbury Plain, watercolour, 8½ × 13
ins. insc. 'souvenir for Lance'. 1943
Garden Threshold (Madams, Glos.), watercolour,
15½ × 22½ ins. 1943 (MN 19/1943)
Incident at Madams,★ watercolour, 15½ × 22½ ins.
1943 (MN 9/1943)
Kensington Gardens, watercolour, 7½ × 10¾ ins.
1943 (MN 28/1943)
Landscape of the Bagley Woods, oil on canvas, 22 ×
34 ins. 1943 (MN 6/1943)
Landscape of the Brown Fungus, oil on canvas,
20 × 30 ins. 1943 (MN 32/1943)
Landscape of the Fungus★ (Gloucestershire), water-
colour, 15½ × 22½ ins. 1943 (MN 20/1943)
Landscape of the Malvern Distance (study 2),
pencil, chalks & watercolour on buff paper,
7½ × 10½ ins. 1943 (MN 16/1943)
Cecil Higgins Museum, Bedford
Landscape of the Malvern Distance (study 3), water-
colour, 15½ × 22½ ins. 1943 (MN 17/1943)
Landscape of the Malvern Distance, oil on canvas,
21½ × 30 ins. sgd. b.l. 1943 (MN 18/1943)
Southampton Art Gallery
Landscape of the Moon's First Quarter,★ oil on
canvas, 20 × 30 ins. 1943 (MN 35/1943)
Landscape of the Moon's First Quarter,★ water-
colour, 7½ × 10¾ ins. 1943 (MN 28/1943)
Landscape of the Puff Ball,★ watercolour, 15 × 22
ins. 1943 (MN 25/1943)
Landscape of the Red Fungus, watercolour, 15½ ×
22½ ins. 1943 (MN 23/1943)
Landscape of the Summer Solstice,★ oil on canvas,
28 × 36 ins.
insc. in full b.l. 1943 (MN 5/1943)
National Gallery of Victoria
Landscape of the Vale, Dawn,★ watercolour, 14⅞ ×
21⅞ ins. sgd. 1943
Birmingham City Museum and Art Gallery
Landscape of the Vale, East, watercolour, 15½ ×
22½ ins.
sgd. in full & dated b.r. 1943 (MN 12/1943)
Landscape of the Vale, Moonlight, watercolour,
15½ × 22½ ins. 1943 (MN 26/1943)
Landscape of the Vale, South, watercolour, 15½ ×
22½ ins. 1943 (MN 11/1943)

Landscape of the Vernal Equinox,★ oil on canvas, 27½ × 36 ins. 1943–44 (MN 10/1943)
H.M. The Queen Mother

Landscape of the Vernal Equinox,★ oil & watercolour, 21¼ × 29 ins. 1943–44

Landscape Study at Hungerford,★ watercolour, 12½ × 22½ ins. sgd. in full b.r. 1943 (MN 3/1943)

Landscape Towards Bredon, watercolour, 15 × 22 ins. 1943

Michaelmas Landscape, oil on canvas, 24⅞ × 30 ins. insc. in full b.r. 1943 (MN 30/1943)
Ferens Art Gallery

Oxford from Hinksey★ (study for oil *Oxford in Wartime*), watercolour, 11¾ × 15¾ ins. 1943 (MN 29/1943)

Study of skyscape for Oxford in Wartime, watercolour, 9¾ × 14¼ ins. 1943

Oxford in Wartime,★ oil on canvas, 45 × 40 ins. 1943 (MN 13/1943)
J.C.R. Worcester College, Oxford

Sickle and Nest, watercolour. 1943

Skylight Landscape, oil on canvas, 26 × 38 ins. 1943

Spinney Idyll, watercolour, 7½ × 10½ ins. 1943

Storm over the Landscape (study 1), watercolour, 15½ × 22½ ins. 1943 (MN 21/1943)

Storm over the Landscape (study 2), watercolour, 15½ × 22½ ins. 1943 (MN 22/1943)

Study in Pale Tones★ (Gloucestershire), watercolour, 15½ × 22½ ins. 1943 (MN 7/1943)

Summer Sketch for Zillah, watercolour, 8 × 12 ins. insc. b.l. with cartouche. 1942–43

Sunflower and Sun,★ watercolour, 22 × 15 ins. sgd. b.r. 1943 (MN 1/1943)
British Council

Sunflowers (notebook sketch), pencil, crayon & wash, 12¼ × 9 ins. *c.* 1943–45

7 notebook sketches of Sunflowers, pencil, crayon & wash, 15⅛ × 10 ins. *c.* 1943–45

Sunrise Landscape, Cleeve Hill, Cheltenham, watercolour, 15½ × 22½ ins. 1943 (MN 4/1943)

Sunrise over the Valley,★ watercolour, 15½ × 22½ ins. sgd. in full b.r. 1943 (MN 33/1943)

Trees in Russell Square, pencil & watercolour, 15¾ × 11 ins. 1943

Unfamiliar Aspect of a Familiar Monster (study of 'Toad's Mouth Rock' nr. Hathersage, Derbyshire)
pencil & watercolour & crayon on brown paper, 7¼ × 10¼ ins. cartouche b.r. & insc.

'For Richard Seddon' & title. 1943

Arrival of the Stirlings, watercolour, black chalk & pencil, 15¾ × 22⅞
insc. in full b.r. 1943 (MN 2/1943)
Whitworth Art Gallery

1944

Christ Church, Oxford, watercolour, 22 × 15½ ins. 1944 (MN 36/1943)

Cloud Cuckoo Nest,★ watercolour, 15½ × 22½ ins. 1944 (MN 7/1944)

Cumulus Head, watercolour, 15½ × 22½ ins. 1944 (MN 11/1944)

Dawn Flowers ('Aerial Flowers' series), watercolour, 15½ × 22½ ins. sgd. b.r. 1944 (MN 12/1944)

Dymchurch Steps (completion), oil on canvas, 26⅛ × 40⅛ ins.
sgd. in full & 1924–44 b.r. (MN 10/1944)
National Gallery of Canada (Massey Foundation)

Farewell,★ oil on canvas, 21 × 24 ins. sgd in full b.r. 1944 (MN 17/1944)

February Landscape, watercolour, 15 × 22 ins. 1944 (MN 25/1944)

Flight of the Magnolia,★ watercolour on tracing paper, squared, 11¾ × 16½ ins. unsgd. 1944 (MN 15/1944)

Flight of the Magnolia, oil on canvas, 19½ × 29½ ins. insc. in full b.l. 1944 (MN 16/1944)

Hill Landscape (Cleeve Hill, Cheltenham), watercolour, 15½ × 22¾ ins. 1944 (MN 3/1944)

Hills and the Plain, watercolour, 11 × 15 ins. 1944

Landscape of the British Museum,★ watercolour, 12 × 15 ins. 1944 (MN 14/1944)
Fitzwilliam Museum, Cambridge

Landscape of the Crescent Moon,★ oil on canvas, 20⅛ × 29¾ ins.
insc. in full b.l. 1944 (MN 26/1944)
Ontario Art Gallery

Landscape of the Moon's Last Phase,★ oil on canvas, 25 × 29⅞ ins.
insc. in full b.l. 1944 (MN 28/1944)
Walker Art Gallery

Landscape of the Vernal Equinox,★ oil on canvas, 25 × 30 ins.
insc. on verso: 'Landscape of the Vernal Equinox 2nd Version 1944, Paul Nash'. 1944
Painted for Margaret Nash.
Scottish National Gallery of Modern Art

March Landscape, watercolour, 15 × 22 ins. 1944 (MN 19/1944)

March Landscape, oil on canvas, 20 × 26 ins.
 1944 (MN 20/1944)
March Storm, watercolour, 15 × 22 ins.
 1944 (MN 13/1944)
March Woods (study 1), watercolour, 15 × 22
 ins. 1944 (MN 30/1944)
March Woods★ (study 2), watercolour, 15 × 22
 ins. 1944 (MN 31/1944)
Midsummer Night, watercolour, 15 × 22 ins.
 1944 (MN 18/1944)
Nocturnal Flower,★ watercolour, 11½ × 15½ ins.
 1944 (MN 22/1944)
Nocturne, Landscape of the Vale, watercolour, 15
 × 22 ins. 1944 (MN 27/1944)
Orchard at Madams, watercolour, 15 × 22 ins.
 1944 (MN 21/1944)
Oxfordshire Landscape, watercolour, 6¾ × 9¾ ins.
 1944 (MN 35/1944)
 Birmingham City Museum & Art Gallery
Path Between Trees (Russell Square Gardens),
 watercolour, 20½ × 13¾ ins.
 1944 (MN 33/1944)
 Milham Ford School, Oxford
Portrait of a Landscape Painted for Two Ladies,★ oil
 on canvas, 20 × 30 ins. 1944 (MN 8/1944)
Road to the Mountains,★ watercolour, 15½ × 22½
 ins. 1944 (MN 29/1944)
Snow Sunrise, watercolour, 16½ × 23½ ins.
 insc. in full & dated b.r. 1944
 National Gallery of Victoria
Sunset Eye: Study 1, watercolour & pencil, 15½ ×
 22½ ins. 1944 (MN 34/1944)
Sunset Flower,★ watercolour, 19 × 14 ins.
 1944 (MN 23/1944)
Sunset over Malvern Hills, watercolour, 11¾ ×
 22¾ ins. 1944 (32/1944)
Sunset over the Plain★ (study 1), watercolour, 14
 × 24 ins. 1944–45 (MN 5/1944)
Sunset over the Plain (study 2), watercolour, 11 ×
 15½ ins. 1944 (MN 6/1944)
Winter Country, watercolour, 15 × 22 ins.
 1944 (MN 24/1944)

WAR PAINTINGS

Battle of Germany, oil on canvas, 48 × 72½ ins.
 1944 (MN 2/1944)
Halifax Attack, watercolour, 15 × 22 ins.
 insc. in full b.l. 1944 (MN 4/1944)
Hampdens at Sunset,★ chalk & watercolour, 11½ ×
 16 ins. insc. in full b.l. 1940–44 (MN 18/1940)
 Brighton Art Gallery
Raid by Lancasters, watercolour, 15 × 22 ins.
 1944 (MN 1/1944)

1945

Eclipse of the Sunflower,★ watercolour, 16½ × 22½
 ins. 1945 (MN 13/1945)
 Victoria & Albert Museum
Eclipse of the Sunflower,★ oil on canvas, 28 × 36
 ins. sgd. b.l. 1945 (MN 14/1945)
 British Council
Edge of the Wood, watercolour, 15½ × 22½ ins.
 1945 (MN 30/1945)
Edge of the Wood, oil on canvas, 21¼ × 30 ins.
 1945 (MN 31/1945)
Flower Resting in the Landscape,★ watercolour
 15½ × 22½ ins. 1945 (MN 27/1945)
Hill, Plain & Cloud, watercolour, 11½ × 18½ ins.
 sgd. in full b.l. 1945
Hill, Plain & Cloud (study 1), watercolour, 11¾
 × 15½ ins. 1945 (MN 19/1945)
Hill, Plain & Cloud (study 2), watercolour,
 11¾ × 15½ ins. 1945 (MN 20/1945)
Landscape after Frost, watercolour, 15½ × 22½ ins.
 1945 (MN 16/1945)
Landscape after Snow,★ watercolour, 15½ × 22½
 ins. 1945 (MN 23/1945)
Landscape Emerging.★ Study 3. watercolour, 11 ×
 15¼ ins.
 cartouche b.r. 1945 (MN 21/1945)
Landscape Emerging. Studies 1 and 2, approx.
 same size as *Study 3*
Landscape Fading, watercolour, 11 × 15½ ins.
 1945 (MN 32/1945)
Landscape of Ancient Country, watercolour, 15¼ ×
 22¾ ins. 1945 (MN 28/1945)
Landscape under Mist,★ watercolour, 11¾ × 15½
 ins. 1945 (MN 18/1945)
Landscape under Mist and Frost (study 1), 15⅛ ×
 22⅜ ins. 1945 (MN 24/1945)
 National Gallery of Victoria
Landscape under Mist and Frost★ (study 2), water-
 colour, 11¼ × 15½ ins. 1945 (MN 25/1945)
Landscape under Snow★ (study 1), watercolour,
 11¼ × 15½ ins. 1945 (MN 22/1945)
*Landscape Through the Window & Through the
 Looking Glass*, watercolour, 15¾ × 22¾ ins.
 1945 (MN 17/1945)
Moonrise, Cleeve Hill, watercolour, 15½ × 22½
 ins. 1945 (MN 33/1945)
Moonrise over Stow-on-the-Wold, watercolour,
 15½ × 22¼ ins.
 sgd. b.r. 1945 (MN 26/1945)
Oxford Garden, watercolour, 11½ × 15½ ins.
 1945 (MN 34/1945)
Solstice of the Sunflower,★ oil on canvas, 28 × 36
 ins.
 sgd. & monogram b.l. 1945 (MN 15/1945)
 National Gallery of Canada

Sun Descending (study 1), watercolour, $11\frac{1}{4}$ × $15\frac{1}{2}$ ins. 1945 (MN 6/1945)

Sun Descending (study 2), watercolour, $11\frac{1}{4}$ × $15\frac{1}{2}$ ins. 1945 (MN 7/1945)

Sun Descending (study 4), watercolour, $11\frac{1}{4}$ × $15\frac{1}{2}$ ins. 1945 (MN 9/1945)

Sun Descending (study 5), watercolour, $11\frac{1}{4}$ × $15\frac{1}{2}$ ins. 1945 (MN 10/1945)

Sun Descending (study 6), watercolour, $11\frac{1}{4}$ × $15\frac{1}{2}$ ins. 1945 (MN 11/1945)

Sun Descending (study 7), watercolour, $11\frac{1}{4}$ × $15\frac{1}{2}$ ins. sgd. in full b.r. 1945 (MN 12/1945)

Study of Sun over Whittenham Clumps, pencil & crayon, 7 × $10\frac{1}{4}$ ins. c. 1945

Sunflower Study, pencil, watercolour & crayon, 16 × $11\frac{1}{2}$ ins. c. 1945

Sunflower and Sun (study), oil on canvas, 25 × 20 ins. c. 1945 Painted for Margaret Nash

The Sunflower Rises★ (unfinished watercolour study for projected oil), watercolour, 17 × $22\frac{3}{4}$ ins. 1945

The Sunflower Rises (notebook sketch), watercolour & pencil, squared, 10 × $13\frac{1}{4}$ ins. 1945

Sunrise Landscape, watercolour, $15\frac{1}{4}$ × $22\frac{1}{4}$ ins. c. 1945
Manchester City Art Gallery

Sunset Eye. Study 2, watercolour, $11\frac{3}{4}$ × $15\frac{1}{4}$ ins. sgd. in full b.r. 1945 (MN 1/1945)

Sunset Eye. Study 3, watercolour, 11 × 15 ins. 1945 (MN 2/1945)

Sunset Eye. Study 4, watercolour, $11\frac{1}{4}$ × $15\frac{3}{4}$ ins. 1945 (MN 3/1945)

Sunset Eye. Study 5, watercolour, $11\frac{1}{4}$ × 15 ins. insc. in full b.l. 1945 (MN 4/1945)

1946 *The Bluff*, watercolour, $7\frac{1}{2}$ × $10\frac{3}{4}$ ins. insc. in full b.l. 1946 (MN 9/1946)

Cloud Flora (study 1), watercolour, $15\frac{1}{2}$ × $11\frac{1}{2}$ ins. 1946 (MN 1/1946)

Clouds, Hill and the Plain, watercolour, $10\frac{3}{4}$ ×

$15\frac{3}{4}$ ins. 1946 (MN 2/1946)

Hydra Dandelion,★ watercolour, $15\frac{1}{2}$ × $11\frac{1}{2}$ ins. sf. & titled b.l.
H.M. the Queen

Landscape in Berkshire, watercolour, 7 × 10 ins. sgd. in full b.l. 1946

Landscape, Isle of Wight (study 1), watercolour, $8\frac{3}{4}$ × $13\frac{1}{2}$ ins. 1946 (MN 11/1946)

Landscape, Isle of Wight (study 2), (unfinished), watercolour, $15\frac{7}{8}$ × $22\frac{3}{4}$ ins. unsgd. 1946 (MN 12/1946)
Victoria & Albert Museum

Landscape, Isle of Wight★ (study 3), watercolour, $15\frac{1}{2}$ × $22\frac{1}{2}$ ins. 1946 (MN 13/1946)

Landscape of the Vegetable Kingdom, watercolour & pencil, $8\frac{3}{4}$ × $13\frac{1}{2}$ ins. 1946 (MN 10/1946)

Landscape of Wittenham Clumps, watercolour & pencil, $6\frac{3}{4}$ × 10 ins. sgd. in full b.r. 1946 (MN 6/1946)

Landscape under Mist (study 1946), watercolour, $7\frac{1}{2}$ × 11 ins. 1946

Landscape with Inhabited Sky, watercolour, $7\frac{3}{4}$ × $11\frac{1}{4}$ ins. 1946

Mist, Hill and Plain, watercolour, 11 × $15\frac{1}{2}$ ins. sgd. in full b.l. 1946 (MN 5/1946)

Ruin in the Forest of Dean, watercolour, 7 × 10 ins. sgd. in full b.l. 1946 (MN 8/1946)

Seascape, watercolour & pencil, 11 × $15\frac{1}{2}$ ins. 1946

Sun Descending (study 3), watercolour, $11\frac{1}{4}$ × $15\frac{1}{2}$ ins. cartouche b.r. 1946 (MN 3/1946)

Thistle in Down Country, watercolour, $15\frac{3}{4}$ × $11\frac{1}{2}$ ins. 1946 (MN 7/1946)

Water World (study 1), watercolour, 8 × 11 ins. 1946 (MN 3/1946)

Wittenham Clumps (unfinished study), oil & watercolour on white board with pencil & colour notes, 22 × 30 ins. 1946 (the last larger work on which Nash was engaged immediately before his death)

LITERARY WORK

1946 *Monster Field, a Discovery* recorded by Paul Nash, Counterpoint Publications, Oxford 1946.
Contributions to: *Vogue, The Listener, World Review, The Central Institute of Art and Design*

Bulletin, Transformation no. 3.
Introduction to Exhibition of his own and Eileen Agar's works.

POSTHUMOUS EXHIBITIONS

1947–48 South Africa
'Contemporary British Paintings and Drawings organised by the British Council'

1948 Tate Gallery 'Paul Nash, A Memorial Exhibition'

1949 Redfern Gallery, Burlington Gardens, London, W.I
 'Paul Nash & Frederick Gore. Paintings, watercolours, drawings, lithographs & wood engravings by Paul Nash'

1949-50 Canada
 'Exhibition of Paintings and Drawings by Paul Nash' organised by the British Council.

1953 The Leicester Galleries, Leicester Square, London, W.C.2
 'A Private Collection of Watercolours and drawings by Paul Nash'

1961 Redfern Gallery, Burlington Gardens, London, W.I
 'Paul Nash. An Exhibition of watercolours, paintings, lithographs and wood engravings'

1965 Marlborough Galleries, Old Bond Street, London, W.I
 'Art in Britain 1930–40 centred around *Axis*, *Circle*, *Unit One*, including paintings, watercolours & a collage by Paul Nash'

1970 Hamet Gallery, Cork Street, London W.I
 'Watercolours and Drawings by Paul Nash'

1971 Northern Arts Gallery, Newcastle upon Tyne
 'Paul Nash, A Northern Arts Exhibition'

POSTHUMOUS PUBLICATIONS

1947 *Aerial Flowers* by Paul Nash. Counterpoint Publications, Oxford 1947

1949 *Outline*, An Autobiography and other Writings by Paul Nash with a Preface by Herbert Read. Faber 1949

1951 *Fertile Image*, (a collection of photographs by Paul Nash) with introduction by James Laver and notes by Margaret Nash, being the correspondence of Gordon Bottomley and Paul Nash edited by C. Colleer Abbott and Anthony Bertram. O.U.P 1955

LIST OF PUBLIC COLLECTIONS
in which Paul Nash is represented

GREAT BRITAIN
London. Arts Council of Great Britain
 The British Council
 The British Museum
 The Imperial War Museum
 The Tate Gallery
Belfast. The Ulster Museum
Edinburgh. The Scottish National Gallery of Modern Art
Aberdeen. The Aberdeen Art Gallery
Bangor. The University College of North Wales
Bedford. The Cecil Higgins Museum
Birmingham. The Birmingham City Museum and Art Gallery
Blackpool. The Blackpool City Art Gallery
Brighton. The Brighton Art Gallery
Bristol. Bristol Art Gallery
Cambridge. The Fitzwilliam Museum
Carlisle. The Carlisle Museum and Art Gallery
Glasgow. The Glasgow Art Gallery and Museum
Harrogate. The Harrogate Borough Library
Hull. The Ferens Museum
Leeds. The City Art Gallery and Temple Newsam House
Leicester. The City of Leicester Museum and Art Gallery
Liverpool. The Walker Art Gallery
Manchester. The City Art Gallery
 The Whitworth Art Gallery, University of Manchester
Oxford. The Ashmolean Museum
Sheffield. The Graves Art Gallery
Southampton. The Southampton Art Gallery
York. The York City Art Gallery

AUSTRALIA
Adelaide. The National Gallery of South Australia
Melbourne. The National Gallery of Victoria
Sydney. The New South Wales Art Gallery

CANADA
Hamilton. The Hamilton Art Gallery
Ottawa. The National Gallery of Canada
Toronto. The Ontario Art Gallery

ITALY
Rome. Galleria Nazionale d'Arte Moderna

NEW ZEALAND
Dunedin. The Dunedin Public Art Gallery

SOUTH AFRICA
Durban. The Durban Art Gallery

UNITED STATES OF AMERICA
Buffalo (New York). Albright-Knox Art Gallery
Toledo. Toledo Museum of Art
Washington. The Washington National Gallery of Art

Index of Paintings, Watercolours and Drawings

General Index